DREAM HOMES

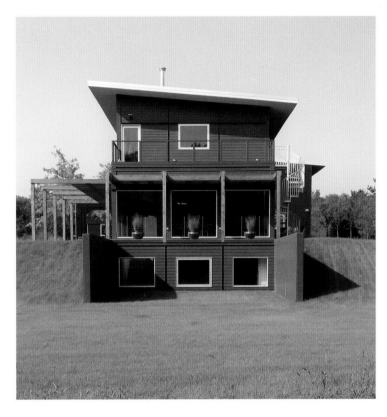
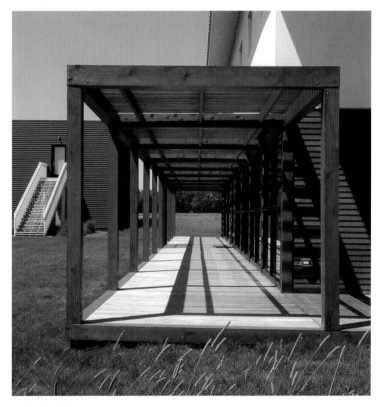

MINNESOTA

AN EXCLUSIVE SHOWCASE OF MINNESOTA'S FINEST ARCHITECTS, DESIGNERS AND BUILDERS

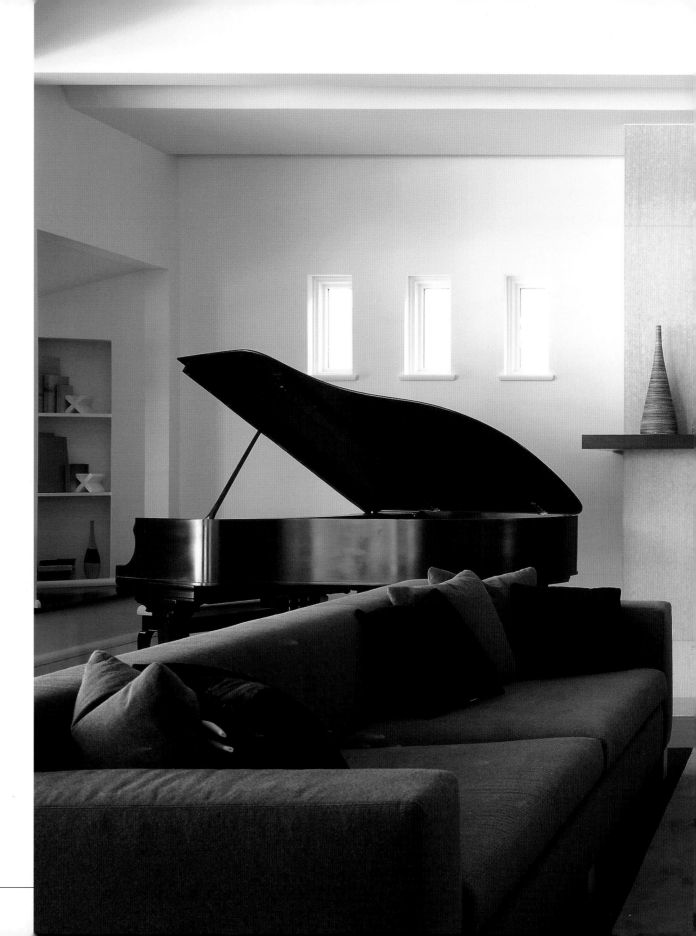

Published by

PANACHE
PANACHE PARTNERS, LLC

1424 Gables Court
Plano, TX 75075
972.661.9884
Fax: 972.661.2743
www.panache.com

Publishers: Brian G. Carabet and John A. Shand
Executive Publisher: Steve Darocy
Associate Publisher: Joanie Fitzgibbons
Editors: Lauren Castelli and Ryan Parr
Senior Designer: Emily A. Kattan

Printed in Malaysia

Distributed by Independent Publishers Group
800.888.4741

PUBLISHER'S DATA

Dream Homes Minnesota
Library of Congress Control Number: 2007930827

ISBN 13: 978-1-933415-35-2
ISBN 10: 1-933415-35-5

First Printing 2007

10 9 8 7 6 5 4 3 2 1

Previous Page: ALTUS Architecture + Design; *page 19*
Photograph by Tim Alt, ALTUS Architecture + Design

This Page: TEA$_2$ Architects; *page 169*
Photograph by TEA$_2$ Architects

DREAMHOMES

MINNESOTA

AN EXCLUSIVE SHOWCASE OF MINNESOTA'S FINEST
ARCHITECTS, DESIGNERS AND BUILDERS

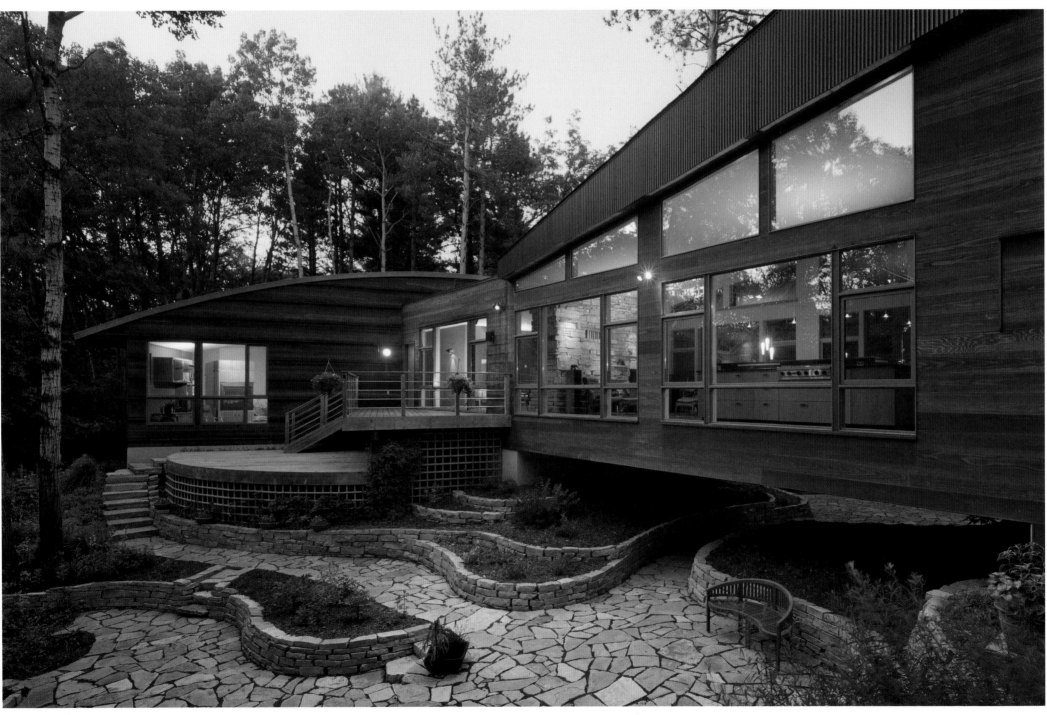

It was the spring of 1954 when I accepted the University of Minnesota's offer to become the third Dean of Architecture in the school's history. Having been schooled in modernism and practiced my design in various metropolitan areas nationally and abroad, the move to a largely rural state was somewhat of a shock, particularly to my wife. Upon arrival, we were struck by the abundance of undeveloped land—my wife marveled that she could practically see the prairie in whatever direction she looked.

My wife's reaction may not have been far different from that of Minnesota's first settlers roughly 100 years earlier. Minnesota was primarily settled by immigrants who followed the early fur traders to the forests and prairies of the upper Midwest to cut timber, build farms, grow crops and mill wheat. The first farmsteads were a practical assemblage of wood-framed vernacular structures that responded to economic realities and the harsh climate of the lonesome Minnesota prairie. Early Minnesota homes tended to be inexpensive simple structures without a great deal of stylistic expression.

As Minnesota's population grew, so too did its cultural diversity, and the house styles followed suit. Architecture of the late 19th and early 20th centuries reflects a range of influences, from Federal, Greek and Gothic revivals, romantic and picturesque Italianate and French to Arts-and-Crafts, Beaux-Arts, Art Deco and Prairie School. I arrived as one of Minnesota's early modernists and brought that to my teachings and faculty at the University of Minnesota.

Though home creators have broadened their architectural vocabularies, they have remained true to many of the principles that influenced the settlers. Today's designs still derive from the natural context of the site, the needs of the occupants, the cultural influences of the community in which they are built and the sustainable and climatic concerns of the region.

The dream homes featured on the following pages have their roots in the early Minnesota vernacular, the period revival styles, the Prairie School, the new Bauhaus and today's modernism. The architects and creators of these dream homes have learned from the past and have created homes unique to their times, their clients' needs and their own visions—and, of course, Minnesota.

Ralph Rapson

Ralph Rapson, FAIA

Water Street Homes, LLC; *page 57*

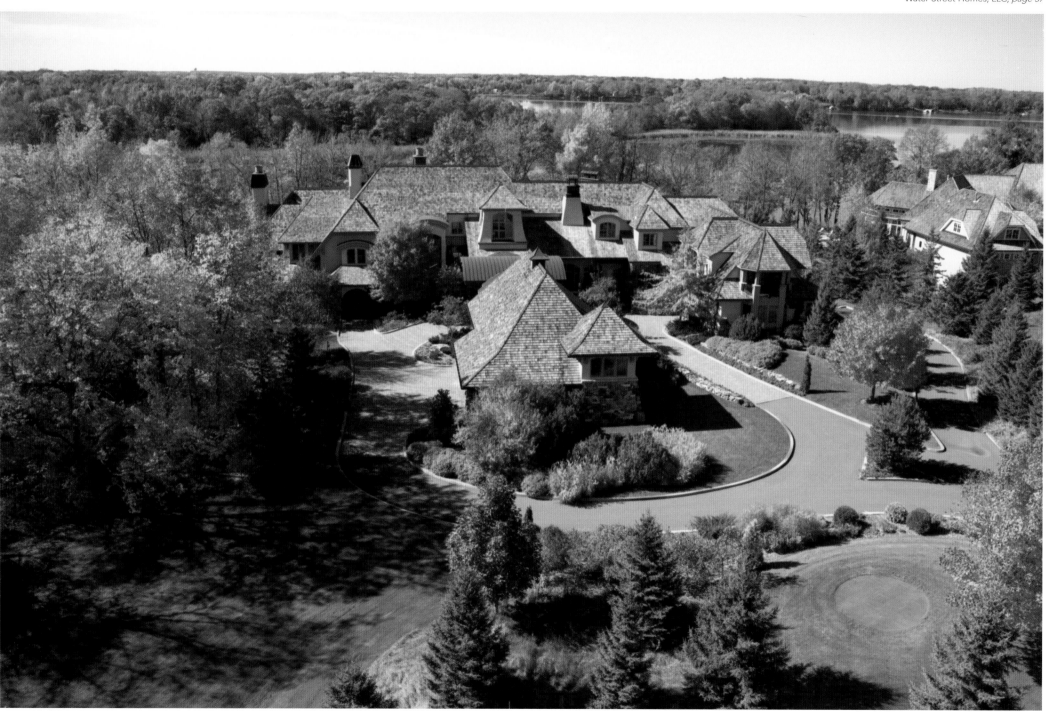

Creativity abounds in the scenic state of Minnesota. The profusion of architectural opportunities, not to mention the breathtakingly beautiful and diverse landscape, has lured creative minds at the top of their profession.

Dream Homes Minnesota is a brilliant assemblage of the work and philosophies of highly respected architects, builders and home designers. The design professionals featured on the pages that follow were selected for their talent, artistry and command of craft. From the Twin Cities to the North Shore, these magnificent homes display thoughtful, sophisticated designs that epitomize their residents' lifestyles and stylistic proclivities. Each has evolved from its creator's vast historical and cultural knowledge, strict attention to detail and innate aesthetic sensibility coupled with hard work and a genuine passion for fine architecture.

From small additions to elaborate renovations, restorations and, of course, new construction projects, the architects, designers and builders of *Dream Homes Minnesota* are interested and well-versed in a wide range of styles—from Classical to Modern and everything in between. Though their ideas and approaches vary, all are bound by the quest to create unique homes that acknowledge their surroundings, possess pleasing proportions and evoke delight.

Whether patrons wish to work with a boutique-sized firm or prefer to draw on the capabilities of a residential specialty studio within a large, general practice firm, there are plenty of excellent professionals from whom to choose. The beautiful homes on the pages that follow display their creators' immense talents, yet the men and women of *Dream Homes Minnesota* measure their success through the happiness of their clients.

Enjoy!

Brian Carabet and John Shand

Brian Carabet and John Shand
Publishers

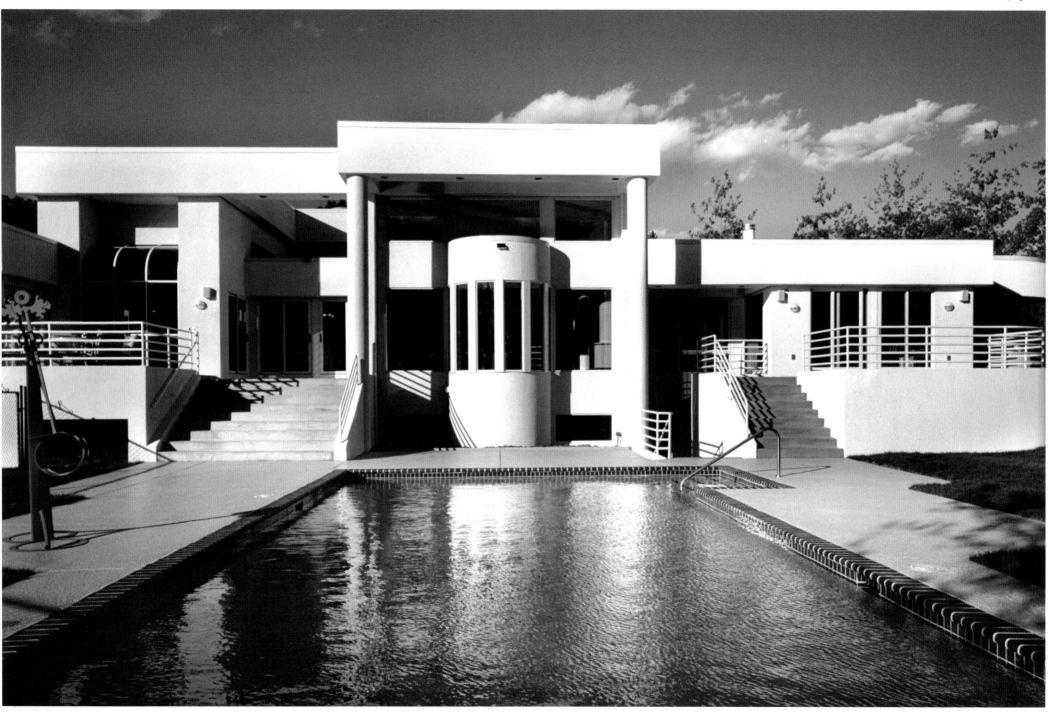

TABLE OF CONTENTS

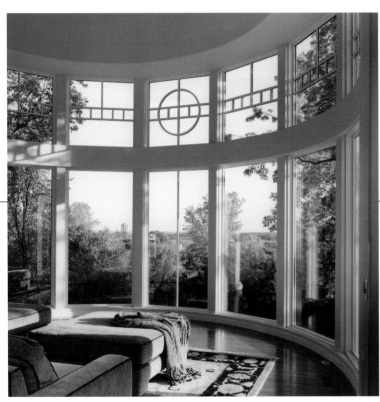

Keith Waters & Associates, Inc.; *page 217*

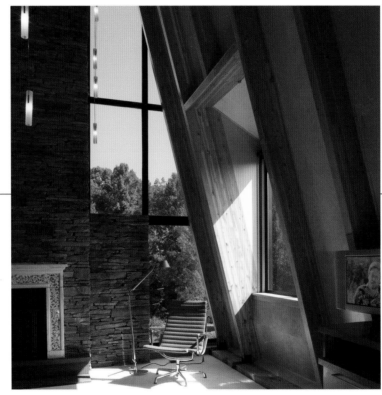

Choice Wood Company; *page 189*

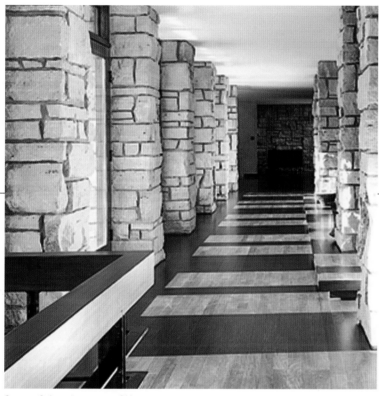

Streeter & Associates; *page 211*

MINNESOTA

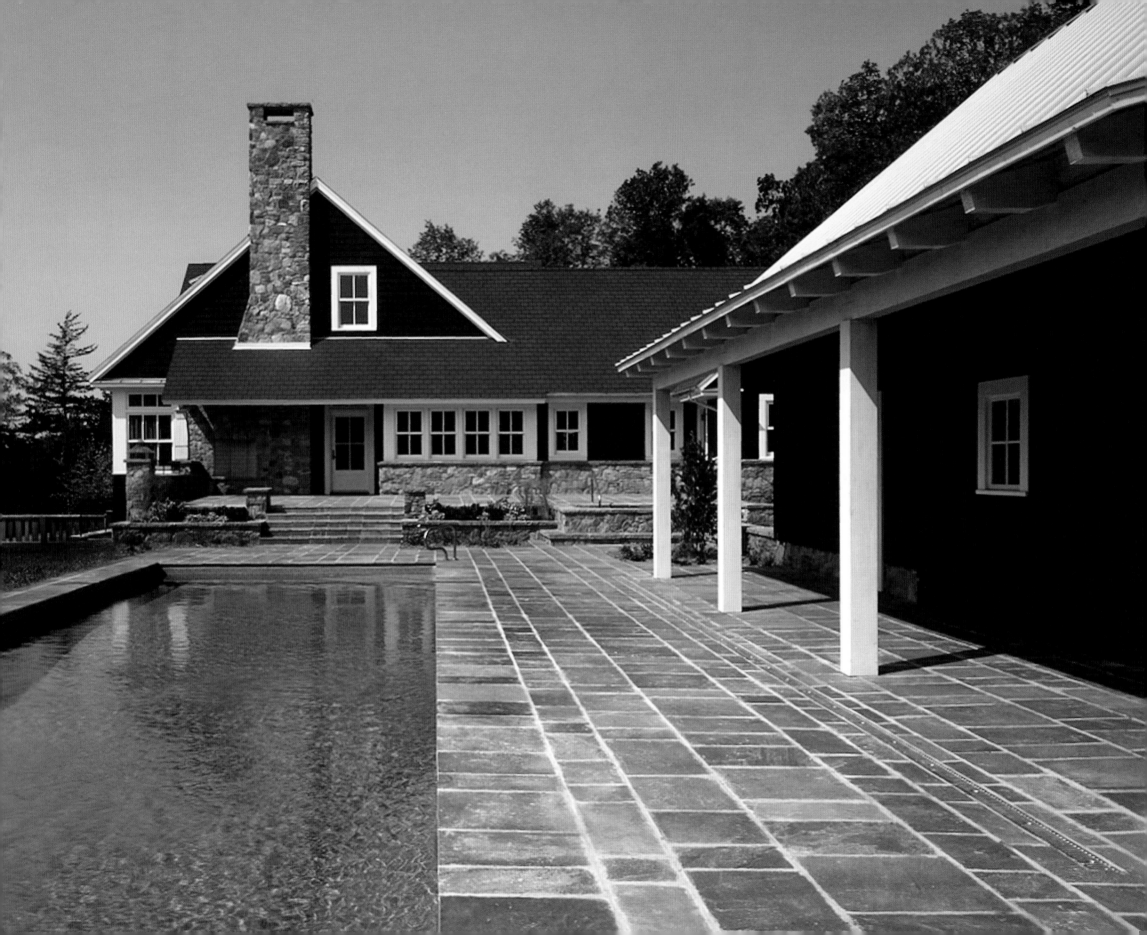

Christine Albertsson
Todd Hansen

Albertsson Hansen Architecture, Ltd.

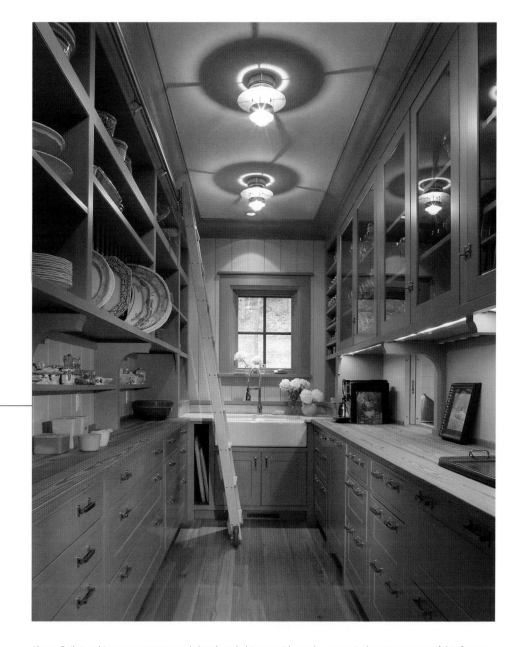

Above: Built-in cabinetry, countertops and abundant shelving provide ample storage in the narrow pantry of this Cannon Falls, Minnesota, residence. A ladder provides access to upper shelves and cabinets, and a service hatch leads to the adjacent kitchen.
Photograph by Dana Wheelock

Facing Page: The low roofs and natural materials of this Cannon Falls, Minnesota, residence emphasize a connection to the land. A quartzite-tiled terrace facing the outbuilding surrounds the tranquil pool.
Photograph by Peter Bastianelli-Kerze

Christine Albertsson, AIA, and Todd Hansen, AIA, may hail from different backgrounds, but they infuse the same values in their enchanting residential designs. Christine credits the pragmatism and love of nature that permeate her work to her upbringing as a Swede in New England. Todd spent his own childhood in the Pacific Northwest, where his family instilled in him a similar deep appreciation of nature and sensitivity to his surroundings.

Thus, when the two met while earning their master's degrees in architecture at the University of Pennsylvania, they quickly connected. Marrying and moving to Minneapolis, they worked for architecture firms while teaching at the University of Minnesota throughout the 1990s before Christine decided to open her own firm in 2000. When Todd joined her two years later, Albertsson Hansen Architects, Ltd. got its official start. They have since focused on creating homes that resonate with their mutual beliefs.

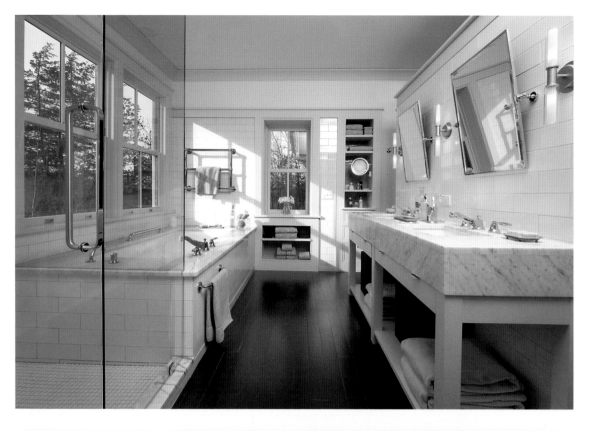

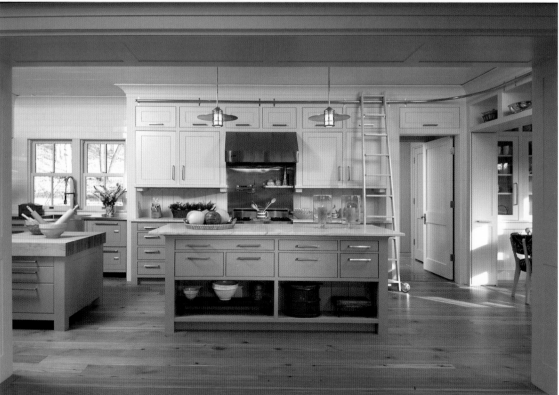

Supporting the idea that all of history's architectural practices are available to architects of today, Todd and Christine attempt to create new architecture that invokes the past while looking forward to the future. Minnesota's impressive palette of historical homes stimulates their new design ideas. They look to these homes for inspiration and reinterpret them to create new structures that seem born of the past.

Visitors often mistake for a remodeling project one log cabin Christine designed from the ground up. Indeed, the home won an architecture award in part because it seemed such a natural part of the landscape. While the cabin has a true log exterior, Christine used stick framing for its structure to allow for modern amenities that true log cabins are not equipped to accommodate. The house thus became a hybrid of old and new, characteristic of one of Christine and Todd's primary architectural philosophies.

Building on their innate appreciation of nature, Christine and Todd work to reinforce a connection with the land in the homes they design. Todd maintains that a home frames the way its residents see and experience the rest of the world, and it therefore should connect thereto. To achieve this, they employ natural materials, carefully control the relationship between the building and ground, create outdoor spaces that extend into the landscape and thoughtfully place windows to take best advantage of the light of the passing day. They orient their homes to capture the most powerful view, whether that be a lake or a forest, but they design the home with the entire site in mind.

Top Left: This west-facing master bathroom captures views of the stunning surrounding landscape: windows above the tiled bath and built-in shelving welcome the light while the white marble vanity and glass walk-in shower brighten and visually broaden the space.
Photograph by Dana Wheelock

Bottom Left: Abundant cabinetry and shelving, accessed by a sliding ladder, create an efficient and functional kitchen, which opens to the adjacent breakfast room and mudroom beyond.
Photograph by Dana Wheelock

Facing Page: A theme of generous simplicity carries through the airy, east-facing great room in this Cannon Falls home. A large opening with paneled jambs presents views of the cross-beamed ceiling, muntined windows and an offset fireplace with wall-length mantel.
Photograph by Dana Wheelock

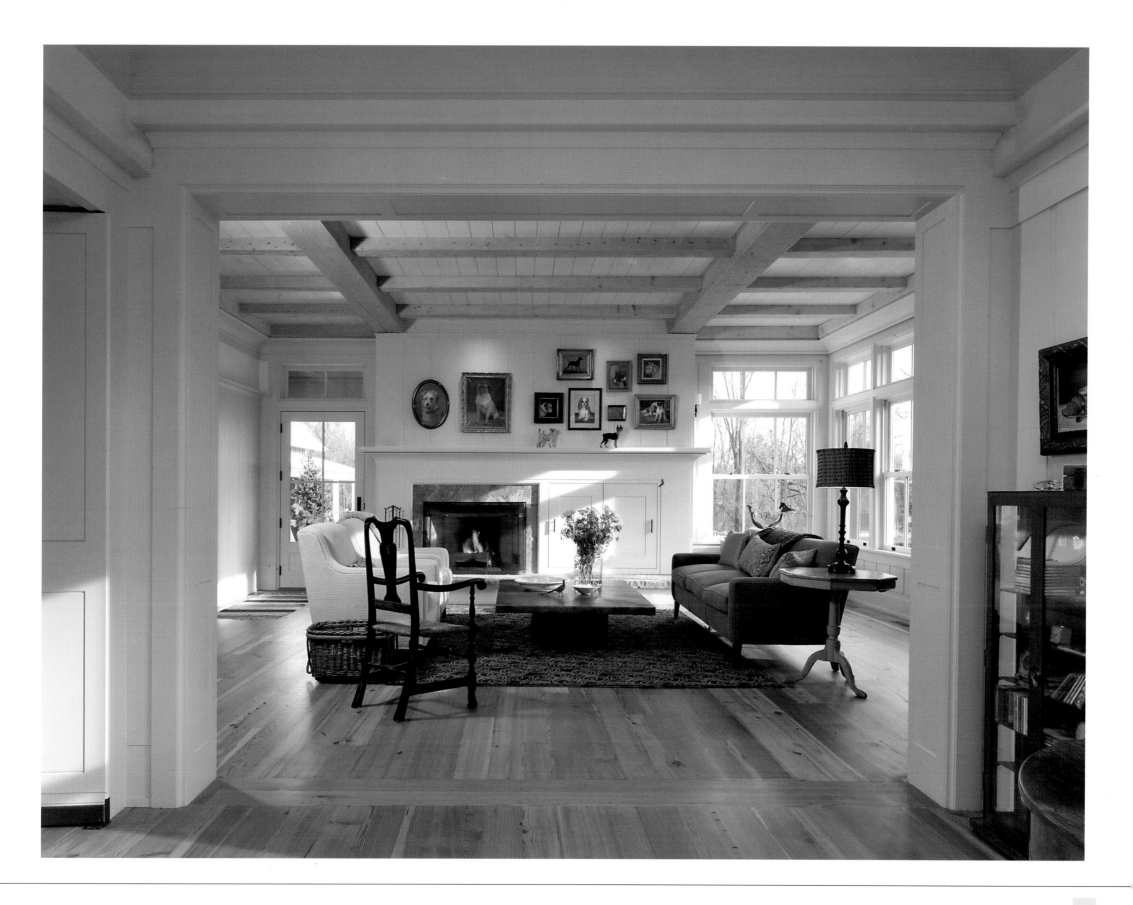

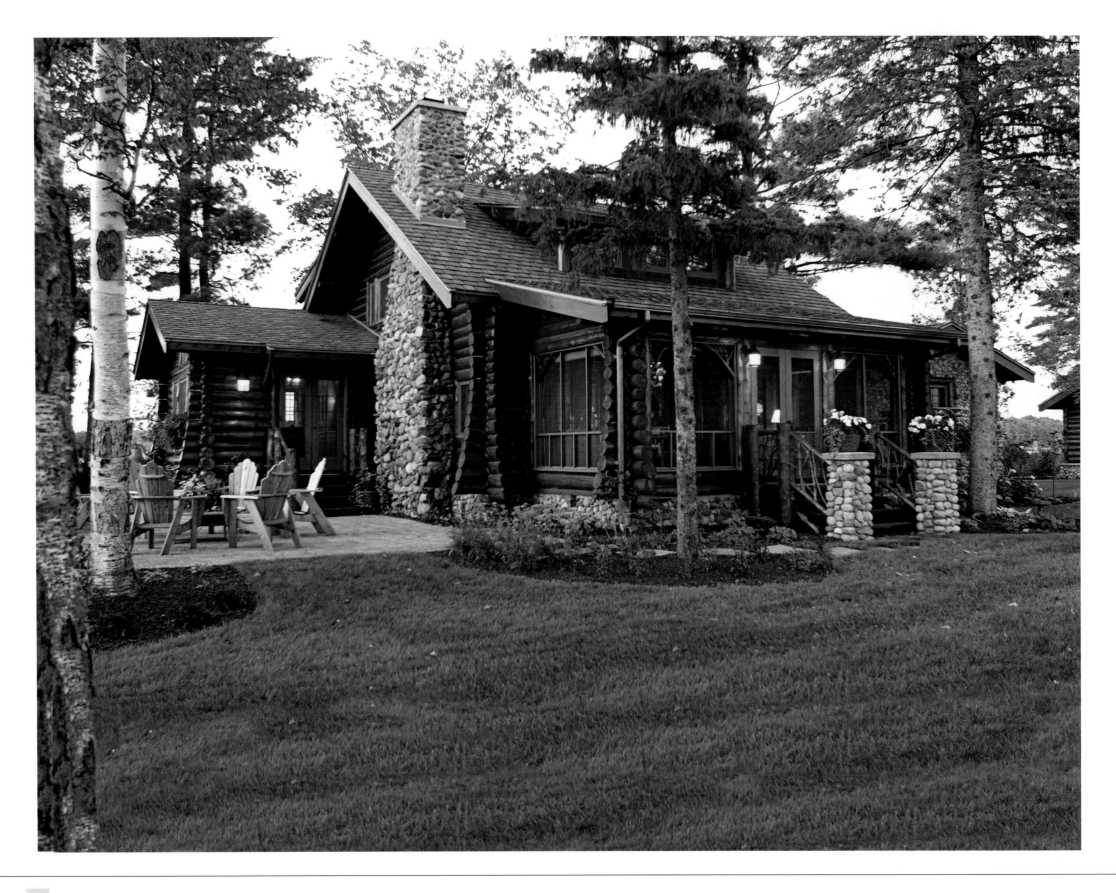

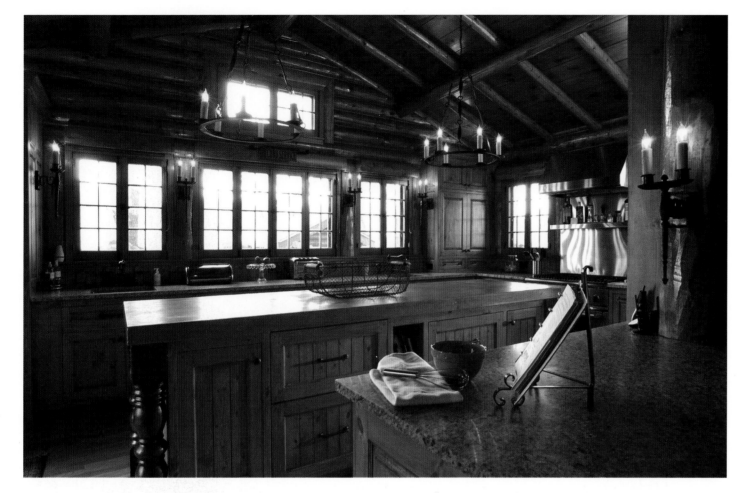

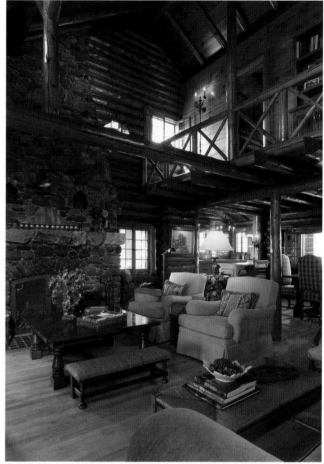

Every angle is an opportunity to highlight and celebrate a part of the natural setting, and the two bring their work outside when necessary and design the landscape as well, bringing out the best of that which is there. They add natural ventilation, porches and exterior seating areas to create an indoor-outdoor dialogue. The rustic, natural elements they employ in construction, such as wood and stone, further emphasize the home's relationship with the environment.

Indicative of the firm's practicality, Todd believes that a building's walls should not merely be surfaces on which to rest furniture. Indeed, he holds that a home should support its residents as fully as possible, including built-in cabinetry and bookcases in many of his homes and hiding small closets behind paneled walls so that details are not simply added after the home is constructed but are intrinsic to the home, itself. In a sense, the rooms serve as furniture in and of themselves, and residents get a sense that the home is truly finished even before they move in.

Eschewing the trend in architecture to design sprawling, high-ceilinged estates, Christine and Todd strive to provide their clients with homes that comfortably accommodate their individual needs while efficiently and gracefully occupying the available space. This could

mean designing a one-bedroom, fewer-than-1,000-square-foot home for a single-person household or creating a structure large enough to house large family gatherings or valued antique collections. Regardless of a project's magnitude, the two approach each home with the determination to provide their clients a renewable product, one that will transcend time to remain useful and beautiful for generations to come.

Above Left: Log walls and rich wood cabinetry lit by iron fixtures and wall sconces comprise the rustic kitchen in this Minnesota lake house.
Photograph by Scott Amundsen

Above Right: The large stone fireplace surround takes center stage in the two-story living room of the lake house. The large, open room provides views of the upstairs landing and dining room beyond.
Photograph by Scott Amundsen

Facing Page: This Minnesota lake retreat is beautifully integrated into its setting; stone and log elements nod to the natural landscape, and an outdoor patio allows for alfresco dining amidst the trees.
Photograph by Scott Amundsen

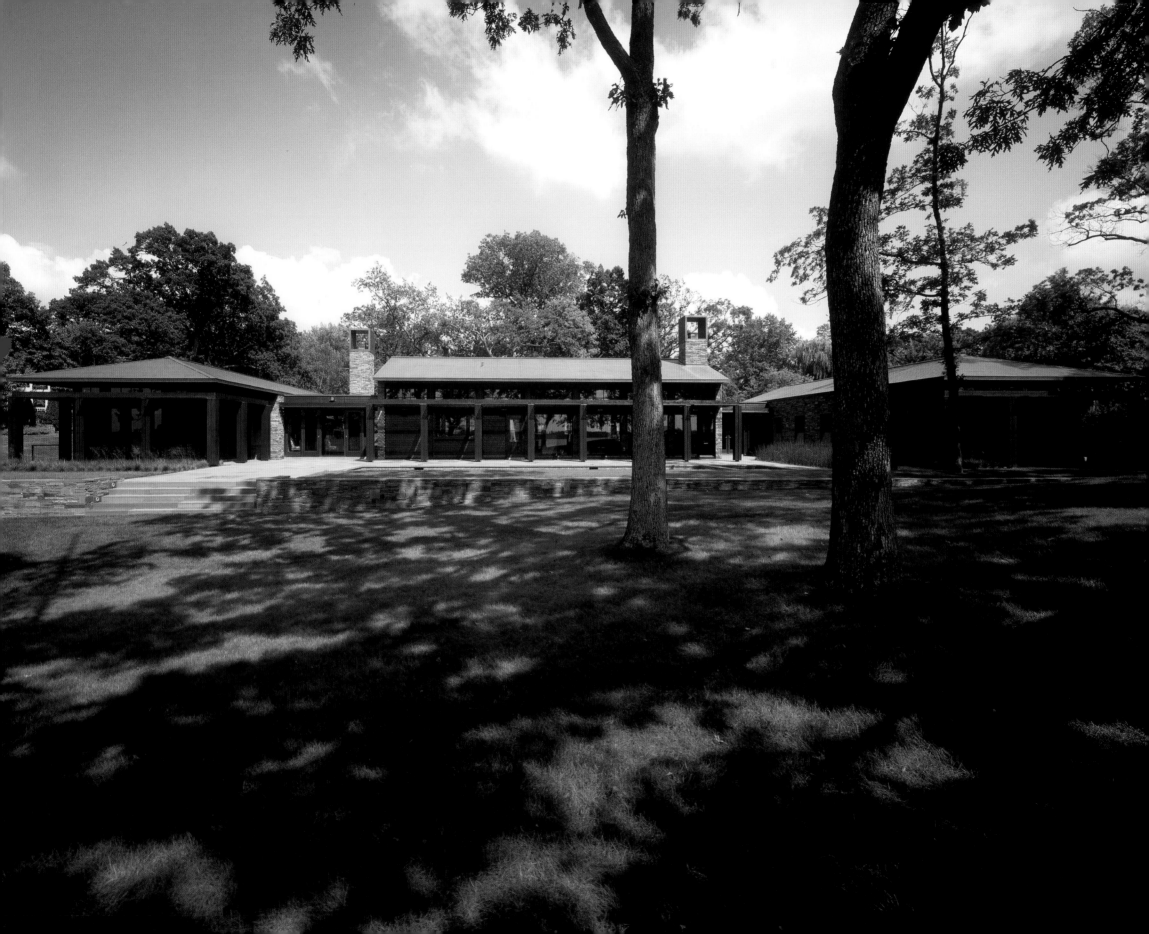

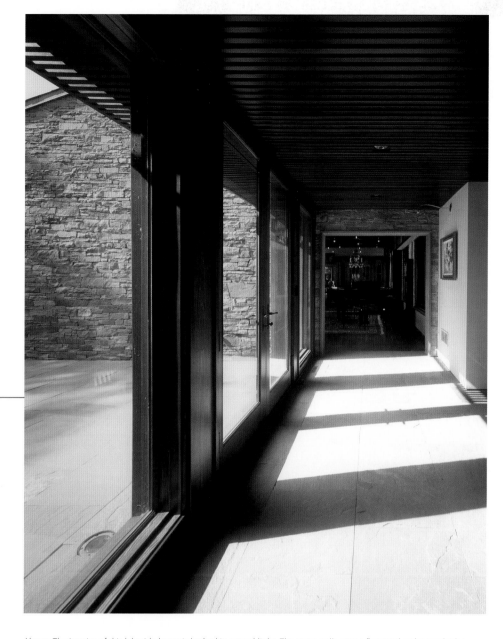

Tim Alt

ALTUS Architecture + Design

ven at an early age, Tim Alt, AIA, knew he wanted to be an architect. As a child, he was constantly drawing and building models. He also received private art lessons from an instructor at the Minneapolis Institute of Art, developing his talent for line, scale, proportion and the shaping of space. He completed his Bachelor of Architecture at the University of Minnesota and later received his certification in both architecture and interior design. His now 21-year career has been recognized in numerous local and national publications and has earned him several awards, including AIA Minnesota's 1995 Young Architect Citation. With his 11-year-old firm ALTUS Architecture + Design, Tim now designs new residences and condominiums as well as select commercial projects from the conceptual to the furnishing stage.

The creative success Tim enjoys stems from ALTUS' design approach as an "issues-oriented firm." He and his team are staunchly devoted to designing for the unique traits and specific needs of the site

Above: The interior of this lakeside home is bathed in natural light. The stone walls, stone floor and cedar sunshades unite the outside and inside.
Photograph by Peter Bastianelli-Kerze

Facing Page: Comprising three connected structures, this lakeside home incorporates dry-stacked bluestone, a copper roof, cedar pergolas and expansive glass to integrate with its site.
Photograph by Peter Bastianelli-Kerze

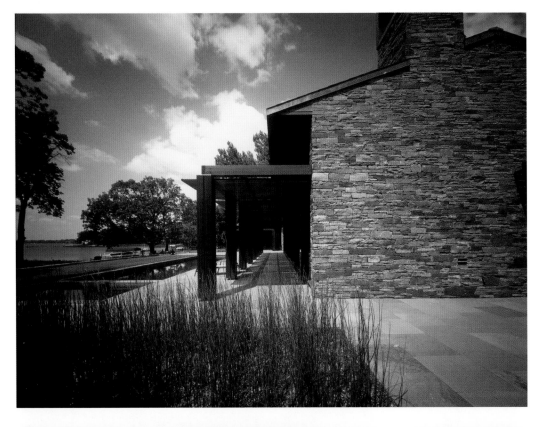

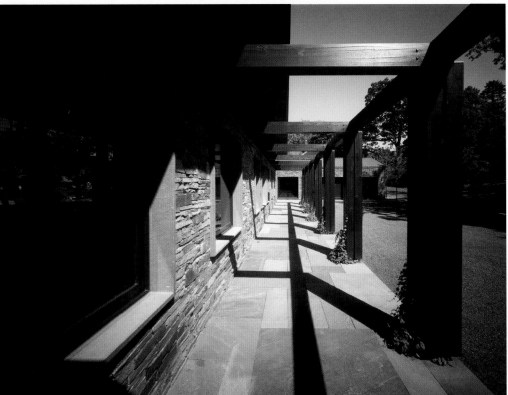

and the client, alike. Eschewing any preconceived stylistic agenda, Tim works to draw out the best qualities of the site—the shape of the land, significant views and patterns of sunlight—and develop them with the client's priorities in mind to create thoughtful, harmonious designs in which the "gifts" of the location and the qualitative issues of the client work together to produce a powerfully expressive resolution.

One of the primary issues on which Tim focuses in order to integrate the site and the client's wishes is the development of light. He states that the first thing he considers before beginning a project is how light "shapes space and enhances the rituals of the day." Depending on the location and the lifestyle requirements specific to the project, Tim works to capture, diffuse or control light from the sun. Encouraging his clients to think about the way light affects their specific daily activities, he works with them to determine how best to position the project on the site, design the quality of spaces in plan and volume and develop the nature of light through the windows and doors to best illuminate these activities.

Tim explains that "sculpting with light" works hand in hand with developing the scale of spaces and structures—another issue he considers when merging the client's desires and the setting. By shaping the scale and the quality of light, one can design a space as an embracing, nurturing or a dynamic, releasing space.

In conjunction with designing through light and scale, Tim places a heavy emphasis on the materials used in construction. Whether it is wood, stone, glass or steel, the inherent characteristics

Top Left: A cedar portico creates a shaded outdoor room, providing access to the stone pool and garden court and views to the lake and sunsets beyond.
Photograph by Peter Bastianelli-Kerze

Bottom Left: The arrival court includes an aggregate drive, cedar-framed tile walkway and stone wall with punched windows, offering glimpses of the lake beyond.
Photograph by Peter Bastianelli-Kerze

Facing Page Left: This pergola forms an abstract porch, establishing delicate shadow patterns and framing views of the forest and prairie landscape surroundings.
Photograph by Tim Alt, ALTUS Architecture + Design

Facing Page Right: A loft space utilizes a hanging stainless steel screen, a curved Venetian plaster wall and Eucalyptus wood "edges" to sculpt space and draw light into the home.
Photograph by Tim Alt, ALTUS Architecture + Design

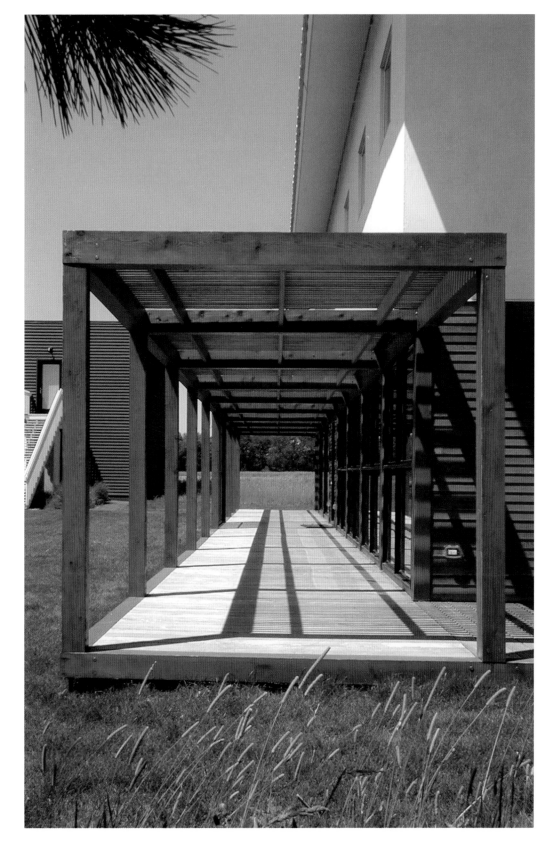

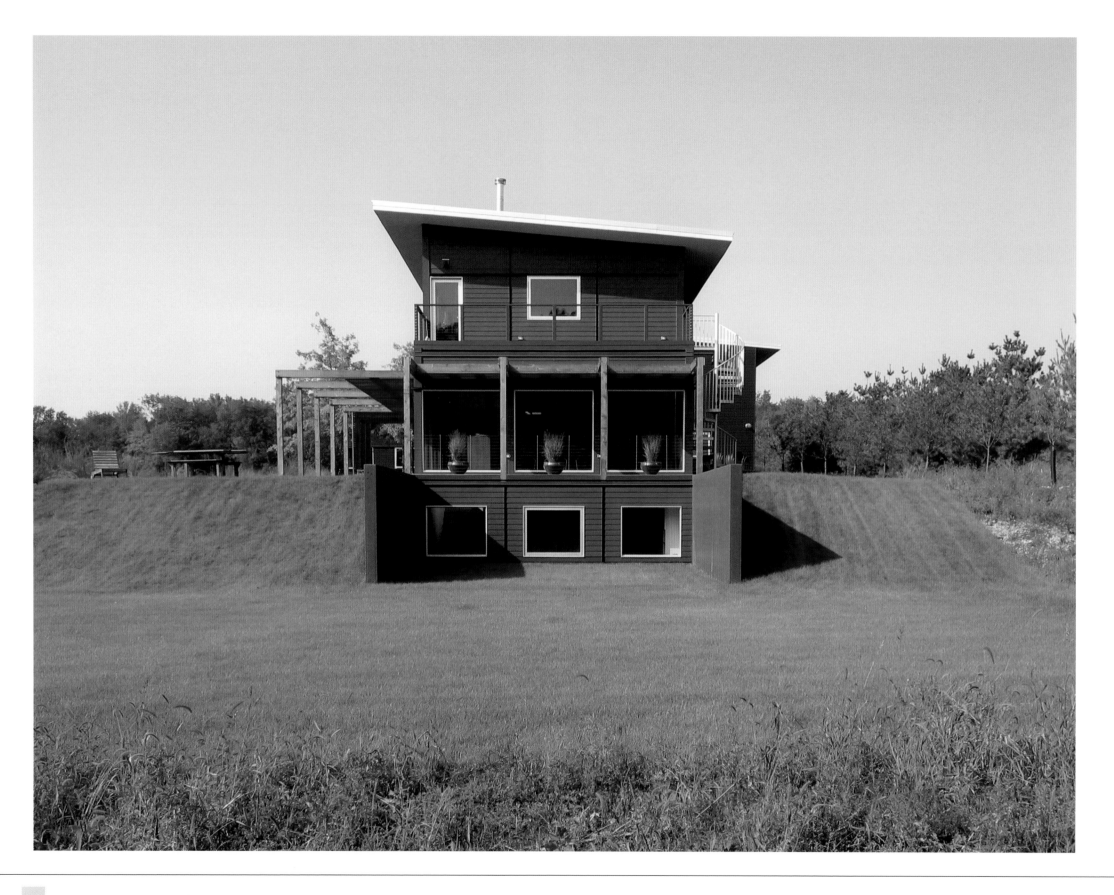

of materials tremendously affect the way a residence interacts with its surroundings and occupants. The varying textures, colors and luminous qualities of specific materials refine and reflect the spirit of the surroundings and spaces they comprise. Therefore, Tim and his firm carefully research and study materials for the exterior and interior as well as furniture for projects to reinforce the overall integration of the work, conveying a timeless connection with its context.

Additional issues that guide the quality and character of Tim's work are the use of state-of-the-art technology and exquisite execution through craft. He believes that architecture must incorporate new, sustainable energy systems and products wherever possible to minimize the impact on the environment. Also, his employment of prefabricated building components in his work minimizes labor and material waste. The efficiency of these construction methods empowers his clients to include better products and high design for the same overall cost. Moreover, extreme attention to detail is a hallmark of Tim's work, and he lends his thoughtful understanding of how things should be constructed to even the smallest detail of a project. This care ensures a home's permanence and durability in both physical and aesthetic terms.

Embracing the Minnesotan love for nature and the outdoors, Tim designs his homes as close to ground level as possible to promote movement from inside to outside. The firm works with landscape architects to further integrate the interior and exterior spaces, establishing a dialogue between the architecture and the landscape. Because he is adept at both architecture and interior design, Tim can truly imbue the homes he designs with a sense of balance and integrity. In so doing, he creates architecture that restores and lifts the spirits of his clients by fully engaging their dwellings with their environments and personalities.

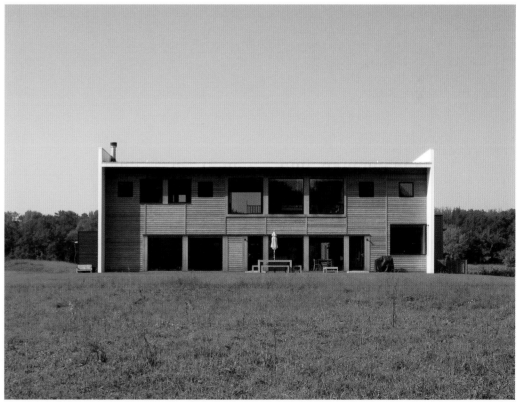

Top Right: The bold, simple forms and materials of this Rochester home rest in a prairie at Mayo Woodlands. The multiple structures are silhouetted by the forest wall.
Photograph by Tim Alt, ALTUS Architecture + Design

Bottom Right: The south face of the house opens to a natural meadow. The natural cedar and windows create a dynamic façade within the white stucco frame.
Photograph by Tim Alt, ALTUS Architecture + Design

Facing Page: The tiered levels of this home create multiple views and outdoor destinations. Large windows are shaded by cedar overhangs and a shallow metal roof.
Photograph by Tim Alt, ALTUS Architecture + Design

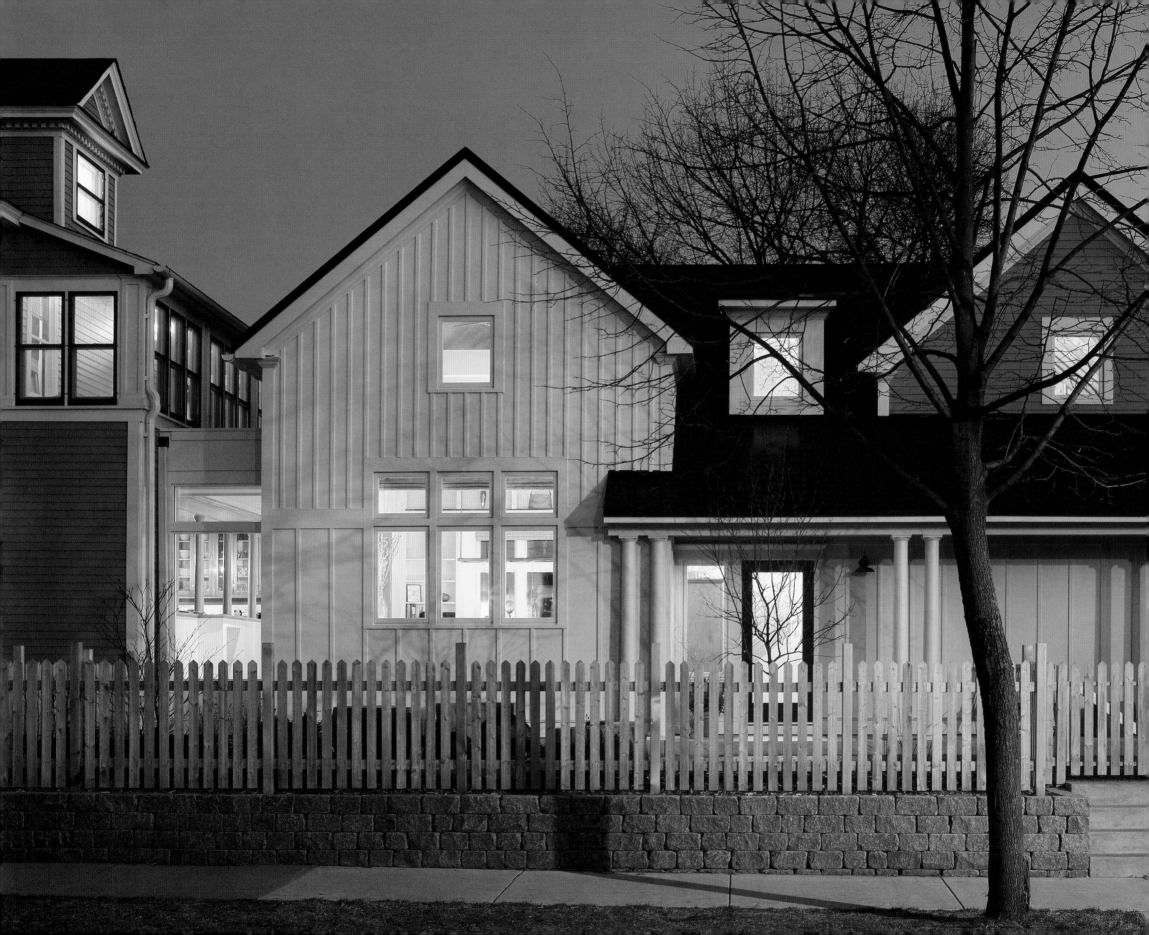

David Amundson
Meriwether Felt

TreHus Architects + Interior Designers + Builders

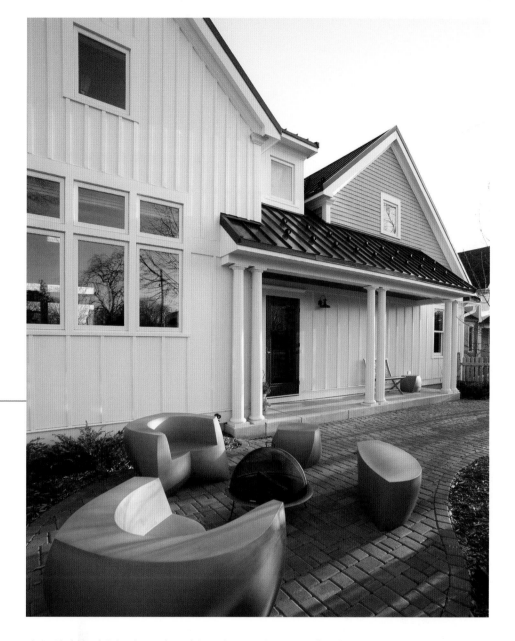

Above: Playful Frank Gehry chairs in front of the mudroom porch create an informal outdoor gathering space. The gabled roofs evoke the gabling of homes along the street.
Photograph by Andrea Rugg Photography

Facing Page: The north façade shows this addition's two-story vaulted family room and upper-level dormers. A picket fence plus handsome board-and-batten siding add traditional detailing, providing a friendly face to passersby.
Photograph by Andrea Rugg Photography

An older wooden house evokes images of carpenters from days gone by, constructing homes to protect their families from the elements and to stand the test of time. The homes of yesteryear represent a precious heritage; having continuously served many generations, they connote durability, aesthetic timelessness and the fastidious care of devoted craftsmen. These qualities are inherent in the remodeled homes of TreHus, a premier architectural design firm and builder in the Twin Cities. Owner David Amundson founded TreHus in 1982. His devotion and reverence for the craft developed at an early age through his great-grandfather and grandfather, Norwegian boat builders who handcrafted sailing vessels for local yachting circles in the late 1800s and early 1900s.

TreHus, Norwegian for "house of wood," continues to honor its heritage by name and by its dedication to artisanship. Every employee is guided by the TreHus mission statement: "To give value to every

customer; To be fair to every worker; To be agents of beauty and order in all that we do." Paramount in the tradition and culture of the company are the Master Builder and Master Carpenter methodologies. The integrated system that defines the Master Builder is one in which the artistry of the architect and the skill of the builder are one. This seamless approach ensures that TreHus is able to design, organize and build with total project accountability. The unique Master Carpenter system allows carpenters to provide focused, dedicated craftsmanship to each and every project. Whereas a project manager handles organizational details, carpenters are given the freedom to concentrate on their craft. This freedom allows TreHus carpenters to create esteemed works of beauty and lasting quality.

With a 25-year history of establishing collaborative and honest client relationships, TreHus has earned the reputation of a trusted partner, one with integrity and the utmost regard for the skills of an artisan. Their unparalleled service has brought many clients back again with new projects and given them the confidence to refer their family and friends.

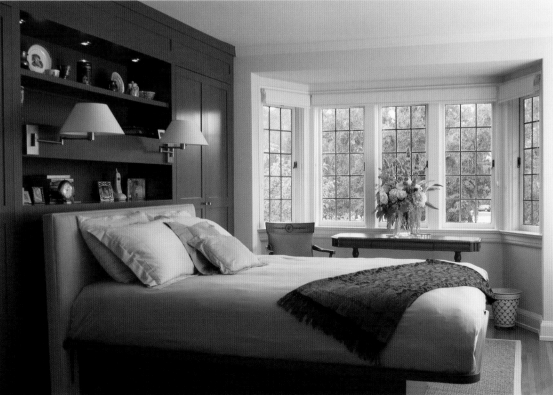

Top Left: The family who commissioned this renovation is the third owner of this turn-of-the-century home. After consulting the original architect's drawings for the house, leaded glass windows, moulding and floors were all restored to their original character.
Photograph by Michael Mandolfo

Bottom Left: Strategically adding full-height cabinetry throughout the house provided additional storage, and in the master bedroom, painting the new cabinetry in dark muted colors help frame a park view through refurbished windows.
Photograph by Michael Mandolfo

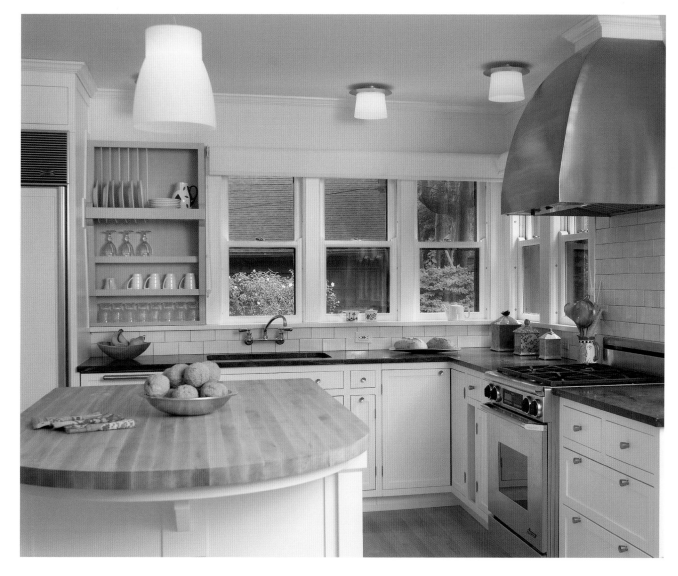

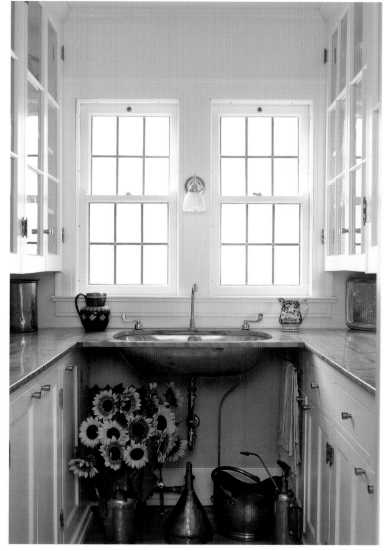

The TreHus team has more than 115 years of combined experience, from historical restoration, residential remodels and additions, to custom home building and interior design. Together they have transformed some of the most beautiful homes in the Twin Cities. Their architectural and design staff holds current memberships with the American Institute of Architects and the American Society of Interior Designers.

The TreHus work philosophy, shared by architect and longtime collaborator Meriwether Felt, AIA, compelled her to join the firm in 2006. A graduate of the University of Texas architecture program, Meriwether brings to the firm 20 years of professional experience creating residential and commercial architecture throughout the United States. She is licensed to practice in California, Colorado and Minnesota. Her portfolio also includes the design of residences and estates in New York and Virginia. Working in many different regions has exposed her to a variety of architectural vernaculars. Meriwether's designs are based on

classic proportions and timeless materials. She approaches each project as a discovery process of the owner's needs. She hopes her homes are a physical and mental refuge for the owner and that they become places that increase in value, and in memories, over time.

Above Left: Additional windows were added to reorient the kitchen work-zone and sink to face the garden. The custom hood, dish rack and cabinetry add historical character.
Photograph by Michael Mandolfo

Above Right: After years of neglect, the original cypress counters and German nickel sink were refurbished. Additional cabinetry was inserted to help with 21st-century needs.
Photograph by Michael Mandolfo

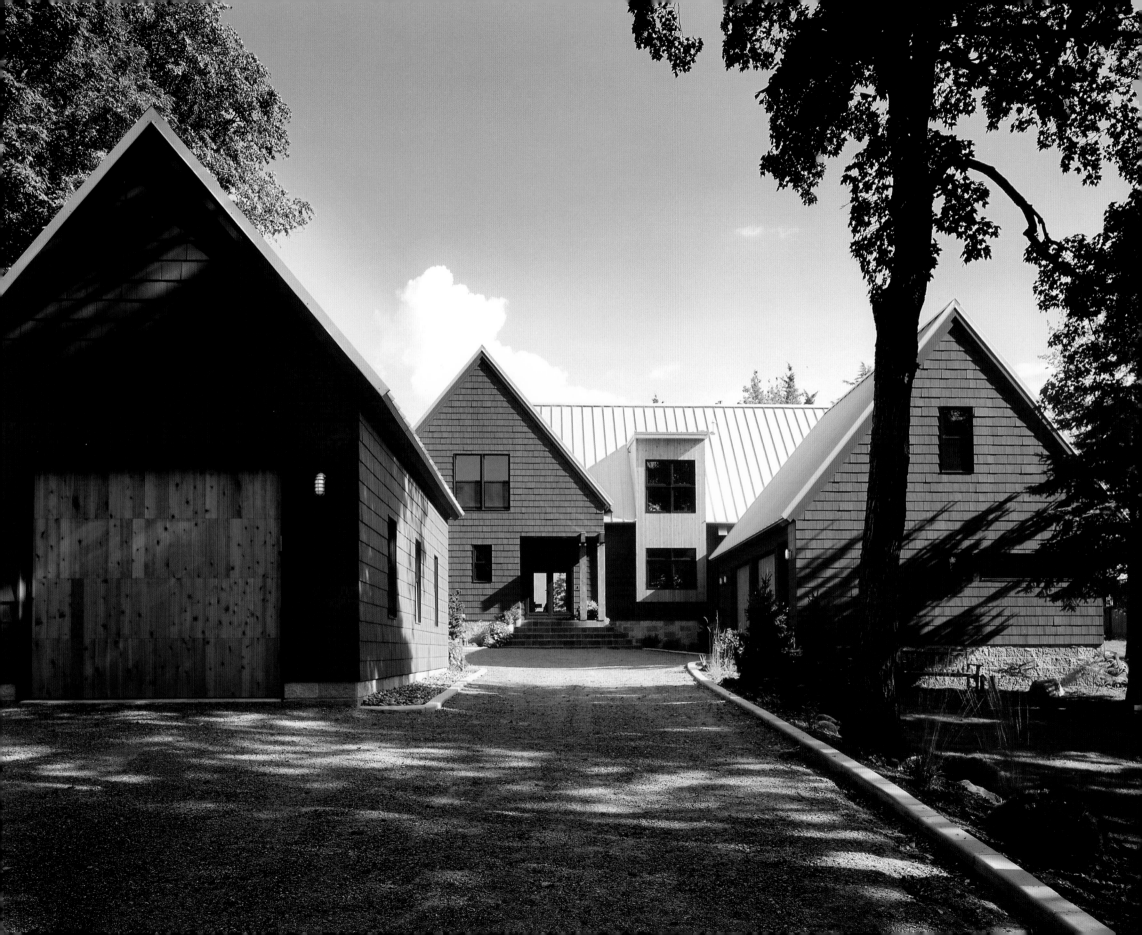

Bryan Anderson

SALA Architects

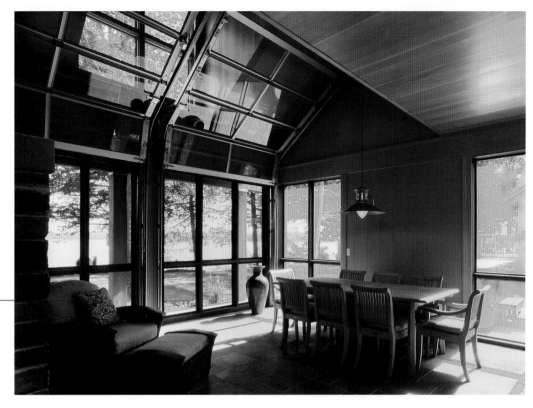

Although formally educated in architecture, emphasizing the importance of continued practical education is not just idealistic talk for Bryan Anderson, AIA; it is a way of a life and the way this young architect has excelled at his craft in such a short time.

To that end, Bryan has traveled the country, from Oregon to learn how to build Cob homes from mud and straw, to Nova Scotia for a vernacular design/build seminar. "I try as often as I can to seek out other experiences that will inform and influence what I do to keep my designs fresh."

Growing up in rural Minnesota, Bryan was surrounded by the simple, practical forms of agrarian vernacular, but always wanted to design houses. He attended North Dakota State University where he excelled and was honored with numerous awards. In 1999, he joined the prestigious Minneapolis firm of Mulfinger, Susanka, Mahady and Partners, now SALA Architects.

Currently dwelling in the city, Bryan combines the formative rural modernism of his past with his travels and a genuine interest in engaging his clients to create environments that nurture their desires and support their day-to-day activities. "The highest compliment in residential architecture is a dinner invitation."

Bryan's projects have appeared in *This Old House*, *Architecture Minnesota* and *Midwest Home* magazines, as well as Sarah Susanka's *Home by Design*.

Above: Glazed overhead doors and a masonry fireplace encourage homeowners and guests to enjoy this screened porch even in inclement weather.
Photograph by Daniel Nordstrom

Facing Page: A series of cascading gables bridge the scale for this new retreat home and older smaller cabins along this remote lake road.
Photograph by Daniel Nordstrom

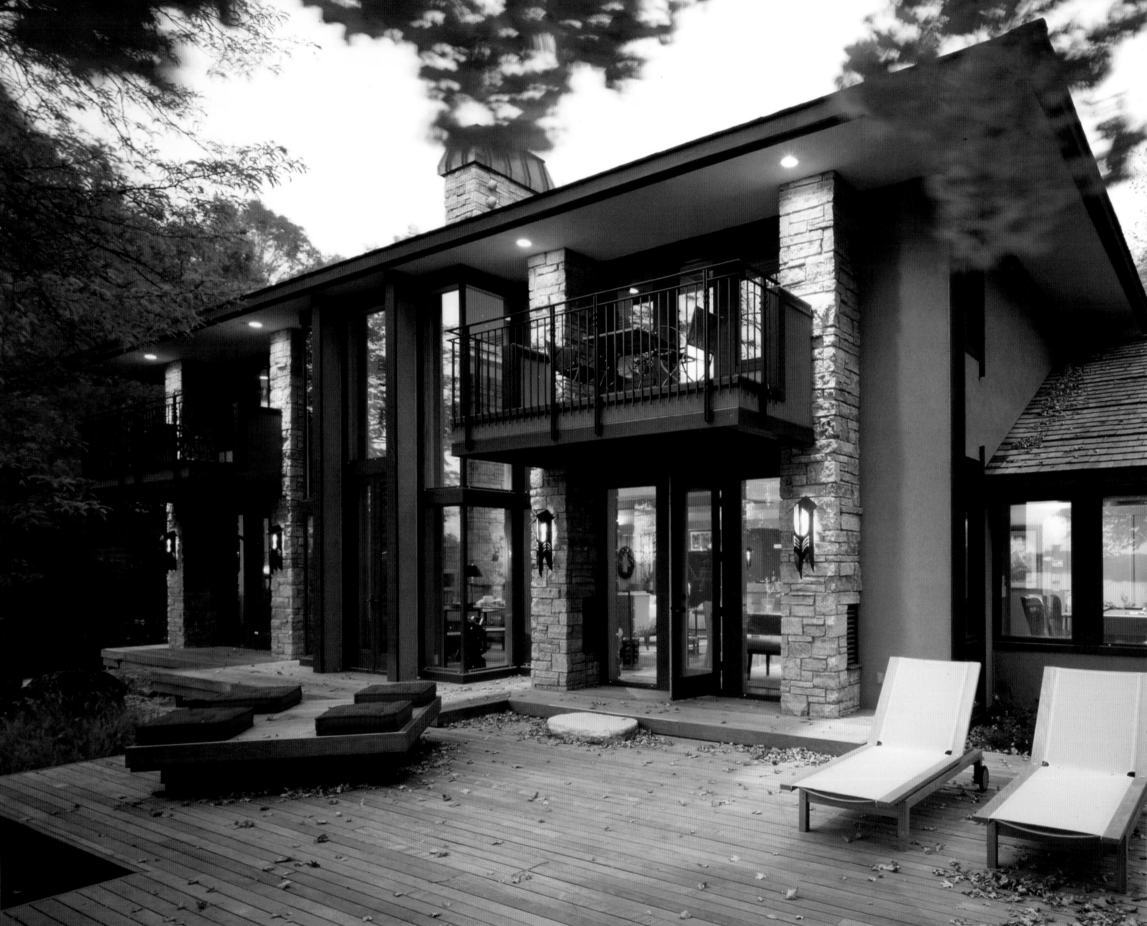

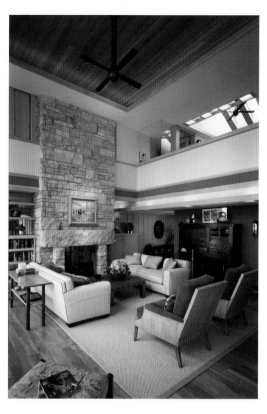

Kelly R. Davis

SALA Architects

An encounter with a Frank Lloyd Wright home at the age of five sparked Kelly R. Davis' passion for architecture. The very long, horizontal house with its hip-roofs and low overhangs projected a connectivity to the earth that set it apart from every other home on the street. The experience left an indelible impression on Kelly's mind, one that would inform his choices and eventually his own work throughout his professional life.

Upon graduating from the University of Minnesota with a Bachelor of Architecture, Kelly Davis, AIA, began working for Michael McGuire and Clark Engler, architects and fellow enthusiasts of the Prairie School of Architecture made famous by Wright. They served as mentors for Kelly, enhancing and bolstering his formal education. Kelly eventually made partner, and McGuire/Engler/Davis designed homes together until 1993. Kelly then made the transition to the firm that would later become SALA Architects and two years later became partner.

Kelly has since established a solid reputation for his commitment to mastering the Prairie vernacular. While his personal architectural philosophy encompasses consistent refinement of one particular style, he maintains that he is not a dictator; indeed, he considers himself an educator, guiding his clients through every stage of their projects to produce homes that are visible manifestations of their personalities and values—homes that will positively affect their lives each and every day.

Published in numerous national and regional publications, Kelly's understated yet timeless designs won him the revered AIA Minnesota and *Midwest Home* 2006 Architect of Distinction award. His dedication to incorporating bold roof lines and natural materials into homes that are fully integrated with their sites ensures that he will carry on Wright's tradition for years to come.

Above Left: The double-high living room is the visual heart of the home and embraces strong views of the lake through its dramatic bay window.
Photograph by Tim Maloney of Technical Imagery Studios

Above Right: A massive stone fireplace is the focus of the living room. A mezzanine and "overlooks" from upper-level guest rooms add scale and visual interest.
Photograph by Tim Maloney of Technical Imagery Studios

Facing Page: The lakeside elevation of the residence was designed to glow like a lantern at dusk. Decks and patios extend the house toward the lake beyond.
Photograph by Tim Maloney of Technical Imagery Studios

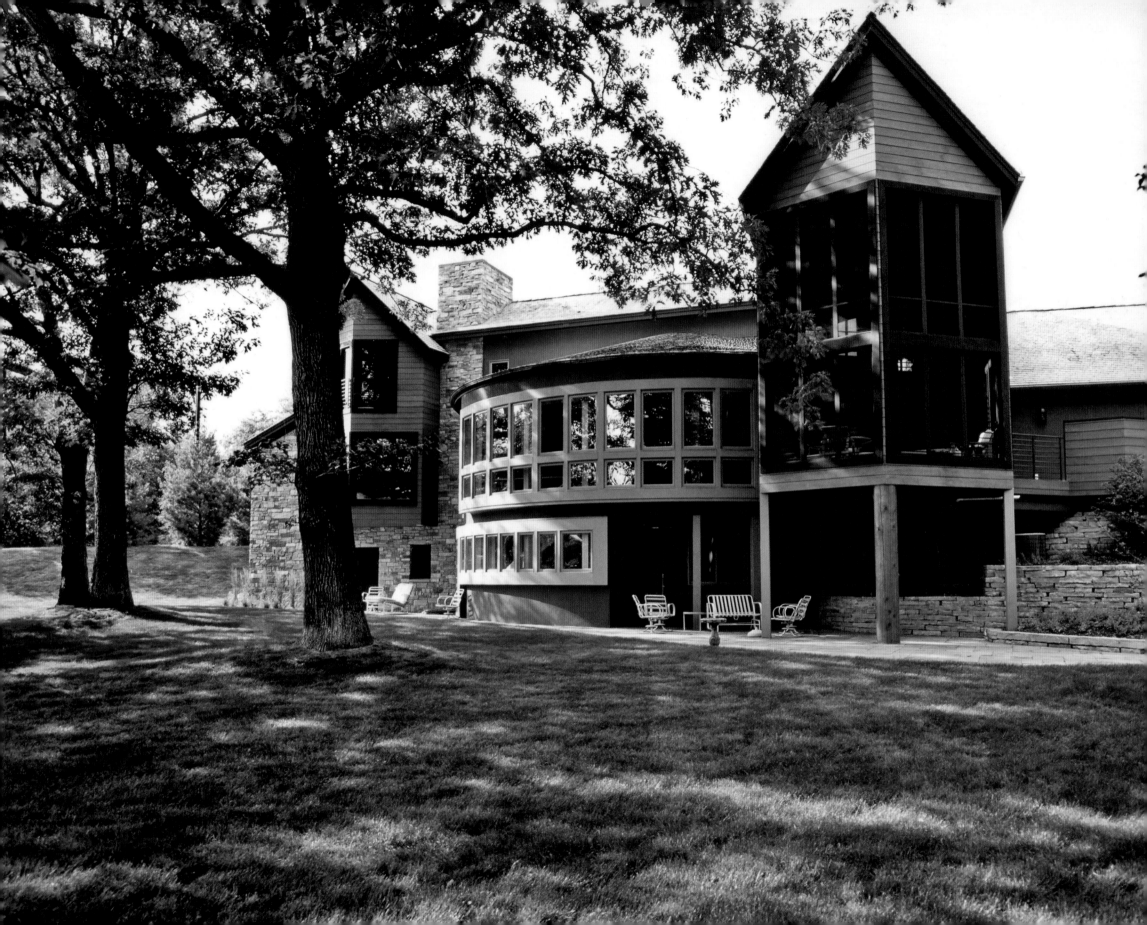

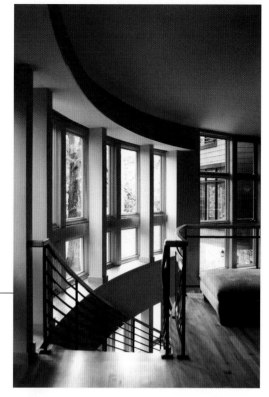

Dale Mulfinger

SALA Architects

A very accomplished and seasoned architect with experience in a wide variety of design styles and project scales, Dale Mulfinger, FAIA, brings nearly 40 years of experience to the architectural community. Co-founding partner of Mulfinger & Susanka Architects, now known as SALA Architects, Dale has built his primarily residential firm to house eight principals and a staff of more than 45. For close to two-and-a-half decades, SALA's multiple award-winning projects have spanned the United States and abroad.

Dale's career began with his pursuit of urban design in 1967—the year he obtained his Bachelor of Architecture from the University of Minnesota. After a decade of designing large-scale projects—primarily campus and town planning—both nationally and internationally, Dale decided to move into the single-family residential sector. Returning to the Minneapolis area, he worked for several firms before partnering with Sarah Susanka in 1983.

The firm has retained its original focus—90 percent of its projects are residential—and the diverse aesthetic strengths and preferences of the firm's 15 designers ensure that any style a client may desire, SALA can beautifully achieve. Dale prefers to work within a rather broad aesthetic vocabulary, allowing his clients' visions for their homes to guide his designs. Doing so allows him to allude to the work of architects of the past, a practice that he considers an honor.

Dale has taught and lectured at numerous universities countrywide and currently holds an adjunct professorship at his alma mater's College of Design. His work has received wide media exposure and won him numerous grants and awards, and he is honored to have become a Fellow of the American Institute of Architects in 2002.

Above Left: The stairway gracefully descends along the curved window wall, providing an elegant connection between the main level and lower level and views to the marsh beyond.
Photograph by Peter Bastianelli-Kerze

Above Right: Montana lodge poles hold up a balcony defining an intimate seating area. The tall living room is comfortable for large cocktail parties or relaxing living for two.
Photograph by Dale Mulfinger

Facing Page: His and her gable elements flank the curved wall of the living room, all with southern views over a marsh. The party room of the lower level spills out onto the terrace.
Photograph by Peter Bastianelli-Kerze

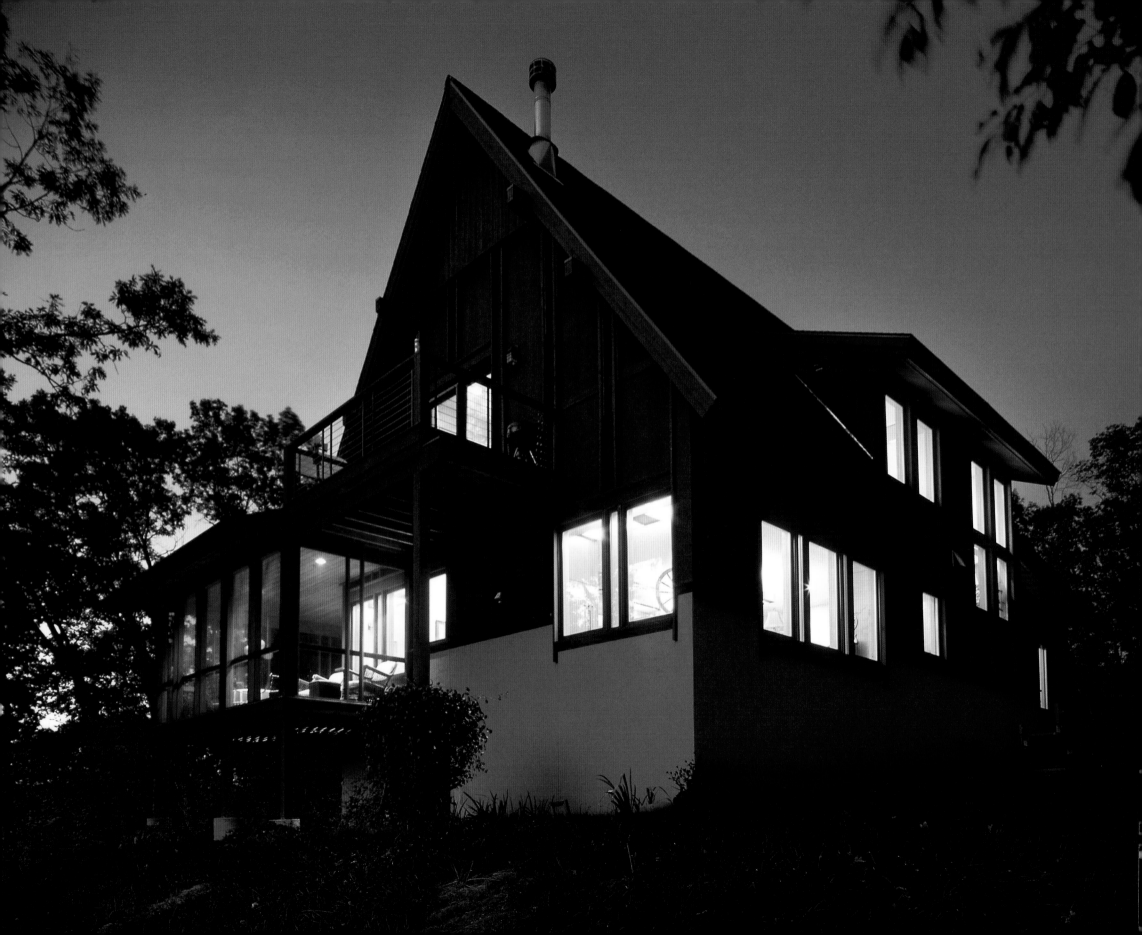

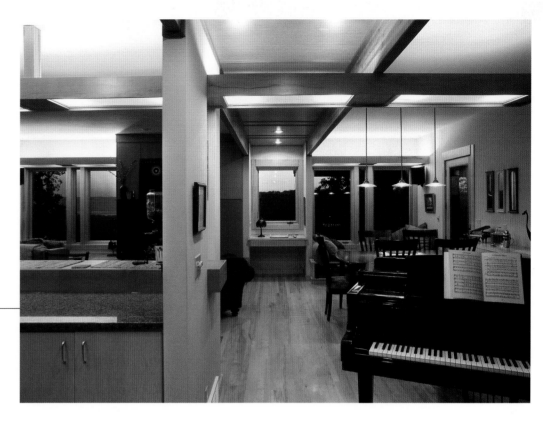

Eric Odor

SALA Architects

Minimalist forms with clean lines best define Eric Odor's style, if one could even assign him a style at all. Indeed, Eric does not adhere to a single design aesthetic, looking instead to his clients for the direction and inspiration manifested in his finely crafted homes. It's all about the craft.

With a Master of Architecture from the University of Minnesota, Eric Odor, AIA, designed high-end Malibu residences as well as low-income housing and filmmaker's production studios in Santa Monica before settling in Minnesota. After completing a total redesign of the Minneapolis Institute of Arts and a conference suite for Cargill at a commercial firm, Eric returned to the more intimate and holistic realm of residential architecture.

In 1997, Eric joined the SALA team and has since created numerous award-winning custom homes, in a variety of architectural vocabularies, that have been published in such magazines and books as *Fine Homebuilding* and former partner Sarah Susanka's *Home by Design*. Eric firmly believes that client involvement is critical to award-winning design, seeing himself as merely a translator of dreams and desires.

Dedicated to all things Green, Eric focuses on innovative and sustainable ideas and materials while constantly striving for the most economical and ecological solutions. His commitment to environmental responsibility inclines him toward the design of smaller homes that make little impact on the land—but cast a lasting impression on their residents for years to come.

Above: This home's circulation spine of fir plywood and Glu-Lam beams meters the residents' journey while defining disparate areas in its very open plan.
Photograph by Daniel Nordstrom

Facing Page: Perched on a scenic bluff, this rural retirement home is a beautiful blend of barn and cathedral.
Photograph by Daniel Nordstrom

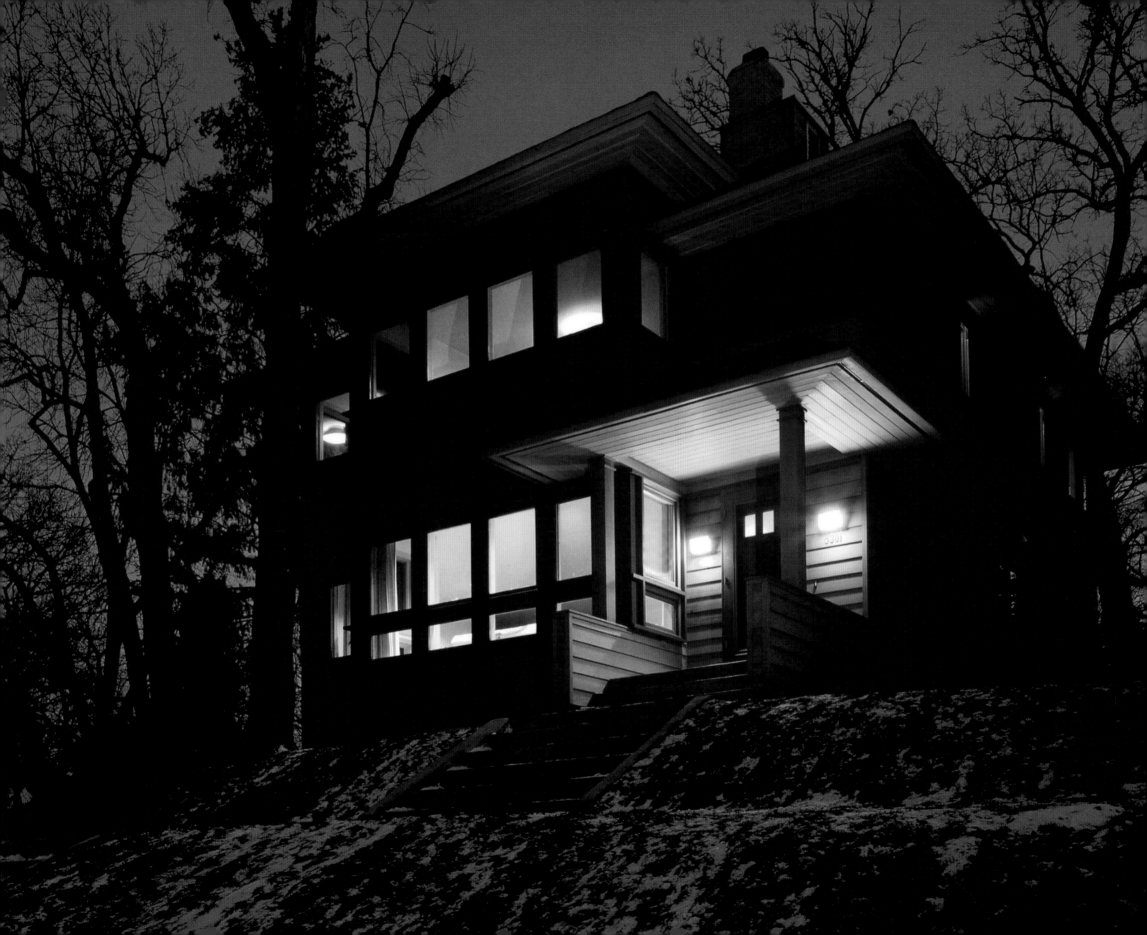

F. John Barbour
Janis LaDouceur

Barbour LaDouceur Design Group

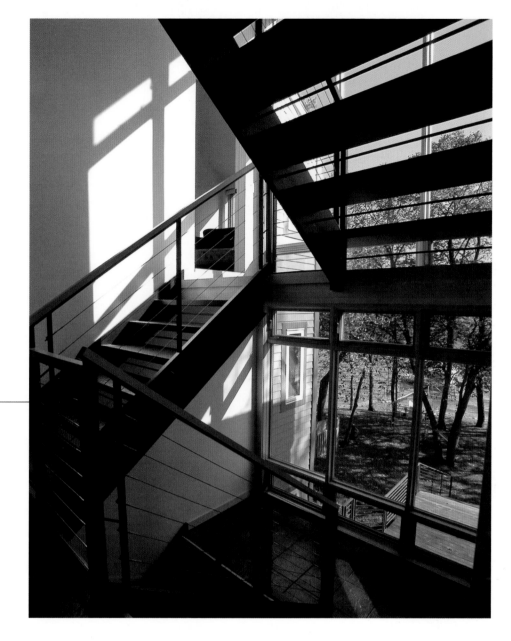

Above: Striking lake views are set up and framed by the conceptual centerpiece of this modern lake home: the stair.
Photograph by William Kloubec, Heliostudio-Kloubec

Facing Page: Complementary to its existing 1920s' neighborhood, this home borrows massing and form from the past, yet the details speak of contemporary culture and technology. John Barbour's personal residence was designed to tell the story of an older Minneapolis neighborhood by borrowing forms and massing from traditional Craftsman architecture while inserting modern details.
Photograph by George Heinrich, Heinrich Photography

John Barbour, AIA, and Janis LaDouceur, AIA, are storytellers. And, as all good storytellers do, they know that fascinating and diverse subjects yield the best stories. Thus, when they undertake the design of a structure, they work to uncover and express the most compelling story the context and clients have to offer. Founded in 1993, Barbour LaDouceur Design Group has since graced the Twin Cities and beyond with its custom residential, cultural museum and community building designs, landscape architecture, urban planning and historic preservation work. Alongside a talented team of individuals who share their passion for architecture, the firm's partners at once uphold and create a legacy.

The idea of storytelling is the keystone for every project the firm completes. The partners maintain that there are three types of narratives a project can represent: an individual's story, the neighborhood's

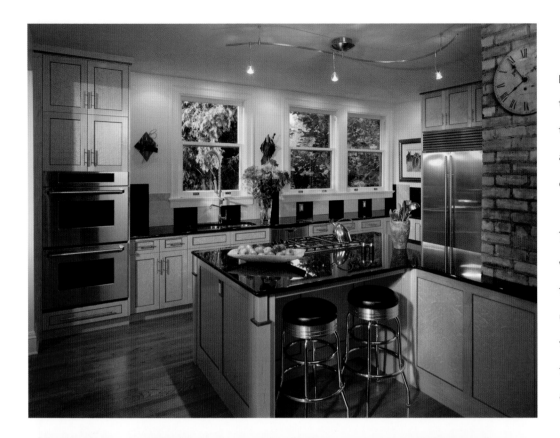

personality or, in the case of a restoration project, the existing building's heritage. For each, they thoroughly investigate the subject at hand, delving into its history to locate the inspiration for the imagery their designs will evoke. This intense exploration precludes the firm's expressing a particular style. Rather than reiterating a theme, John and Janis continually craft unique forms completely authentic to their physical and cultural contexts and to the personalities they embody.

The extent of the architects' inquiry is made manifest in the projects themselves, a few of which powerfully illustrate the firm's narrative prowess. One commission involved the partners' transforming a historic building into a boutique hotel. When excavating the basement, the team uncovered a coal vault that stored the original building's fuel. With a beautiful arched ceiling, the vault easily transformed into a wine cellar and exclusive dining room for the new hotel. Along with their wine, diners enjoy a slice of the building's past. The firm frequently takes advantage of such opportunities to celebrate a structure's origin and evolution.

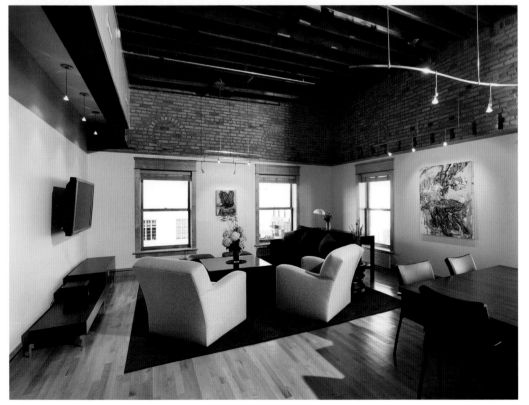

New construction—and residential projects in particular—requires a different kind of analysis. Janis and John spend a great deal of time getting to know their clients, noting the things they like to do and the way they dress, learning what they liked to do as children and what motivated them then and now. The principals carefully listen as the clients share their lives, and accordingly the homes they create allow their clients to live their histories. Often they will glean from clients' stories architectural preferences of which they may not be consciously aware. Janis relates that the childhood fantasies of many women will prompt her to suggest that they may want a windowseat for their bedrooms. Delightedly surprised, the clients nearly always respond, "How did you know?" Janis and John's ability to discern clients' desires is as impressive as their gift for sculpting a structure into a shape that embodies its narrative crux. They curved a sailor's house to resemble

Top Left: A lovely kitchen was created from several rooms of this turn-of-the-20th-century home. Existing elements, such as the chimney and original wood trim, were left and exposed to remind the owners of the home's history.
Photograph by Karen Melvin Photography

Bottom Left: Renovating this loft revealed the building's history, including round windows that were bricked in, a steel beam and cast-iron columns that were inserted. New modern elements and art contrast nicely with the old.
Photograph by Jim Gallop, Gallop Studio

Facing Page Left & Right: Designed for competitive sailors, this house picks metaphors from generations of sailing lore. A lighthouse, a widow's walk and curved billowing sails sculpt a portrait of this life.
Photograph by Jim Gallop, Gallop Studio

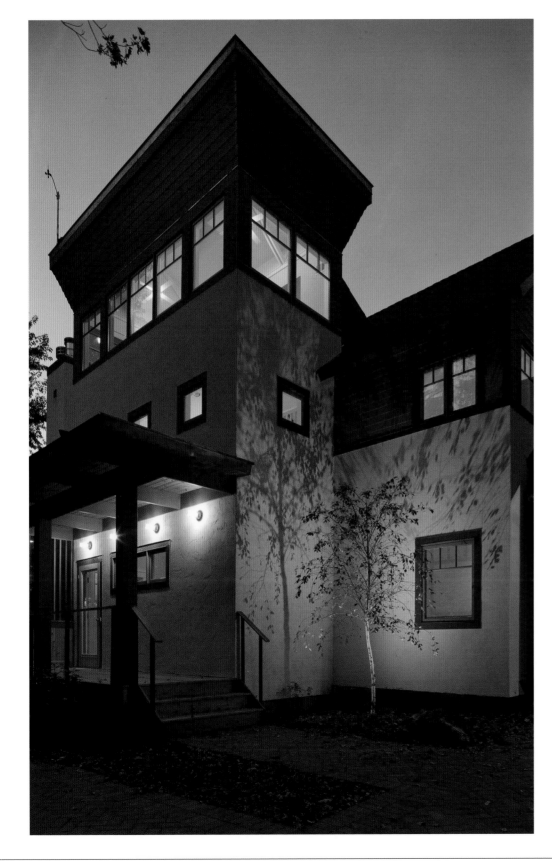

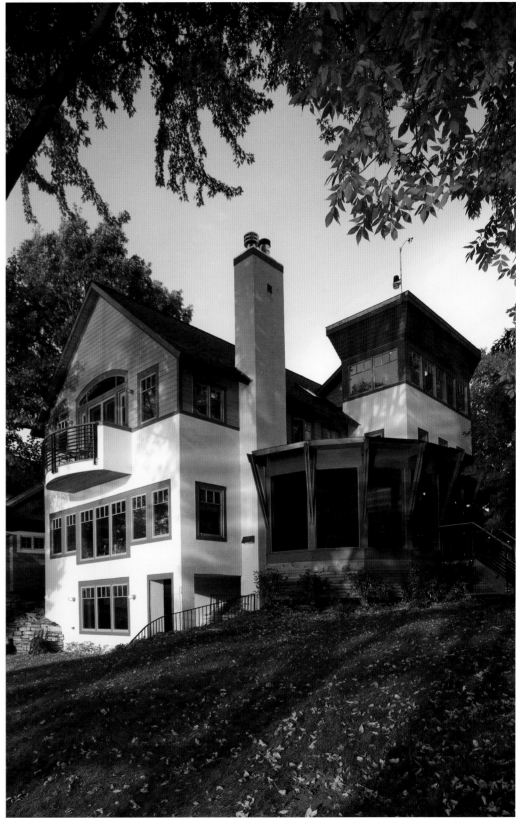

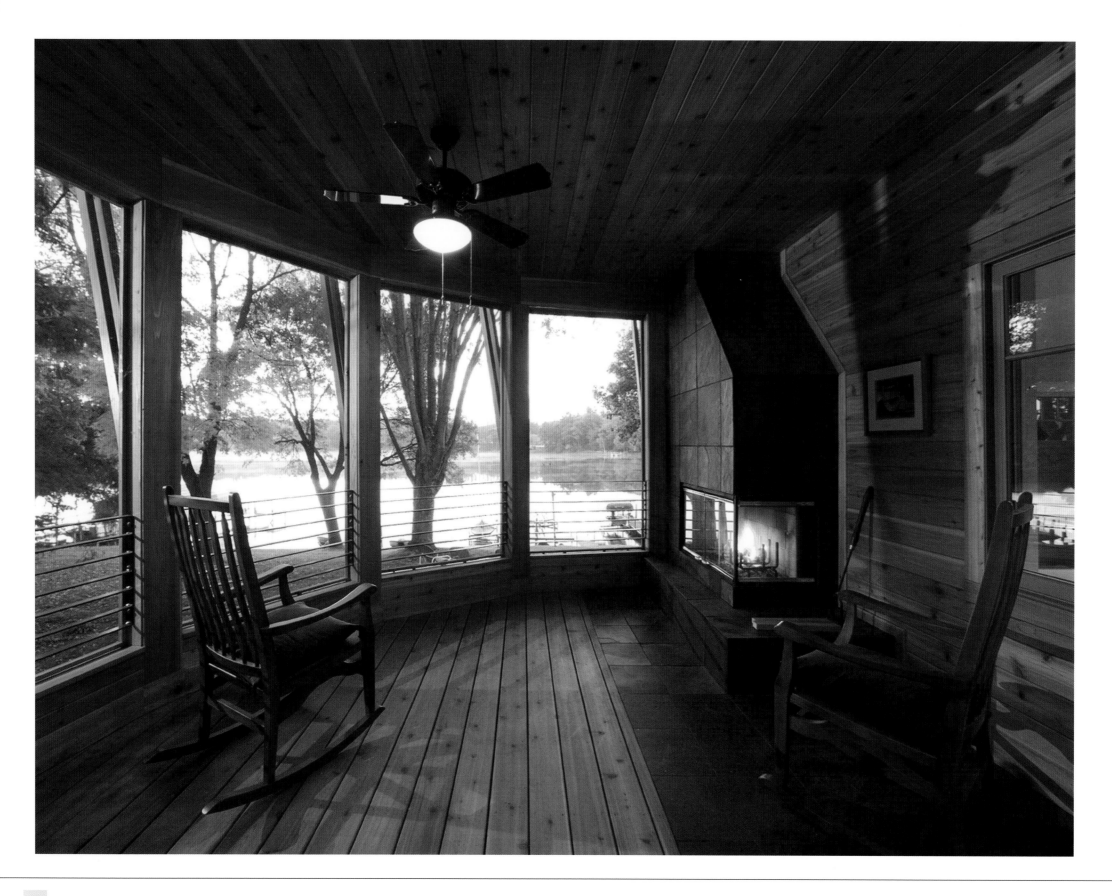

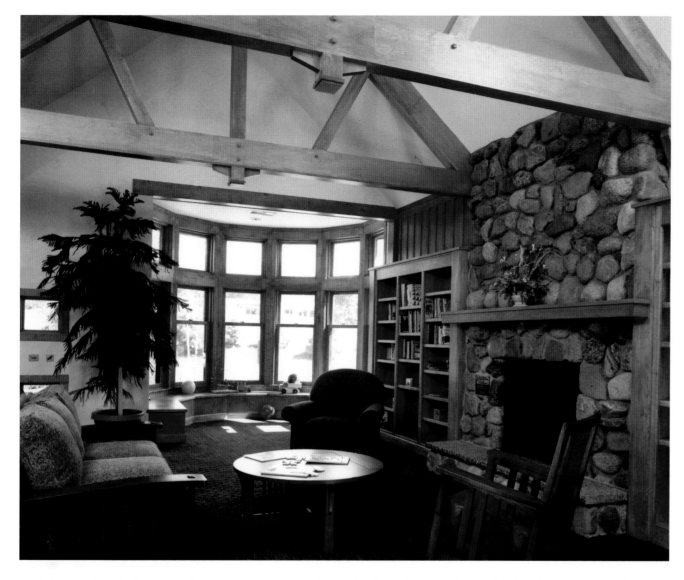

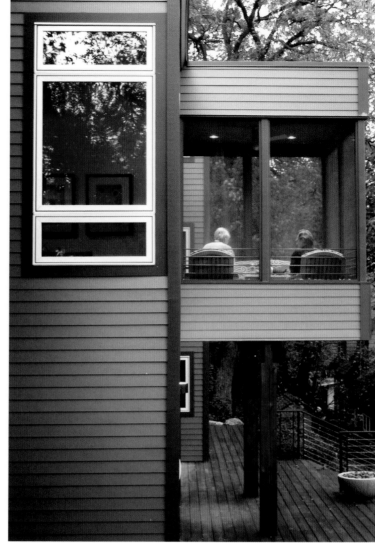

a ship's sails; they designed an airplane museum as a series of aluminum hangars; they nodded to the tribe's past when they created an Ojibwe museum composed of and resembling fallen birch trees. True artists, they successfully meld each sculptural form with the surrounding environment—whether natural or built. Indeed, much of the firm's work is urban infill architecture, and the partners strategically design homes that tie the neighborhood together and look as though they belong. John garnered significant attention for the design of his own home, which he fashioned after the Arts-and-Crafts homes around what was believed to be an unbuildable lot. Not only did the 2,400-square-foot home fit beautifully on the site, it seamlessly blended with the neighborhood's aesthetic fabric.

In addition to its numerous national and local AIA awards and various media appearances, including *Architectural Record* and *Architecture Minnesota*, Barbour LaDouceur is privileged to be a part of the Minnesota Design Team, an

AIA Minnesota committee that volunteers to help redesign and restore neighborhoods and towns. Their work stands as testament that in telling the stories of others, John and Janis become authors of Minnesota's architectural future.

Above Left: Designing on an existing farm presents a unique opportunity, as each generation has added a new building according to the era's traditions. Since there was a 1920s'-era barn, the new structure was designed and built in the 1920s' Arts-and-Crafts style with field stone and handcrafted trusses.
Photograph by Don Wong Photography

Above Right: In this lake home composed of geometric forms, this screened-porch thrusts you toward the lake and surrounds you with trees.
Photograph by William Kloubec, Heliostudio-Kloubec

Facing Page: This porch echoes a ship's wood-paneled captain's quarters, creating a restful setting for competitive sailors at the end of the day.
Photograph by Jim Gallop, Gallop Studio

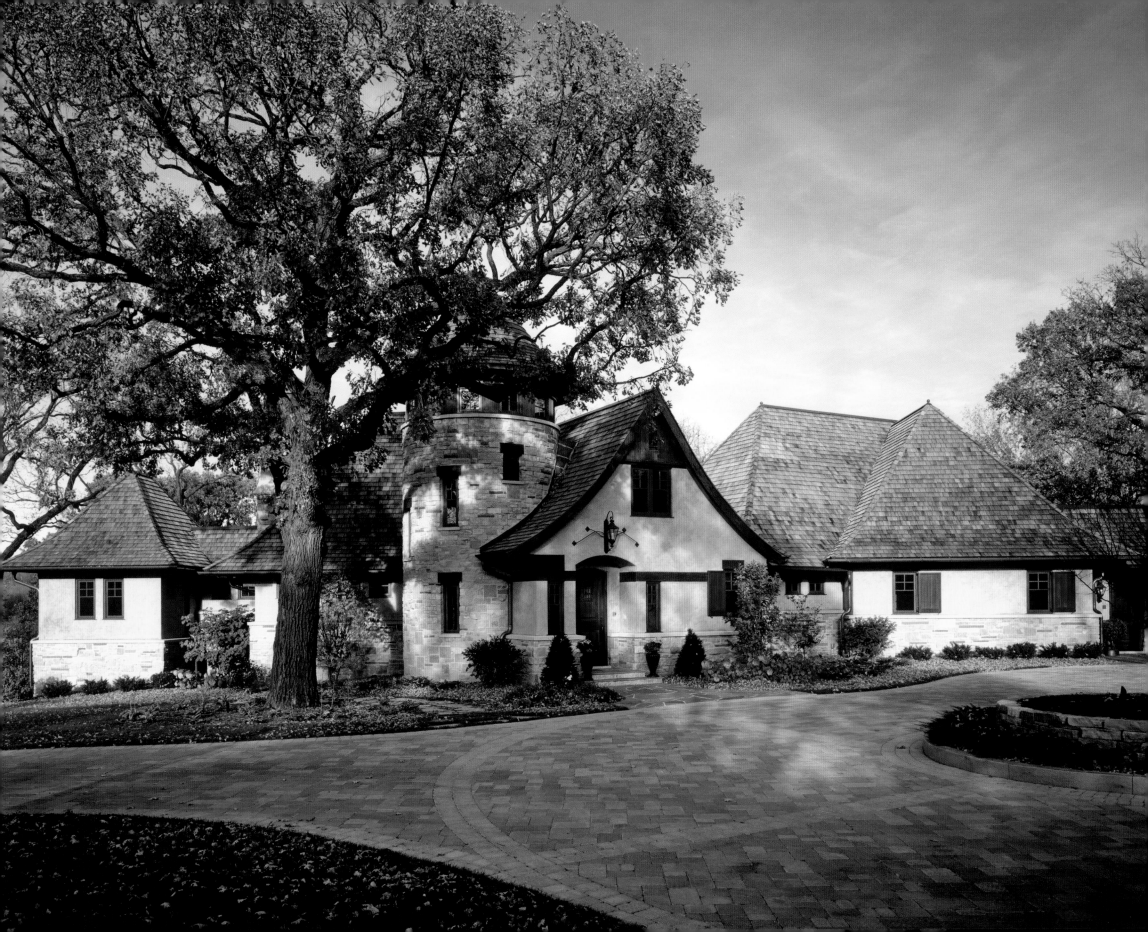

Kurt Baum

Kurt Baum & Associates

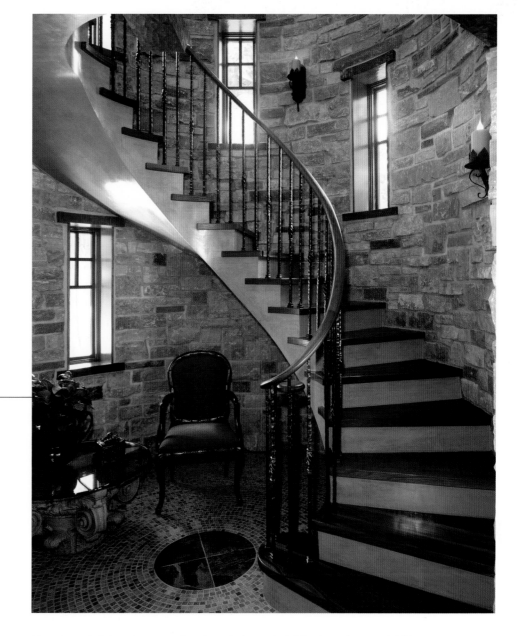

Above: Located off the main entrance, the staircase leads to a play loft for the residents' grandchildren.
Photograph by Greg Page

Facing Page: A gracious courtyard welcomes guests at the main entrance of this Old World-style home.
Builder: Streeter & Associates.
Photograph by Greg Page

Kurt Baum & Associates wants you to live your dreams. Kurt founded his unique architecture firm nearly 10 years ago with this in mind, and it is why he offers his clients unmatched service throughout the whole process of designing and building clients' highly customized projects. In order to do this, the firm purposely limits the number of projects it takes on each year. This allows Kurt and his team the time to spend listening and understanding the needs and concerns of clients as he helps design and build their dream homes or ideal spaces. The results speak for themselves.

Kurt grew up in Appleton, Wisconsin, and attended architecture school at the University of Minnesota. His local roots, strong work ethic and Midwestern values combine with a global outlook he has gained through extensive travel and study abroad. With a keen eye for both contemporary style and Old World

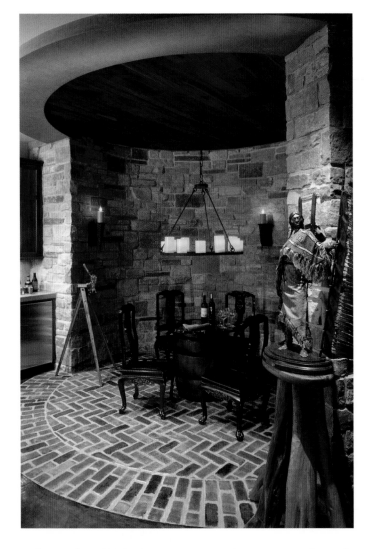

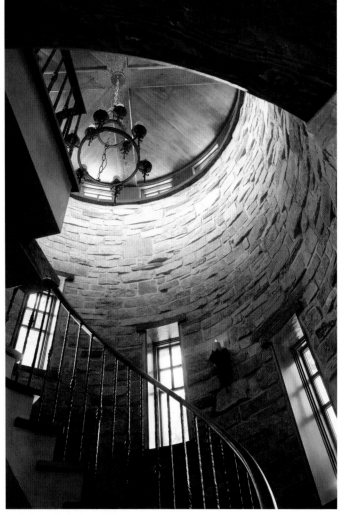

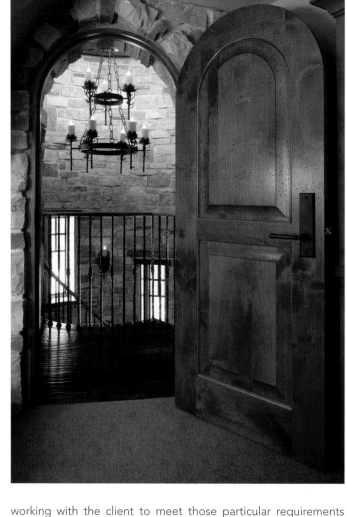

craftsmanship, Kurt's designs are award-winning, aesthetically pleasing and highly functional. He creates unique spaces that meet client needs and have an exceptional attention to detail. By understanding how each client intends on living, interacting and using each space, he can project a vision that is in harmony with the client's dream, style and budget.

While the majority of the firm's residential work takes place in the Twin Cities metro area, it is not uncommon for it to engage in projects across the state and in neighboring states such as Wisconsin, Iowa and Montana, among others. Many of

Kurt's residential endeavors consist of designing or renovating lakefront homes, which are exceptionally endearing to Kurt as he grew up on a lake himself and has a great affinity for designing proportionally sound, aesthetically satisfying homes that capture the majestic views that accompany the water.

Other notable projects that have been immensely gratifying for Kurt include designing a future retirement home and guest house in Montana that featured an accompanying horse stable and riding arena. While Kurt certainly does not consider himself an expert when it comes to matters equine, the process of

working with the client to meet those particular requirements proved both an enjoyable educational experience and a gratifying opportunity to fulfill his client's vision.

Above Left: The wine-tasting recess is nestled below a stairway.
Photograph by Greg Page

Above Middle: A turret clad in earthen material encases the main entrance staircase.
Photograph by Greg Page

Above Right: The play loft and turret are visually connected yet separated by striking wood details.
Photograph by Greg Page

Facing Page: The lake side of the home features a pool, spa and plenty of space to entertain. Builder: Streeter & Associates.
Photograph by Greg Page

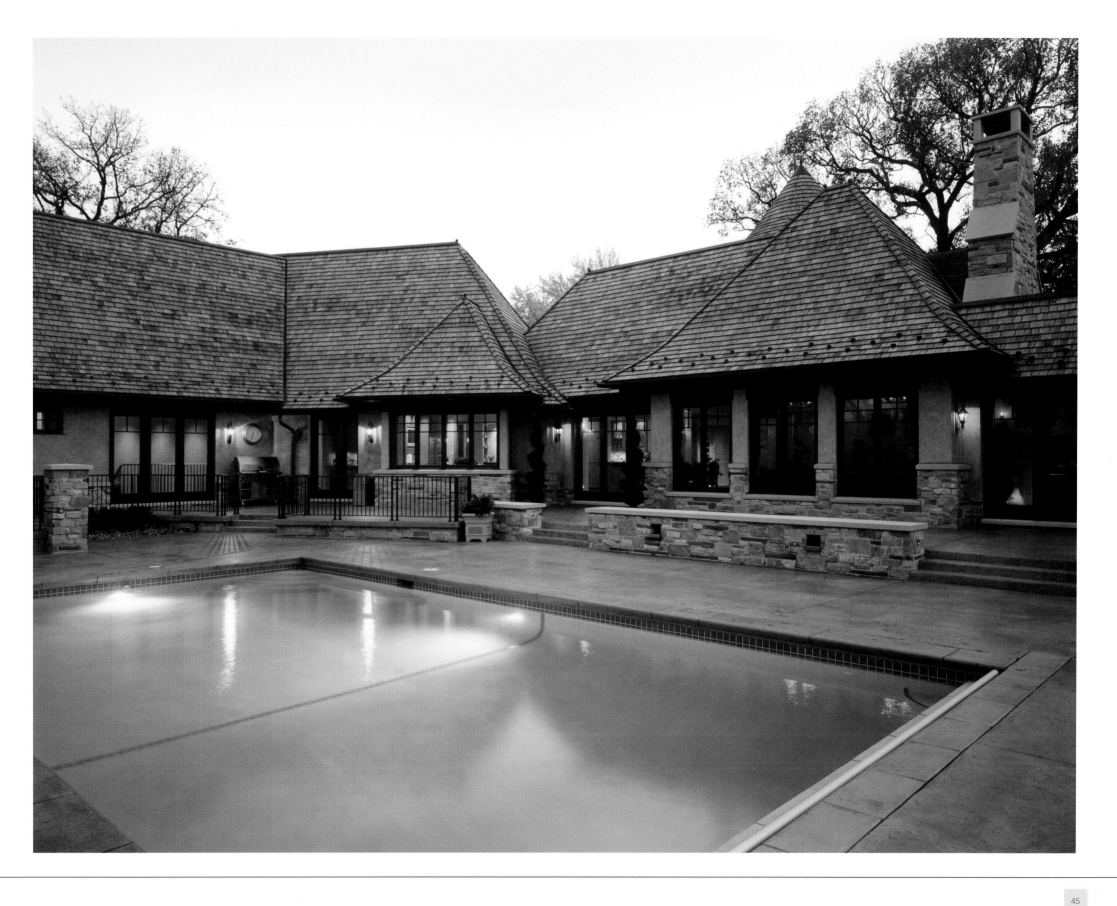

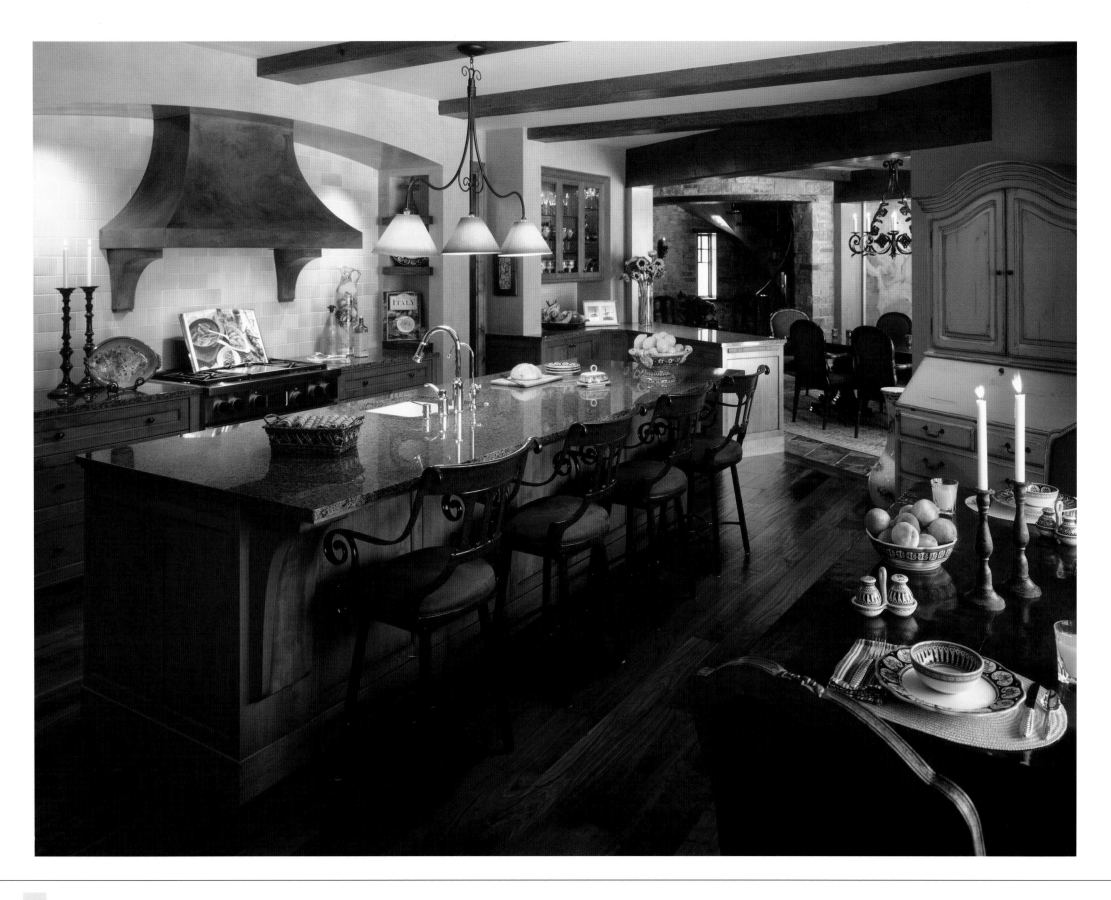

With a mixture of urban and rural projects, Kurt Baum & Associates strives to tailor the style of each home to its particular settings, in addition to the client's program, while staying true to the desired style, but will always adapt a style to meet precise objectives. For example, clients may desire a Victorian-style house, although they do not actually want to live like Victorian people—in very small rooms—so Kurt and his staff craft a design that captures the character of the age, but dovetail that design with the technology and comforts of modern life.

In essence, collaborating with Kurt Baum & Associates on a residential project is an introspective process that yields a highly customized, stylistically accurate home that meets the specific lifestyle needs of the always-satisfied customer.

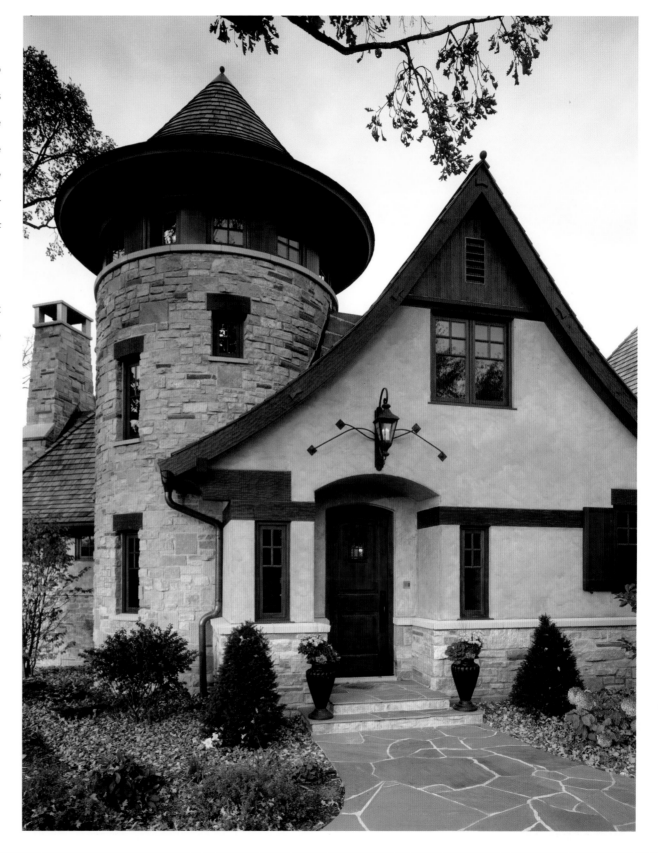

Right: The success of this Old World-style home's design was achieved through paying close attention to each and every detail. Builder: Streeter & Associates.
Photograph by Greg Page

Facing Page: A response to the clients' love of Tuscany, the kitchen is at once warm, spacious and inviting—an exquisite nod to Italy's finest villas.
Photograph by Greg Page

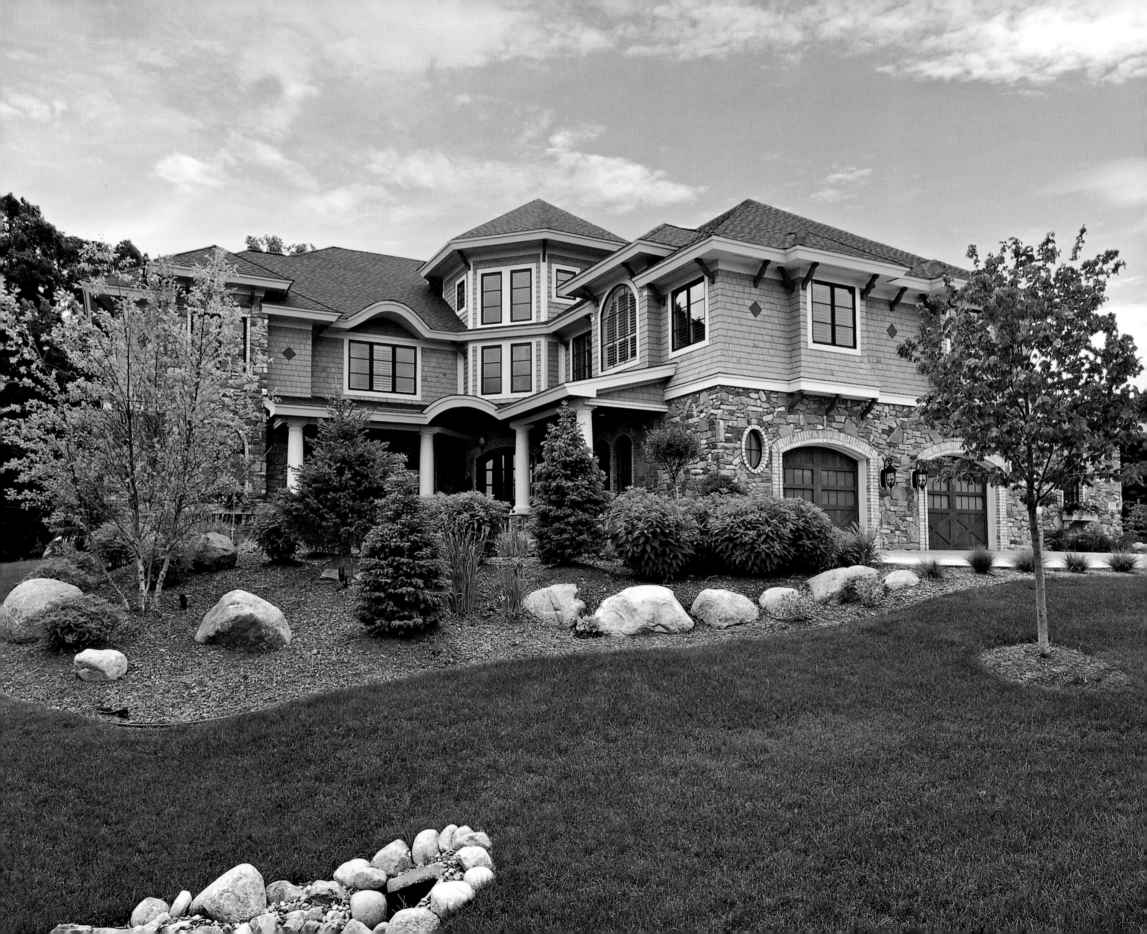

Bruce Carlson
Sherry Carlson

Carlson Custom Homes

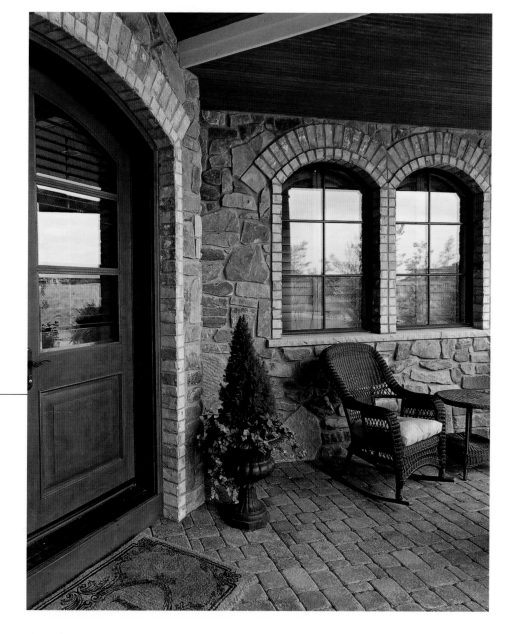

Above: The exquisite stone and brick details carry the theme of arches and curves in the 13,000-square-foot single-family home.
Photograph by Jennifer Terrell

Facing Page: This elegant home is nestled in a prairie restoration area of Wild Meadows North in Medina, Minnesota.
Photograph by Jennifer Terrell

Designing and building a dream home is a highly calculated and thoroughly involved endeavor. When this process is done right, however, the results are an ever-enduring, one-of-a-kind dwelling fully customized for its proud owners. In 1995, Bruce and Sherry Carlson recognized an untapped niche market for genuinely custom-built, single-family homes and founded Carlson Custom Homes in the delightfully charming town of Chaska, Minnesota. For the past 12 years, these dedicated builders have worked intimately with select clientele to fashion ideal solutions to particular tastes—no matter how extravagant or whimsical.

Because Bruce and Sherry take on less than 10 projects a year, Carlson Custom Homes is able to provide its clients an unparalleled personalized experience. This service is what makes this builder distinctive in an often highly impersonal industry. From conception to completion, the Carlsons are attentive to their

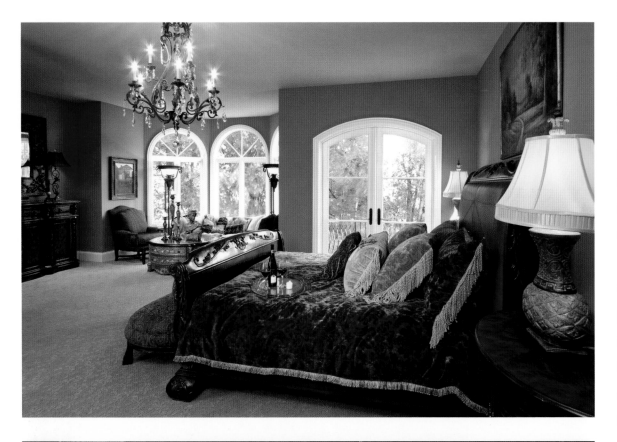

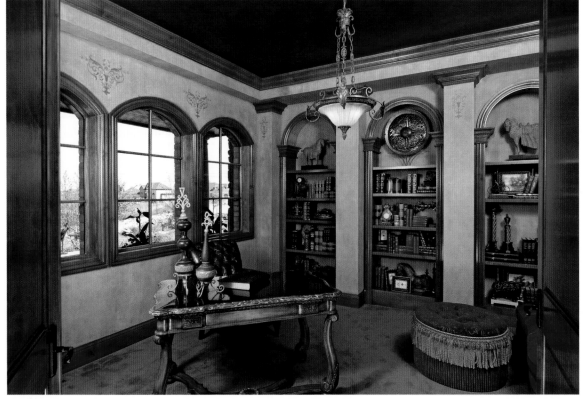

clients' goals, requirements and visions, providing hands-on involvement throughout the process. Readily accessible to homeowner inquiries—from design plans and landscaping, to specialized detailing and finishes—Bruce and Sherry encourage their clients to visit the job site and to stay in contact with them and the superior subcontractors they employ. This level of attention and communication is essential to ensuring every conceivable detail is accounted for. Because of this personal touch, many clients often remain good friends for years after their homes are completed.

After close consultation with the homeowners and architects to produce just the right plan, concept drawings and drafts are finalized. Next, Carlson Custom Homes begins the hard work necessary to make those visions a reality. Bruce and Sherry hire only highly skilled subcontractors who are experts and specialists in their fields, most of whom have collaborated closely with the Carlsons through the years. Clients benefit from the quality working relationships this builder has taken the time to develop. Bruce and Sherry frequently use specialized providers to acquire distinctive materials that add both elegance and uniqueness to a home. Recently, Sherry obtained reclaimed terra-cotta tiles from an old church in France, providing a one-of-a-kind product to a satisfied client.

Top Left: This spectacular master suite retreat features ample space to escape and relax.
Photograph by Jim Kruger, Landmark Photography

Bottom Left: Textured stucco walls add warmth and charm to the Mediterranean study, with its flair of arches and curves.
Photograph by Jim Kruger, Landmark Photography

Facing Page: The details in this French country home are magnificent. The grand staircase, turret and French balcony lend to the beauty of the architecture.
Photograph by Jim Kruger, Landmark Photography

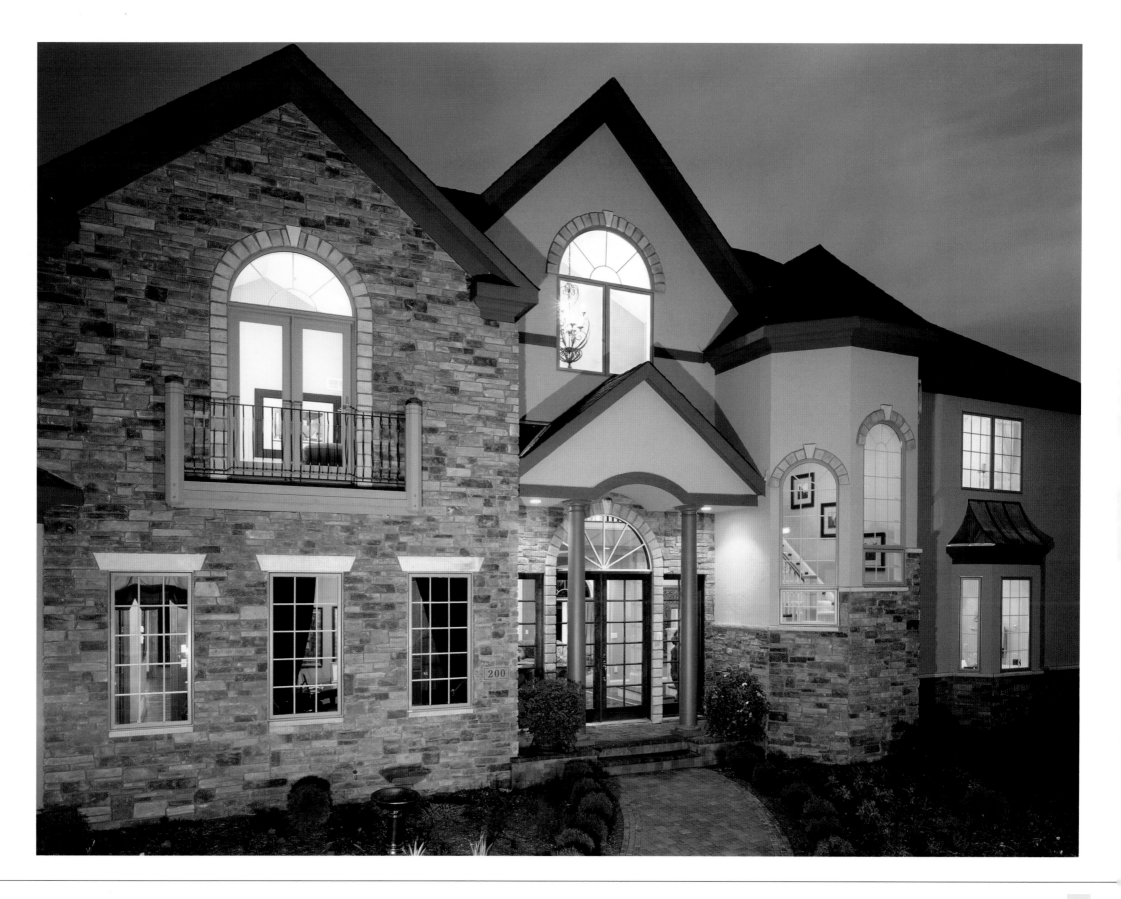

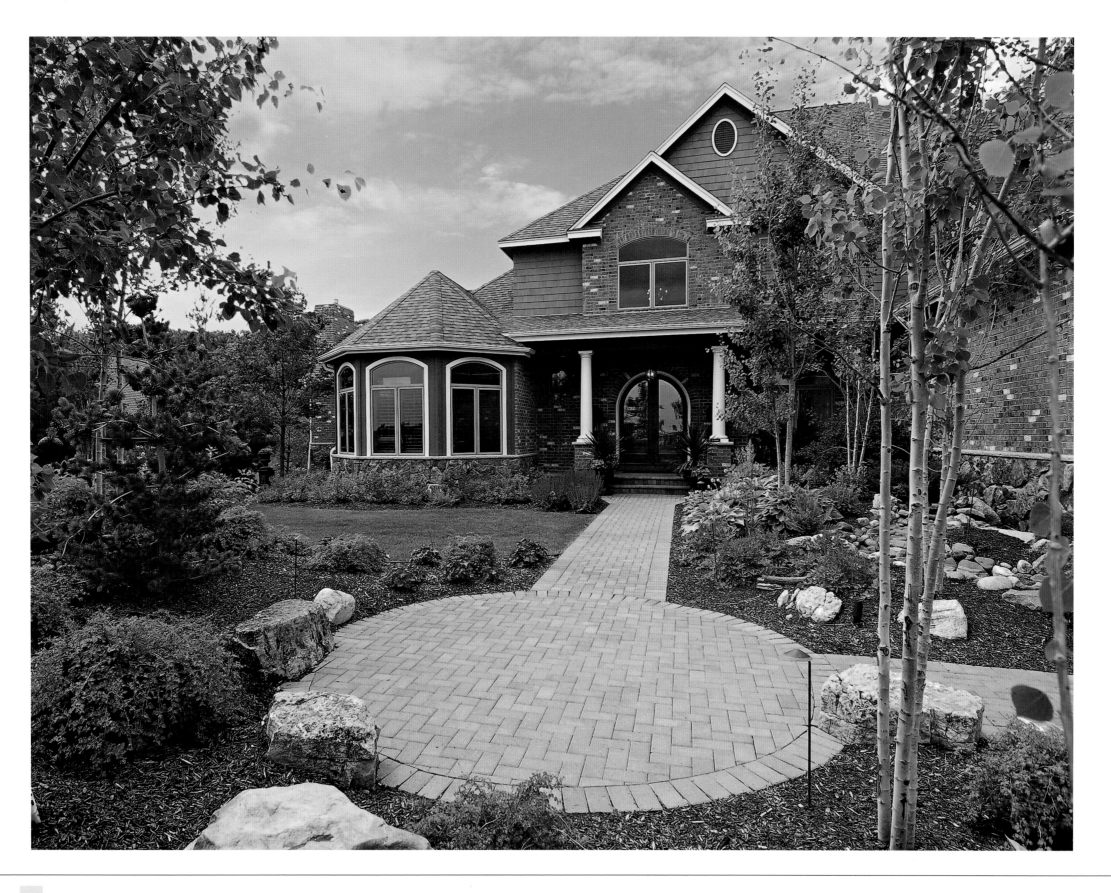

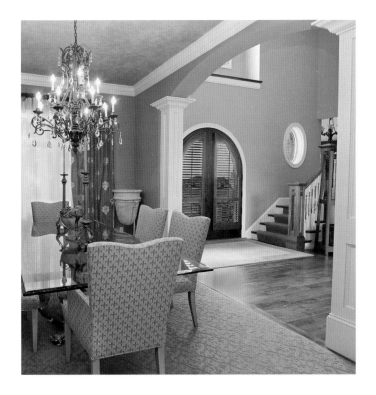

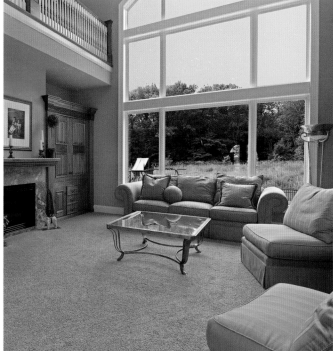

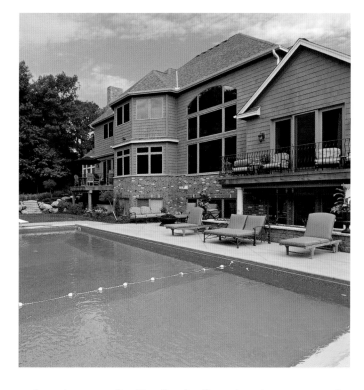

In addition to employing accomplished craftsmen and using highly specialized materials, Carlson Custom Homes goes out of its way to fulfill exceptional client visions. Sherry says, "Whatever the customer wants to dream up or come up with, we'll research it and make it happen." One buyer is building a 20,000-square-foot home with the Carlsons on Prior Lake and has made a rather ambitious request: an indoor pool with a retractable roof. Once Bruce and Sherry install it, the pool will be perhaps the first of its kind in the Gopher State. It is possible that this type of extravagance will be more commonplace in the near future, as is the once amusing, but now familiar, outdoor kitchen.

Another benefit of collaborating with these visionary builders is their dedication to professional development. The Carlsons are ever furthering their knowledge of architectural design and cutting-edge styles from across the country, blending new elements with more traditional aspects of Minnesota

architecture. In recent years, the couple has visited numerous states, like Arizona, California and Hawaii, and brought back rich details and unique concepts from those locales. For example, the Carlsons have recently incorporated immaculate interior doors handcrafted by Phoenix's Craftsmen in Wood, Mfg. into Carlson Custom Homes' creations.

Not only does this builder add value and vision to Minnesota's architectural landscape via a wide range of styles, but Carlson Custom Homes is also doing its part to preserve the Land of 10,000 Lakes through ecologically responsible designs and practices. One key partner in this philosophy is Marvin Windows and Doors, a leading company in the installation of environmentally conscientious products. In addition to using energy-efficient window, heating and structural components, Bruce and Sherry are doing the necessary research and will soon construct a concrete house. This will be an innovative

and environmentally friendly dwelling that incorporates the robust and durable material in a revolutionary way, providing sustainable living and using renewable energy.

Above Left: The combination of rich colors and textures adds to the ambience in this formal dining room.
Photograph by Jennifer Terrell

Above Middle: Expansive windows enhance the beauty of the living room, as do the built-in bookcases.
Photograph by Jennifer Terrell

Above Right: The exterior establishes harmony with the prairie preserve and creates beauty with the natural surroundings.
Photograph by Jennifer Terrell

Facing Page: This European-influenced luxury home is appointed with a rich interior of walnut cabinets and rustic alder beams.
Photograph by Jennifer Terrell

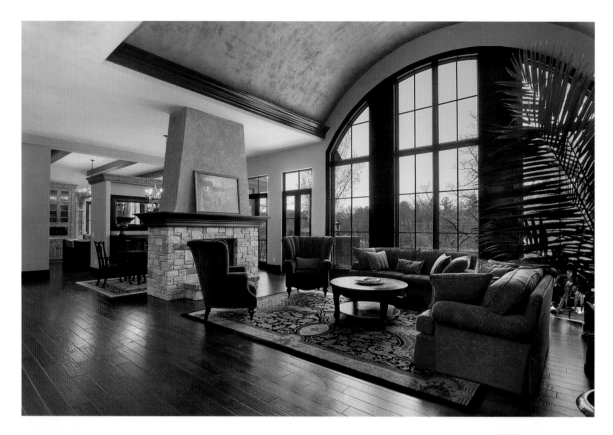

Bruce and Sherry Carlson have built vibrant, personally expressive and functional dream homes throughout the greater Twin Cities area for more than a decade. These attentive builders remain committed to envisioning and realizing first-rate solutions for their clients through collaboration in a network of premier architects, subcontractors and craftsmen. In addition, this couple is redefining Minnesota's residential landscape through environmental stewardship and by incorporating innovative design aesthetics from across the nation. All of these elements make Carlson Custom Homes a first-class builder of elegance and distinction.

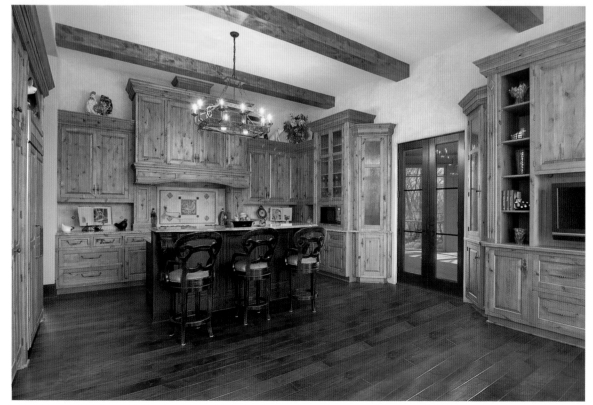

Top Left: The home reflects a French palette of colors, design and function and displays authentic French materials throughout. The barrel vault plays on the 16-foot wall of windows overlooking a lake.
Photograph by Jennifer Terrell

Bottom Left: The cabinets are reminiscent of a French-style kitchen, with inset doors and black iron hinges.
Photograph by Jennifer Terrell

Facing Page: A French chateau overlooks Mirror Lake in Edina, Minnesota. The stately arched front door adds elegance to the stone and brick exterior.
Photograph by Jennifer Terrell

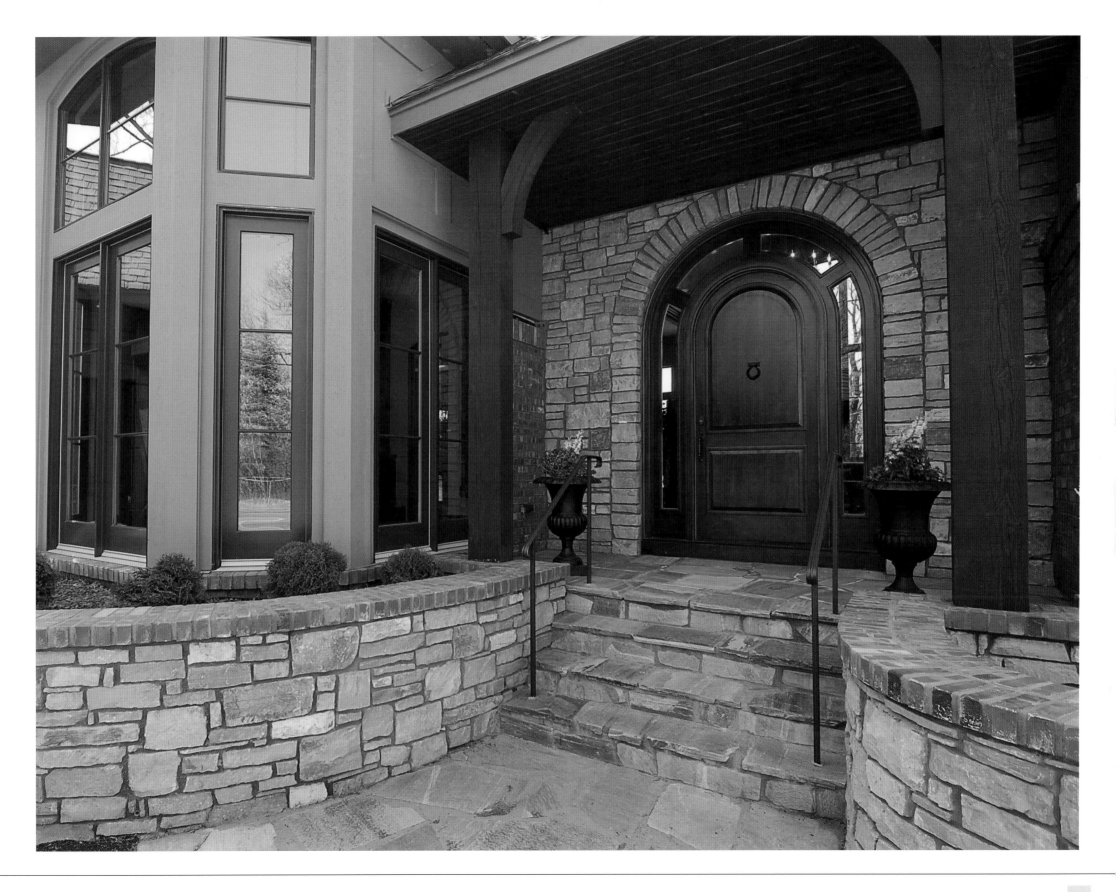

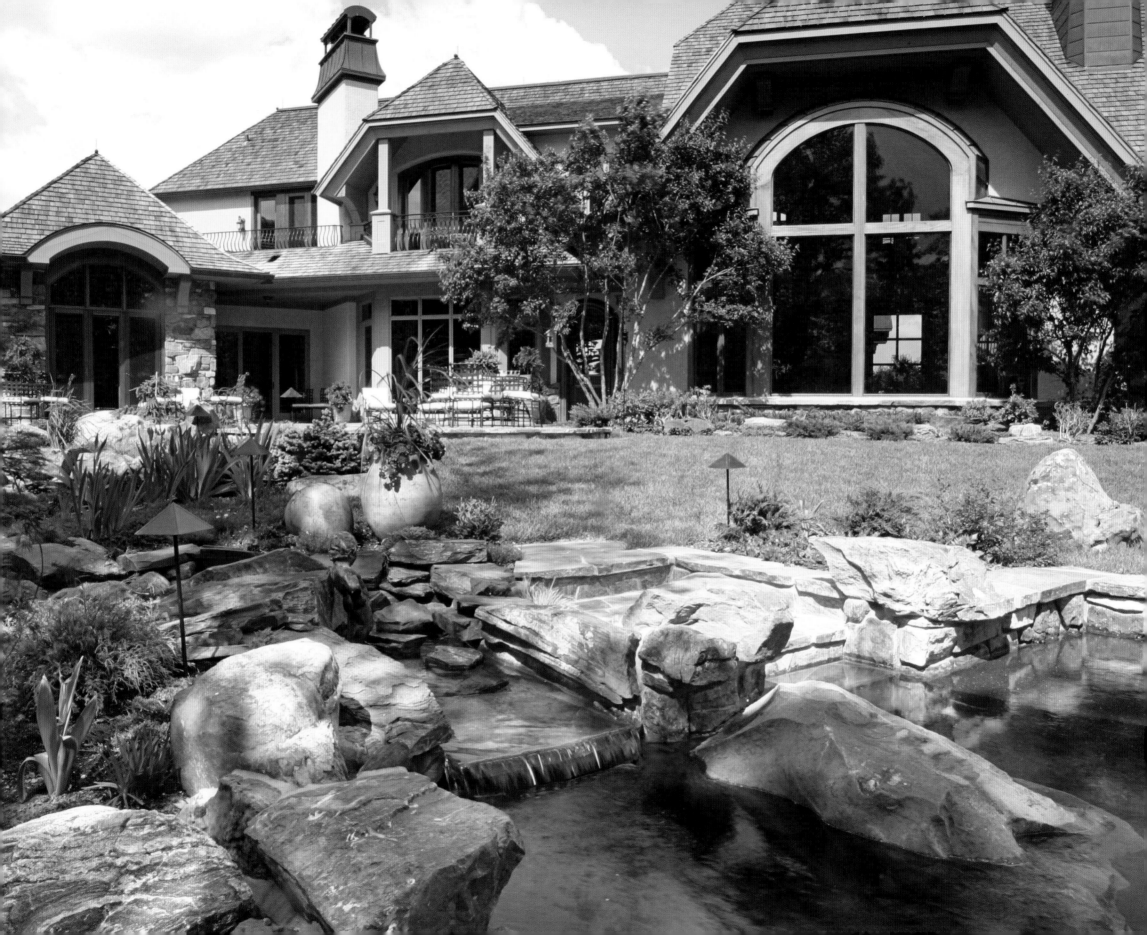

Rick Carlson
Water Street Homes, LLC

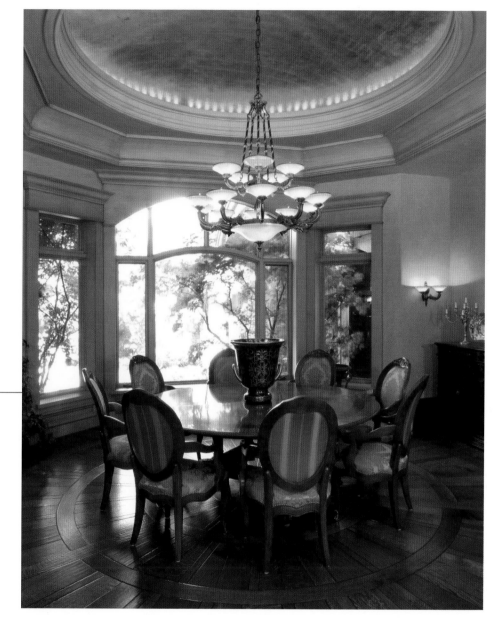

Above: The copper leaf ceiling of the dining room reflects light on the round table and intricate hardwood floor pattern below, setting the tone for an intimate dining experience.
Photograph by SKY Sotheby's International Realty

Facing Page: A babbling brook connects the lakeside spa of Dunrovin to the pool, where it eventually cascades over the waterfall.
Photograph by SKY Sotheby's International Realty

Offering extensive principal involvement throughout the entire process of designing and building a lavish custom home, Water Street Homes provides clients the thorough consultation and unwavering attention that is to be expected from a boutique operation. Owner Rick Carlson has been around the building industry most of his life and has been a partner or principal of luxury home builders since 1986.

At Water Street Homes, Rick oversees a team that collaborates to provide full-service general contracting duties to a niche clientele, which results in the firm building about eight extravagant residences per year.

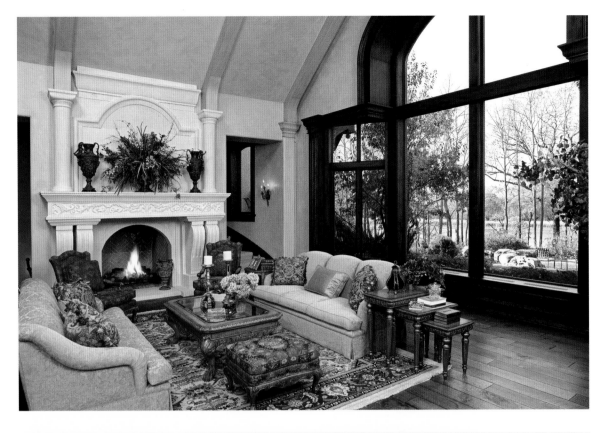

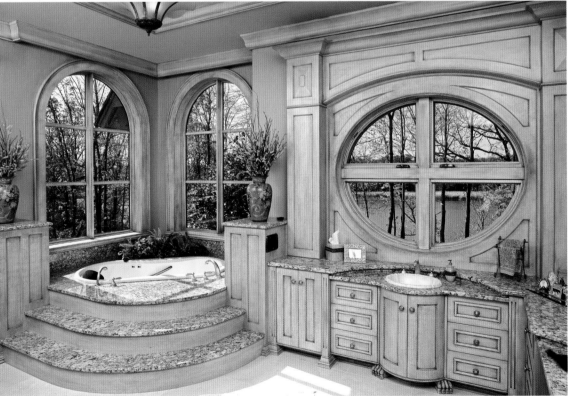

Clients who work with Water Street Homes can expect hands-on, enduring principal involvement from the beginning stages all way through landscaping and moving into the house. While such unwavering immersion from the owner proves exceptionally beneficial, building is a team effort and requires skilled craftsmen. The most important job of the general contractor is to assemble the best, most qualified team for the project. From the architect, designer and project manager down to every subcontractor, Rick's years of experience and relationships are invaluable.

Water Street Homes has increasingly utilized progressive technology in the form of computer-aided design to more effectively and expeditiously streamline the design process. Employing such technology allows the project team to effectively design the intended home—down to the smallest details—and communicate it to the client. Moreover, the technology today is sophisticated enough that it can identify at early stages in the process potential design problems, inside and out, that may otherwise be undetectable with traditional blueprints.

Top Left: The living room, replete with hand-carved stone fireplace, opens up to the natural beauty beyond through a massive wall of glass.
Photograph by SKY Sotheby's International Realty

Bottom Left: This master bath offers intimate luxury: Bathers enjoy breathtaking views yet the opportunity for privacy at the touch of a button.
Photograph by SKY Sotheby's International Realty

Facing Page: The kitchen at Dunrovin, one of four in the residence, looks like a functional piece of art; yet it performs with the best of kitchens.
Photograph by SKY Sotheby's International Realty

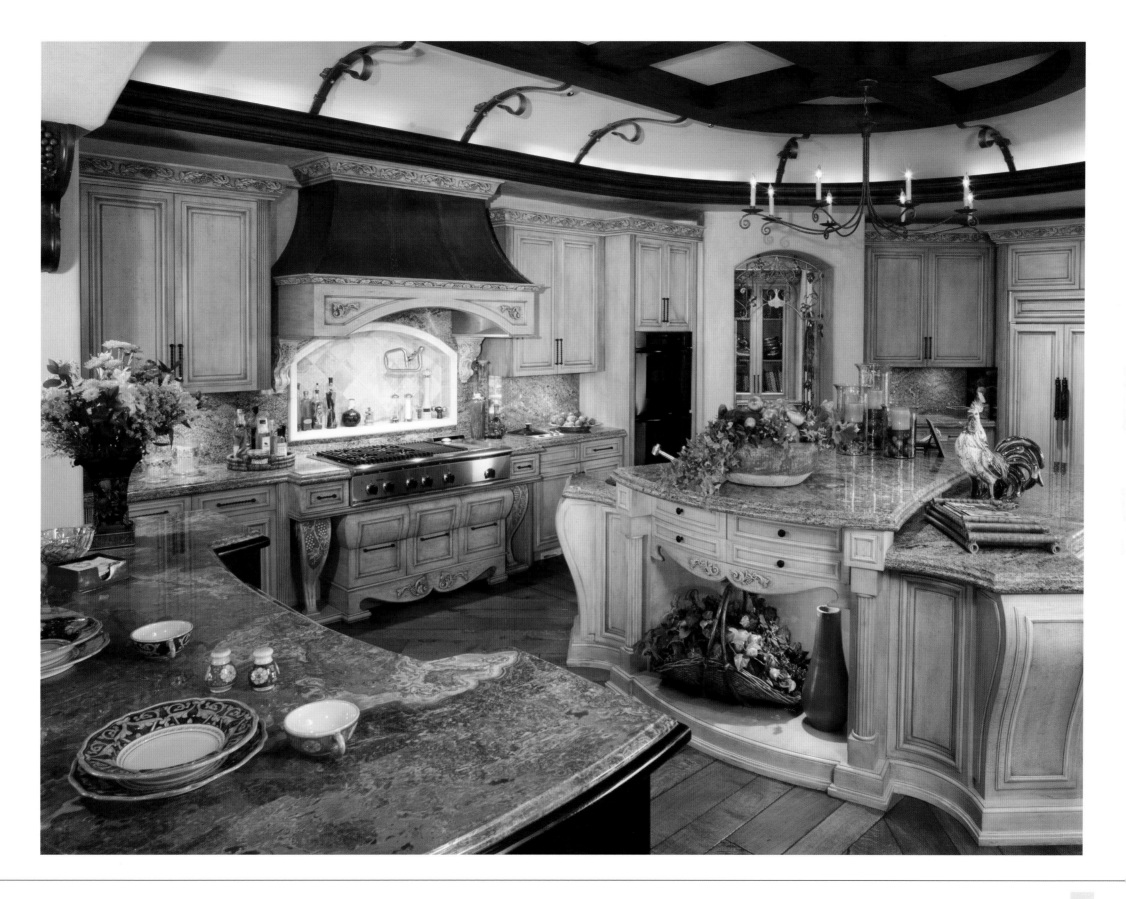

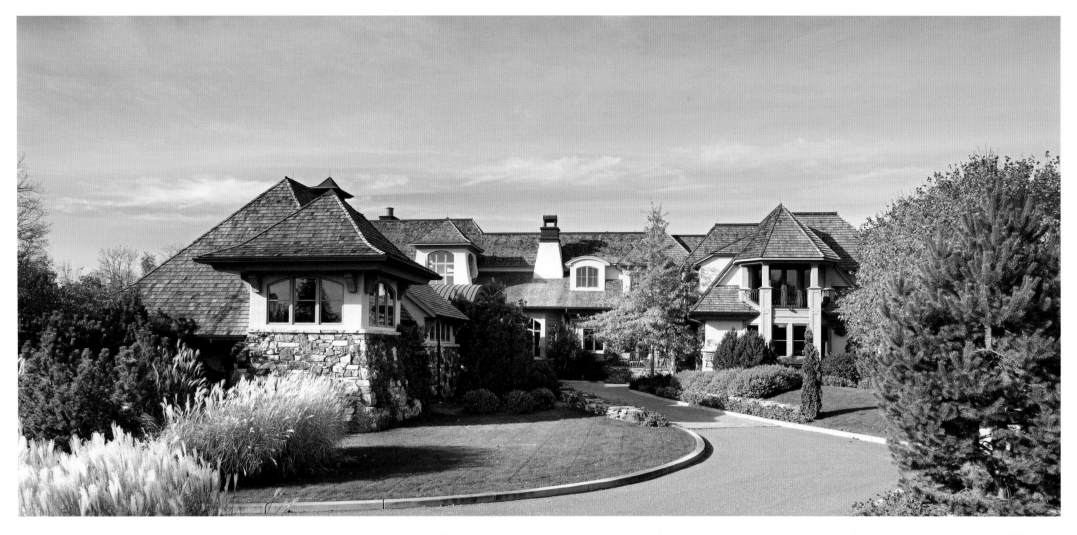

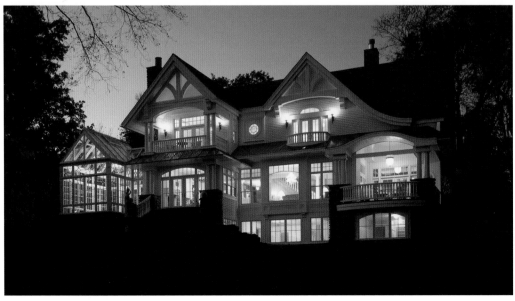

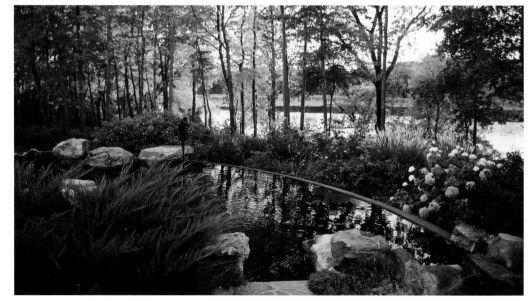

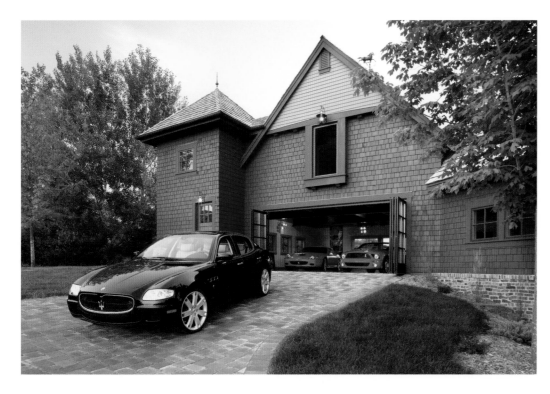

While all of Water Street Homes' custom residences are unique in their own right, Rick and his team have an affinity for incorporating stone and other natural products into its designs.

So whether it is a luxury lakefront home on the shimmering shores of Lake Minnetonka or a quaint residence in the woods of western Minneapolis, rest assured that working with Water Street Homes will deliver you your own dream home of Minnesota.

Above: The accessory building at EdgeMoor holds more than hay: The post-and-beam design keeps these 500-horsepower beauties track-ready.
Photograph © George Heinrich Photography

Right: Beauty and brawn: Stainless steel lights artfully highlight the cars poised below the steel beams, spanning nearly 40 feet. Custom cable rails allow uninterrupted viewing from the loft above.
Photograph © George Heinrich Photography

Facing Page Top: As you drive past the private golf hole of Dunrovin, the carriage garage and entry give you a glimpse of what awaits.
Photograph by SKY Sotheby's International Realty

Facing Page Bottom Left: The glass conservatory captures the sun and the stars; the architectural windows overlooking the lake capture the views beyond.
Photograph © Karen Melvin Photography

Facing Page Bottom Right: Lined with natural boulders and featuring a waterfall, the black-bottom pool fits in harmoniously with nature itself.
Photograph by SKY Sotheby's International Realty

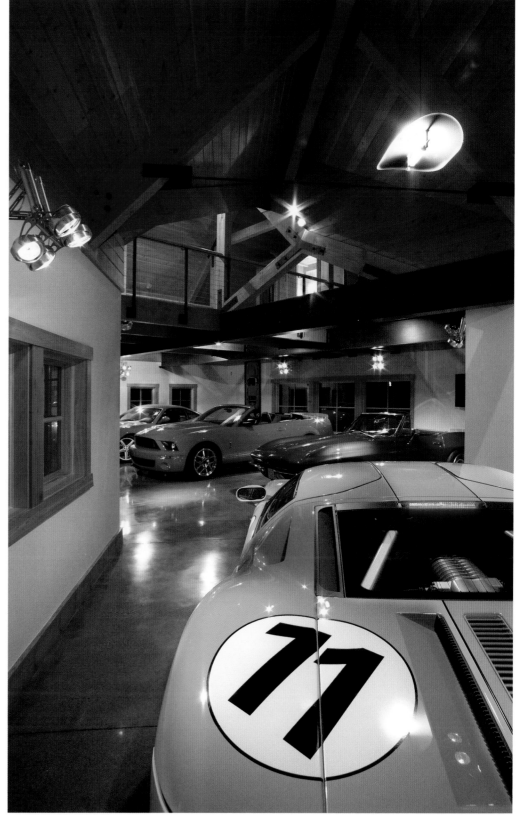

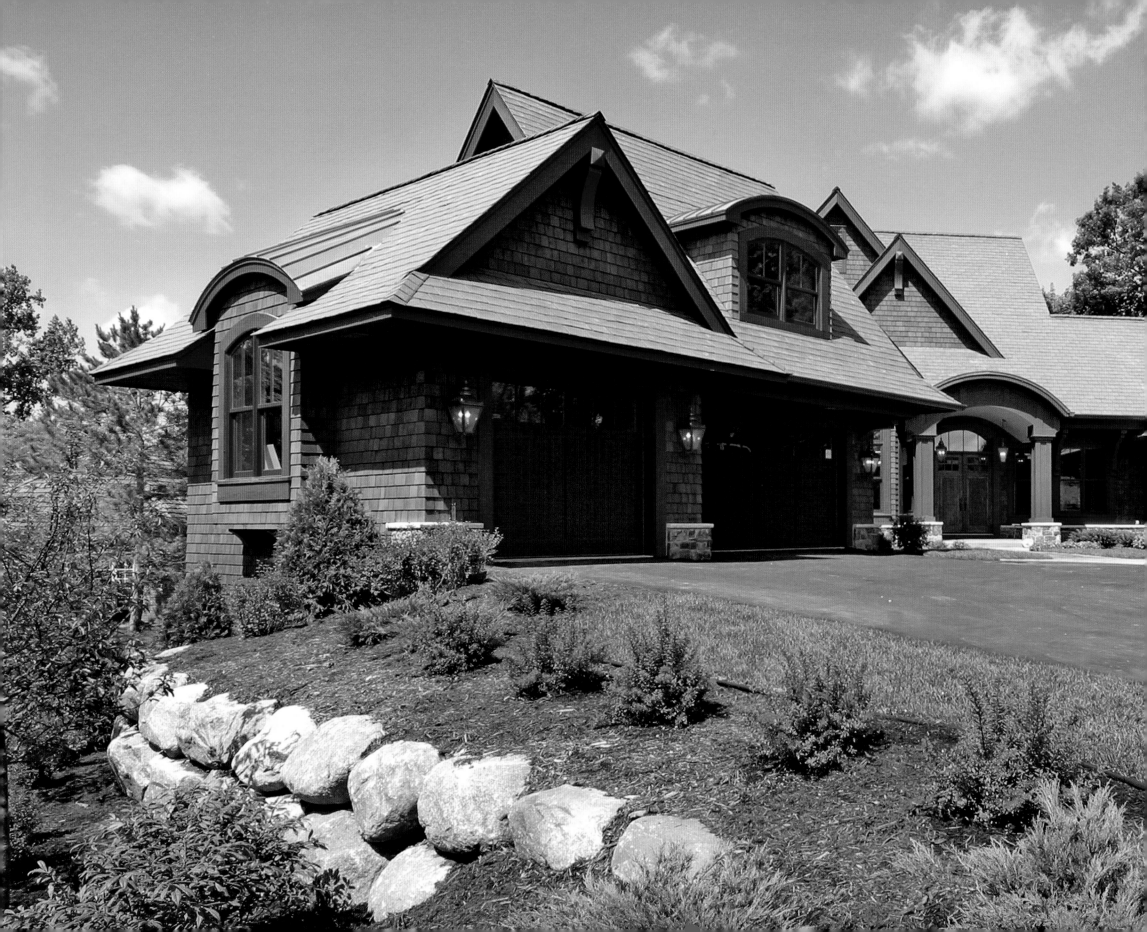

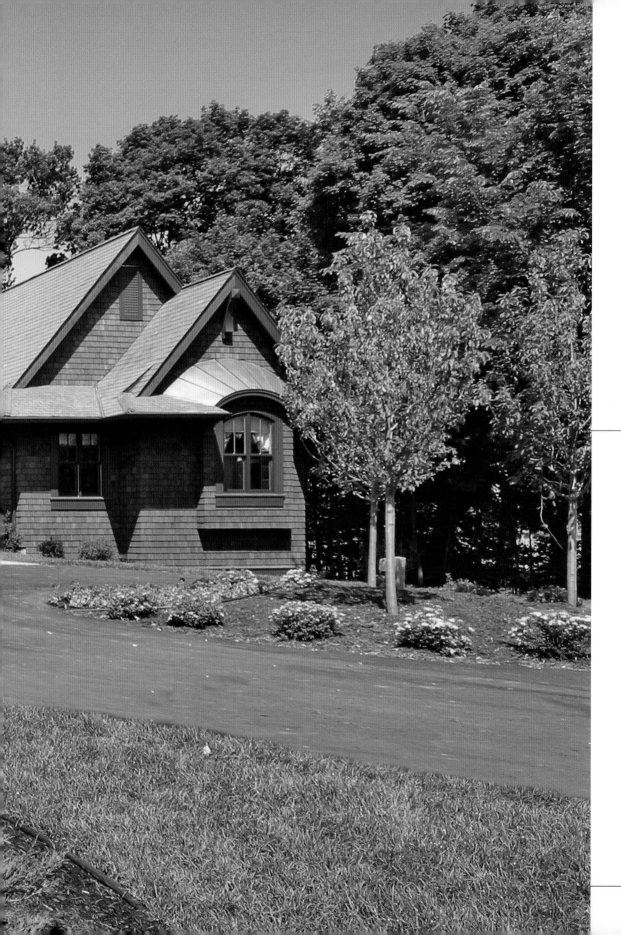

K.C. Chermak

Pillar Homes

For K.C. Chermak, founder and owner of Pillar Homes, building homes that change lives is his passion. K.C. differs from most homebuilders in that his more than 20 years of experience in the industry encompass more than just construction; he began in real estate where he gained keen business savvy and developed a grasp for what the client needed. The bottom line: He determined that the buying public deserved much more than they were getting. In 1995, with the founding of his design/build/land-development firm, he joined a new wave of builders that build traditionally sound homes, yet are second-to-none in technology. K.C. holds that the home is the center of the family and their social life. It is the most obvious signature of one's individuality, and his company strives to reflect and represent all that is unique about each client and their home.

Left: Lakeside living on Lake Minnetonka is enhanced by a home that embraces one upon approach.
Photograph by Jon Huelskamp, Landmark Photography

Pillar Homes is a unique conglomeration of ideas from the business, marketing and creative processes, to architecture and construction. Blueprints originate from a small, trusted group of independent architects who keep the designs fresh and diverse. K.C. carefully pairs clients and architects based on style preferences and design needs. In building custom homes, people are executing their passions, whether they encompass vibrant color, childhood memories or each family member's interests.

Above: The home allows for stunning sunset views of Lake Minnetonka.
Photograph by Jon Huelskamp, Landmark Photography

Left: Reflected on the surface below, this grand entry creates a dramatic scene.
Photograph by Jon Huelskamp, Landmark Photography

Facing Page: The oval window detail in the kitchen can be viewed from this island peek-a-boo.
Photograph by Jon Huelskamp, Landmark Photography

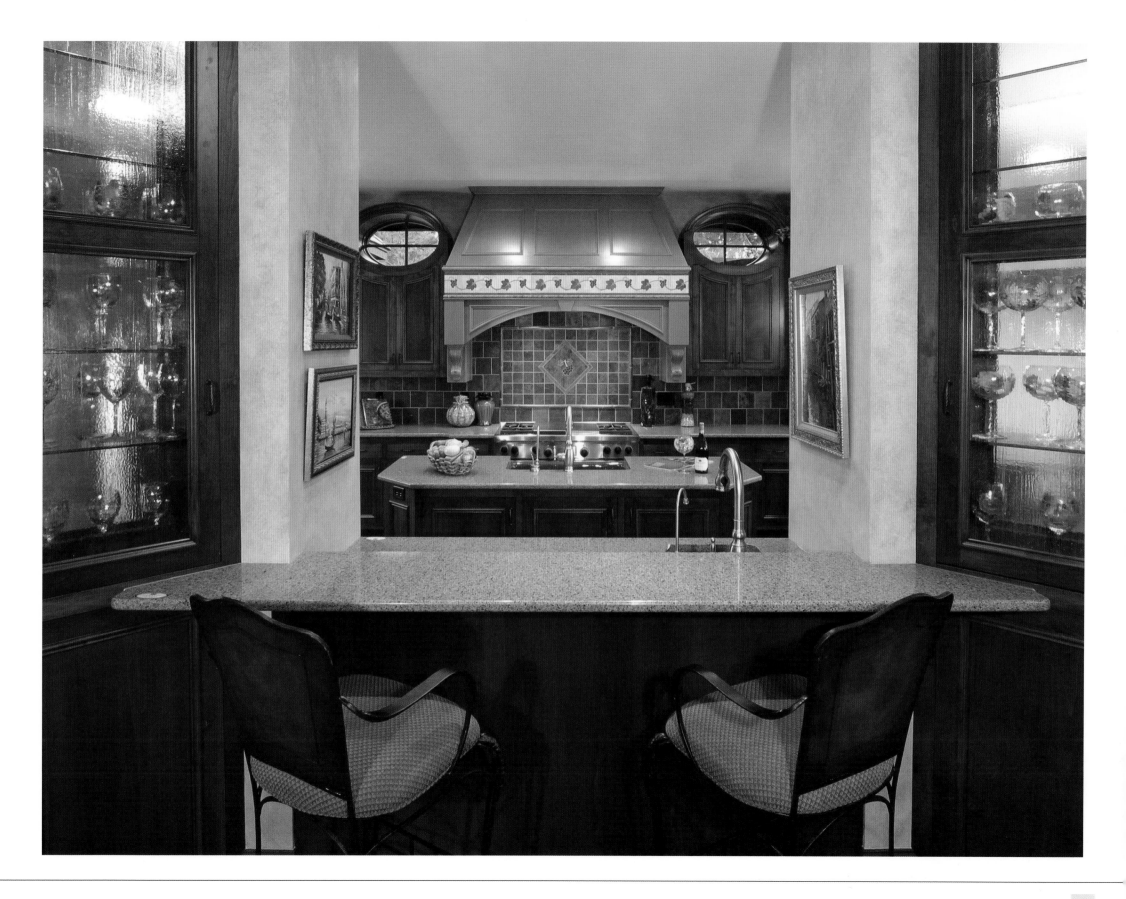

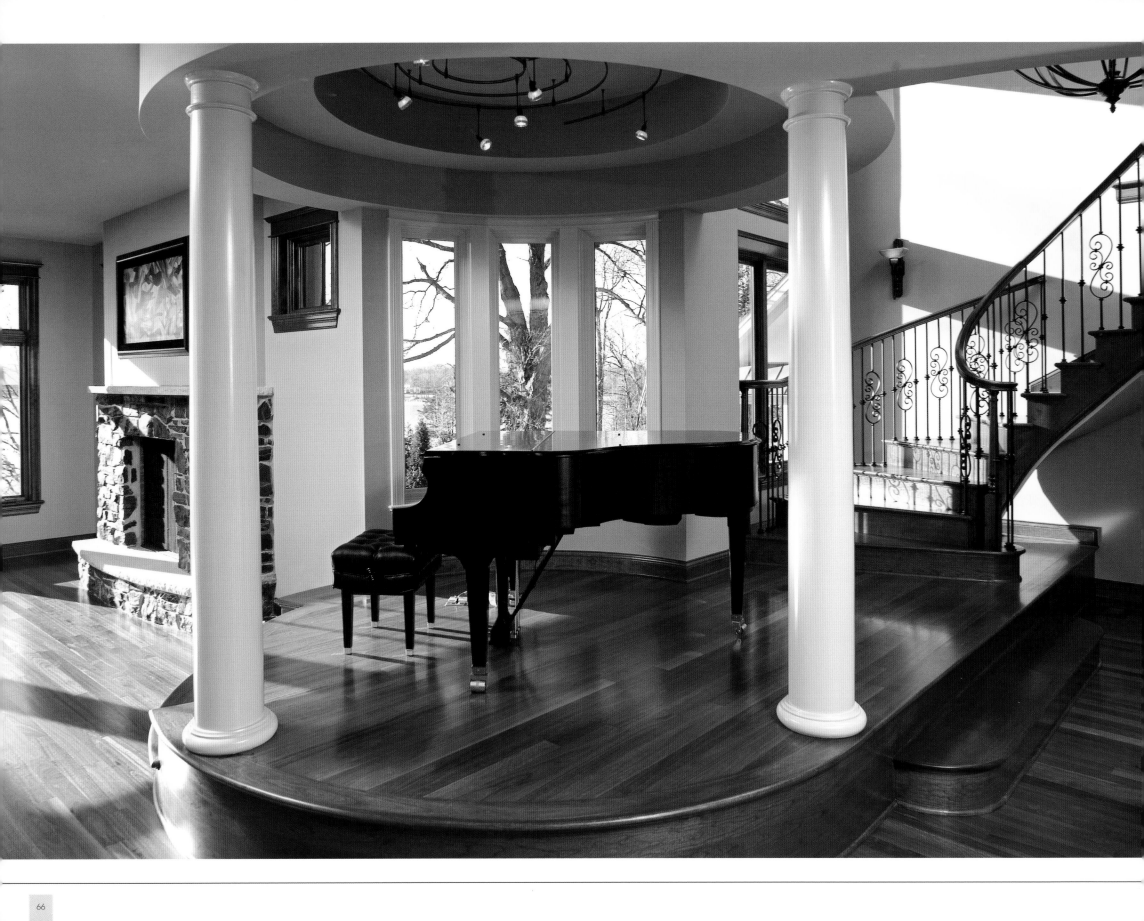

Pillar Homes' mission is to start with an impressive design, incorporate quality craftsmanship and utilize expert interior designers, ensuring the smallest of details are built into every project. Within a custom design/build firm, K.C. has the unique ability to guide his clients in all areas of the home-building process and expose them to a "total idea" they might not have had the opportunity of exploring. In an effort to discourage clients from getting bogged down or stressed, the company maintains a passionate, vibrant and lively environment to help homeowners through the building phase of the project.

Today people are building to create a better lifestyle; they want their homes to feel elegant and sophisticated, yet livable. The Pillar Homes team is driven to create a home that achieves this goal and reflects the people for whom they build. Homes must be realistic for today's active families, and the team employs a variety of techniques to achieve this. Organized areas and innovative solutions—including cubbies at the door for each family member, heated garages, garage lockers and designated niches for studying designed for open parental discretion—create order and family-focused environments. K.C. consistently hears from visitors and clients alike that his homes are tangibly nurturing to families.

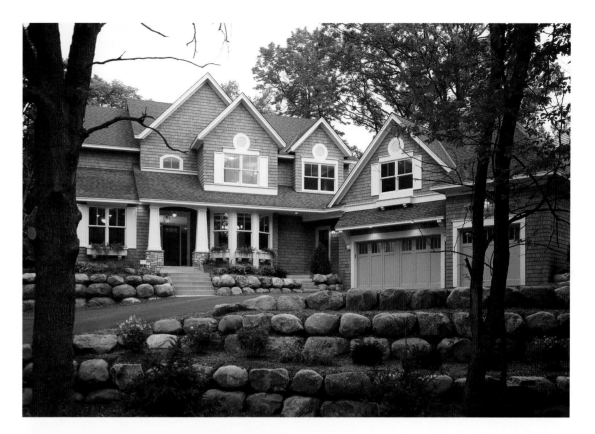

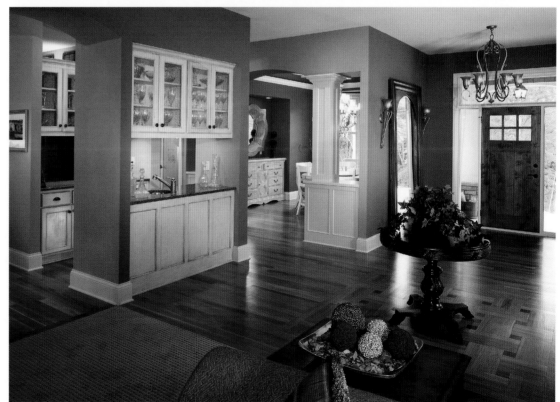

Top Right: Though traditional in design, the terraced boulder work makes this home unique.
Photograph by Jon Huelskamp, Landmark Photography

Bottom Right: The home design had to incorporate the owner's request for a home that allows for lots of easy casual entertaining.
Photograph by Jon Huelskamp, Landmark Photography

Facing Page: This inviting circular grand piano level makes one long to play.
Photograph by Jon Huelskamp, Landmark Photography

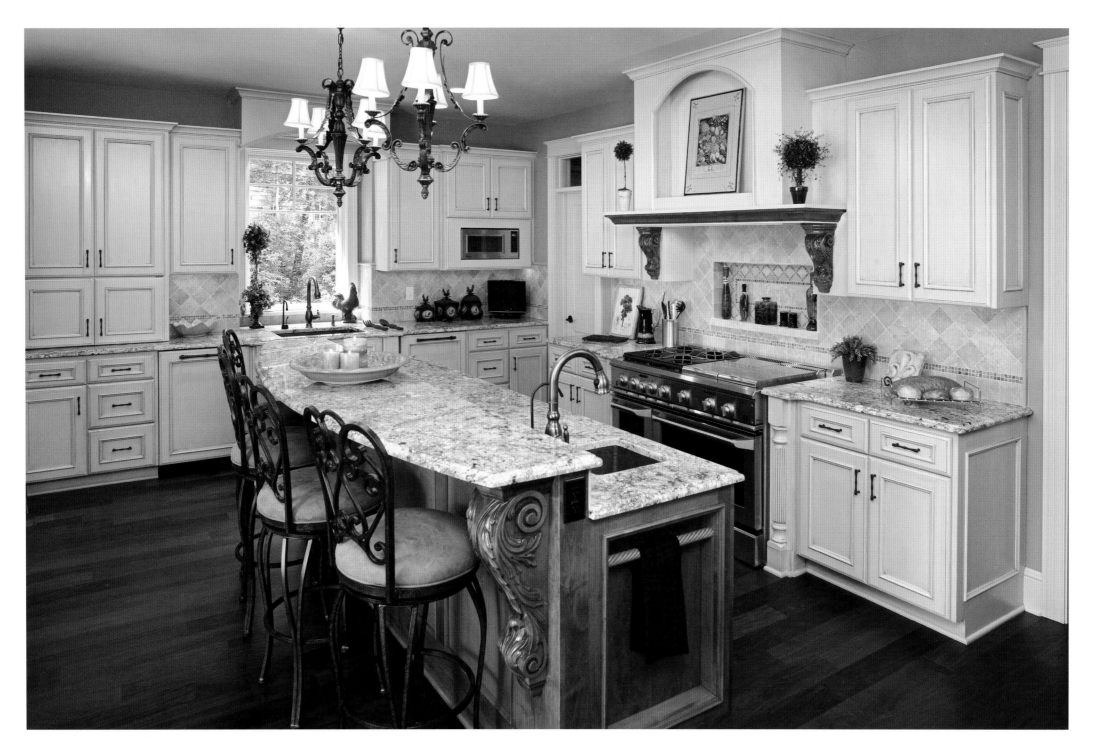

As a recognized member of the Twin Cities' building community and the 2007 Vice President and 2008 President of the Builders Association of the Twin Cities, K.C. defines his success not by his company's Trillium, Reggies or People's Choice Awards but by his ability to make the building process enjoyable for his clients and to achieve complete customer satisfaction. Indeed, K.C.'s motto is, "I'd love to build your dreams, but I'd rather create your passion." The Pillar Homes team helps discover these passions and interprets them into the homes they create.

Above: This very functional kitchen has all the amenities: not too big, not too small—just right.
Photograph by Jon Huelskamp, Landmark Photography

Facing Page: This gabled home is a warm and welcoming sight to behold.
Photograph by Builderwebsites.com

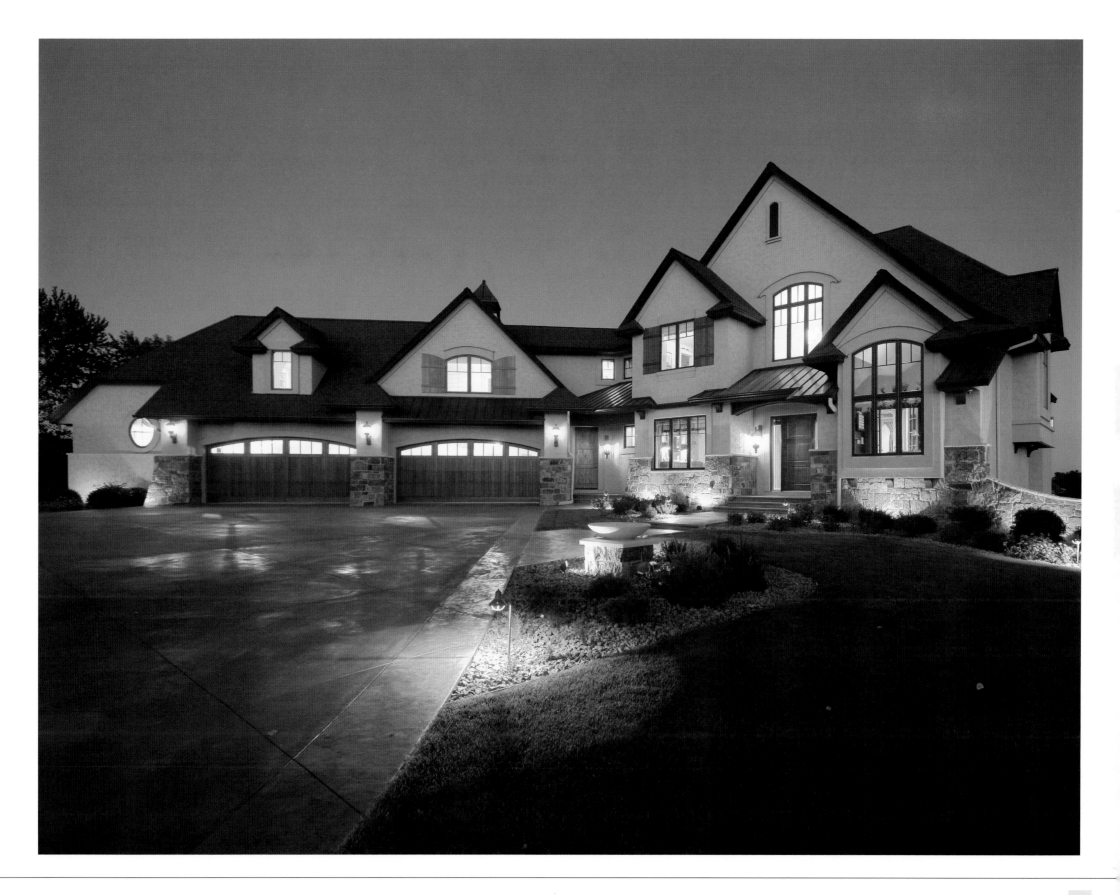

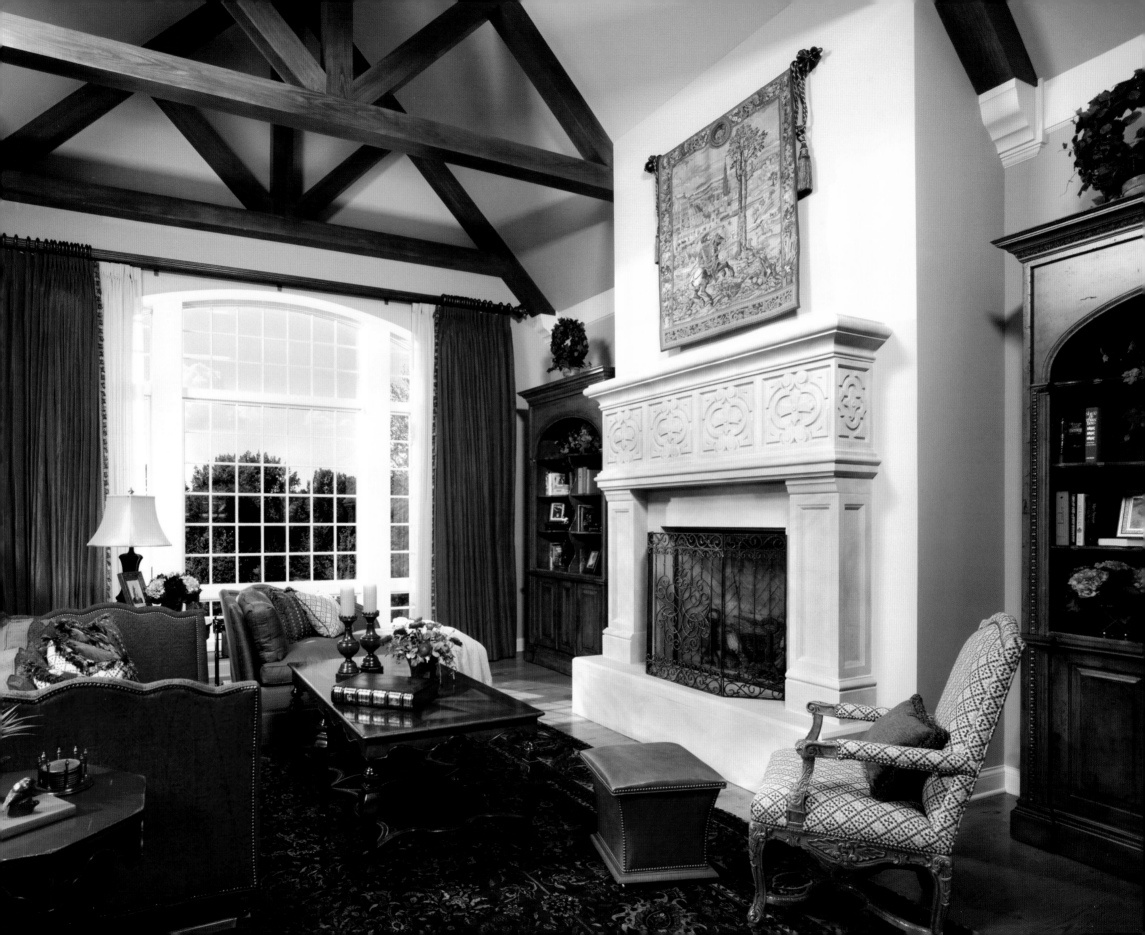

Larry Cramer
Jennifer Cramer-Miller

L. Cramer Designers + Builders

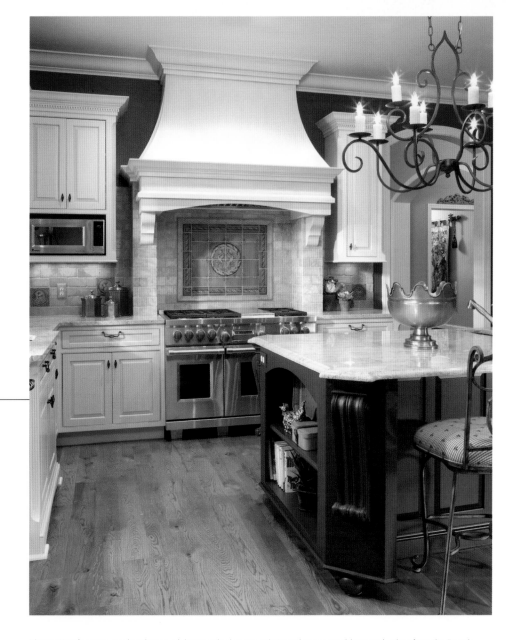

Above: Fine furniture-grade cabinets, elaborate tile designs, substantial crown mouldings and colors from the French countryside bring this kitchen to life.
Photograph by Karen Melvin

Facing Page: Exposed wood beams in this impressive L. Cramer great room add visual excitement—further enhanced with the grand, cast-stone carved fireplace.
Photograph by Karen Melvin

It is rare to find a builder who treats each project as though it were his own home, but Larry Cramer and his team do just that. Indeed, the intimate team at L. Cramer Designers + Builders not only treats every client as its only client, it views each aspect of the design-build process through the client's eyes. The firm's staff includes an architectural designer, construction project managers and job superintendents and oversees every stage of a project. They offer a completely turnkey process, ensuring that the client's vision is realized within the timeframe and budget allotted—a distinctive quality in the building world.

The success with which the firm reaches this goal time and again is a result of the vast experience Larry Cramer brings to the industry. A builder for more than 40 years, Larry founded L. Cramer Company, Inc. in 1978 and has since built a reputation in the Twin Cities for consistently creating homes that fulfill clients' dreams and exceed their expectations. Producing 10 to 12 projects per year, L. Cramer specializes in

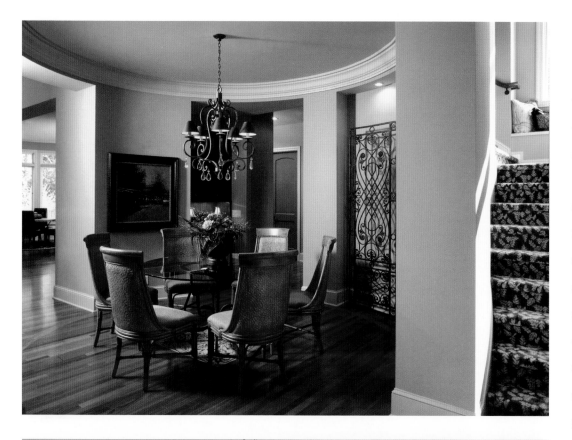

luxury custom homes, averaging in cost and size from $1.8 to 4 million and 8,000 to 13,000 square feet. Homes range in style from classic cottage to contemporary, traditional to eclectic, and the firm takes on a handful of historic renovation and remodeling projects. Regardless of style, the clients' needs and desires remain the steadfast focus of the entire team.

One hallmark of L. Cramer's exceptional work is the firm's close attention to both tangible and intangible details, explains Jennifer Cramer-Miller, the company's vice president and Larry Cramer's daughter. "From the millwork to the doors, every element of an L. Cramer home reflects careful thought and quality craftsmanship." Jennifer acknowledges that a large part of what one responds to when appreciating a fine home is the cabinetry, and the team spends a great deal of time creating custom cabinetry for their homes. Less evident but equally important is a deep sensitivity to the balance of natural light—L. Cramer homes are characterized by windows that surround the interior spaces, bathing them in sunlight throughout the day—and the positive psychological effects of higher ceilings, which provide an expansive feel while maintaining a comfortable scale.

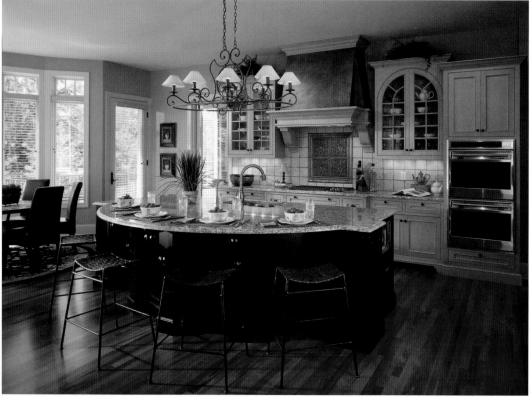

Top Left: This distinctive L. Cramer dining room features a spherical shape to enhance the architectural experience.
Photograph by Karen Melvin

Bottom Left: This L. Cramer kitchen flows effortlessly into the rounded dinette space. The finish on the black rubbed-through island contrasts artfully with the hearthstone fennel furniture-grade cabinetry.
Photograph by Karen Melvin

Facing Page: This exceptional L. Cramer great room sings quality with its southern chestnut floors, rich Umbria woodwork, natural stone fireplace and significant moulding.
Photograph by Karen Melvin

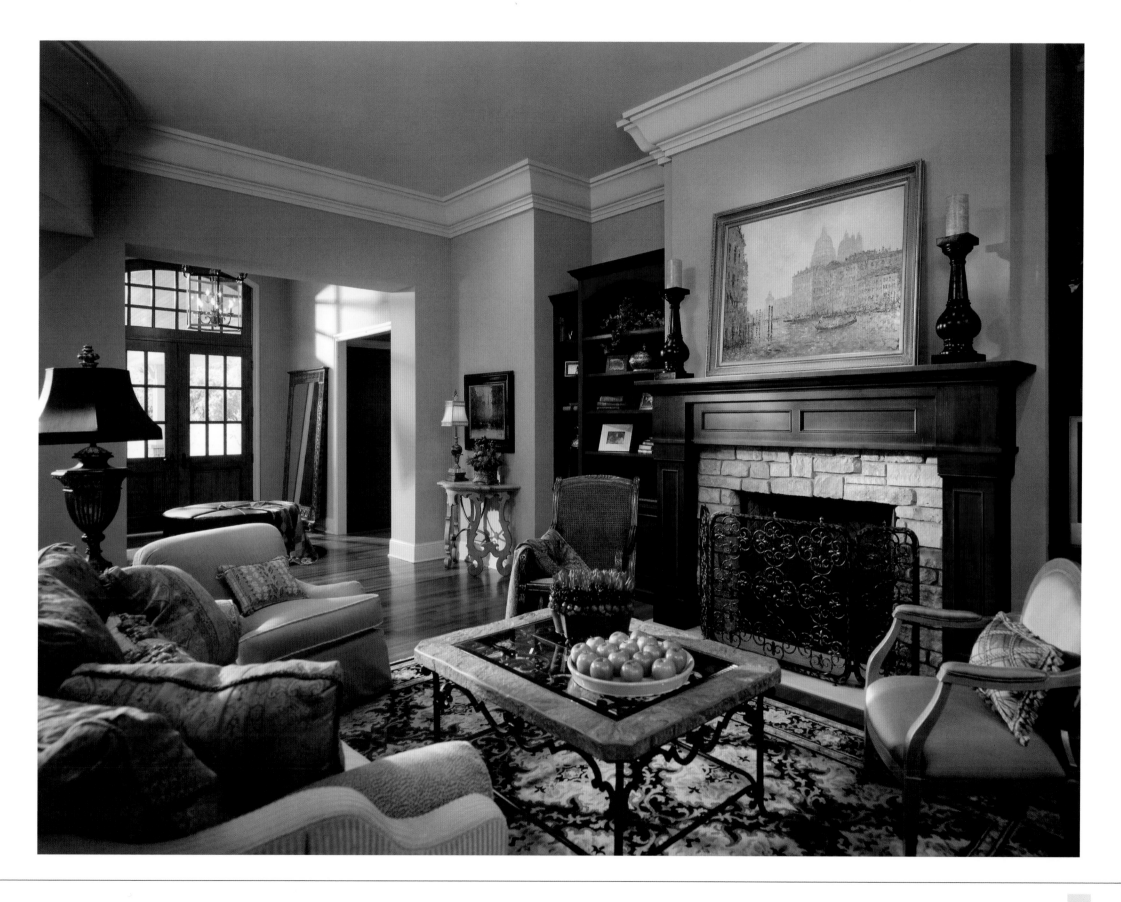

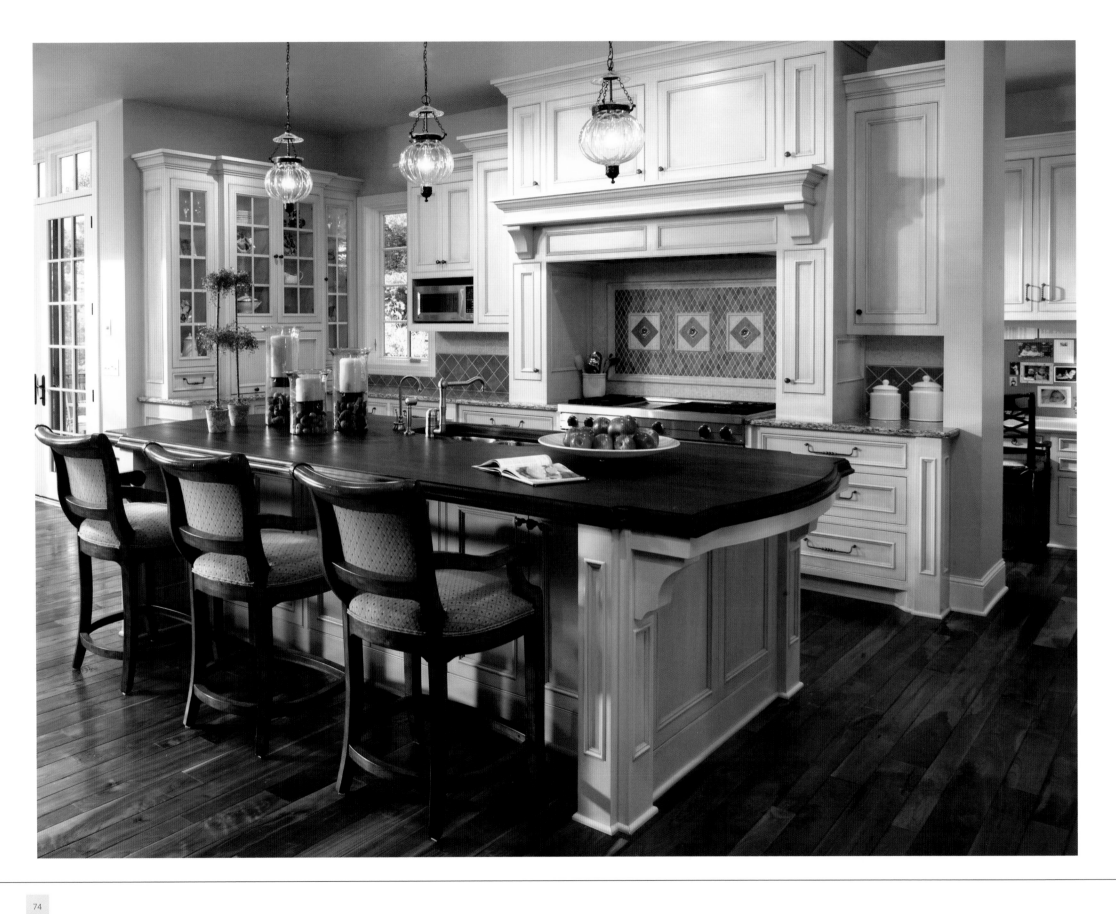

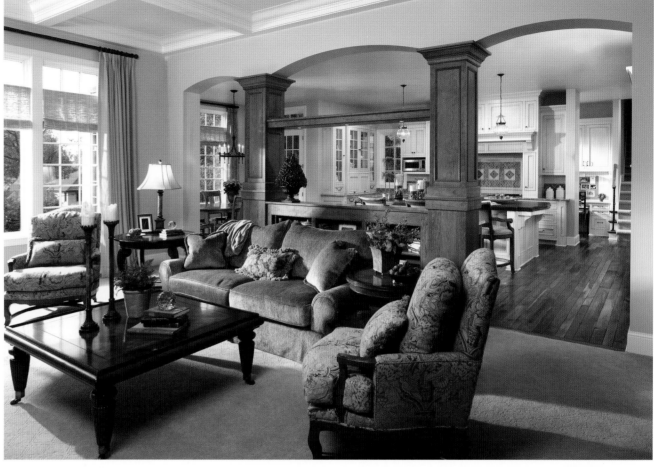

Larry's incredible wealth of experience and the custom process allow him the opportunity to produce almost anything within the realm of possibility. His deeply rooted knowledge of building history and construction techniques help him to provide extremely high quality—along with unique and exciting elements. One client shared a long-harbored private dream to be a drummer; therefore the team created a drum stage with retractable curtains in his home. For another client—a passionate NASCAR fan—the team created a racing-themed room, placing a car that had been cut in half in front of a large screen so that the client could imagine he was driving a NASCAR track in his home. L. Cramer has also designed rooms in which people can hit golf balls, scale rock-climbing walls and enjoy full basketball courts—spaces that fully support and celebrate the homeowners' hobbies and lifestyles.

The exceptional homes created by the L. Cramer team have earned a number of Trillium Awards and Reggie Awards of Excellence, and Larry Cramer has previously been named "Builder of the Year." The team's deepest sense of pleasure and satisfaction comes from the close relationships it builds with each of its clients, who frequently phone and write to state their deep gratitude for their beautiful homes—and even invite the entire company over for a social gathering. L. Cramer's dedication to customer satisfaction, commitment to honesty and fairness, and genuine love and passion for creating beautiful tailor-made homes for every client ensures that the firm will be receiving many more grateful notes and invitations from satisfied customers.

Above Left: Richly stained built-in bookcases flank the window in this cozy gentleman's study.
Photograph by Karen Melvin

Above Right: The open relationship between this comfortable gathering space and lovely kitchen is architecturally distinguished with cherry wrapped columns and a buffet.
Photograph by Karen Melvin

Facing Page: Enameled custom cabinets are punctuated with a detailed stone mosaic backsplash and extra-thick teak counter with carved edge.
Photograph by Karen Melvin

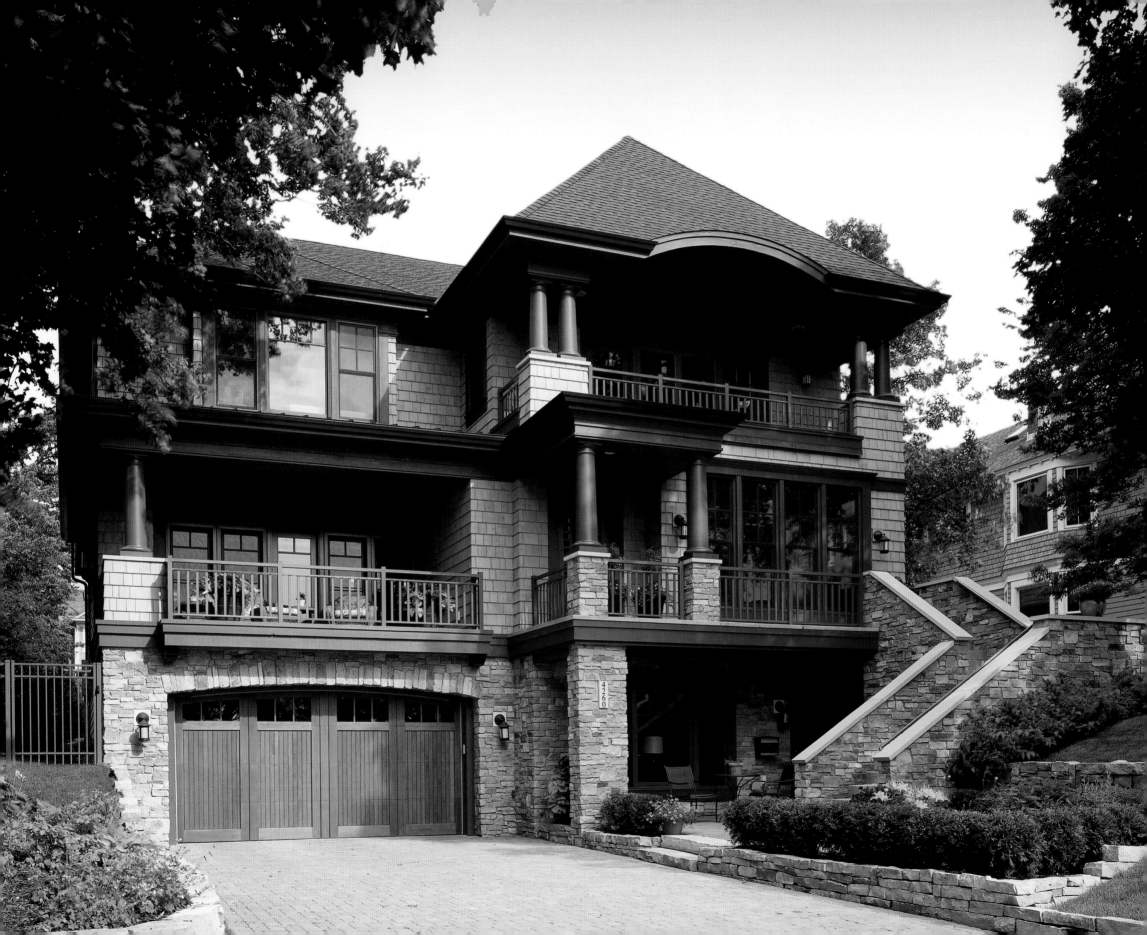

Charles Cudd

Charles Cudd Company

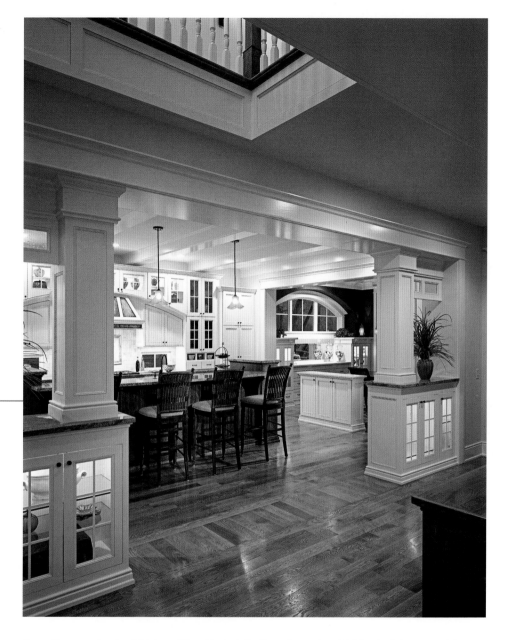

Above: The copper hood and rich form of the cabinetry in the Queen Avenue home's kitchen lend character and charm to the design.
Photograph by George Heinrich

Facing Page: This Queen Avenue home—a Minneapolis infill project designed on a 60-foot-wide lot with no alley access—fronts Lake Harriet, one of the beautiful inter-city lakes Minneapolis so proudly boasts. The Shingle-style home was designed to fit into a neighborhood originally built in the period from 1900 to about 1940.
Photograph by George Heinrich

Motivated by the responsibility to be "awake to beauty," for more than three decades the award-winning design/build firm of Charles Cudd Company has artfully created inspired architectural design that exhibits the fine craft and luxury that has come to define its new custom homes. President and founder Charles "Chuck" Cudd was born with construction in his blood: His father was a homebuilder and Chuck worked for him as a youngster, gaining tremendous direction and insight into the industry. Passionate about the conception and creation of fine homes, he founded the firm as design/build, and although the idea may seem a recent innovation, it is actually an age-old architecture practice.

The firm of more than 40 team members, as well as a handful of trusted subcontractors, features a Custom Home division as well as its Portfolio Homes division. Vice President and home designer Charles Ainsworth brings his architectural talent to the firm and heads up the Custom Home division.

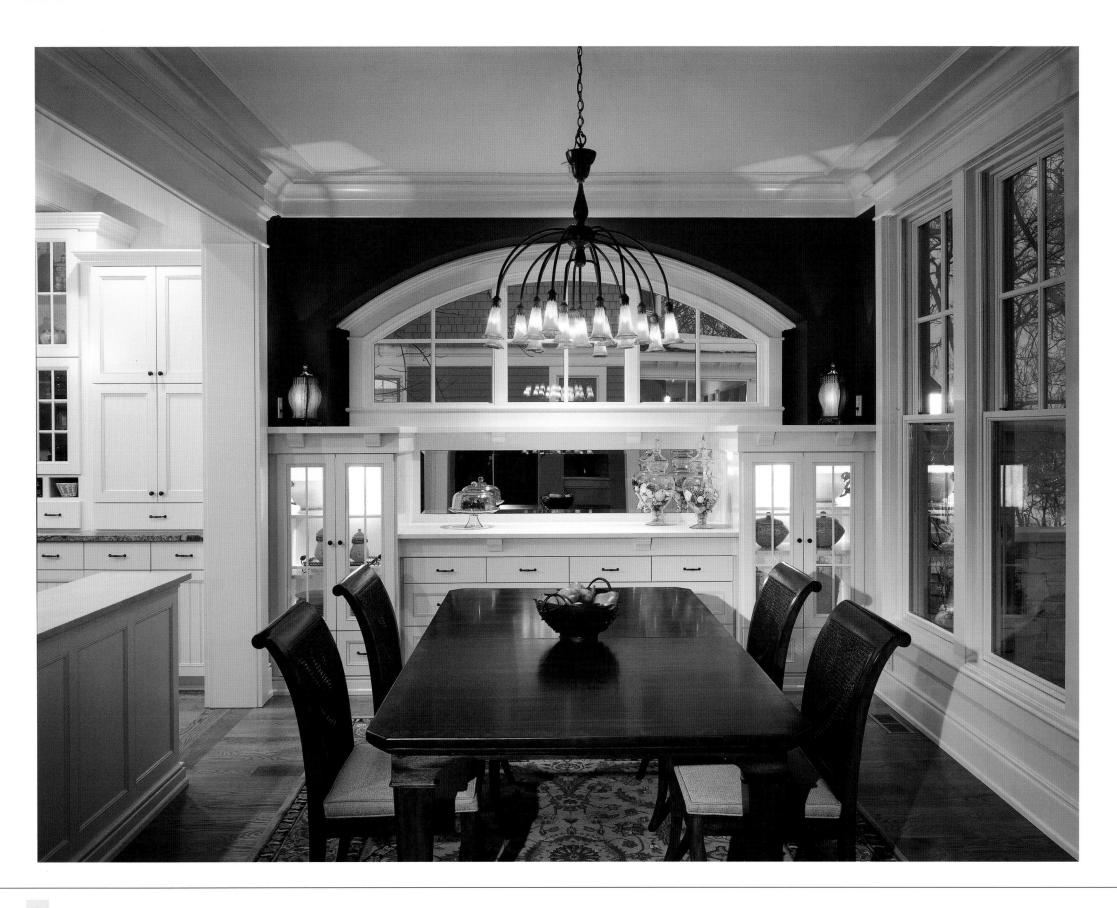

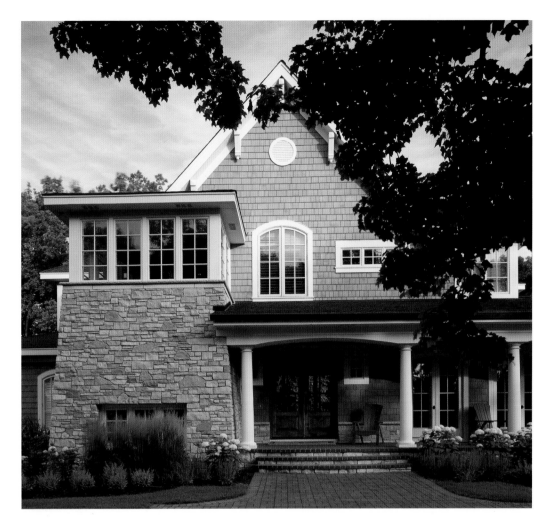

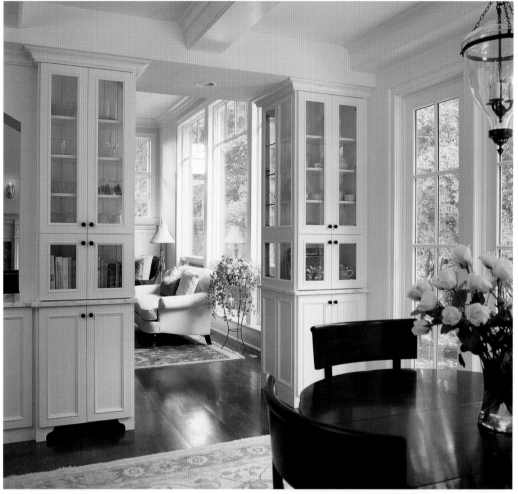

Charlie meets with clients to create a concept that includes their stylistic desires, accommodates their specific "needs" and incorporates the site characteristics into a unified custom design. After the design has been adapted to CAD files, the plans progress to the production supervisor, who leads the construction management. Charlie's wife, Penny, a long-time certified kitchen designer and cabinet professional, helps Charlie with design development as well as cabinetry configuration and customer coordination.

With decades of success to its name, Charles Cudd Co. has long subscribed to the most basic of design principles: classical forms and proportions within the boundaries in which the structures originated. The firm believes in eschewing the common act of simply "piling disparate forms and details together for show," a common condition found in many new-home neighborhoods. As a custom builder, Charles Cudd Co. designs and builds styles to its clients' preferences—soft

contemporary, Old World Italian, Tudor, Craftsman, Prairie—while ensuring, importantly, that they will fit architecturally and proportionally within their surroundings.

The company does not employ single-sighted design and construction; it builds with the greater scope of the neighborhood in mind, sensitive to its existing built environment and condition of the site. A deep sympathy for the natural landscape, particularly in Minnesota, is also crucial to the

Above Left: For the design of this home in the Wayzata area by Lake Minnetonka, the client wanted the feeling of a period home from the New England seacoast. The stone stair tower anchors the large forward-facing gable and the extended front porch.
Photograph by George Heinrich

Above Right: The interior of this seacoast home captures and reflects light in the manner of homes by the ocean.
Photograph by Susan Gilmore

Facing Page: The glass doors, the mirror and the arched window work together to create a beautiful, period built-in buffet in the dining room of the Queen Avenue home.
Photograph by George Heinrich

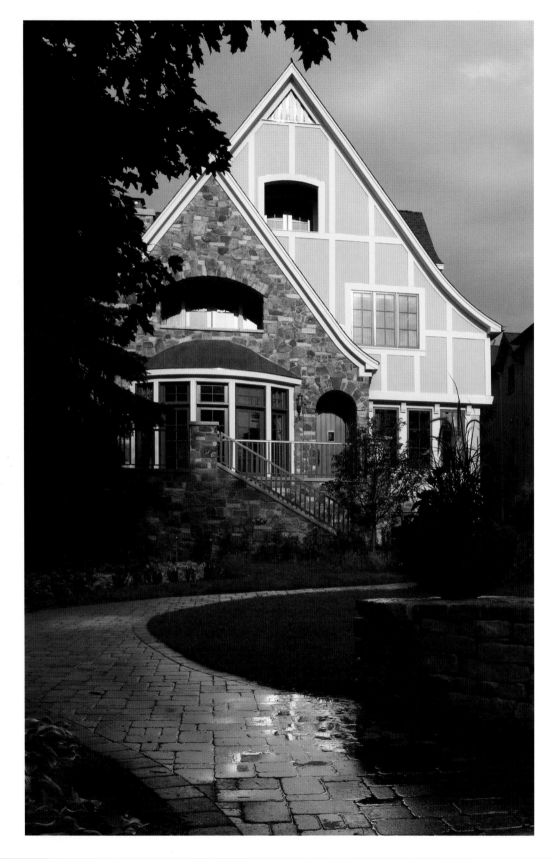

firm's designs. Charles explains, "We respect the natural canvas we are given … so as not to violate a sacred trust." To that end, the company does a lot of design work in old neighborhoods around lakes overflowing with high-quality home stock, as well as infill housing in those neighborhoods.

Although renowned as a builder of luxurious homes, Charles Cudd firmly maintains that a home does not need to be massive to be an inspiring work of architecture. Homes on smaller, more limited budgets can yield brilliant design and solution-based construction, as well, as the myriad sizes and scopes of the firm's projects attest. While its homes have received numerous Reggies and Trilliums and have been Parade of Homes winners, what matters most to the team at Charles Cudd Company is the ability to create homes of which it—and its clients—can truly be proud.

Above: The client for this Lake Harriet Tudor is a serious cyclist and occasional racer with a number of very impressive bikes in his collection. The firm created a special room off the driveway for his "bike shop" so that his bikes would not need to share the garage space.
Photograph by George Heinrich

Left: This Tudor-style home, again on Lake Harriet, is a different expression of period homes from this venerable neighborhood. It is substantial, yet beautifully fits on a challenging lot only 50 feet wide, with rear access.
Photograph by George Heinrich

Facing Page Left & Right: The living room and the dining room of this Tudor are across from each other on each side of the entry gallery. All three spaces share this beautiful, tall butternut wainscot, which provides the interior with a rich warmth and careful period detail.
Photographs by George Heinrich

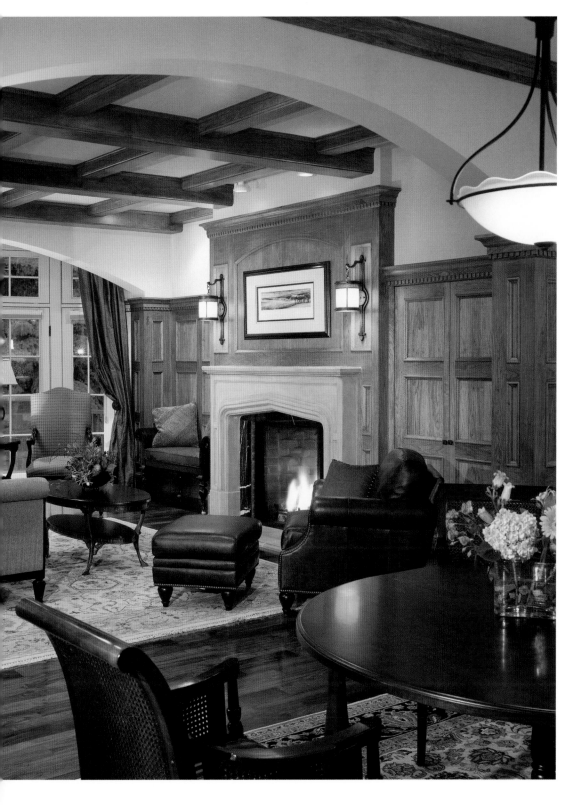

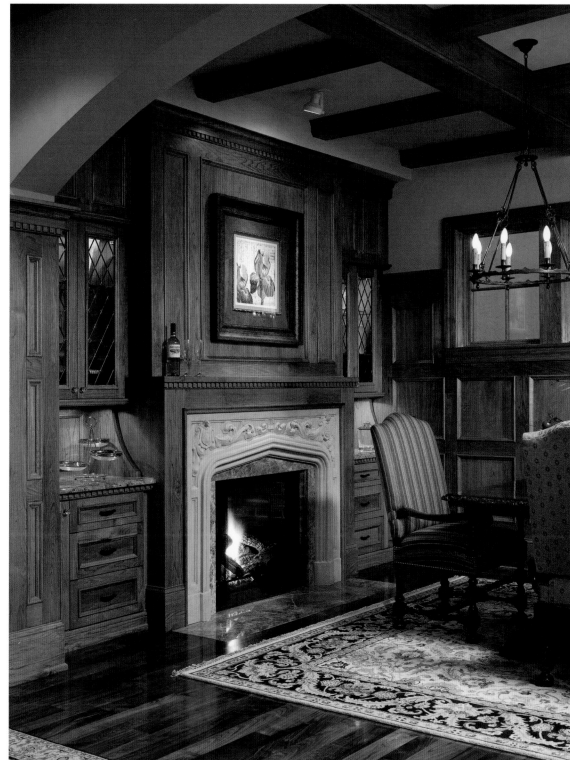

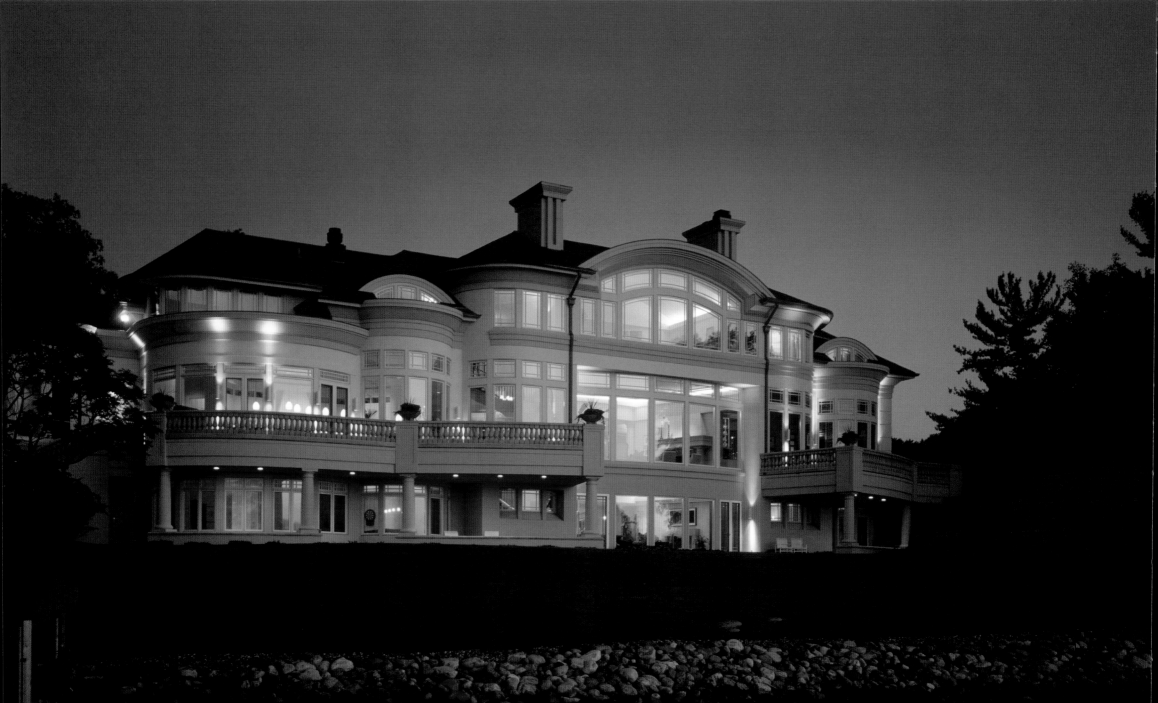

David Erotas
Holly Erotas

Erotas Building Corporation

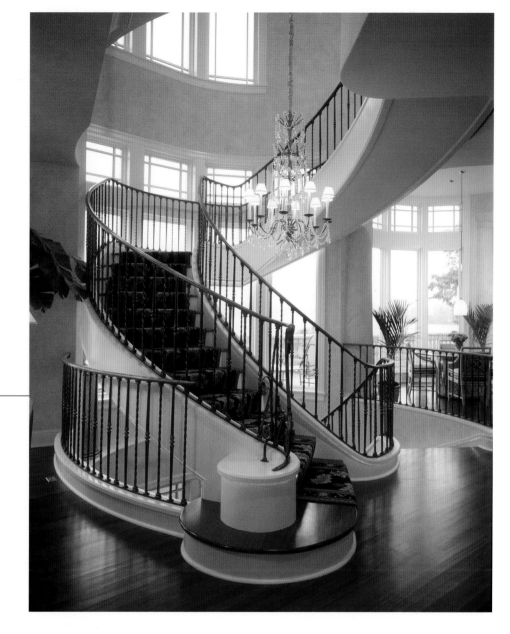

A high-end custom home is a beautiful blend of art and function, an aesthetically expressive, intricately detailed structure that is at once solid, well-built and able to support its residents' lives as it simultaneously appeals to their artistic sensibilities. David and Holly Erotas not only understand, but have made this their building ideology. Each home created by Erotas Building Corporation, the custom residential construction firm founded by the husband-wife team in 1992, invariably conveys the team's talent for marrying architectural vision with structural precision.

David's background represents his natural penchant for balancing artistry and utility. He pursued his first passion, fine art, in high school and college, where he met his wife, Holly, before becoming a carpenter's apprentice in the early 1970s. Upon moving to Minnesota a decade later, he continued to gain firsthand industry experience as a carpenter and construction supervisor, an occupation that is at

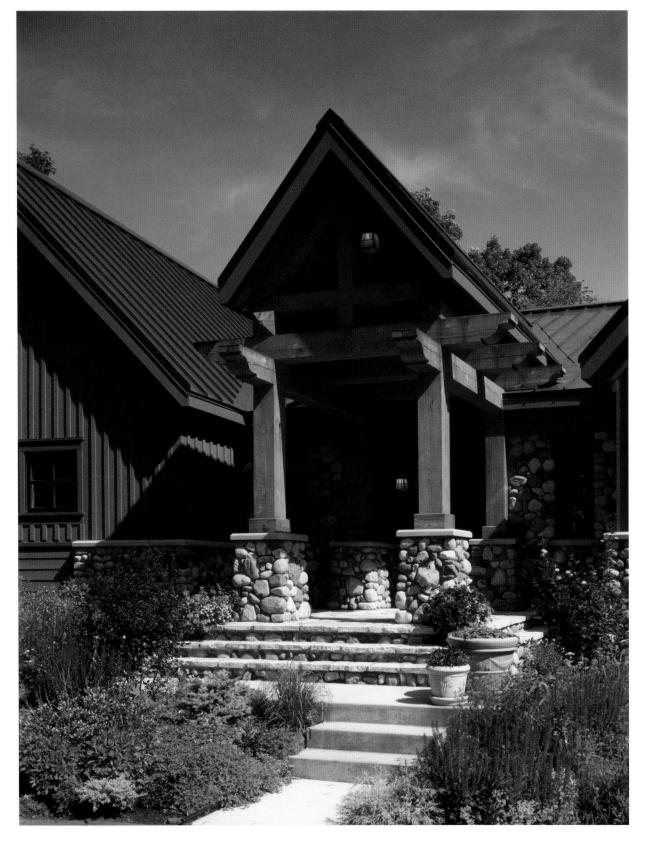

once creative and practical. With Holly's training in art and office management, they were well equipped to launch Erotas Building Corporation and establish their "architectural builder" concept.

Erotas Building Corporation's defining characteristic is the rigor with which David, Holly and their team work to ensure that every detail is painstakingly and accurately executed. This team now includes both of their daughters, Alethia and Emily, who bring strong artistic talent to the business. The principals play equal roles in the process: David oversees construction from foundation to finish, ensuring that the architects' vision is fully captured, and Holly, Alethia and Emily collaborate with clients and their interior designers, facilitating decisions and details and preserving the purity of the design intent. David is also a partner with Tim Kunkel, a master carpenter who coordinates the field operations in the carpentry contracting firm of Minnesota Structures Inc., a company of highly trained and skilled carpenters who perform all of the carpentry labor for Erotas Building Corporation. As David firmly believes that carpentry labor is the backbone of any home, this team association is an integral part of the

Left: This Colorado contemporary home with 100-year-old wood timber framing and a metal standing-seam roof is set in a freeform organic landscape.
Photograph by Karen Melvin

Facing Page Left: A boulder fireplace and vaulted ceiling accent the living room portion of the 70-foot-long public wing, which also contains the kitchen and dining room.
Photograph by Karen Melvin

Facing Page Right: This open kitchen features a massive island of anodized stained wood and 2 ½-inch-thick waxed concrete countertops, all sitting on reclaimed wide oak flooring.
Photograph by Karen Melvin

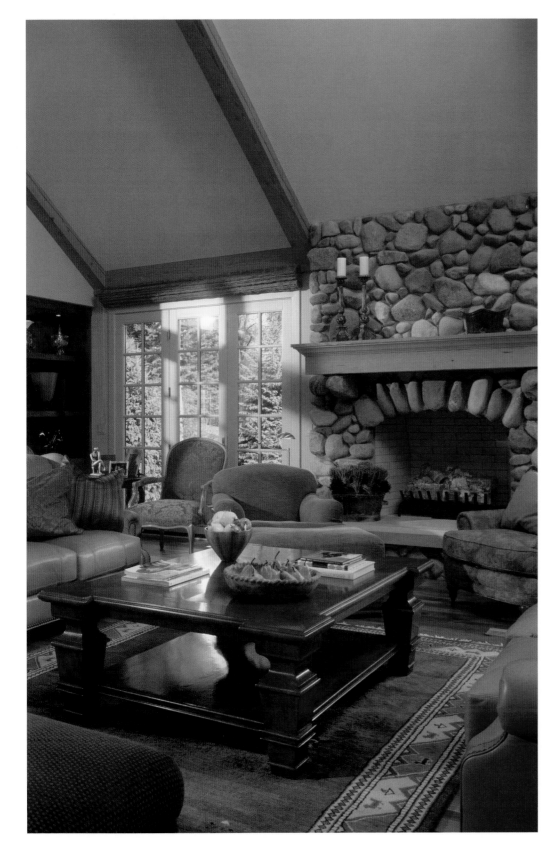

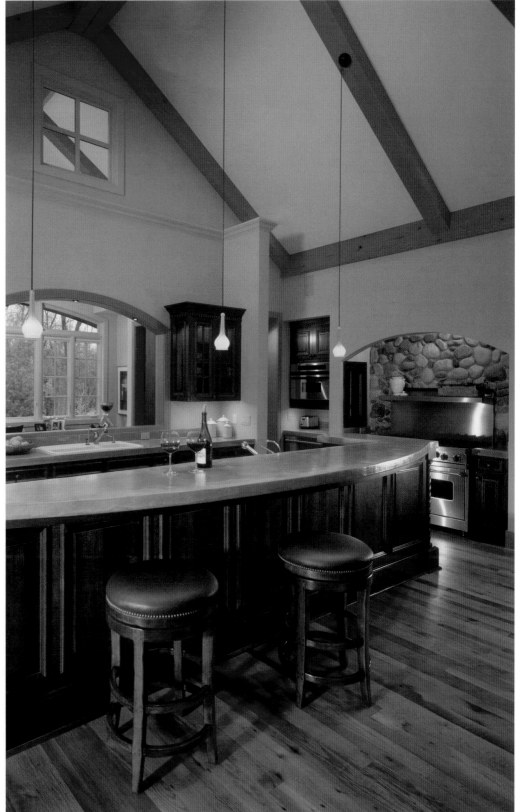

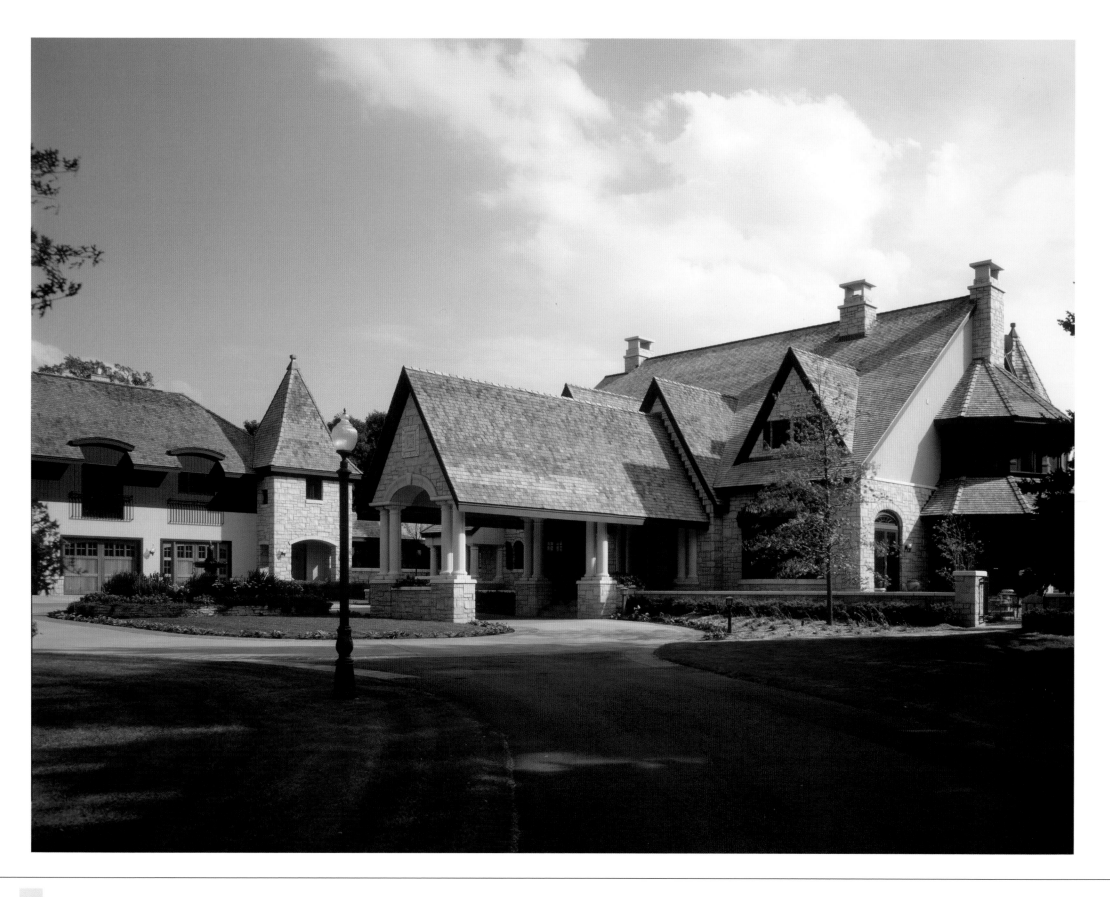

consistently excellent quality produced by Erotas Building Corporation. David and Holly also extend the "team approach" to include the architect, interior designer, landscape architect and, of course, client. This creates an atmosphere of successful cooperation and communication that turns each home into a unique "jewel."

Working with a broad array of talented architects in the Twin Cities and in select locations throughout the country affords Erotas Building Corporation the opportunity to create homes in a variety of architectural vernaculars. From Venetian villas and Georgian estates to Arts-and-Crafts bungalows and rustic contemporary lake houses, the firm's portfolio represents its capacity for constructing a broad range of styles. David and Holly pride themselves on their artistic diversity and acumen and look forward to the challenge of each new set of architectural plans with confidence and skill.

While each Erotas Building Corporation home is unique, all represent the principals' deep commitment to excellence in every aspect of construction, beginning with the foundation and ending with the last piece of cabinet hardware. David and Holly resolve to build homes that endure and grow gracious with time. This can only be accomplished by ensuring that the core and structure of the home are sound and properly constructed from the outset,

Top Right: Oak-paneled walls and coffered beamed ceilings lend a traditional English flair to the private library and living space.
Photograph by Karen Melvin

Bottom Right: Dual working islands and custom china storage feature painted and stained cabinetry, highlighting the antique family heirloom chandelier.
Photograph by Karen Melvin

Facing Page: English country in style, this lake home with sandstone and stucco exterior boasts stacked screen porches and an attached carriage house with a separate tower entrance.
Photograph by Karen Melvin

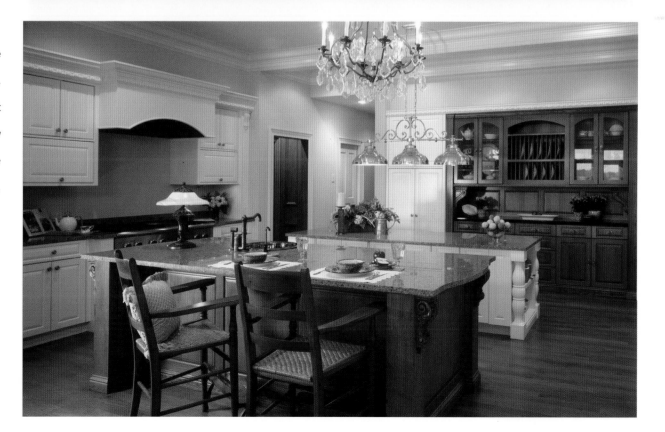

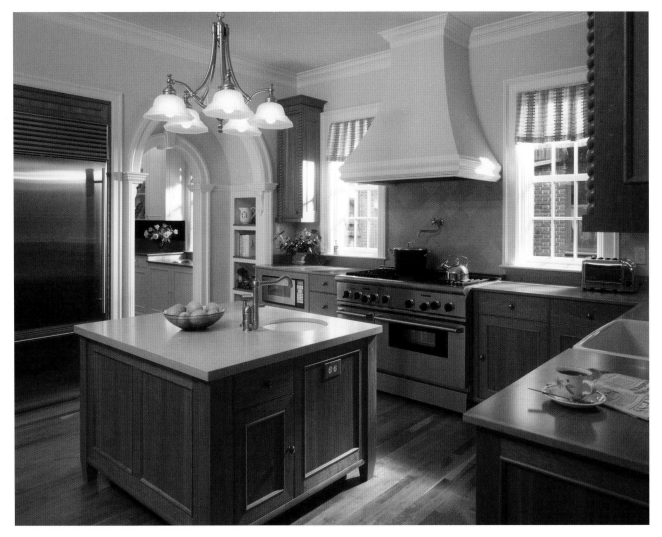

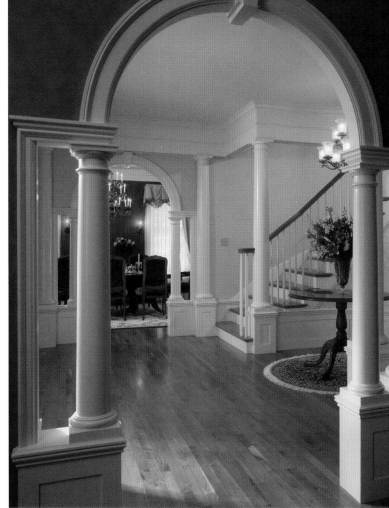

prior to the installation of the cosmetic finishes—countertops, millwork, paint and the like. The couple describes the process as somewhat similar to building a wedding cake: If the cake is not well made and properly assembled, neither the beautiful icing nor the cake will last.

Above all else, the firm adheres to the belief that the construction of each custom home should be enjoyable for all. David and Holly understand the significance of the experience—their clients are emotionally and financially investing in homes that will support their families and them for many years, and often many generations. Not only do the principals make the decision-making process easy, they make it fun, striving to guarantee that clients love every second of the experience.

Erotas Building Corporation's dedication to providing its clients with the most innovative, best quality homes at the highest value—and to provide a joyful environment—has earned it a vast, loyal clientele base that grows largely by referral. While

delighted to have been featured in many national publications, including *The Not So Big House* by notable architect Sarah Susanka, David and Holly assert that their reputation is their true reward.

Above Left: This family-oriented cherry and French limestone kitchen is replete with elegant rope detailing and a sweeping custom range hood.
Photograph by Karen Melvin

Above Right: Understated and inviting, this front entry features multi-layered crown moulding, columns and keystone archways.
Photograph by Karen Melvin

Facing Page: This red brick, classic Georgian home has stone-capped parapet walls and a columned portico that has been painted white.
Photograph by Karen Melvin

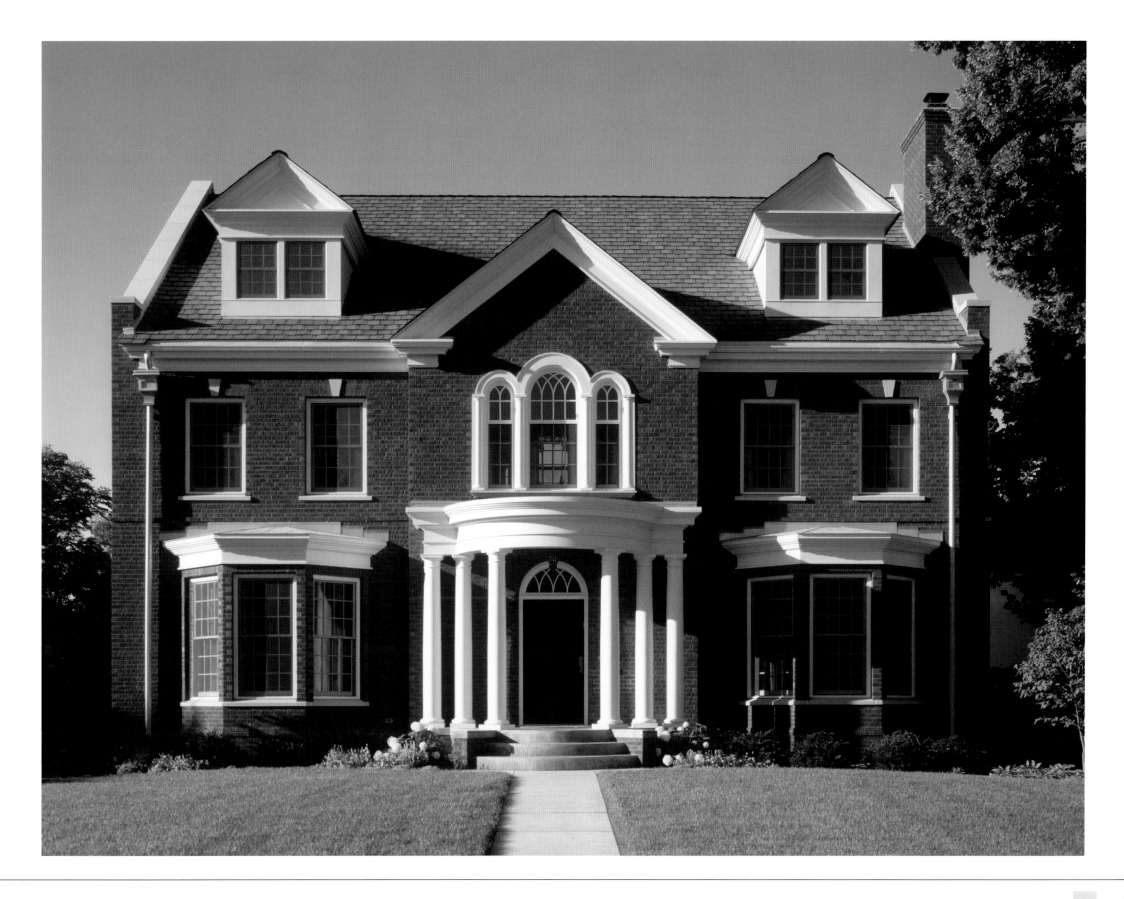

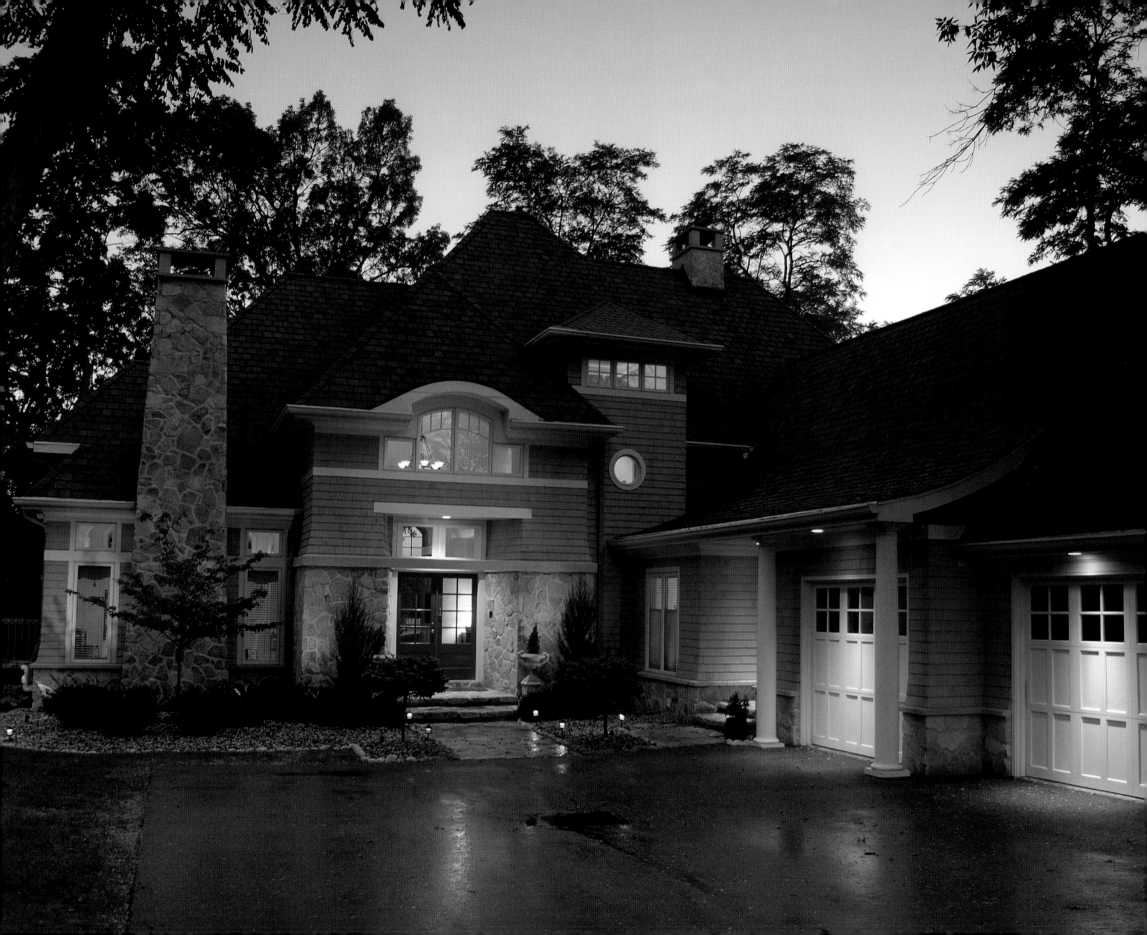

Peter Eskuche

Eskuche Creative Group, LLC

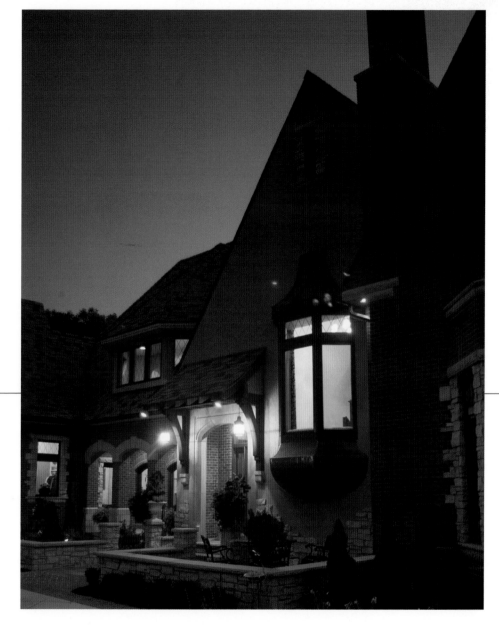

Above: Mixing traditional materials, modern technology and Old World detailing, this elegant home appears as if it had been built more than a century ago.
Photograph by Sanderson Photography, Inc.

Facing Page: This home has a timeless appeal while employing updated waterfront architecture of its own style.
Photograph by Sanderson Photography, Inc.

Achieving timelessness in the architecture of a home is a goal many strive for but few successfully accomplish. It takes the skill of an artisan who understands that the realization of this goal is twofold: on the one hand, a home must possess an appeal that is not tied to a particular era or design trend. On the other, it must serve the present and future needs of its residents functionally. Peter Eskuche, AIA, masterfully achieves timelessness in its full sense in each home design he crafts.

Peter's educational background provides him a distinct edge in achieving enduring aesthetics. He earned his degree in fine arts and interior design rather than architecture. To meet the requirements of the lengthy licensure process—which he completed in 1996—he not only studied under licensed

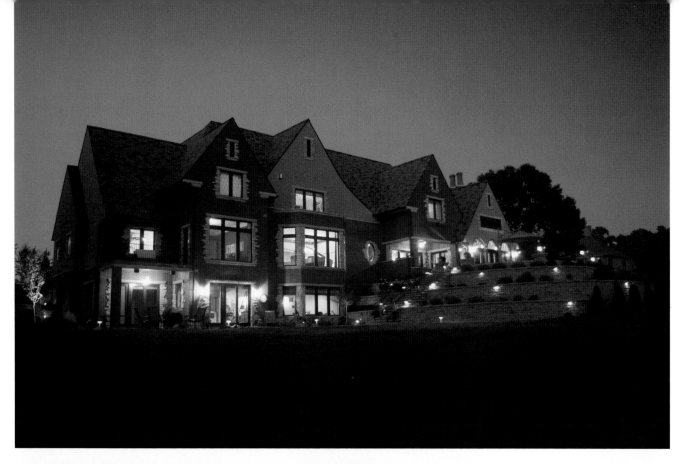

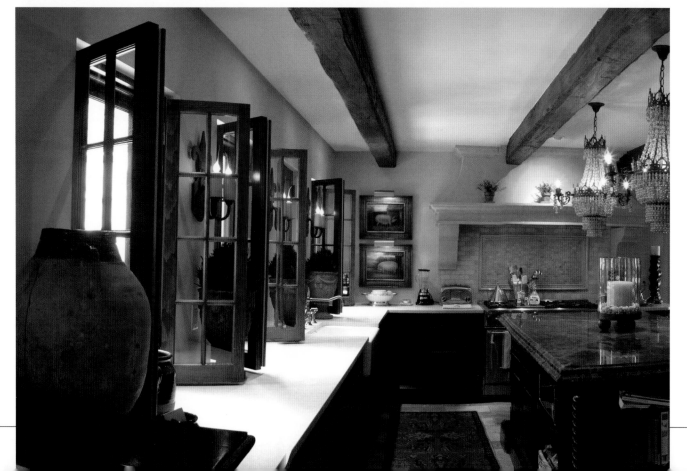

architects but worked for a construction firm, giving him a practical education in the field. In 2001, he founded Eskuche Creative Group, and the vibrant young company has since enjoyed remarkable success.

Peter's fine arts education gave him a clear understanding and appreciation of scale, proportion and human dimension, allowing him the freedom to incorporate unique architectural elements into his designs while maintaining visual balance. His understanding of these artistic fundamentals allows him to push the envelope of structural possibility, while his construction experience gives him command of accuracy and precision in each project.

Peter grounds the essence of each and every home design to the clients' desires in a unique way. Each client reviews his extensive questionnaire, a tool that allows him to get inside the individual's thoughts and design a home that will serve his or her lifestyle in innovative ways. He actually crafts ideas on paper right in front of his clients, creating stacks of sketches in order to gain more useful feedback. His goal is to design a home capable of being his client's ideal and last residence, the layout and size of which is smart: large enough to support raising a family and yet small enough to provide comfort once the family has spread out. Peter thus designs homes that support residents' lives now and in the future—that transcend time both aesthetically and practically.

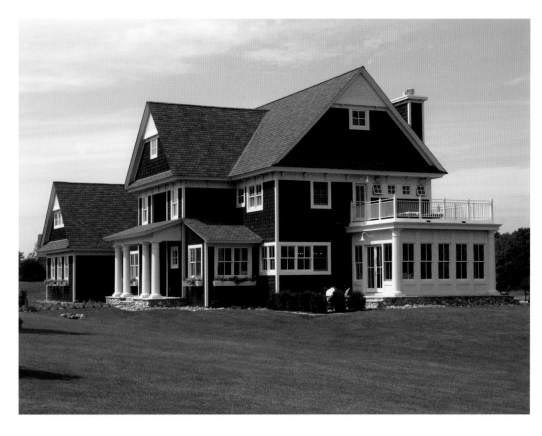

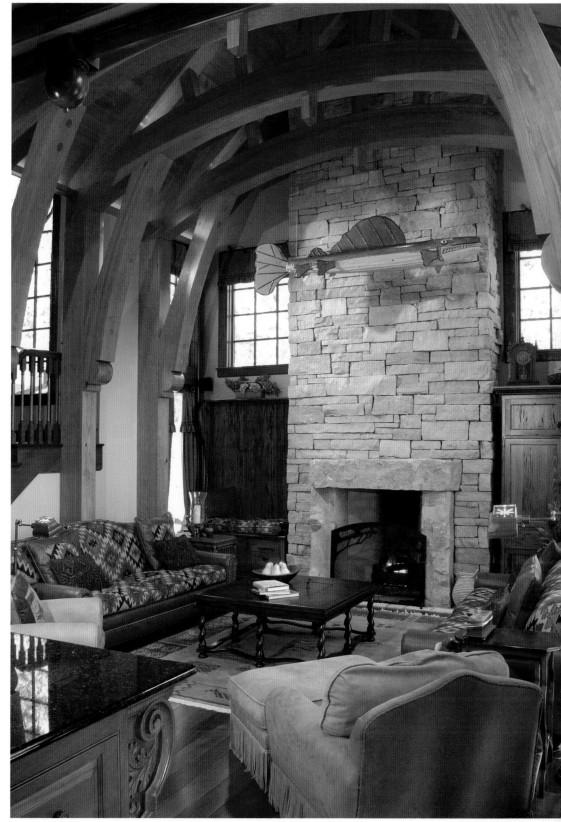

Above: Turn-of-the-century details are adapted here evoking an updated, clean coastal architecture.
Photograph by Peter Eskuche

Right: Bold use of wood and stone creates a robust, textured look that has been tailored to the homeowner's personality.
Photograph by Sanderson Photography, Inc.

Facing Page Top: The lake-facing view of this home holds true to the traditional elements of its architecture, while maximizing the view of the lake.
Photograph by Sanderson Photography, Inc.

Facing Page Bottom: This kitchen remodel illustrates how the firm employs new technology to create a timeless look; adorned with natural stone and wood materials, it evokes that Old World feel while skillfully hiding the old structure.
Photograph by Peter Eskuche

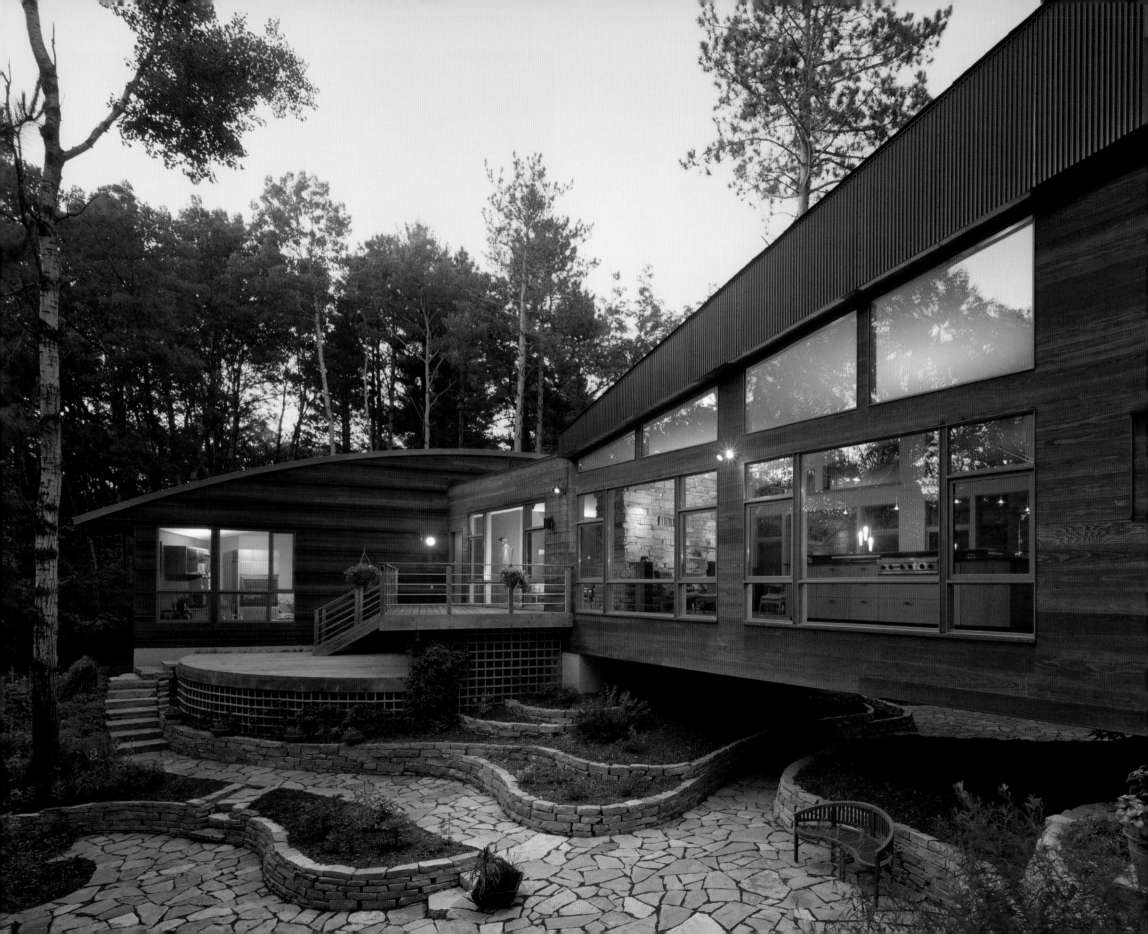

Cheryl Fosdick

CF design ltd

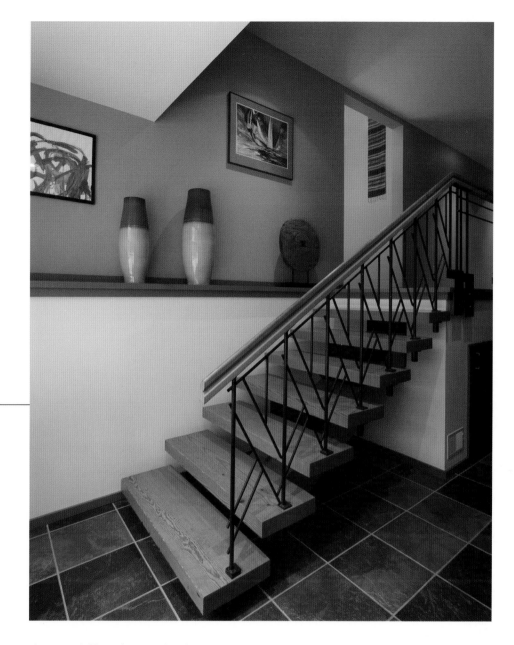

Above: Recycled fir treads on a single-timber stringer rise delicately from the entrance to airy bridge spaces beyond.
Photograph by Don Wong Photography

Facing Page: Spanning two forest hills, this house floats in a clearing, where stone patios flow like water.
Photograph by Woodruff/Brown Photography

Good design breeds good design—or, in the case of Cheryl Fosdick, owner and principal designer of CF design ltd, good designers. Raised in Chicago in a Mies van der Rohe-designed apartment building—then an archetypical suburban rambler with a carport—and later in St. Paul's prolific University Grove neighborhood, Cheryl was surrounded by structures that inspire. This early exposure to the work of renowned architects and to classic Modernism may very well have influenced her decision to pursue architecture as a career. Earning an undergraduate degree in Environmental Design—her first four years of undergraduate work were in Biochemistry—and a Master of Architecture, she founded a residential design firm devoted to creating powerful homes that enhance the beautiful surroundings in which Minnesotans live.

Cheryl's unique scientific background lends discipline and order to her design process. She firmly believes that good work derives from two key tenets, both rooted in a modernist philosophy. First,

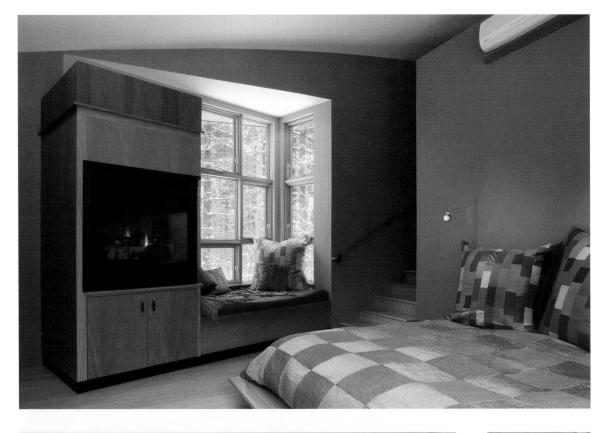

homes are created for people. Rather than profess a certain cultural idea or follow a set of predetermined rules, a home's design must support the people for whom it is conceived. Their personalities and aspirations provide its inspiration and incite its evolution. Accordingly, Cheryl becomes very familiar with her clients' lifestyles, encouraging them to critically explore the places and ways they have lived in the past, and that investigation informs the design. Homes thus fulfill clients' needs and desires—and clients become and remain close friends of the firm.

In addition to her deep sensitivity to clients, Cheryl is carefully attuned to a home's environment. Maintaining that architecture has the power to reveal a site's full potential, she thoughtfully plans each home to introduce its latent appeal. Varying the solidity and transparency to maximize light and views and fostering an atmosphere of openness yields homes that borrow space equally from inside and out. Cheryl encourages her clients to think about not only what is contained within the walls, but what is beyond them as well—both views work together to create one's experience of a home and generate a more complete and enriched sense of place. What results is a structure so integrated with its site that it reveals the site's true beauty, honoring the land it graces.

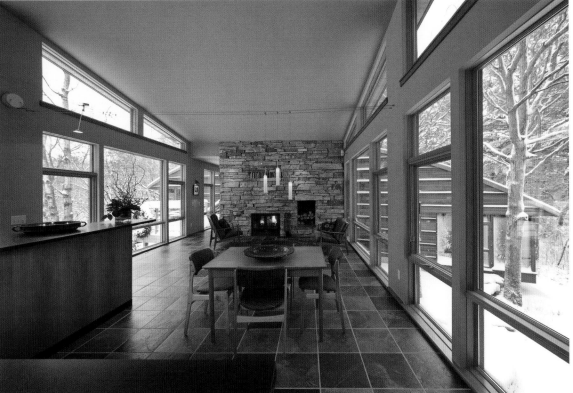

Top Left: On a cold day, the daybed and glowing fire reach out to the woods beyond, for solitude and reading in northern light.
Photograph by Don Wong Photography

Bottom Left: Suspended between the entry and private family areas—in the combined kitchen, dining and living spaces—daylight and the sense of the forest canopy are extraordinary.
Photograph by Don Wong Photography

Facing Page: Snow settles on the projected sill and screen as the curving roof form and hill merge during a winter storm.
Photograph by Don Wong Photography

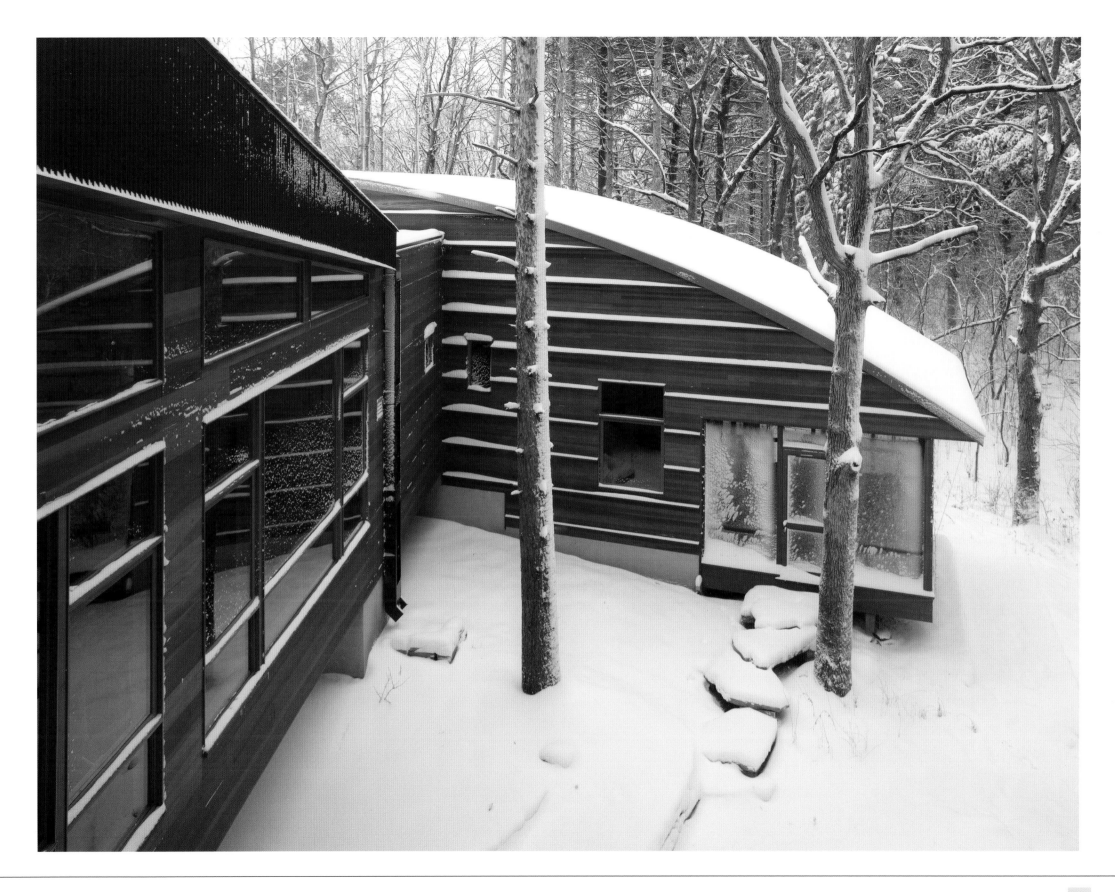

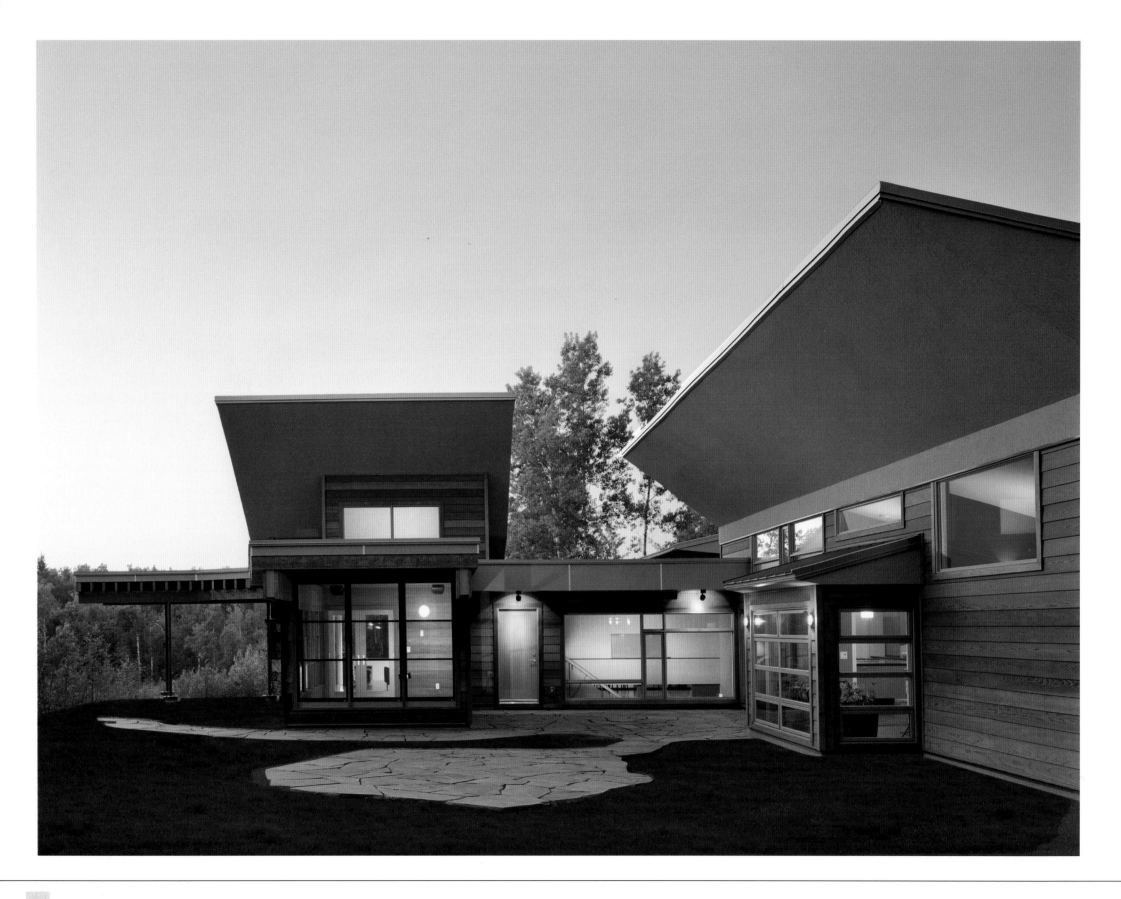

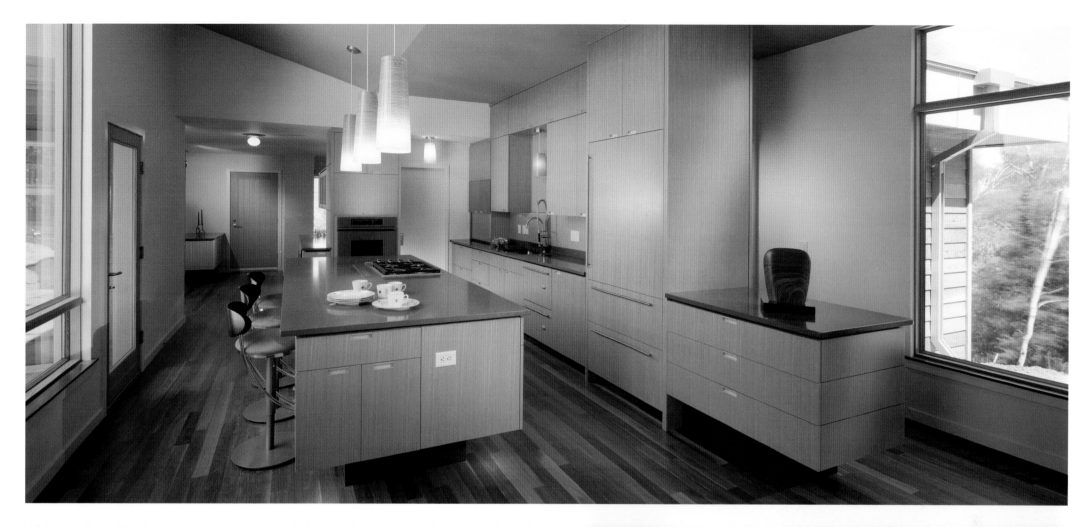

While people and landscape are essential to good design, Cheryl believes that a great home has an element of mystery and intrigue, an unusual feature that originates during the design discussion, yet cannot be programmed and may not be discovered until long after the project is complete. These details, she states, simply "happen" as a result of careful listening and thoughtful design. A small stone seat may appear off the landing midway up a delicate stairway of open risers and thin wood treads, for example, inspired by the client's mention that they enjoy whitewater canoeing from eddy to eddy in a particular river. These subtle nuances of a home, while virtually inexplicable, prove time and again to

Above: Simple and elegant planes fold away from one another to provide for the floating forms of an island kitchen.
Photograph by Woodruff/Brown Photography

Right: For this interior room, an illusion of immense space is found through light from a greenhouse beyond, reflection and fabric-like tile walls.
Photograph by Woodruff/Brown Photography

Facing Page: On the edge of a creek valley, stucco roof figures are both shelter and ladles of light and poetry, inside and out.
Photograph by Woodruff/Brown Photography

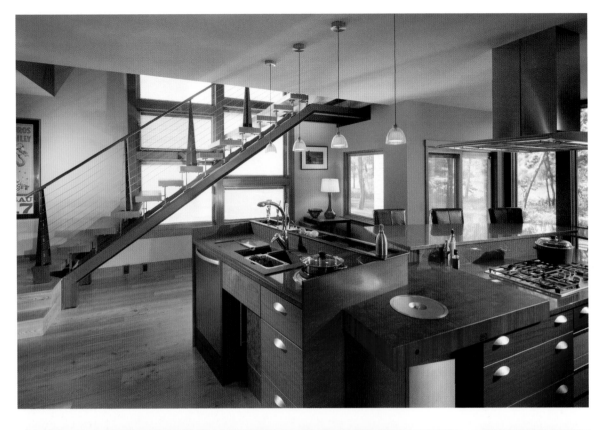

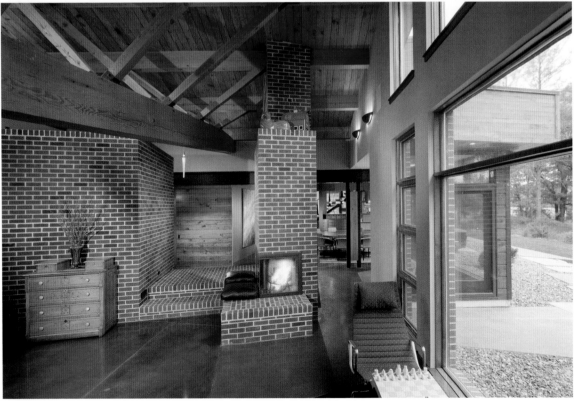

be the most memorable, both to the home's inhabitants and to its visitors. Moreover, Cheryl feels that mystery begets mystery: Projects with unexpected elements inspire new clients to trust and anticipate surprise and wonder in their own projects.

As her work has evolved, Cheryl has become increasingly interested in the sculptural aspects of structure in a home, inside and out. She nourishes a penchant for design of cabinetry and assemblies by collaborating with a group of outstanding fabricators. Roofs, an area of missed potential to Cheryl, are able to change one's perception of both the experience of the site and the structure. Cheryl works to design roofs that best capitalize on the site's inherent beauty while deliberately guiding the way one sees through the walls. Roofs thus introduce people to her projects in different and exciting ways, enhancing the sense of place she seeks to foster.

While Cheryl's approach to projects ensures that each home is unique, her work embodies the idea that one cannot hurry good design. She encourages her clients to meet as often as they are able—the more, the better—to fully explore their desires and discuss their ideas and to take time to rest quietly with the notions discussed in the design process. The time necessary for this thorough investigation is well worthwhile, as it results in homes of which everyone involved is proud. Cheryl very strongly believes that her work matters. When a family is so excited about their home that they cannot wait to show off what they have done together, the teamwork of designers, craftspeople and clients is complete—and the poetry and performance of the design is set in motion.

Top Left: An animated and delightful kitchen space for animated and delightful residents, this is a tactile and rich assembly in which every action has its playful posture.
Photograph by Woodruff/Brown Photography

Bottom Left: Dual sentries of the brick wine cellar and fireplace divide to feature a "keel" of reverse trusses over a large mosaic of stained concrete floors.
Photograph by Woodruff/Brown Photography

Facing Page: On a smooth river site, this house of COR-TEN, brick, concrete and wood metaphorically sails as a vessel of the owners' suite, which projects outward to draw guests near.
Photograph by Woodruff/Brown Photography

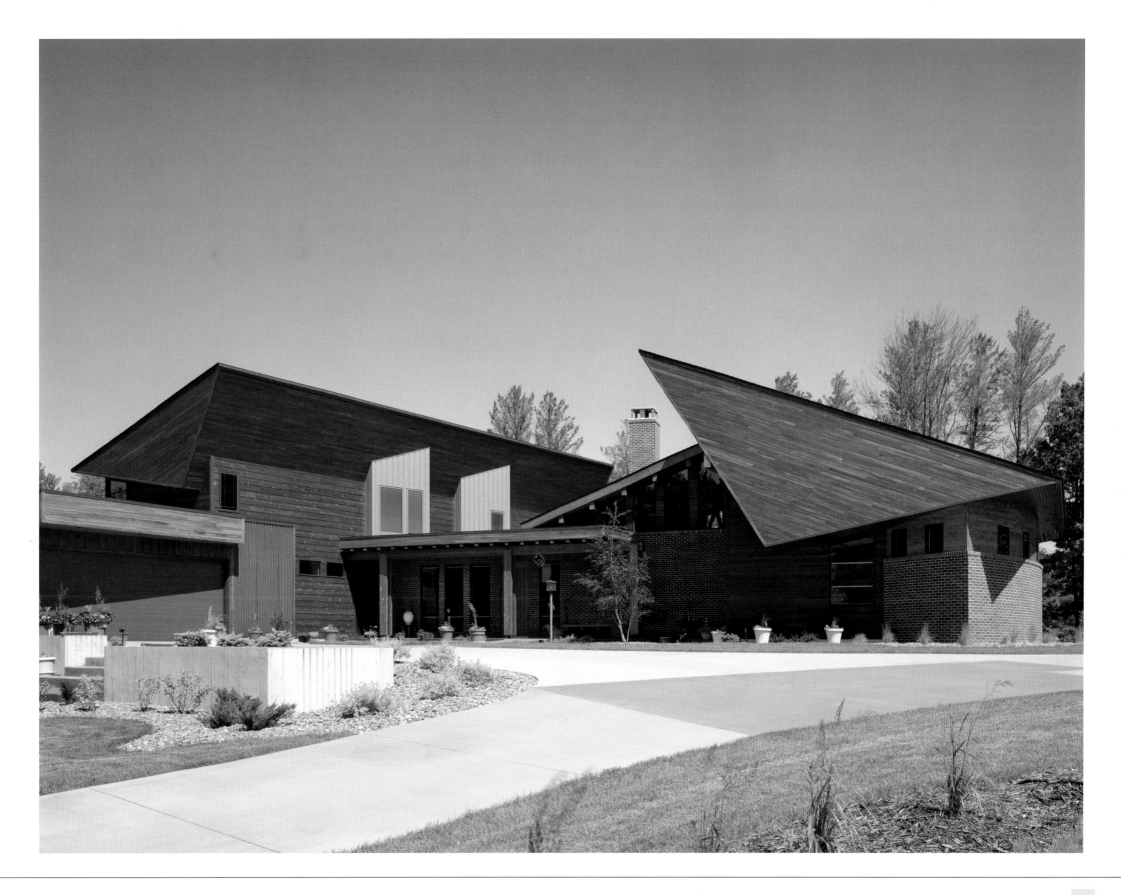

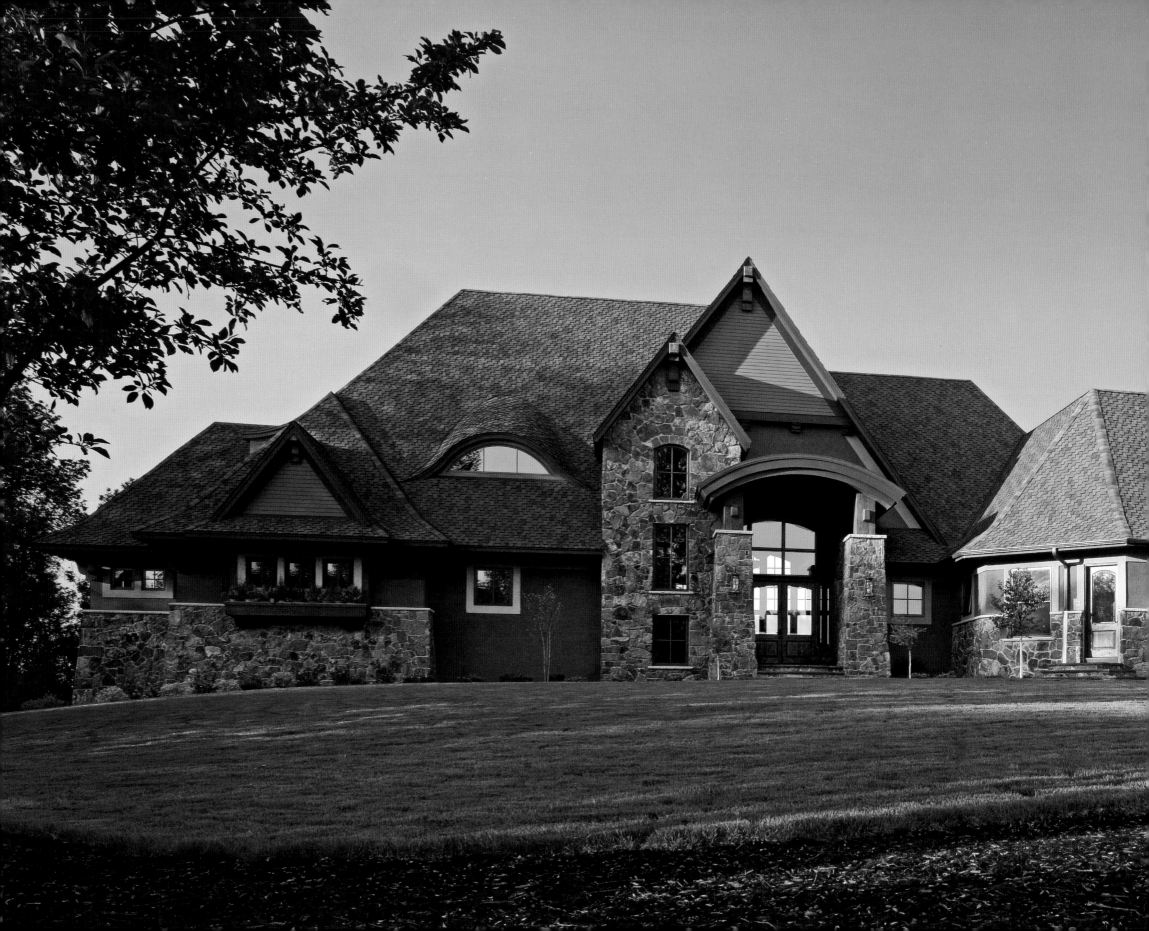

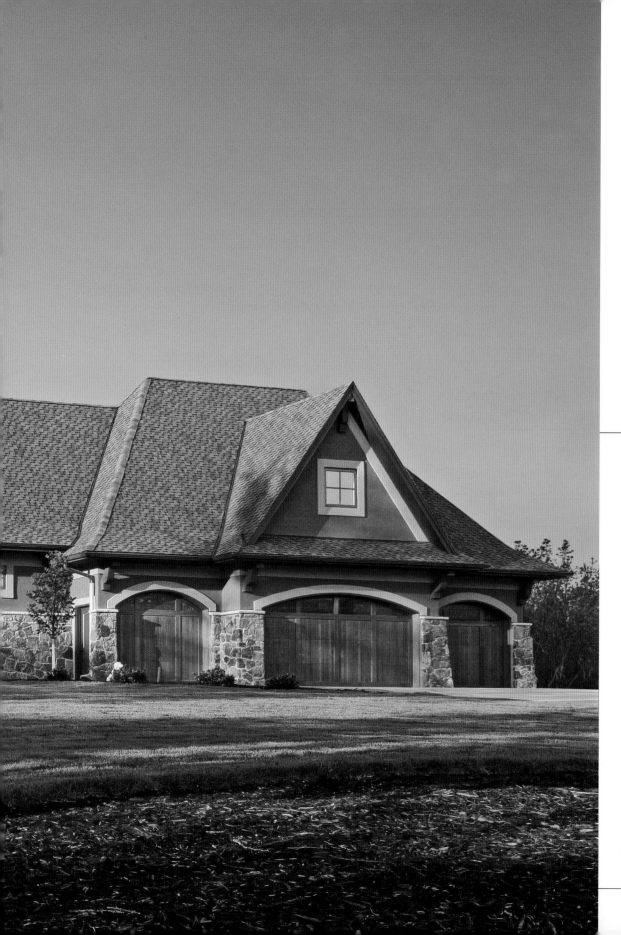

J. Sven Gustafson

Stonewood, LLC

S ven Gustafson's family has been building homes since 1920 when his great-grandfather was hand-crafting farmhouses in Wisconsin. Since those early days the technology has vastly improved, but for Sven, a fourth-generation homebuilder and current president of Stonewood, LLC, that commitment to quality artisanship and attention to detail has never waned.

In an era of increasingly large homebuilders focused on the bottom line above all else, Stonewood offers the benefits of a full-service builder, but remains a boutique operation of just 15 employees, comprised largely of family members and talented professionals with lifelong

Left: Abundant natural materials imbue this Mendota Heights residence with a warmth evocative of its environment.
Architecture by Kathy Alexander.
Photograph by Jim Gallop

backgrounds in the industry. In fact, Sven's father, Jeffrey, who preceded him as president of Stonewood, remains a critical component of Stonewood, overseeing construction of its model homes, and his wife, Anna, and mother, Ethel, head up Stonewood's full-service interior design and furnishing business—Stylebook Interior Design.

Sven's father was actually going to law school when he set to work renovating a home, much like his father and grandfather before him. He cherished the experience so much that he quit law school and ventured into the homebuilding industry. As a youngster, Sven often tagged along on job sites with his father, enamored by the creativity and artistry of the profession, working for his father before engaging in his own renovation projects during high school and later during his tenure at St. Olaf College.

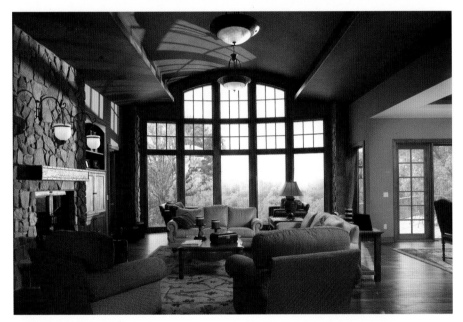

Today, Stonewood prides itself on engaging clients with the utmost respect and care, because collaborating on a custom home provides Sven and his team the opportunity to connect with clients, ascertain what constitutes their particular dream home and then carefully craft a unique, custom residence they will cherish for years to come. No matter how exceptional a request a client may have, Stonewood is eager to take on the challenge. In the past they have built homes replete with such extraordinary amenities as indoor basketball courts, karate dojos and even ice skating rinks—lending credence to the most enduring characteristic of Stonewood's residential endeavors: customization.

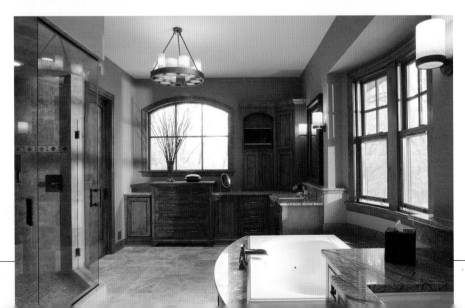

Top Left: Rich interior detailing makes the Mendota Heights residence's kitchen an elegant setting in which to cook and entertain.
Architecture by Kathy Alexander.
Photograph by Jim Gallop

Middle Left: The wall of glass and stone fireplace surround create a strong indoor-outdoor relationship in the living room.
Architecture by Kathy Alexander.
Photograph by Jim Gallop

Bottom Left: Abundant natural light and sophisticated features create a luxurious atmosphere in which to bathe. Architecture by Kathy Alexander.
Photograph by Jim Gallop

Facing Page: The living room's rich wood floor and ceiling are echoed in the built-in cabinetry and stair rail, providing a sense of rustic comfort.
Architecture by Kathy Alexander.
Photograph by Jim Gallop

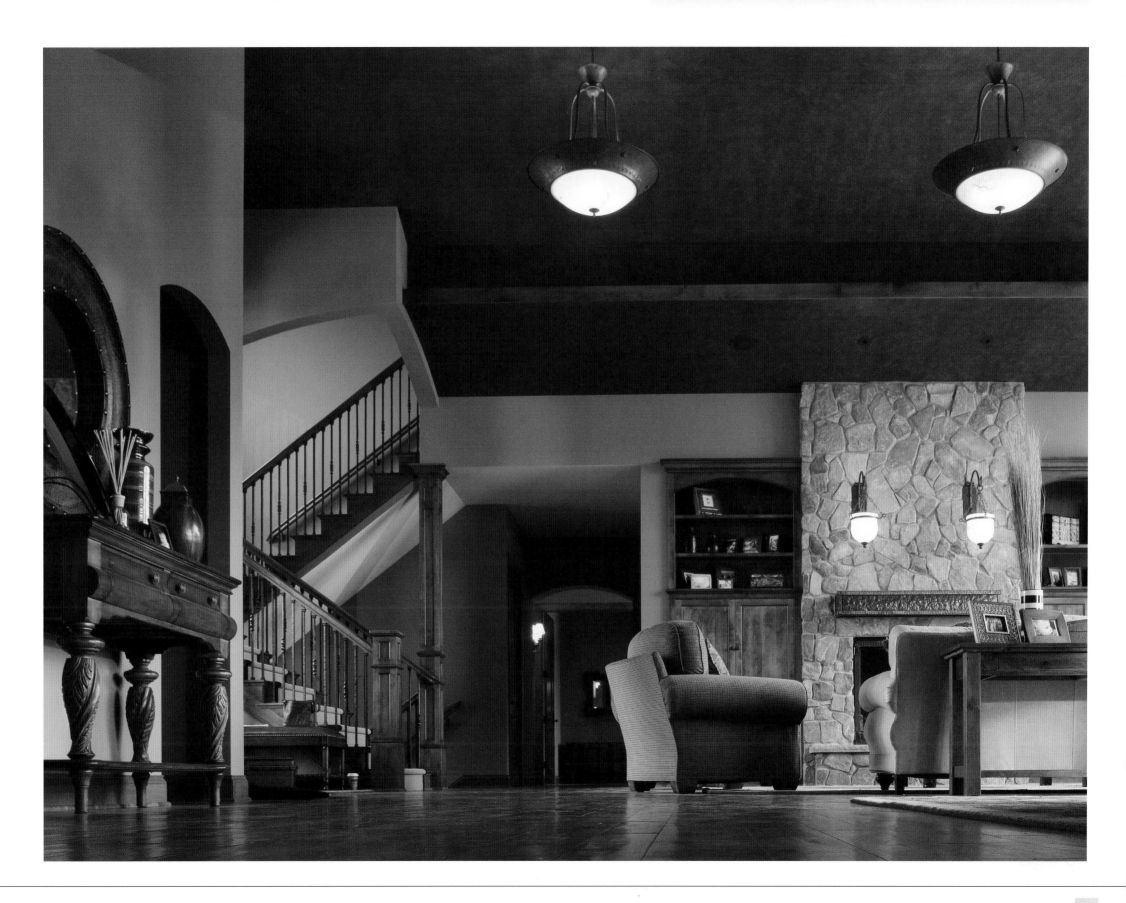

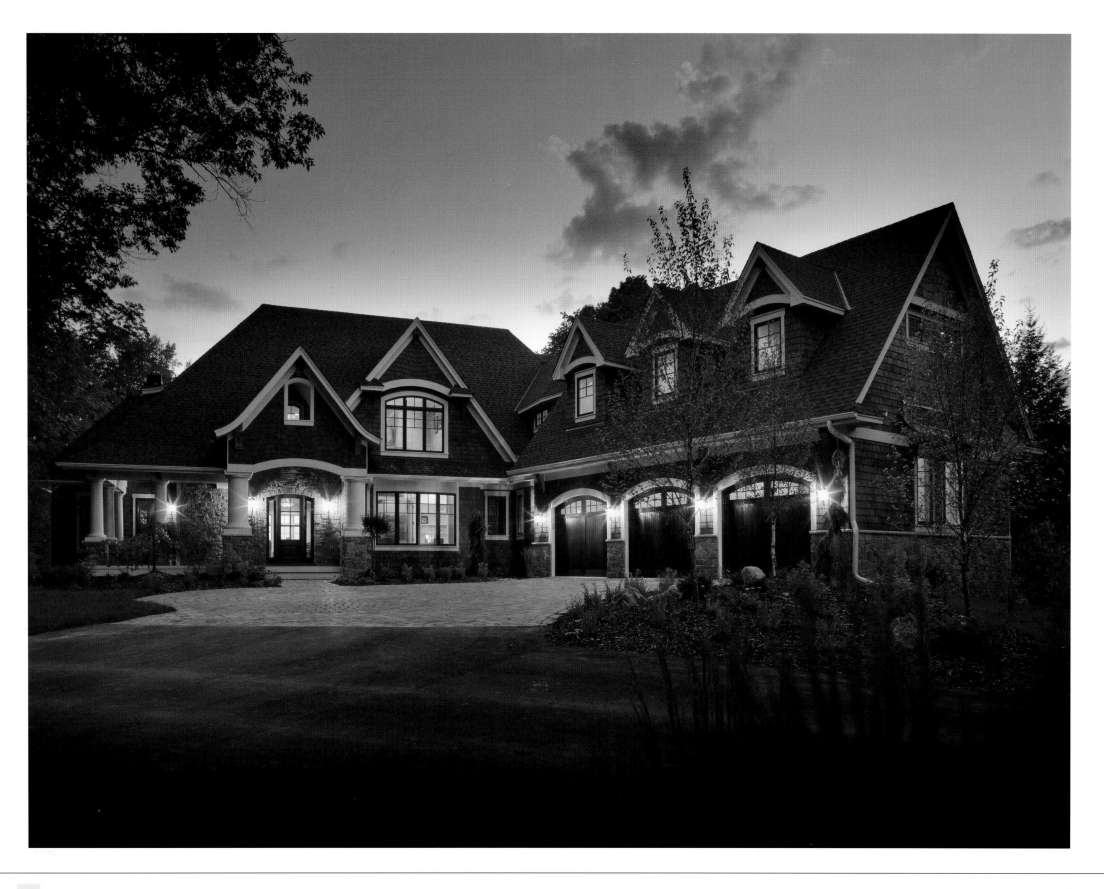

While a large portion of Stonewood's custom residences consists of what are known as lakestyle homes, there is no custom residential project the company will not entertain. However, it is well known for its signature lakestyle homes, which often have a cozy cottage feel to them, albeit highly functional and tailored to the client's desires. Sven himself grew up passing many days at his grandparents' lakestyle house, spending ample time boating on venerable Lake Minnetonka, where so many of Stonewood's creations can be found that the company has come to be known as the "Lake Minnetonka builder."

Furthermore, Stonewood usually has more projects on Lake Minnetonka than any other builder. In many ways this is a reflection of Sven's own upbringing around the 14,000-acre body of water and a result of his understanding the laid-back lifestyle that surrounds lake life, combined with his architectural expertise to fashion aesthetically pleasing homes that capture the serenity of that culture. Indeed it is a perfect fusion of state-of-the-art technology and quaint cottage-like design that yields Stonewood's highly recognizable and sought-after lakestyle homes.

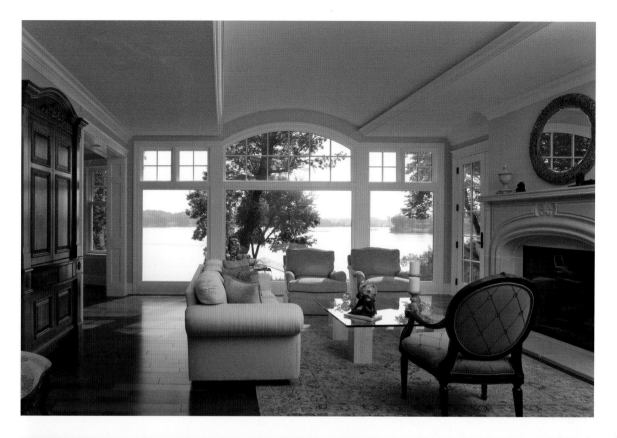

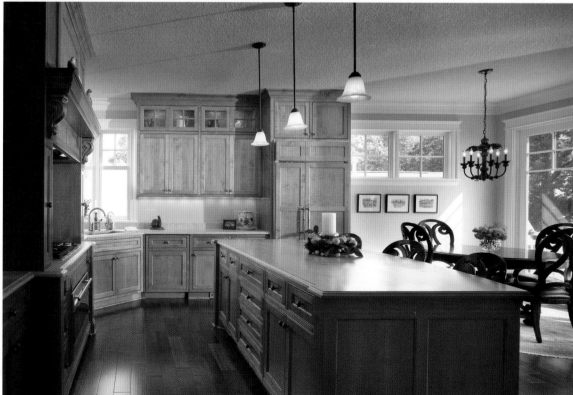

Top Right: The formal living room opens to an exquisite view of Lake Minnetonka. Architecture by Kathy Alexander; Interior design by Stylebook.
Photograph by Jim Gallop

Bottom Right: The kitchen and breakfast nook take advantage of excellent views. Expertly crafted cabinetry encloses the oven, cook top and hood, creating interior seamlessness. Architecture by Kathy Alexander; Interior design by Stylebook.
Photograph by Jim Gallop

Facing Page: Large columns and precipitous gables welcome residents and guests, alike, to this Orono home on Lake Minnetonka. Architecture by Kathy Alexander; Interior design by Stylebook.
Photograph by Jim Gallop

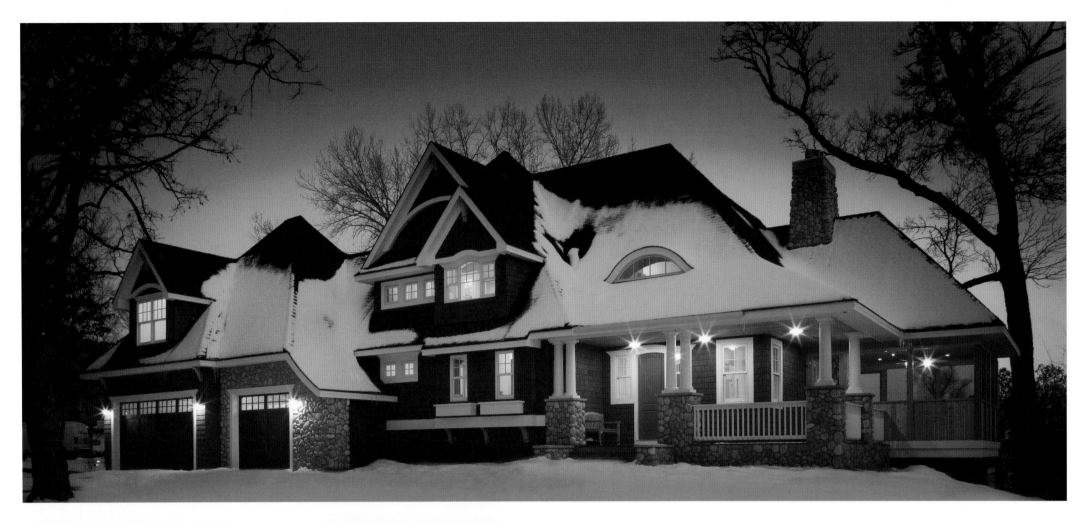

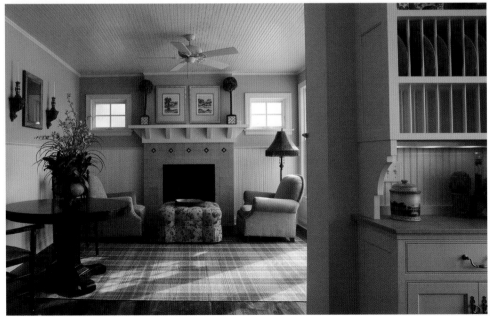

Another reason Stonewood stands apart from its peers is that it utilizes a highly ethical, transparent "open book, cost plus" system in the production process, thereby eliminating any budget ambivalence by keeping the client abreast of actual production costs throughout the design and building process. Sven and his team approach each project as if they were designing a custom residence for their own families, working diligently to afford clients the very best building experience possible. Moreover, subcontractors bid against one another, ensuring that the client receives the best possible price throughout the entire project.

Above: Blanketed in snow, this Orono home in Lake Minnetonka emerges as a warm haven—outside and in. Architecture by Kathy Alexander; Interior design by Stylebook.
Photograph by Jim Gallop

Left: Replete with detailed wainscoting, crown moulding and a finely crafted mantel, this cozy living room harkens to an earlier time. Architecture by Kathy Alexander; Interior design by Stylebook.
Photograph by Jim Gallop

Facing Page: The kitchen of this Minnetrista home on Lake Minnetonka blends beautifully with the rest of the home, due to carefully constructed cabinetry. Architecture by Kathy Alexander; Interior design by Stylebook.
Photograph by Landmark Photography

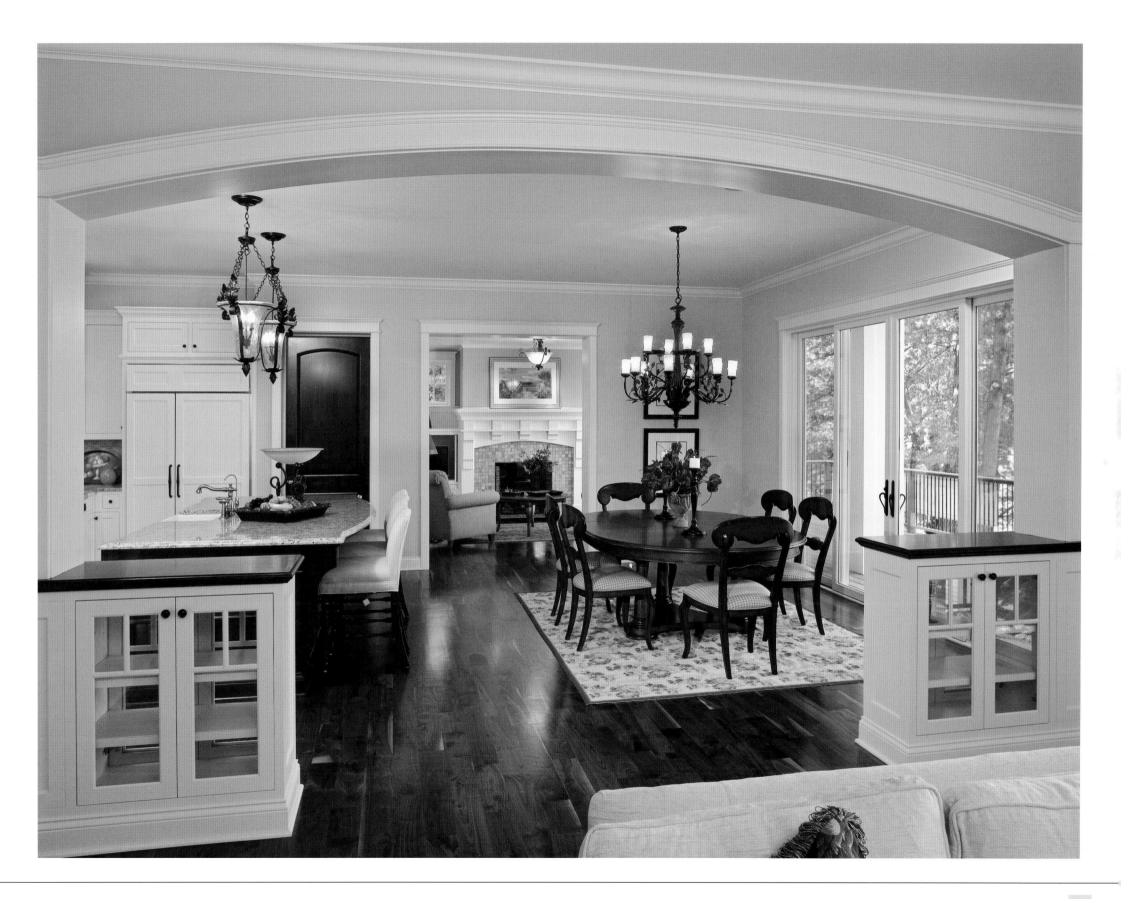

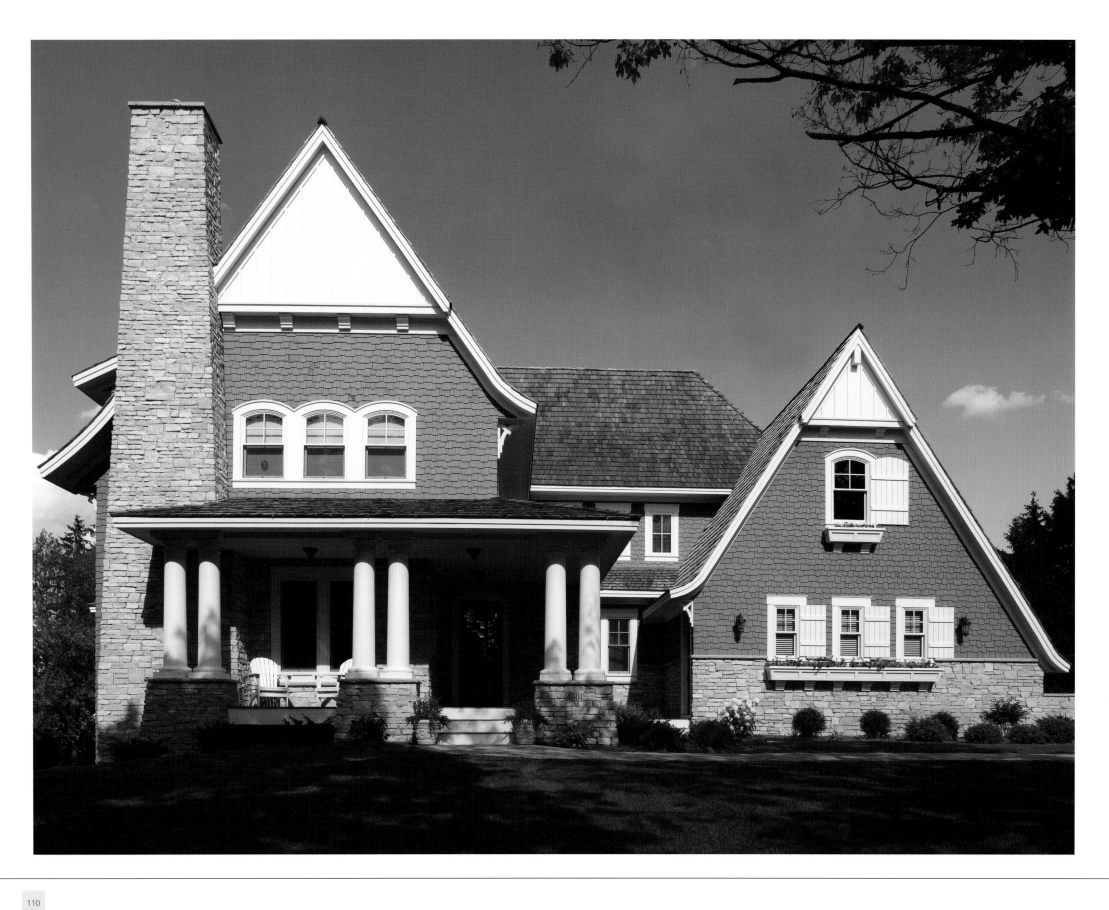

When it comes to building the actual residence, Stonewood incorporates a plethora of Green initiatives in addition to utilizing geothermal heating and highly efficient HVAC systems, not merely complying with Minnesota's stringent energy codes, but always exceeding them. Moreover, by utilizing its spectacular in-house interior design and furnishing team, Stonewood creates highly imaginative and conceptually pleasing interiors that give each residence a refined and alluring appearance. In addition to crafting unique custom residences, Stonewood has further expanded its business into home renovation, and large-scale home renovations account for approximately 30 percent of the company's overall volume.

Whether designing a custom-built residence or renovating an existing home, Stonewood works to ensure that the relationship continues well beyond the project's completion. Satisfied clients can expect Sven and his colleagues to stay committed to customer satisfaction, performing walk-throughs one year after completion and making repairs and adjustments as necessary. Further, all of Stonewood's clients have Sven's personal cell phone number, and no inquiry is too mundane for Stonewood's affable president. Clients sometimes call Sven on the weekend with simple questions, such as how to change the furnace filter.

When dealing with a time-tested, family-owned business like Stonewood, that is the kind of customer service clients have come to expect.

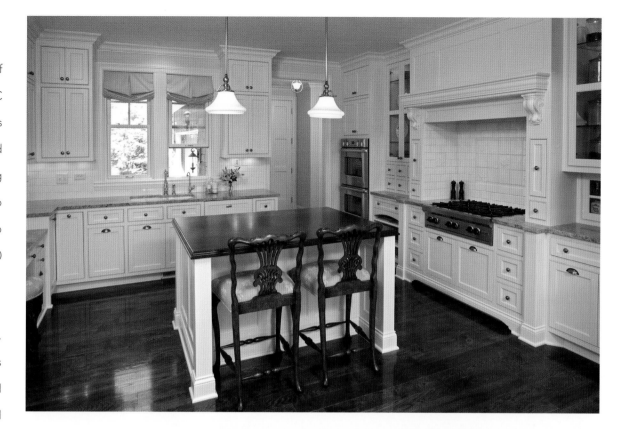

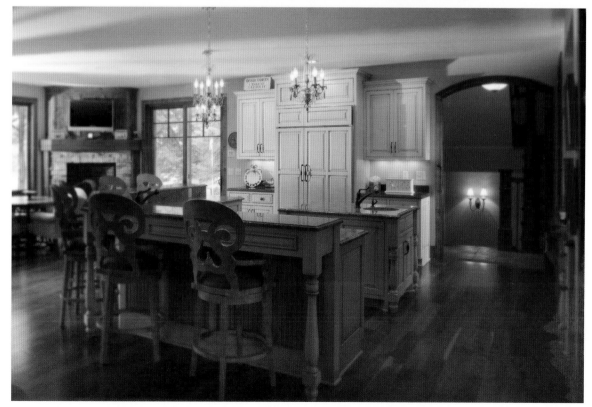

Top Right: This charming kitchen in an Orono residence on Lake Minnetonka seems inspired by a dollhouse. Interior design by Stylebook.
Photograph by Landmark Photography

Bottom Right: Precisely detailed, built-in wood features turn cabinetry into fine furnishing in this Edina residence's kitchen. Architecture by Kathy Alexander; Interior design by Stylebook.
Photograph by Jim Gallop

Facing Page: The combination of complementary natural materials seamlessly fuses this Edina residence with the landscape. Architecture by Mike Sharratt; Interior design by Stylebook.
Photograph by Jim Gallop

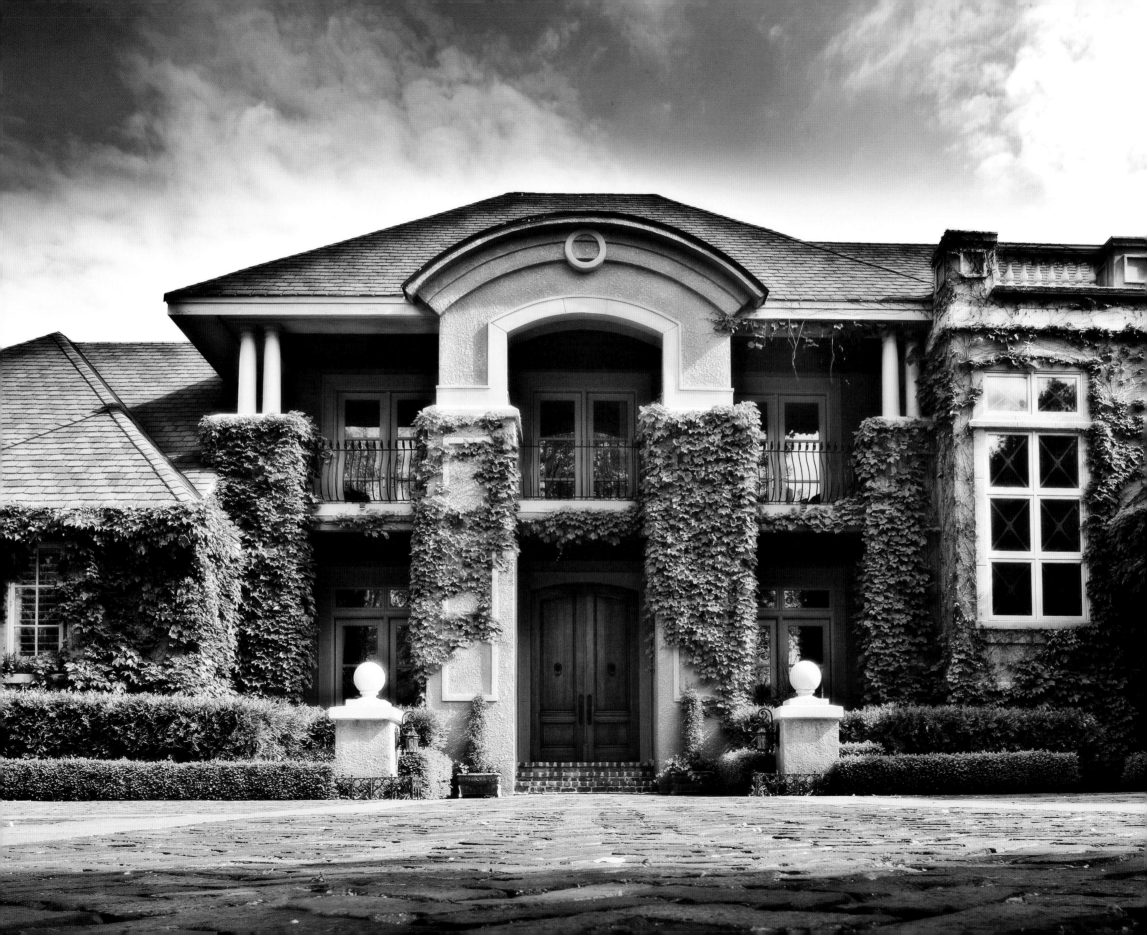

Kevin Keenan
Tim Sveiven

Keenan & Sveiven Inc. Design/Build Landscape Architecture

Above: A vine-covered window and window box add to the romantic detail.
Photograph by Gallop Studios

Facing Page: Replete with recycled clay street pavers, this Old World entry courtyard dramatically welcomes residents and guests.
Photograph by Gallop Studios

Crafting an immaculate landscape is a delicate balance of science and art.

By its very nature, exceptional landscape design is both wonderfully innovative and highly personal—a mixture of grace, environmental sensitivity and unique individual pleasures—in equal measures. It blends architectural vision with horticultural expertise in ways that fit and enhance the owner's lifestyle.

Clients who collaborate on projects with Keenan & Sveiven benefit from the creativity, insight and expertise that are to be expected from a vibrant, multi-faceted firm, but also reap the advantage of earnest involvement normally found in a boutique operation. The result is a carefully considered design,

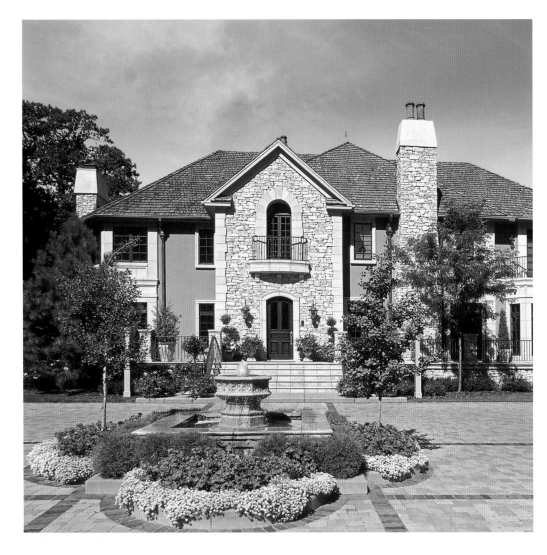

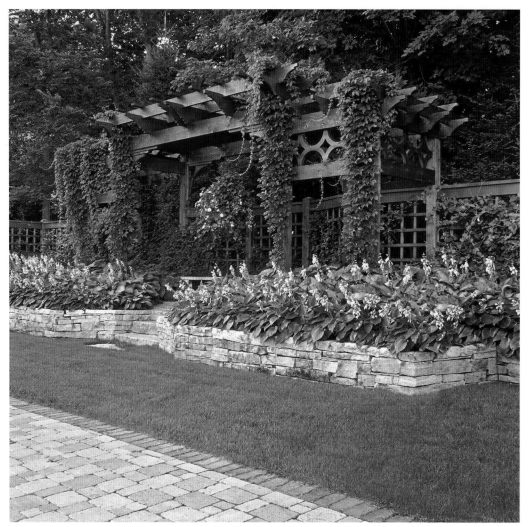

prudently tailored to the customer's needs and desires and built to exacting standards—the final product is something special.

Since 1990, President Kevin Keenan has worked with Vice President Tim Sveiven and their industrious staff of licensed landscape architects and construction crews to listen to clients' goals and translate them into deftly crafted landscapes. The team at K&S continues to blur the line between what traditionally has been viewed as two separate disciplines, re-conceptualizing architecture and landscaping as one interconnected, all-encompassing outdoor domain.

As a design-build shop, K&S has the ability to both plan and execute intricate projects in-house and has reaped great success in this capacity, which is a direct result of years of hands-on project

involvement. Moreover, when projects arise that require special expertise or extraordinary capabilities, K&S acts as a general contractor, finding the appropriate skilled parties to fulfill such tasks. Headquartered in Minnetonka, K&S has the familiarity and acumen to handle a wide variety of different projects, but with a reputation built on meticulous work and outstanding aesthetic vision, the company is known for its comprehensive estate-sized projects. While most of K&S' projects take place in the greater Twin Cities area, the firm's work can be found statewide, in addition to in Wisconsin and South Dakota.

When it comes to the landscape design itself, there is no formulaic approach; copious options exist for how to embark upon the project, and it is the firm's flexibility and its ability to listen to the client that truly shine through at this stage. When possible, K&S likes to adapt the design to mesh with existing

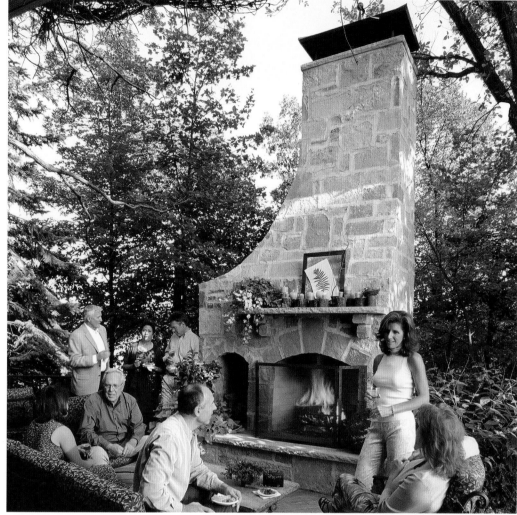

Above Left: A sunken patio with low, brick garden walls and a stone patio surface create the perfect atmosphere for garden parties.
Photograph by Jerry Swanson

Above Right: An outdoor fireplace supports one side of the cedar deck, which is perched over the hillside.
Photograph by Joe Michl

Facing Page Left: Manicured gardens surrounding the fountain add elegance to this formal front-entry courtyard.
Photograph courtesy of Keenan & Sveiven Inc.

Facing Page Right: A vine-covered pergola surrounded by a shade garden creates a private retreat just outside the home.
Photograph courtesy of Keenan & Sveiven Inc.

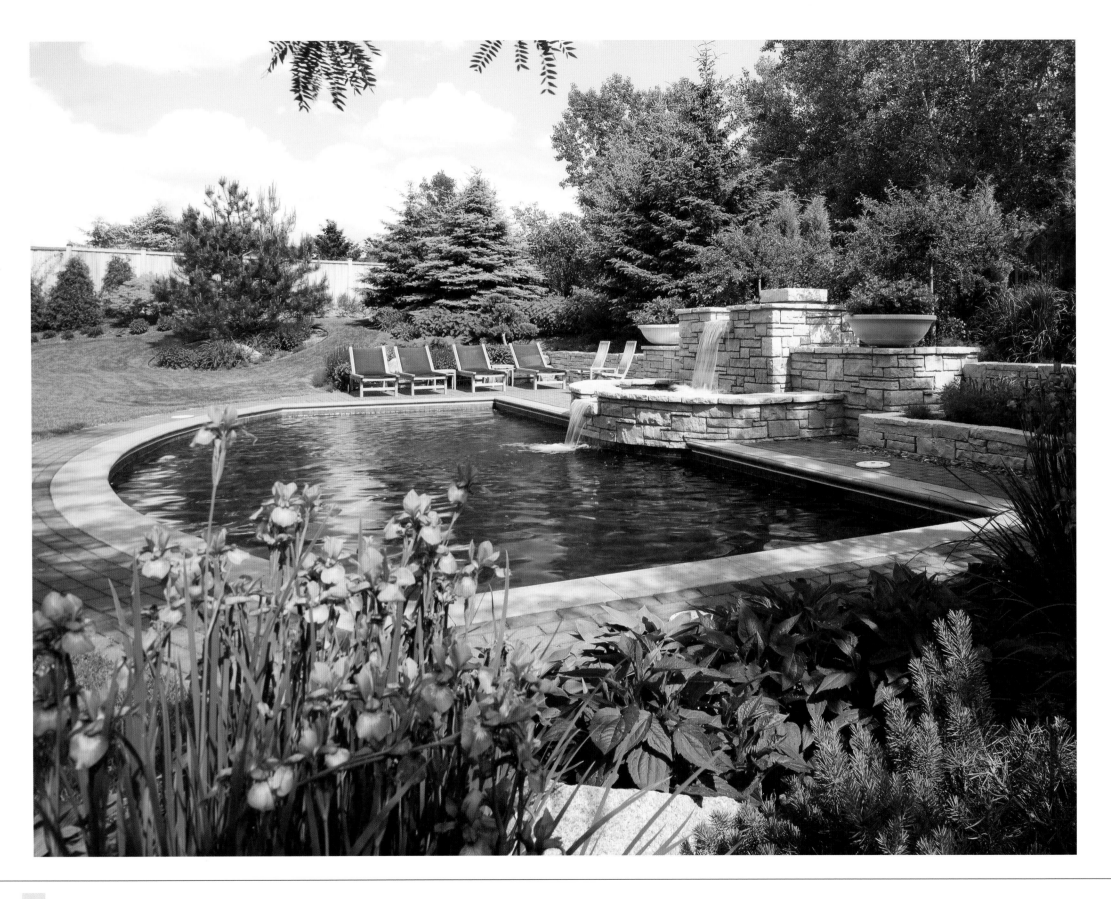

architectural elements, such as constructing a brick and stone retaining wall that matches the brick and stone of the adjoining house. Of course, if the site includes a shimmering lake or existing mature trees, nature has already provided a template and the team simply designs and builds around those choice elements. However, when existing natural elements are lacking, the firm has the especially advantageous ability to incorporate vibrant plants and trees into projects thanks to its companion entity, K&S Tree Brokers. The tree broker division buys and sells wholesale trees throughout the nation and is often a provider of hand-selected, quality plant materials in K&S' landscape designs.

Recent years have seen the projects become grander in scale, and K&S designers often find themselves harkening to those tried-and-true elements. In spite of the industry-wide emergence of using faux-finished materials, the K&S group prefers to use

Above Left: The tranquil rectilinear pool and the lush gardens to its left quietly juxtapose the wild natural environment beyond. A small pool house at the shallow end of the pool affords swimmers a resting place.
Photograph by Stuart Lorenz

Above Right: Swimmers can drink and dine in resort style at the pool-side kitchen and bar.
Photograph by Jerry Swanson

Facing Page: The backyard swimming pool with fountain and waterfalls creates a veritable oasis against the densely planted backdrop.
Photograph by Gallop Studios

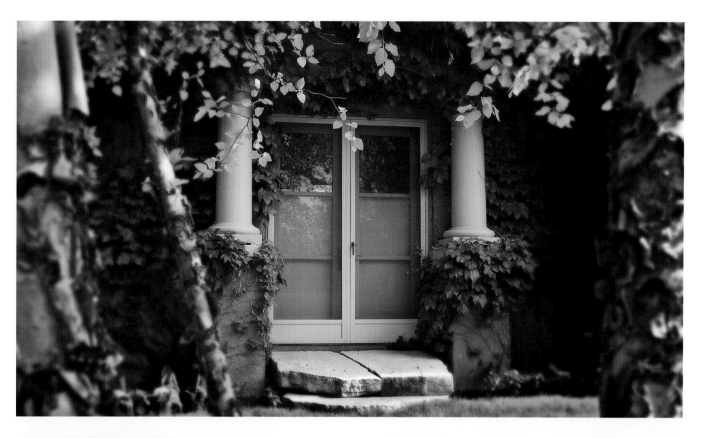

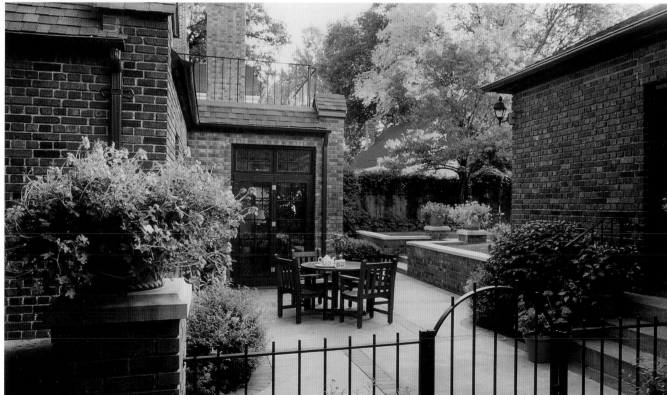

Top Right: Large stone slabs serve as steps up to the vine-covered door's threshold, lending a sense of rusticity.
Photograph by Gallop Studios

Bottom Right: A small backyard patio of concrete with brick accent bands and a low, brick garden wall step up to a manicured lawn area beyond.
Photograph by Jerry Swanson

Facing Page: With rock outcroppings delineating its edge, this manmade pond looks completely intrinsic to its environment. The floating fountain adds a touch of luxury.
Photograph by Jerry Swanson

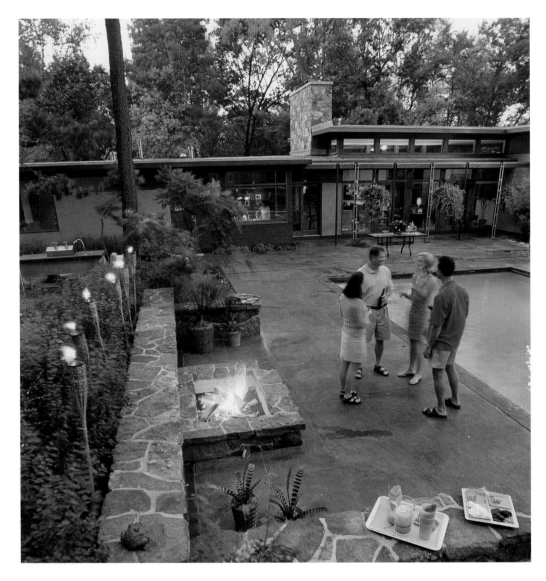

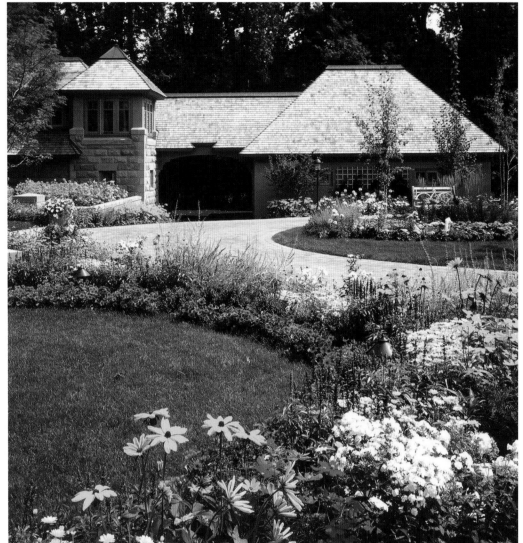

authentic, real materials to create high-quality, timeless designs. While K&S' designs incorporate a delicate balance of both hard and soft landscape elements, naturally there are certain combinations and particular materials that have become more prevalent in its residential landscape projects. But rather than sticking to convention, the team at K&S delicately blends the client's vision and goals with its vast experience crafting aesthetically pleasing landscapes—striking a balance between form and function that simply feels right.

Despite Minnesota's unforgiving winters and surprisingly warm summers, when the weather turns, Minnesotans want to be outside. K&S landscape designs, featuring swimming pools, outdoor kitchens, grills, fireplaces and outdoor rooms, become an extension of their homes. These exterior spaces not only allow for alfresco living and dining, they foster residents' connection with the region's captivating landscape.

As K&S continues to grow and its projects expand in scope, more and more people are realizing the value and intricacy of fine landscape architecture. Keenan & Sveiven is comprised of talented people that create remarkable outdoor living areas and remain dedicated to producing quality landscape designs, collaborating extensively with clients and taking on challenging projects.

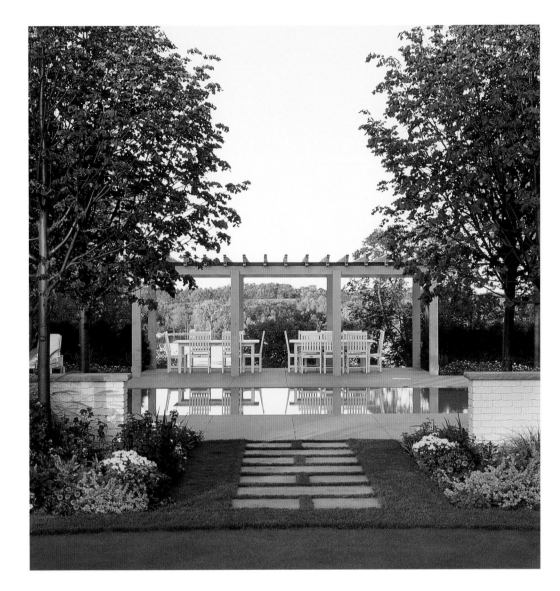

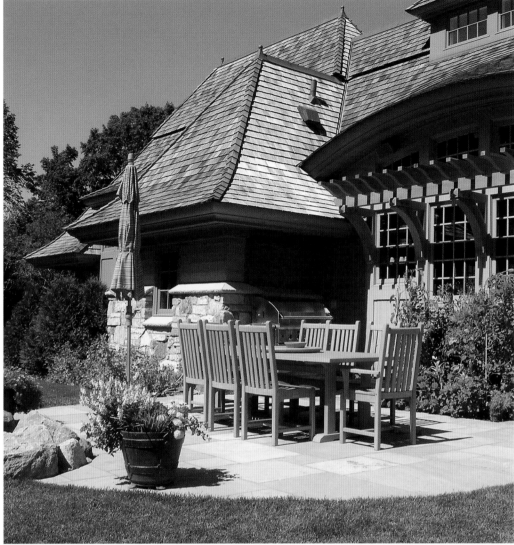

Above Left: From the backyard putting green, a step-stone path leads through the white-brick garden walls to the pool and pergola beyond.
Photograph by Jerry Swanson

Above Right: A teak table and chairs turn this small stone patio into an alfresco dining space.
Photograph by Keenan & Sveiven Inc.

Facing Page Left: The backyard pool area and poolside firepit serve as an extension of the house.
Photograph by Joe Miehl

Facing Page Right: Lush gardens flank the driveway and front-entry walk and adorn the carriage house in the background.
Photograph by Jerry Swanson

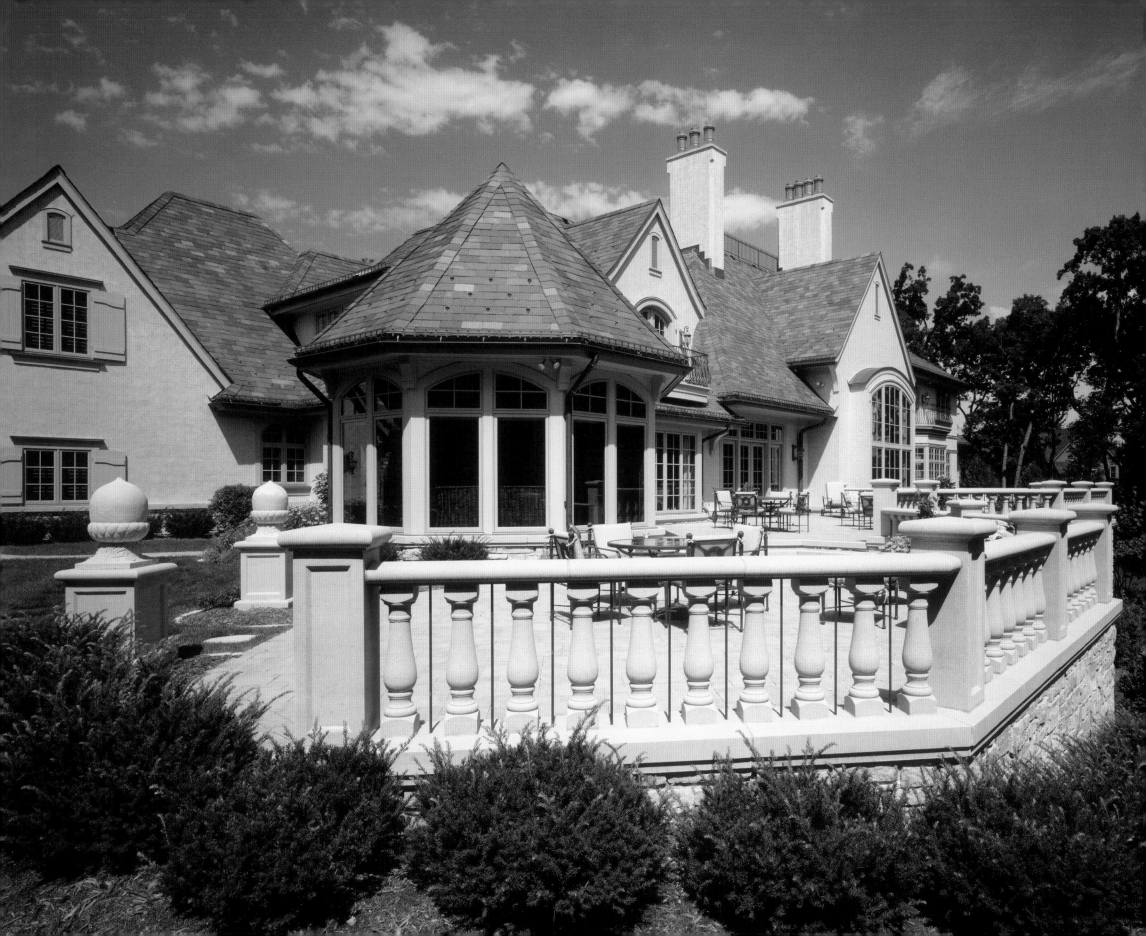

Gary Kraemer

John Kraemer & Sons

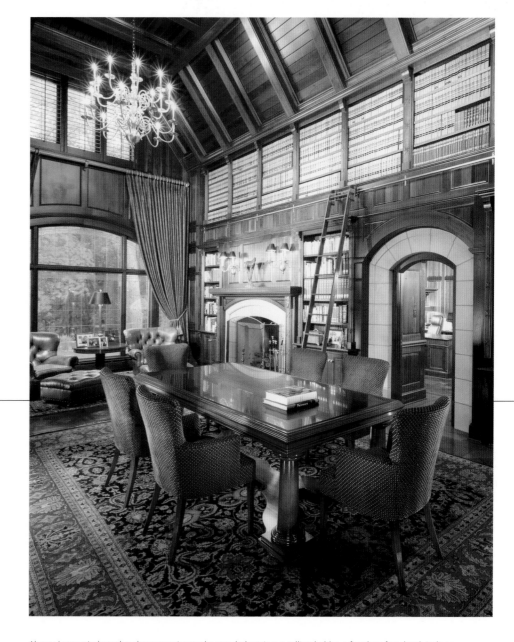

Above: Large windows that draw attention to the wooded setting, a rolling ladder, a fireplace faced with Indiana limestone and an Indiana limestone archway are just a few of this walnut-paneled library's features.
Photograph by Kallan MacLeod

Facing Page: Accentuated with a Vermont slate roof, the home has a stucco exterior that blends beautifully into the stunning terrace, which boasts Indiana limestone balusters and railings.
Photograph by Alex Steinberg

The distinguishing factor that goes into the creation of truly great homes is meticulous attention to detail—and not simply to the finishing touches. An experienced homebuilder understands that this active engagement begins with the initial planning stages of the process. Ample research and foresight help ensure that the end result is a creation of which all involved are equally proud. Second-generation homebuilder Gary Kraemer knows this well—indeed, he owes the immense success of his residential construction business to this credo. Since 1978, John Kraemer & Sons has graced the Twin Cities with painstakingly crafted homes that clients have dubbed "flawless" and "sensational."

One cannot produce sensational work without a source of inspiration. For Gary, that is and always has been his father, John. Raised in the business, Gary watched his father run a business in which customers

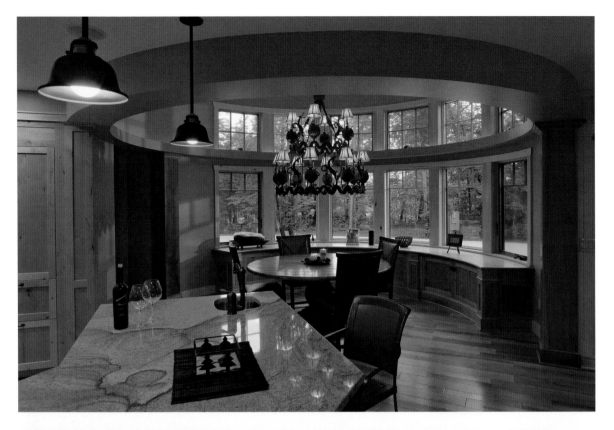

always came first and every person involved in a project was treated with respect. As early as age seven, Gary went with his father to job sites, picking up nails and helping in any way possible. Today Gary continues to uphold the reputation he and his father built nearly four decades ago.

The company's innate passion for building drives the spirit of John Kraemer & Sons. Every professional that Gary employs shares a love for custom home construction and deep commitment to excellence. To the clients' benefit, the staff includes a dedicated team of superintendents and carpenters, several of whom have known and worked with the Kraemer family since Gary was a child. The company delivers on its conviction that "a satisfied customer is not good enough." Gary insists that he personally be involved in every project, ensuring that the quality of both the experience and the product exceeds the client's expectations.

It is not surprising, then, that the majority of John Kraemer & Sons' clients are referred by previous customers and the many talented architects with whom the firm often collaborates. The Kraemer & Sons team is deeply grateful for the acknowledgement and support of both and feels that it reflects the atmosphere it strives to cultivate with clients and architects, alike. Unique among other homebuilders, Gary is not interested in turning the company into a design/build firm. Instead, John Kraemer & Sons' energy is devoted solely toward constructing the finest possible new residences, renovations

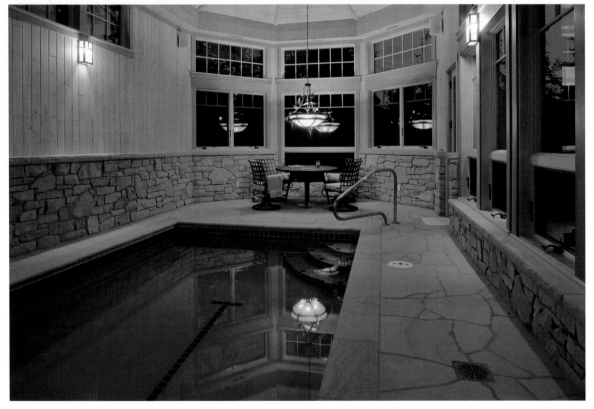

Top Left: Reclaimed flame birch flooring unites the kitchen—replete with a granite-top island—and the rounded dining area, which has custom-built rounded cabinetry.
Photograph by Alec Johnson

Bottom Left: In a northern Minnesota vacation home, this indoor lap pool is enclosed primarily by windows and wainscoting; Dunnville stone graces the lower level and deck. The V-joint walls and ceiling are comprised of knotty white cedar.
Photograph by Alec Johnson

Facing Page: Rounded slate-covered roofs with copper eyebrow accents inform this residence, which is clad in Dunnville stone and cedar shake siding. Adjacent to the terrace, the screen porch has retractable screens that roll up into the ceiling.
Photograph by Alec Johnson

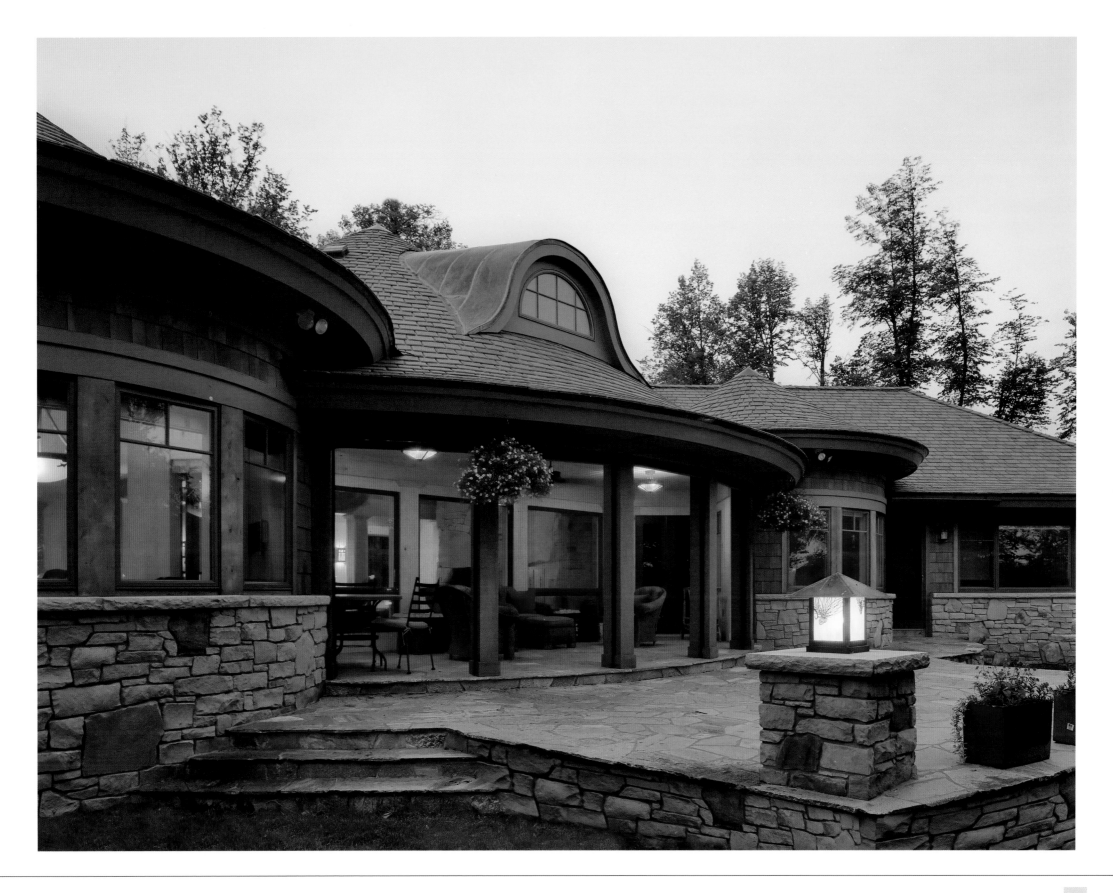

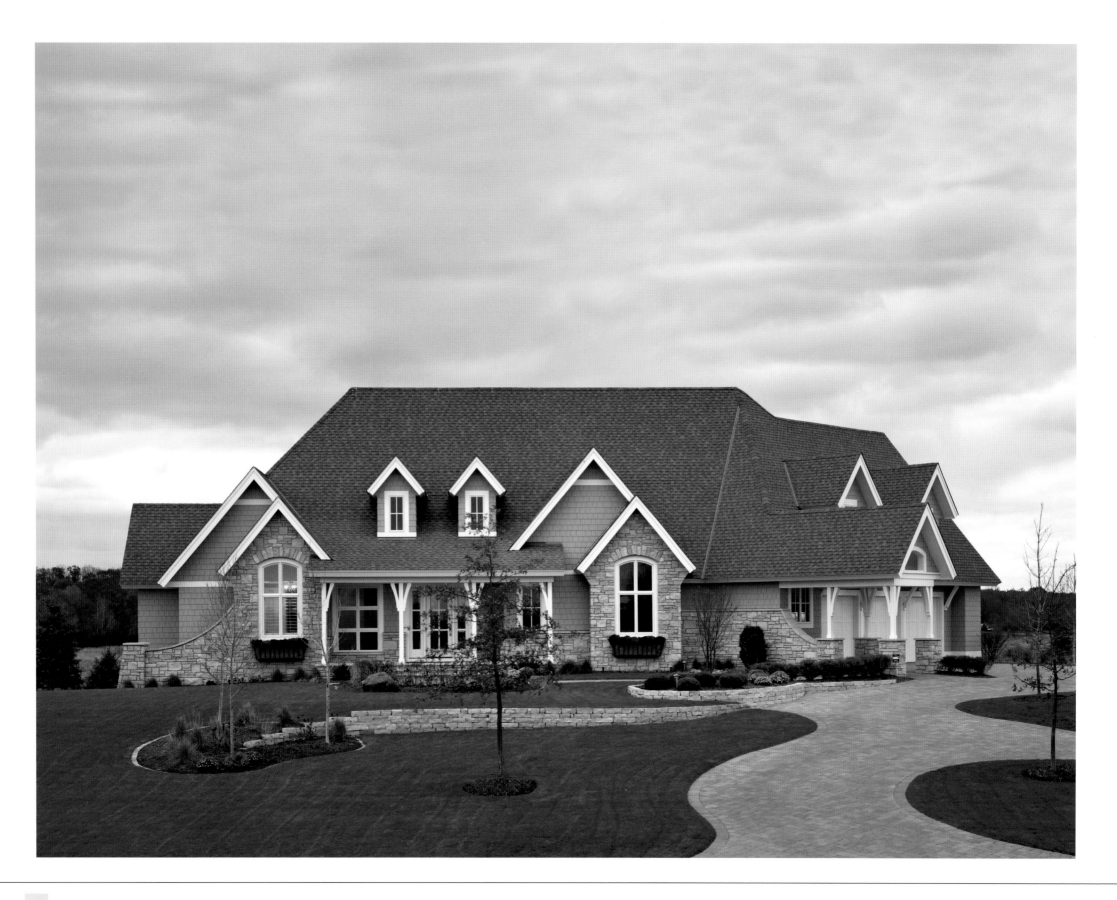

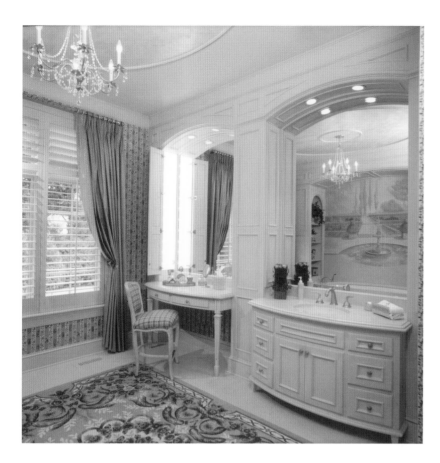

and home additions. The attention to detail and superior craftsmanship for which John Kraemer & Sons has become so well known is evident from the moment one pulls up to any of its gorgeous custom homes.

While stylistically diverse, all of the firm's homes exhibit superior woodworking expertise. Wood abounds in the millwork and mouldings, and substantial doors and custom cabinetry are characteristics of nearly every home constructed. From faux-painted walls to exquisite wine cellars and breathtaking cabinetry, unique interior details are another hallmark of every John Kraemer & Sons home.

Above: Reflected in the mirrors of the custom-built vanity and make-up table is an exquisite hand-painted mural, which is located above the bathtub. Make-up-area lighting can be hidden behind cabinet doors when not in use.
Photograph by Karen Melvin

Right: This grand two-story living room possesses an intricately faux-painted vaulted ceiling with lighted cove mouldings.
Photograph by Mike Zaccardi

Facing Page: Set on two-and-a-half acres overlooking the Credit River, this 2007 Reggie Award of Excellence-winning home's exterior has James Hardie shake siding and Fond du Lac stone.
Photograph by Mike Zaccardi

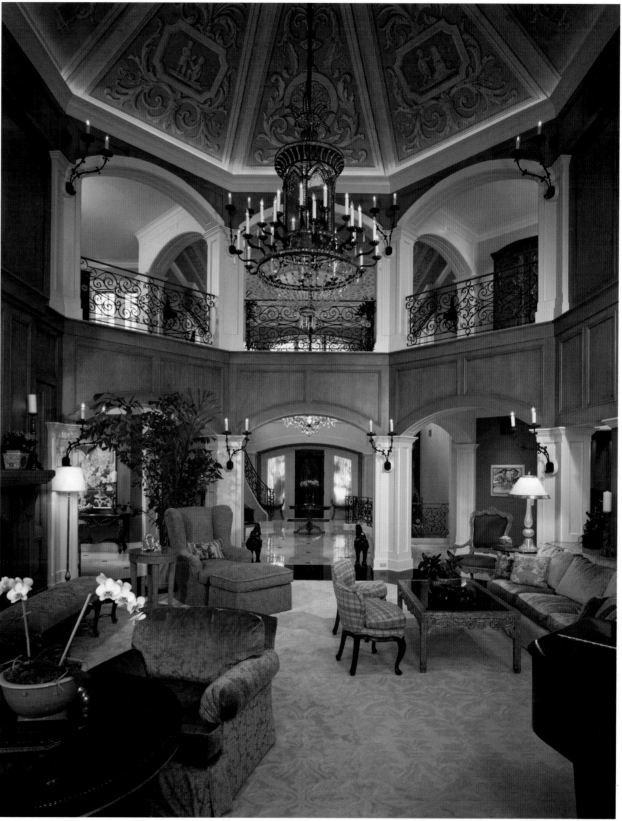

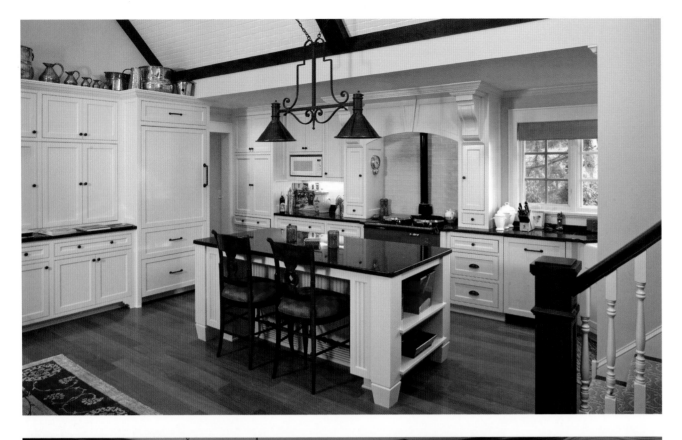

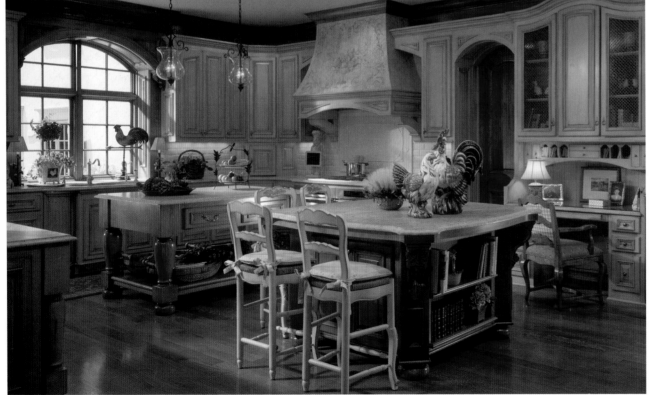

John Kraemer & Sons has been rewarded with numerous prestigious awards for its excellence over the years. The company has been recognized as the Builders Association of the Twin Cities' (BATC) Builder of the Year. This honor is given by subcontractors to builders who excel in the areas of ethics, quality and attention to detail. The firm has also been a recipient of the BATC Fall Parade of Homes' most prestigious award, the Reggie Award of Excellence. One can also commonly find John Kraemer & Sons' homes featured in publications such as *Midwest Homes*, *Mpls. St. Paul* and *Trends*.

Dedicated to giving back to the industry and the community, the company is becoming increasingly involved in the Home Builders Association of the Twin Cities and volunteers in a number of local organizations. With a third generation coming aboard—Gary's three sons share their father's life-long passion for building—the Kraemer name promises to be synonymous with beautiful custom homes for years to come.

Top Left: A guest-house kitchen, this space features custom-built enameled cabinetry and a high-vaulted v-groove wood ceiling with richly stained beams.
Photograph by Mike Zaccardi

Bottom Left: Carved millwork abounds in this kitchen, which is replete with two islands and white oak flooring. Much of the alder wood cabinetry is faux finished to look worn and comfortable.
Photograph by Karen Melvin

Facing Page: Designed in the Cotswold style, this Lake Minnetonka guest house is adorned with a stucco and brick exterior and machine-cut cedar roof shakes.
Photograph by Mike Zaccardi

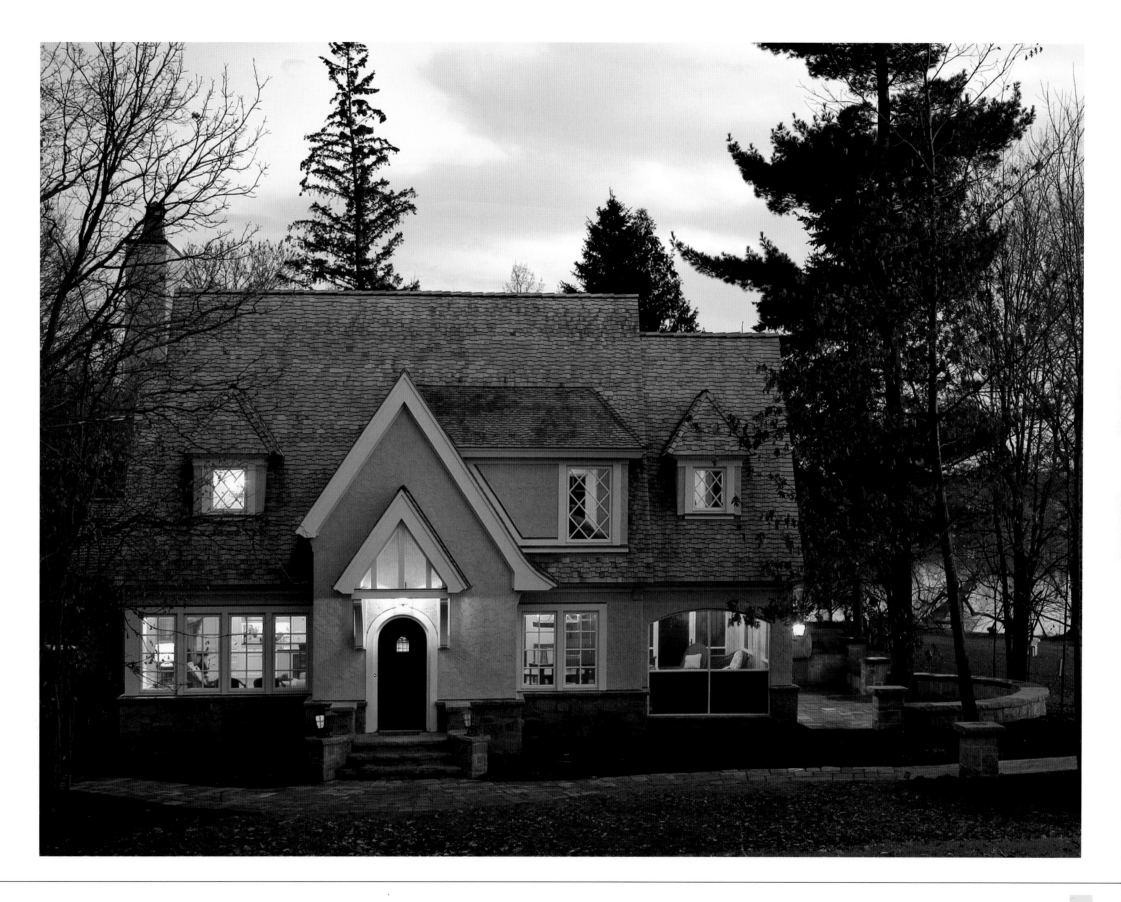

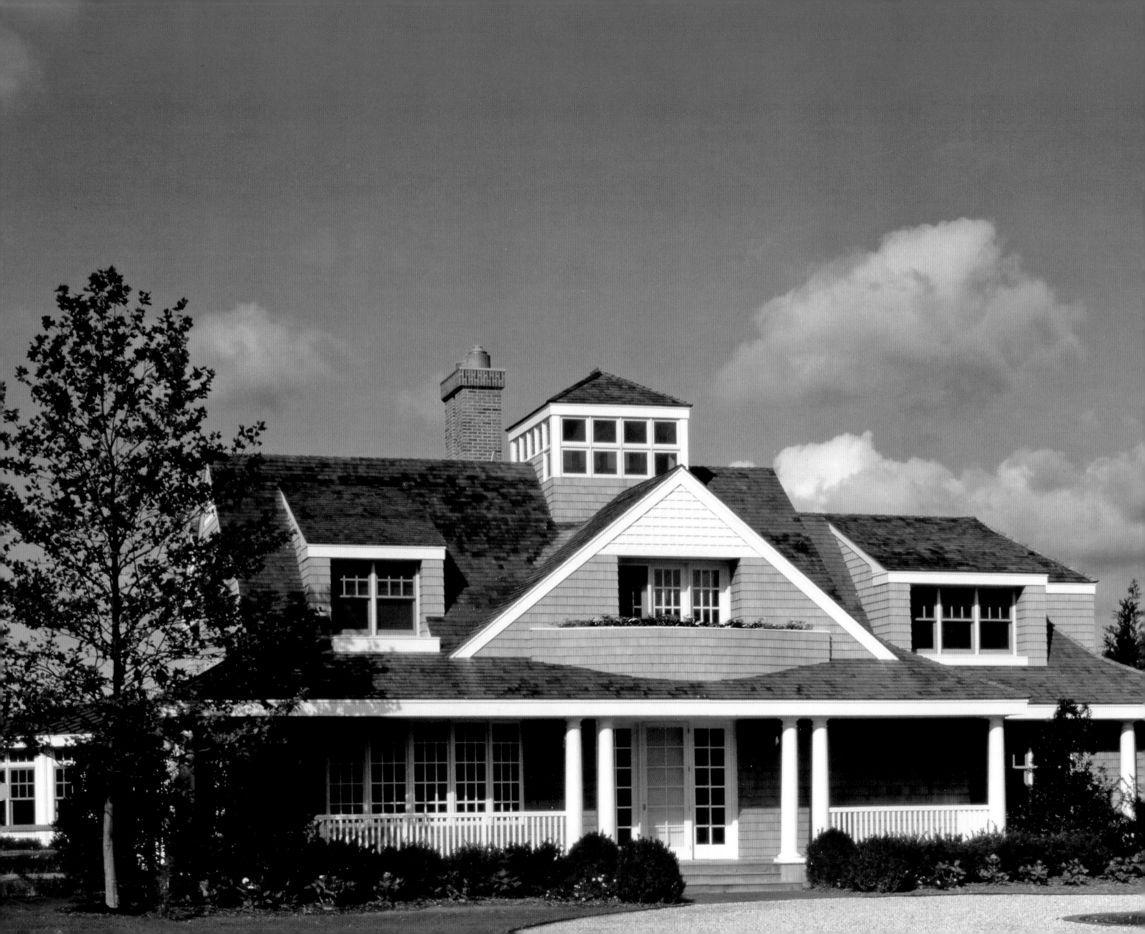

Robert Lund

Robert Lund Associates Architects, Ltd.

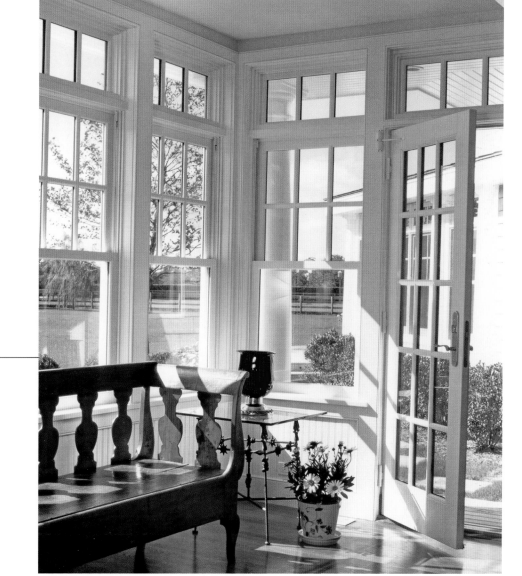

Above: South-facing living room windows open the house to natural light, garden access and views to the distant horse paddocks and orchards.
Photograph by Robert Lund Associates Architects

Facing Page: The owner wanted a modern farmhouse feel—including the traditional welcoming entry porch—for this new house set among horse farms. The rooftop monitor floods the interior spaces with daylight; the bowed planter provides privacy for a second-floor bedroom terrace while reinforcing the entryway below.
Photograph by Robert Lund Associates Architects

Robert Lund's clients are often surprised when they move in. They call to tell him that living in their new house or the newly renovated home he designed is way beyond their expectations. As one recent client put it, "The house feels tailor made. We wouldn't change a thing; yet there are aspects of it we never even realized we had." Years later, clients will come back for more—a Manhattan pied-à-terre, a Long Island winery and a synagogue have been just a few of these follow-up projects.

An architect needs to ask the right questions, be a good listener, Robert says. Most clients find it hard to articulate what they are looking for. One couple was a particularly good example of this. The wife said she wanted a cozy English cottage, ironically producing pictures of huge French chateaus in meeting after meeting to illustrate her point. Her husband, in the meantime, dreamed of an "Atlantic

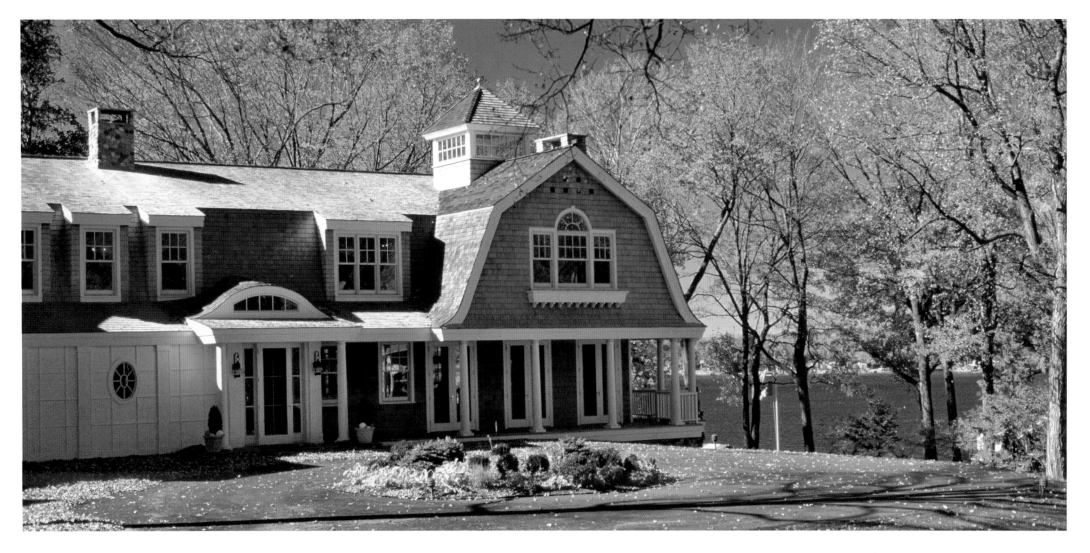

City hotel"—all glass and an expansive view. Somehow, Robert forged a compromise they both loved. Defining his work in "styles" is something he does not like to do. Nonetheless, his work encompasses a wide range of vocabularies, from modern houses to Tudor manors, Shingle-style to Colonial. He explains that, unless otherwise requested by a client, each style grows out of the design process. It is easy to see the grace and skill with which he articulates each element.

Overcoming obstacles, finding solutions to problems that may initially seem insoluble, is what Robert likes to do best. He describes every project as a puzzle with many different elements—site, suitable scale, sun's trajectory, circulation, views and client program. The design process is about boiling those elements down to find the key that links all the puzzle pieces together. That is the challenge that intrigues him. A remodel presents the added challenge of assessing the

strengths and weaknesses of the original structure and then maximizing its assets and eliminating its liabilities. One of the most striking examples of Robert's creativity is a project he undertook in a strictly regulated, environmentally sensitive area where the footprint of the house had to be maintained. The clients wanted to transform a 1970s' "modernist mistake" into a Mediterranean villa. They got just what they wanted—based on a Robert's initial "back-of-a-napkin sketch"—and the resulting renovation was featured in several publications.

Above: A new house was given a linear form, tracing the crest of a hill that sloped gently to the lake shore. The owners, a passionate boating family, requested that all rooms and spaces open to views of the lake.
Photograph by Robert Lund Associates Architects

Facing Page Left: The dining gazebo is located at a bend on the hillside crest, providing protected panoramic views of the lake.
Photograph by Robert Lund Associates Architects

Facing Page Right: The oversized bay window in the breakfast room captures light from sunrise to sunset; the double gable on the master suite above echoes themes from a turn-of-the-century country club across the bay.
Photograph by Robert Lund Associates Architects

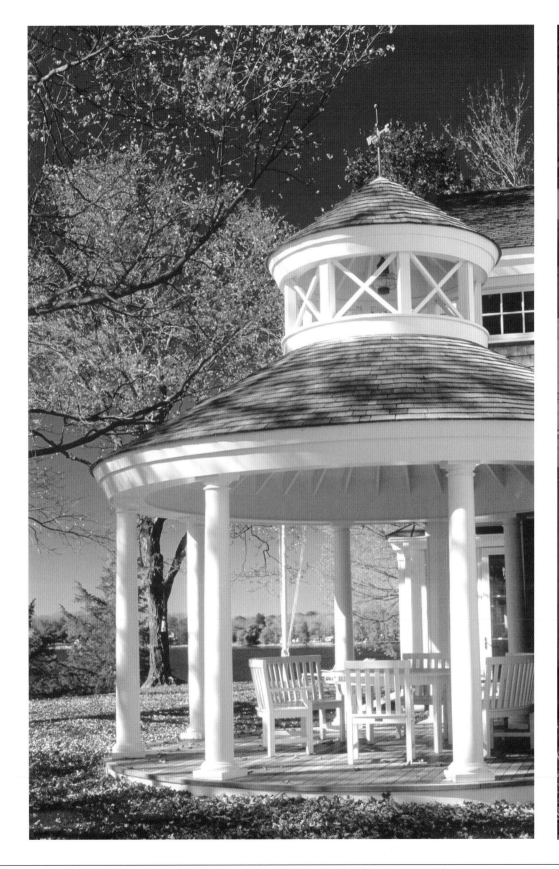

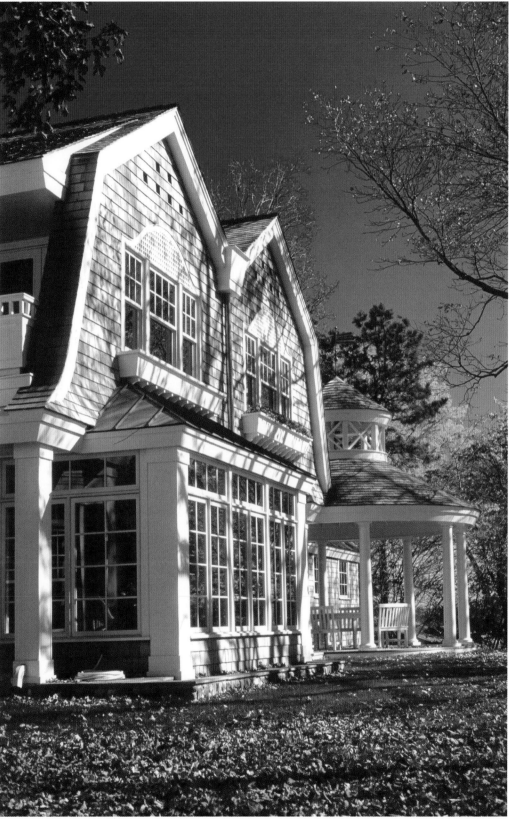

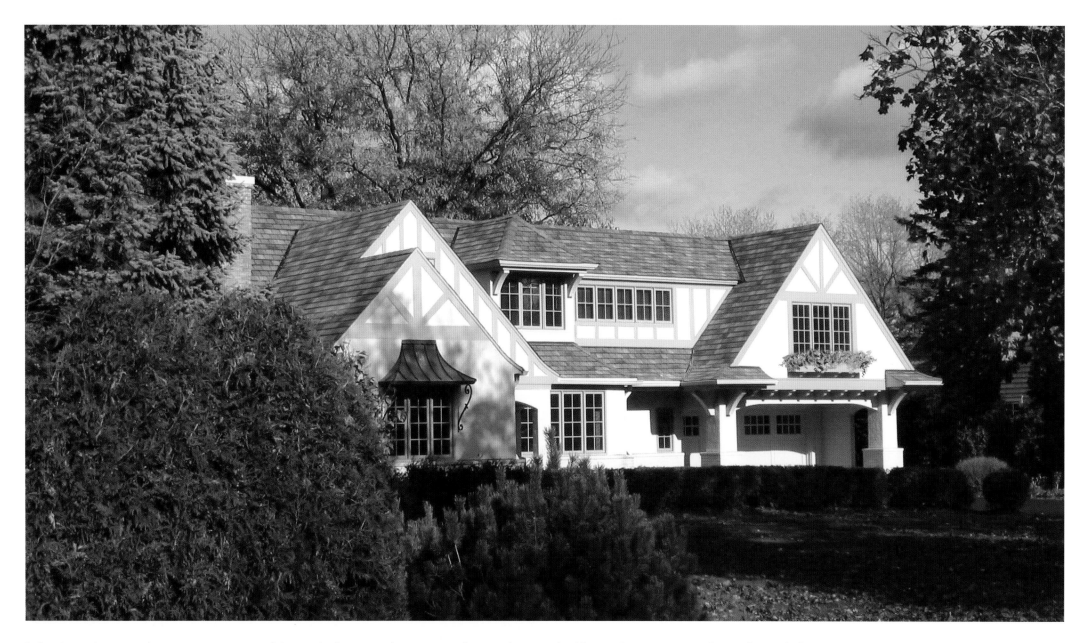

Robert's entrée into architecture was not typical. He studied organic chemistry in college and was accepted to dental school—an opportunity that pleased his parents much more than it did him. Robert's longtime love of drawing and math prompted him to pursue a different path. He enrolled in architecture school in New York City, a decision that would lead to both career success and vocational fulfillment.

After graduation, Robert worked for world-renowned architect Philip Johnson at the firm Johnson/Burgee, where he had the opportunity to work on designs that included the Neiman Marcus building in San Francisco and Dr. Robert Schuller's Crystal Cathedral in Garden Grove, California. Robert cherishes his experience under the tutelage of the Pritzker Prize-winning architect. In 1986, he opened his own firm, Robert Lund Associates Architects, in New York City. In 1992, he moved back to his native Minneapolis so his son could grow up among his large extended family, skiing and ice skating in winter and sailing in the summer—sports Robert had enjoyed as a child. He maintains a New York office in Bridgehampton, New York, and commutes between the two.

Above: The goal of this full interior and exterior renovation was to enhance a weak Tudor exterior and to open up and rearrange, significantly, the internal spaces.
Photograph by Robert Lund Associates Architects

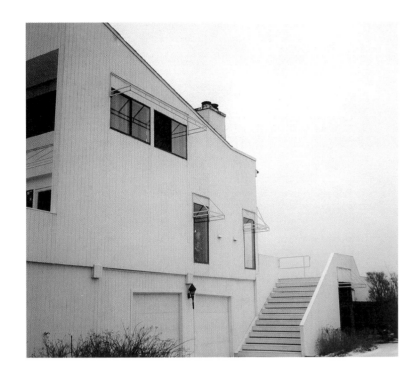

The most rewarding aspect of the design process, Robert says, is when clients call out of the blue two or three years after the project is completed to say how much they love living in the house. Frequent phone calls such as this are among the many reasons that, after 35 years as an architect, Robert still loves coming into the office every morning. *The New York Times*, *Architectural Digest*, *Oculus*, *Architecture Minnesota* and *The New York Observer* have all recognized the firm's remarkable work. It is, however, the gratitude and enthusiasm of his clients that is his greatest reward.

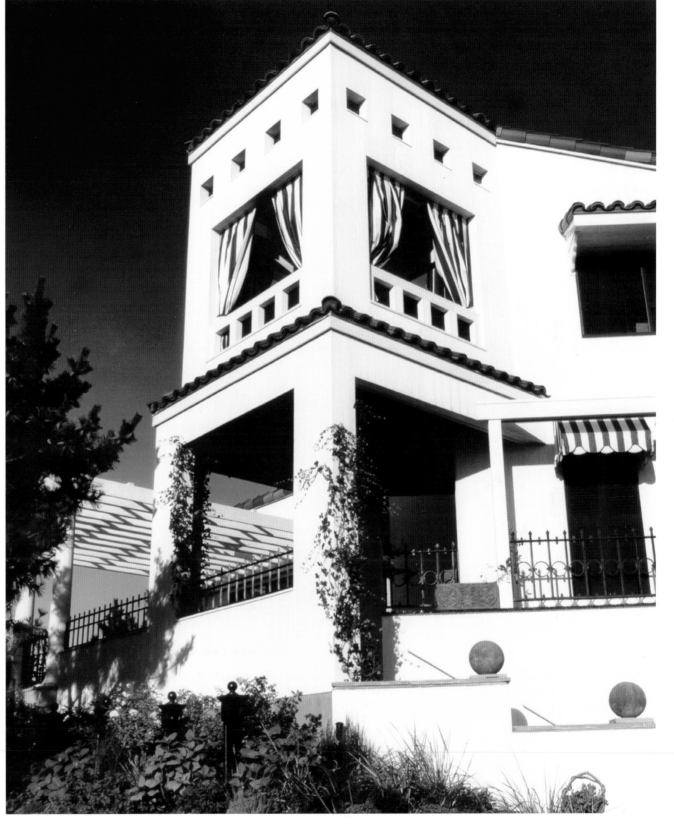

Above & Right: This extensive remodel transformed an ordinary house, above, in an environmentally sensitive area into a Mediterranean-style villa. The re-worked entryway, right, with adjacent dining terrace areas and roofed outdoor porch above captures distant water views. *Photographs by Robert Lund Associates Architects*

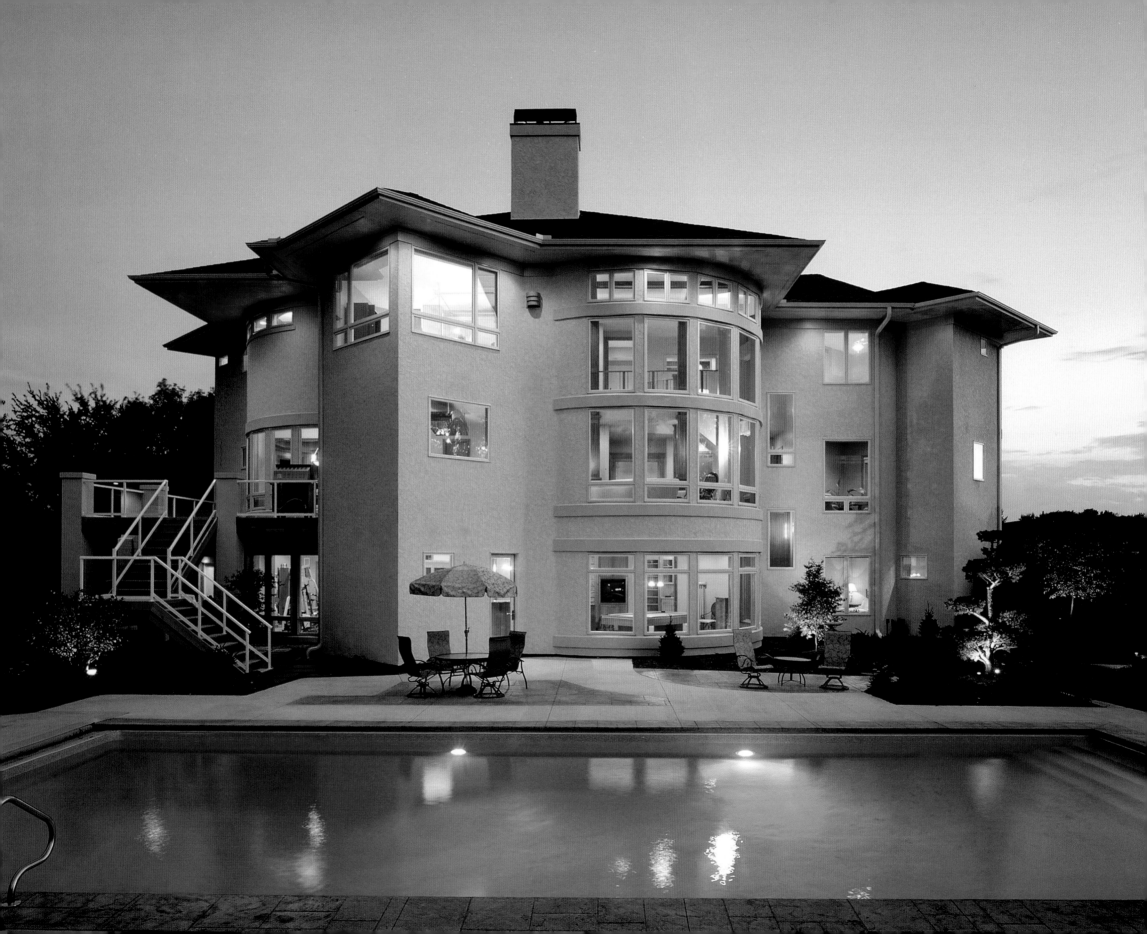

Al Maas

A. Maas Construction, Inc.

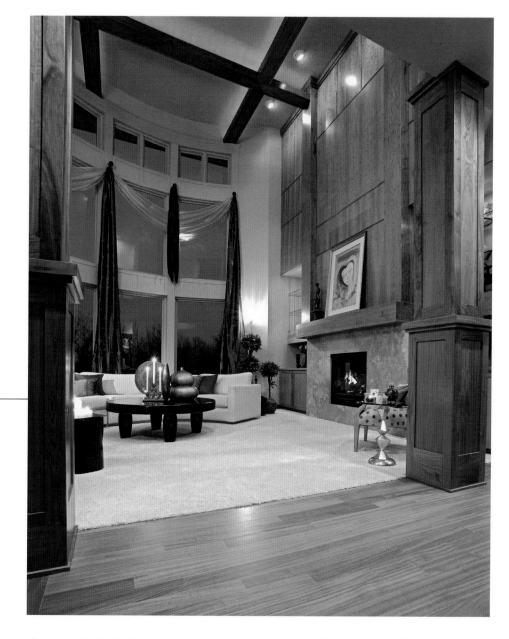

Above: Accent lighting highlights the details of this two-story great room and illuminates the beautiful combination of the cherry, black walnut and Sapelli woodwork.
Photograph by Landmark Photography & Design, LLP

Facing Page: The abundant use of windows allows the natural lighting and landscape to bring warmth to this contemporary two-story home.
Photograph by Phillip C. Mueller Photography, LTD

For Al Maas, construction is truly a family business. As a young boy, his father encouraged and taught him about construction, fueling his interest. Al's intrigue in the construction industry grew to a full-fledged passion, and in 1988, with his wife, Lynette, A. Maas Construction was founded. Today, the firm is home to a talented team, constructing custom homes of the utmost quality in the Twin Cities and throughout the southern metropolitan area.

The concept of family does not stop with the firm's origin. As each home is an expression of the client who will live there, the process of designing and constructing the home necessitates an intimacy evocative of family. Each member of the A. Maas team develops a close relationship with clients from the outset, learning the family's preferences and personalities and helping to better guide them through

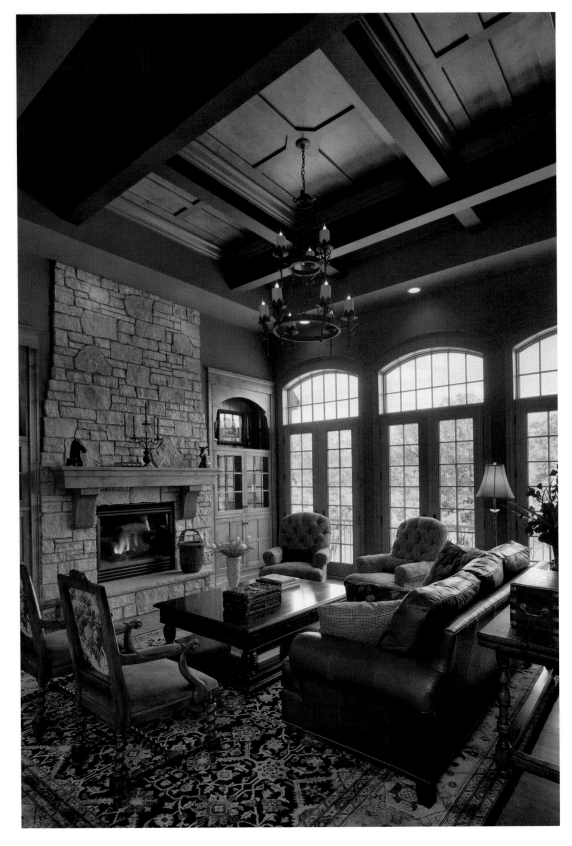

the design process. The personal attention they receive invokes the clients' trust and instills in them the confidence that their homes will accurately and beautifully reflect their lifestyles.

Just as the team encourages clients to design and build for themselves and their families, the company's principals stress to everyone involved in the project to build each home as if it were his own. Not surprisingly, A. Maas Construction homes are characterized by precise craftsmanship and acute attention to every detail. Working closely with home designers that have partnered with A. Maas Construction for years, the team consistently crafts exquisite structures in a variety of architectural styles. Whether imbued with Old World charm or a contemporary feel, each home is, at heart, a functional and practical framework to support its residents' way of life.

While all of the firm's projects are challenging in their own ways, one stands out as especially demanding. Spanish Mission in style—a genre not typical to the region—the home not only features many elaborate details inside and out, but also includes a roof system suggestive of the Southwest's requisite clay-tiled roofs. To protect the estate from the brutal Minnesota winters while upholding its stylistic integrity, the firm employed an alternate, weather-friendly roofing material. This home and countless others exemplify the firm's resourcefulness

Left: Beamed ceilings, the wrought iron chandelier and the natural stone fireplace bring a comfortable feel to this stately traditional great room.
Photograph by Saari & Forrai Photography

Facing Page Right: This Spanish-style home, set on a golf course, features red concrete tile roofing, Colorado Red Sandstone and stucco detailing.
Photograph by Saari & Forrai Photography

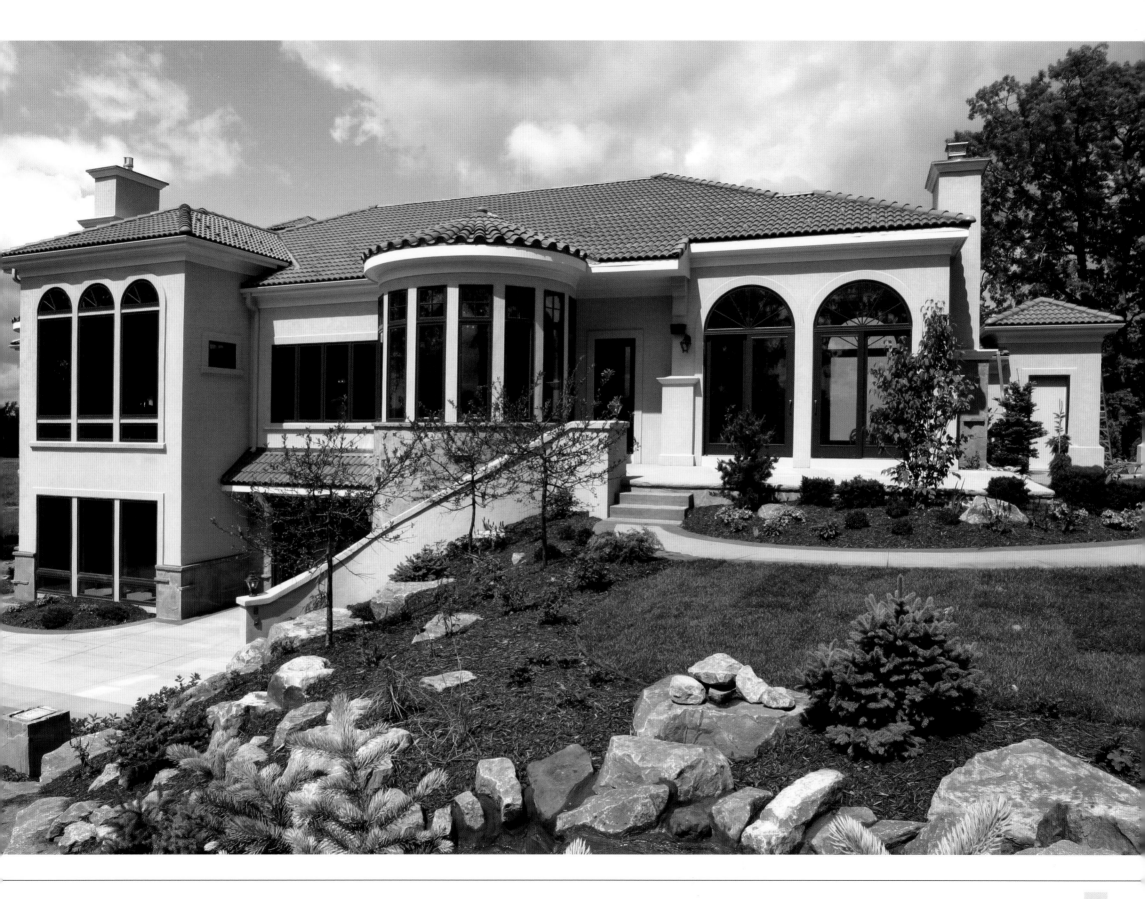

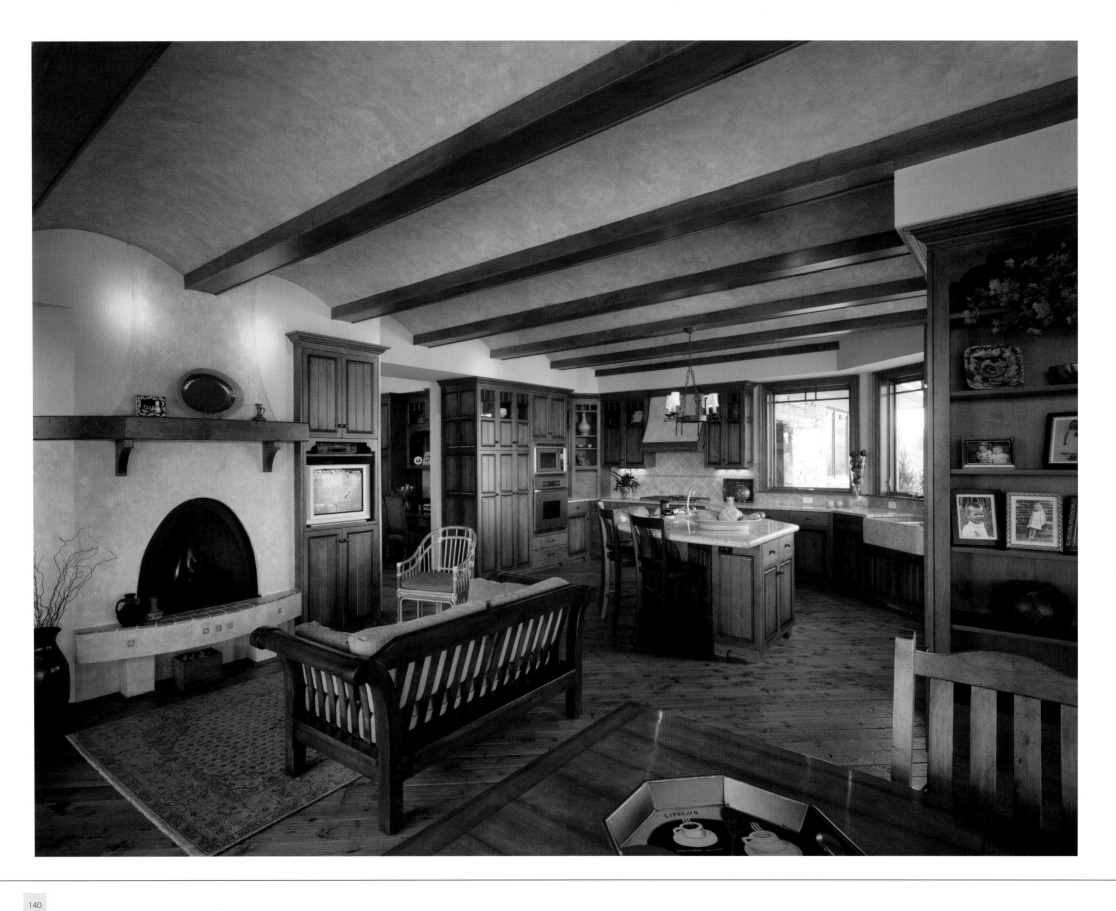

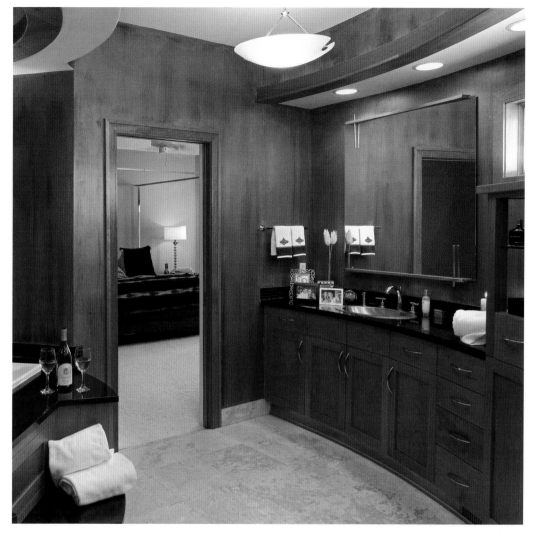

and resolve. The A. Maas staff's ingenuity and wealth of experience, coupled with the talented craftsmen with whom they collaborate, ensure that even the most intricate features and details will be attended to.

A member of the Builders Association of the Twin Cities, the Builders Association of Minnesota and the National Association of Home Builders, A. Maas Construction has been featured in such publications as *Mpls. St. Paul Magazine* and *Midwest Home*.

In addition to this exposure, the firm has won several Trillium and Reggie Awards for Excellence, achieved over the years. Though small in size, the firm's ambitious undertakings, tenacious spirit and drive to build timeless homes has earned it the reputation as one of Minnesota's finest custom

home builders. The homes it constructs will forever impact the lives of its clients and leave them with the utmost satisfaction for generations to come.

Above Left: Architectural details of this home, which overlooks a spectacular lake and golf course, reflect the beauty of its natural surroundings.
Photograph by Landmark Photography & Design, LLP

Above Right: Subtle angles and interior ambient lighting help showcase this elegant master suite.
Photograph by Saari & Forrai Photography

Facing Page: The design elements, featuring an adobe-style fireplace and a hand-painted, beamed arched ceiling, bring a rustic charm to this kitchen/hearth room area.
Photograph by Saari & Forrai Photography

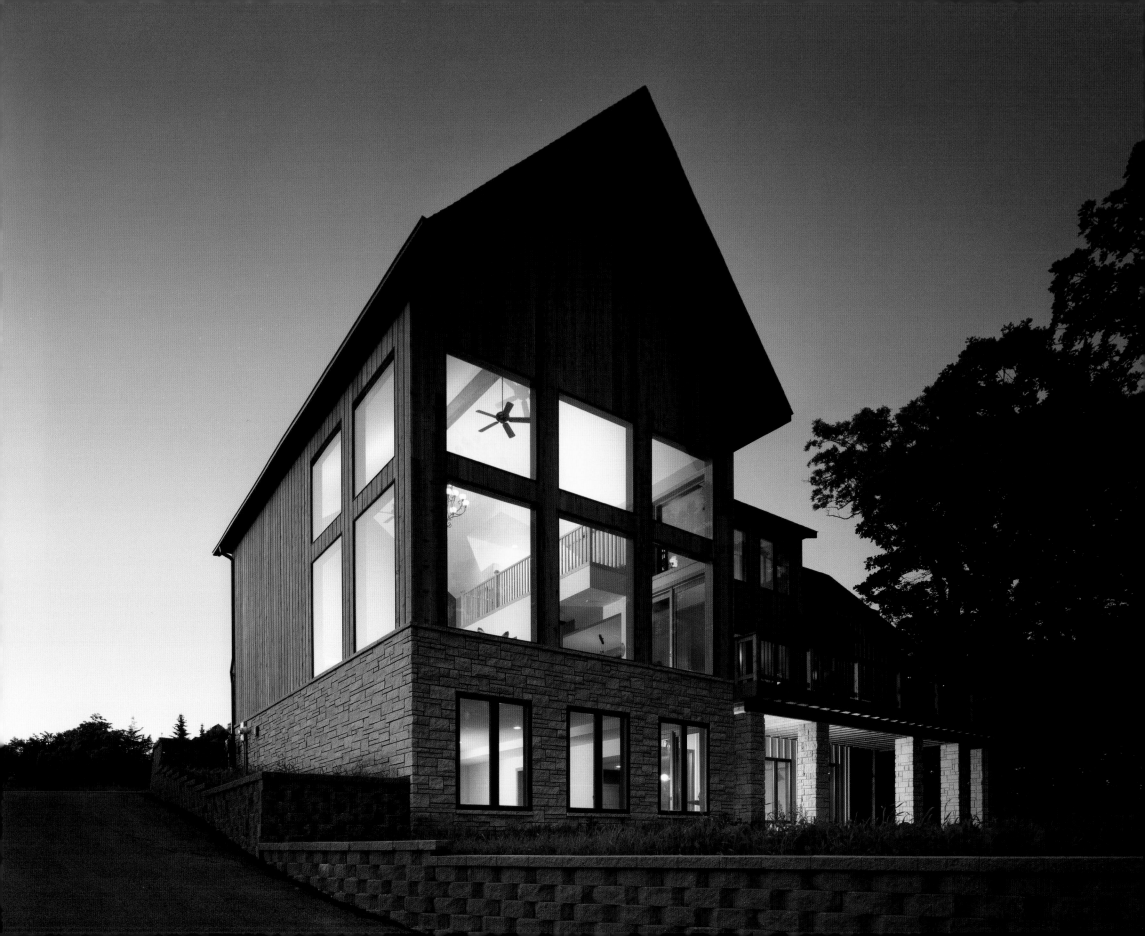

Teresa McCormack

The Urban Studio, LLC

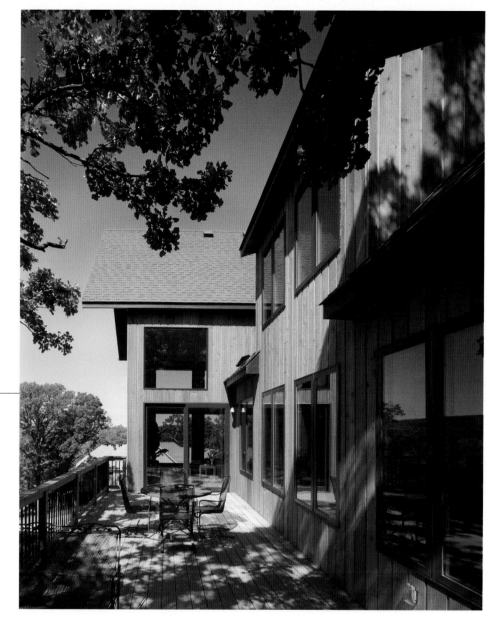

Above: While the elevator penetrates the interior vertically, the large deck provides horizontal access around the exterior of the home, stretching from the master suite to the great room.
Photograph by Peter Brown and John Woodruff

Facing Page: Located atop a hill, this fully accessible residence provides views for miles and, as shown, glows like a lantern at sunset.
Photograph by Peter Brown and John Woodruff

In 2003, Teresa McCormack, AIA, left the large architectural firm she had been working for with aspirations of engaging in smaller, more intimate projects that were previously unfeasible. With that goal in mind, Teresa started The Urban Studio in Rochester in 2003 and since then has worked closely with her small but highly talented staff to ascertain each client's vision, shape that vision into an executable design, and enact that design with an adroit hand that has come to fruition after 20-plus years in the design and construction industry.

Born on a farm in central Iowa, Teresa completed her undergraduate studies at Iowa State University, where she majored in architecture, only to fall in love with one of her peers there who hailed from Minnesota. Thus, she relocated to Minnesota, where she earned her master's degree in architecture from the University of Minnesota, and has called the Gopher State home ever since.

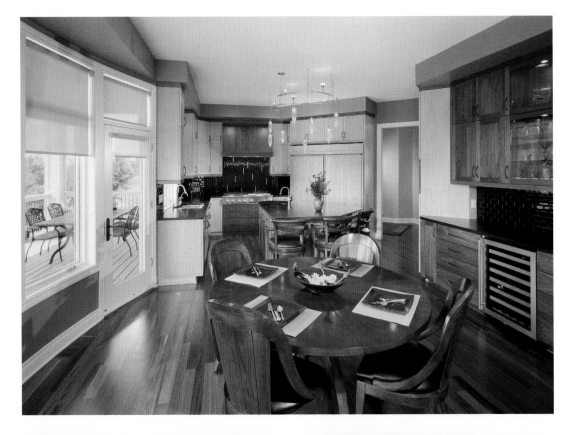

After a stint working in the Twin Cities area, Teresa has spent the last 10-plus years working in Rochester, which she enjoys very much for its warm, small-town feel that dually engenders a rich history, both rural and urban, in addition to its smaller communities and inviting surrounding areas. Teresa oversees a small, four-person team that consists of an office manager and three assistants, who handle a variety of project responsibilities in addition to bringing their own unique perspectives to the design process. Team member Nicole Pierson, a talented intern and major contributor to the success of the firm, purchased a historic downtown building soon after the firm's inception and began renovations. To date, the building houses The Urban Studio and loft housing, combining the historic character of the existing buildings with fresh new detailing.

The design process begins with an initial meeting with the client, at which point Teresa gauges the client's motives for the project, what they like and dislike about their current home and their particular lifestyle and, essentially, begins the working relationship that is imperative to crafting and implementing their unique design. Afterwards, Teresa and her assistants each consult their list of the client's ambitions and craft a quick sketch of how they would engage the project. This process yields several different approaches toward the same goal, which not only offer the client several different avenues to realizing their dream, but oftentimes result in their hand-picking various elements of the different designs.

Teresa and her team will often create paper models in addition to the sketches to ensure that the client thoroughly understands the design. Moreover, the models serve to help the client understand the build space and how they can relate to it, since most people are not exceptionally adept at reading and understanding floorplans. With design plans formulated,

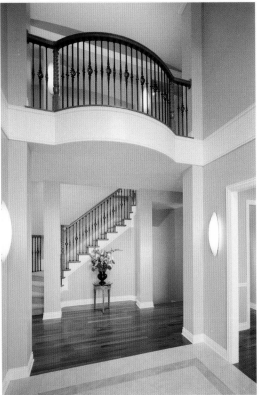

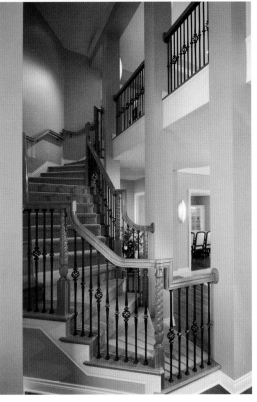

Top Left: Sleekly elegant, the kitchen enjoys views of the valley beyond and shares the curved wall of glass with the breakfast nook and great room.
Photograph by Peter Brown and John Woodruff

Bottom Left: A traditional front entry showcases a curved ceiling and second-floor balcony.
Photograph by Peter Brown and John Woodruff

Bottom Right: The sweeping stair as accessed from the front hall and viewed from the great room. The reverse turn signifies that the upper floor is private family space.
Photograph by Peter Brown and John Woodruff

Facing Page: Tucked beneath a steep, sweeping roofline, this large home blends with neighboring smaller homes, while its rear façade is an explosion of glass in three stories.
Photograph by Peter Brown and John Woodruff

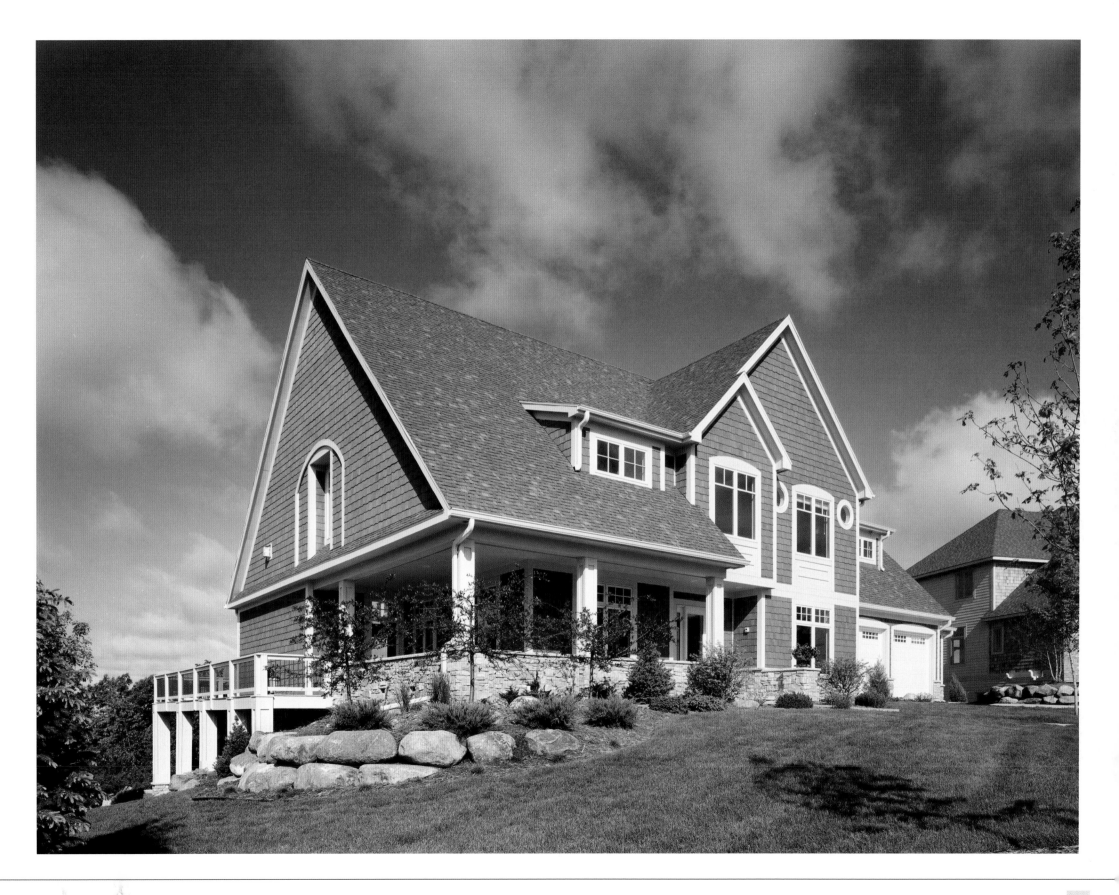

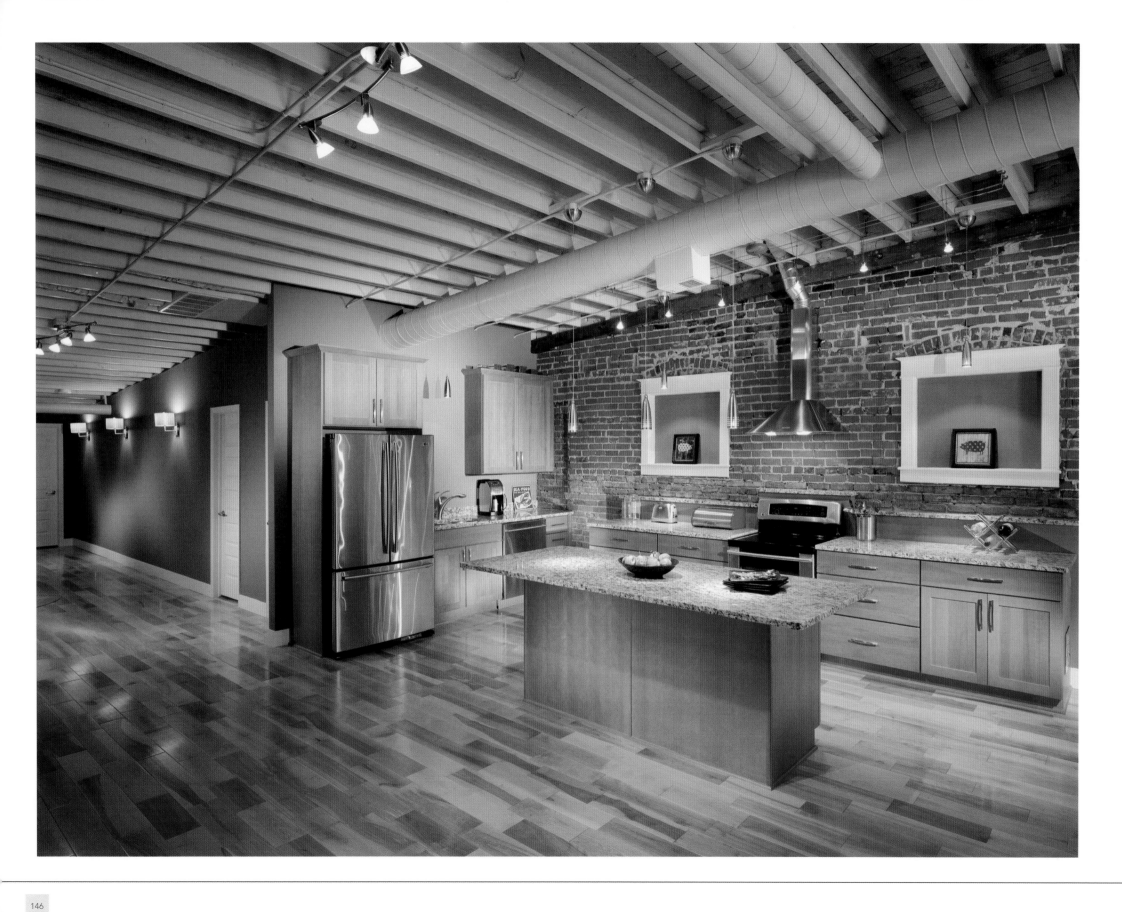

Teresa's vast commercial experience comes into play, as she employs the most economical way of effectively realizing the client's vision, in addition to often selecting material elements from a much broader palette when working with larger-scale residences or utilizing wide open spaces.

Teresa cites the process of going from the preliminary sketches to the finished photographs—especially at the floor level—as the most enjoyable aspect of her work. Indeed, one of her recent projects was uniquely challenging, albeit exceptionally rewarding, as it involved working with a paraplegic gentleman to, in principle, throw his disability by the wayside thanks to the design of his new home.

Relatively dormant since his accident, he engaged in a partnership with Teresa that eventually concluded with a very private but functional home that met his requirements. Early on in the design process, the gentleman actually had another project site selected, but realizing it would be unable to accomplish his goals, went shopping with Teresa and bought a new lot with grandiose scenery and highly sought-after privacy. When finished, his home featured a working elevator, a long deck and adjacent hallway that afforded unobstructed, panoramic views outside and other creature comforts specific to his needs.

While Teresa does not claim to have a specific style, she is often told by people that they can recognize her work, which is often characterized by abundant natural light—a necessity during long Minnesota winters—and utilizing familiar base materials in an exceptional fashion. Whether a project involves architectural services, consulting or actual construction of the project itself, collaborating with The Urban Studio is a rewarding experience for both clients and Teresa and her staff.

Top Right: Teresa worked with specialty lighting and multiple material choices to combine the homeowner's love of modern design and tactile finishes in this high-end basement remodel.
Photograph by Peter Brown and John Woodruff

Bottom Right: The kitchen is fully accessible and articulates the universal design features that enhance the experience of daily meal prep and entertaining alike.
Photograph by Peter Brown and John Woodruff

Facing Page: A loft apartment designed by Urban Studio intern/building owner Nicole Pierson. Unused for 75 years, the renovation highlights the contrasts of new finishes in a 100-year-old space.
Photograph by Peter Brown and John Woodruff

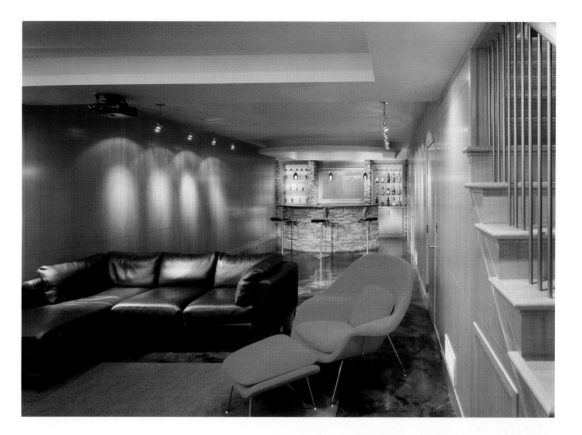

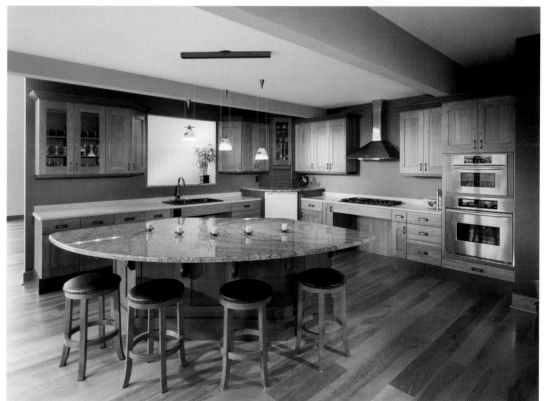

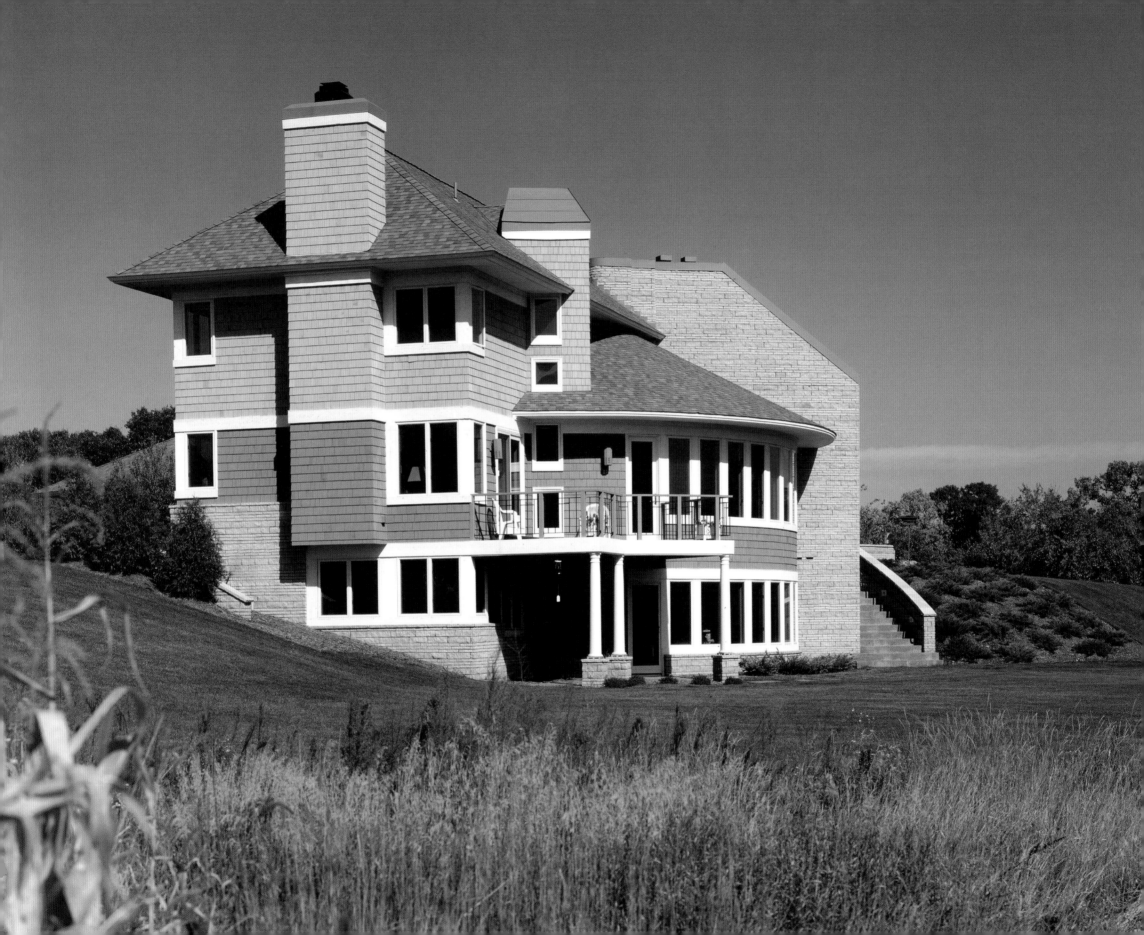

Rosemary McMonigal

McMonigal Architects, LLC

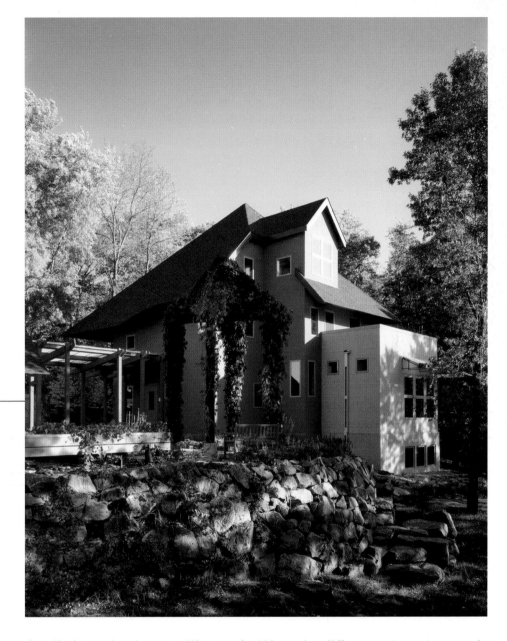

Above: The design explores the question, "What is a modern Midwestern house?" The two-acre site contains mature oaks and lowland marsh preserve. The home's footprint is 1,000 square feet.
Photograph by Karen Melvin Photography

Facing Page: The circular core of this prairie house has panoramic vistas of 22 acres, which feature a lake, a wooded ravine, WPA coniferous trees and an original farmstead preserved on site.
Photograph by James Erickson Photography

Rosemary McMonigal, AIA, CID, formed McMonigal Architects in 1984, based on the belief that architecture, interiors and landscape are interconnected disciplines—a philosophy that consistently results in beautiful and livable projects. Clients benefit from successful collaborations between these disciplines, and from Rosemary's dual background as a registered architect and certified interior designer.

Inspired by clients, no two houses designed by McMonigal Architects are the same. Rosemary emphasizes that the houses she and her team design reflect their clients', not an architect's, portrait. The firm's goal is to have clients walk into their house and say, "This is our home."

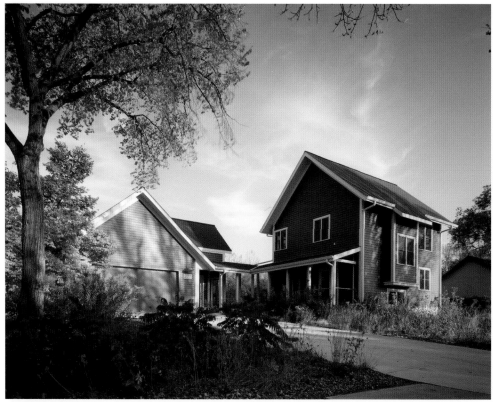

McMonigal Architects offices in a charming, rehabilitated 1800s' Minneapolis building. Speaking to their dedication to detail and excellence, the firm received an American Institute of Architects small project award for the design of this space. The staff is committed to designing personal reflections of their clients while integrating the home to its site and respecting the budget. Rosemary believes architecture is influenced by the time, place and people who live there. Clients are often drawn to McMonigal Architects not only for its design work but also because they know the firm is devoted to healthy, energy-efficient and sustainable homes and has been a leader in Green design.

A Twin Cities-area native, Rosemary was educated at the University of Minnesota where she gained early exposure to the importance of the environment in relation to architecture, which continues to impact her projects today. Her firm's work includes new construction, renovation and addition commissions.

Top Left: This farmhouse met goals of chemical sensitivity, accessibility/future adaptability, accommodating the clients' 17-inch height difference and rooms with windows on multiple sides for daylight and ventilation.
Photograph by Andrea Rugg Photographer

Bottom Left: Perched high above a lake on natural forms of rugged hills and bluffs, rock outcroppings, white pines and birch trees, the house is a private retreat.
Photograph by Karen Melvin Photography

Facing Page Top & Bottom: The clients were ready to simplify their lives and trade their large house for a small cottage on the lake. The proximity to the lake was facilitated by preserving the footprint of the existing house.
Photographs by Phillip Mueller Photography

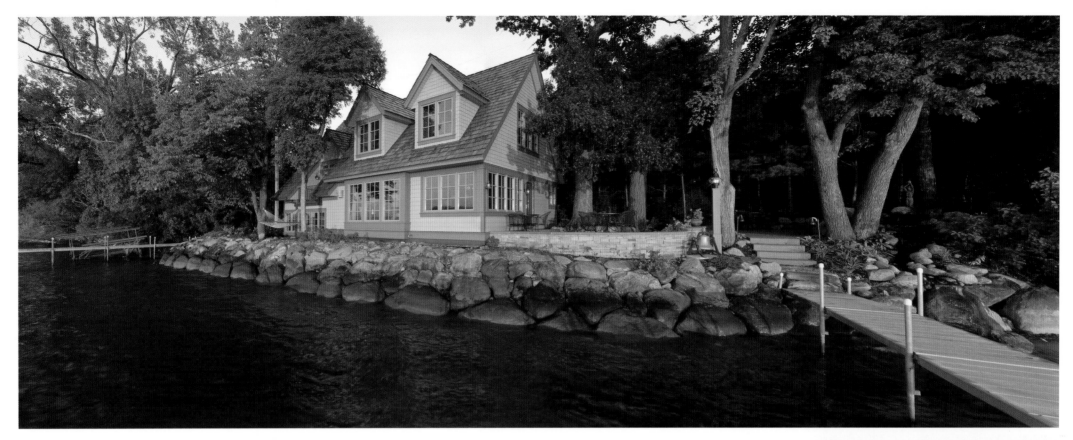

Rosemary takes her vocation to heart. Eschewing fashion trends and styles that change, she feels that the most exciting facet of her work is creating architecture that reflects the firm's clients and endures. Knowing and ensuring that the homes she and her team design meet this excellence and are going to be used and enjoyed for years to come makes the process rewarding.

It is the "science" of the homes in which we live that fascinates Rosemary. She compares homes to "living laboratories for people." Some of the systems the firm uses are unique: Homeowners experience and offer feedback about new products and technologies, each home is tested prior to completion and Rosemary and her team build on this knowledge. McMonigal clients know that their input is vital in helping the firm learn what is working and what needs improvement—it is how good design systems evolve.

Once the clients have moved into their homes, they are certainly not forgotten. Rosemary follows up three months, six months and as many as five years later to make certain that all systems are in order and to discern whether anything needs to be modified to support the home's current condition. More than a warranty, her continued support represents the professionalism that has come to define the firm.

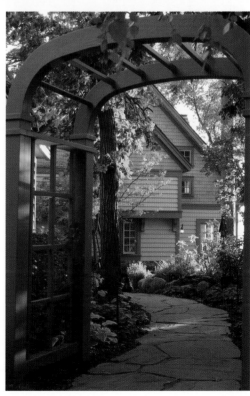

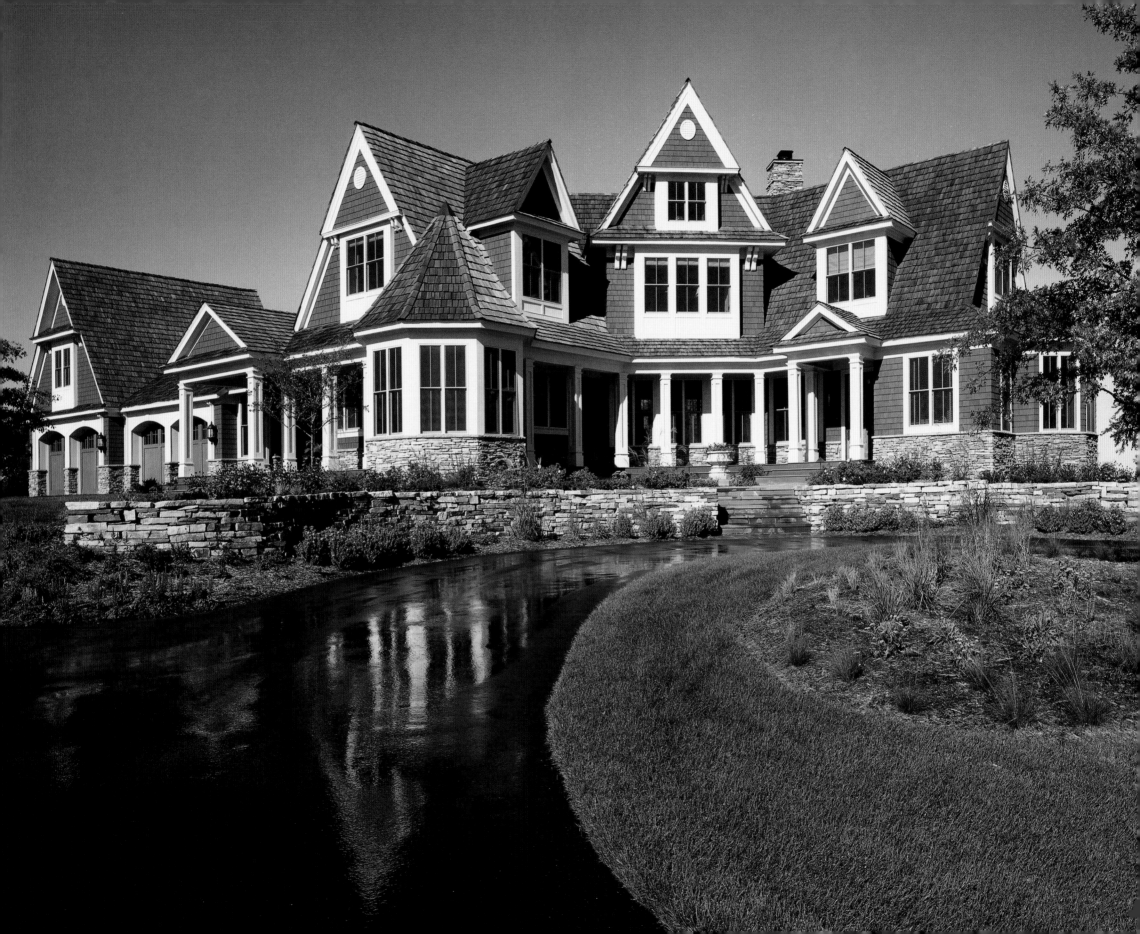

James McNeal

De Novo Architects, Inc.

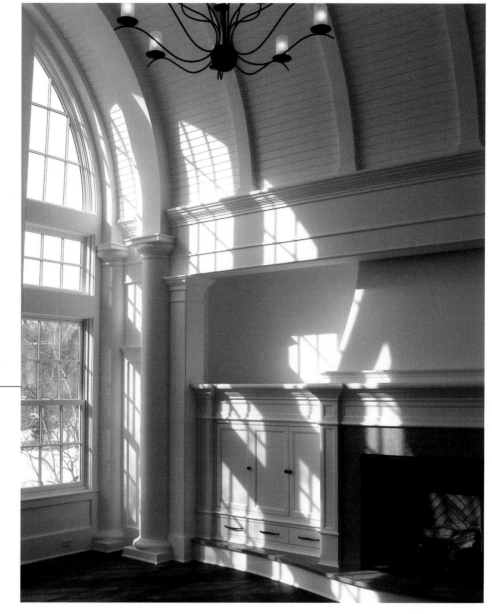

Above: Strong classical architectural detail gives great character to this two-story volume of space, with a barrel-vaulted ceiling and arched window.
Photograph by De Novo Architects

Facing Page: This two-and-a-half story Shingle-style house has four outside rooms that offer magnificent views on all sides.
Photograph by Wheelock Photography

Jim McNeal, AIA, is known for his artistry. His renderings of projects capture the essence of his designs and enable clients to visualize any space. Indeed, his preferred means of expression has long been drawing, and he often articulates his thoughts graphically rather than linguistically. As an adolescent, he was a very accomplished artist, often being called upon to create artwork and murals for his school. Thus, it was only natural that he pursue a career as an architect, one that allows him to express his ideas not only on paper but also in physical space. A graduate of the University of Minnesota's architecture department, Jim founded his architecture firm in 1993 and since has built his eight-person company with a primary objective: "to be highly creative."

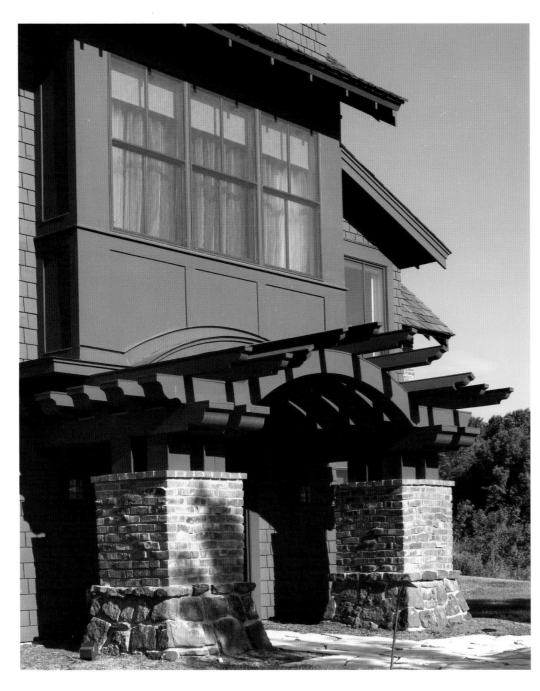

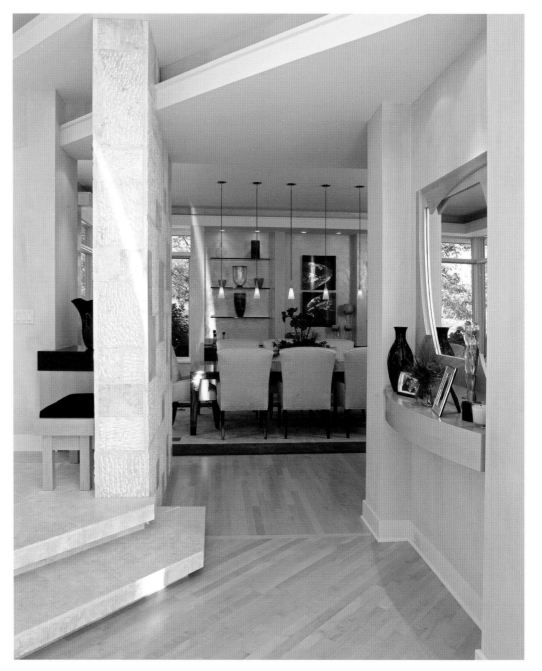

Jim recently changed the name of his firm to De Novo Architects, reflecting the type of work he and his team produce. A Latin phrase meaning "from the beginning" or "anew," *de novo* describes the inspiration for the designs Jim's firm creates. Weaving together what is learned from the past along with new ideas, new materials, the "new" of today, results in the creation of timeless designs. Consequently, Jim brings to each project his strong grasp of previous historical movements to which he can refer or react when planning new structures or remodeling existing ones. De Novo is most well known for its flexibility in designs, and Jim and his staff embrace all architecture genres, enjoying the challenge of transforming any space into a desired look or style.

Above Left: Massive forms and detailing with a variety of materials create a sense of permanence and style in both the interior and exterior of this home.
Photograph by Saari & Forrai Photography

Above Right: Modern, open, welcoming spaces are created with crisp vertical and horizontal forms.
Photograph by Jim Kruger, Landmark Photography

Facing Page: This farmhouse form in rural Minnesota has been reassembled into a luxury home while maintaining a homestead feel.
Photograph by Jon Huelskamp, Landmark Photography

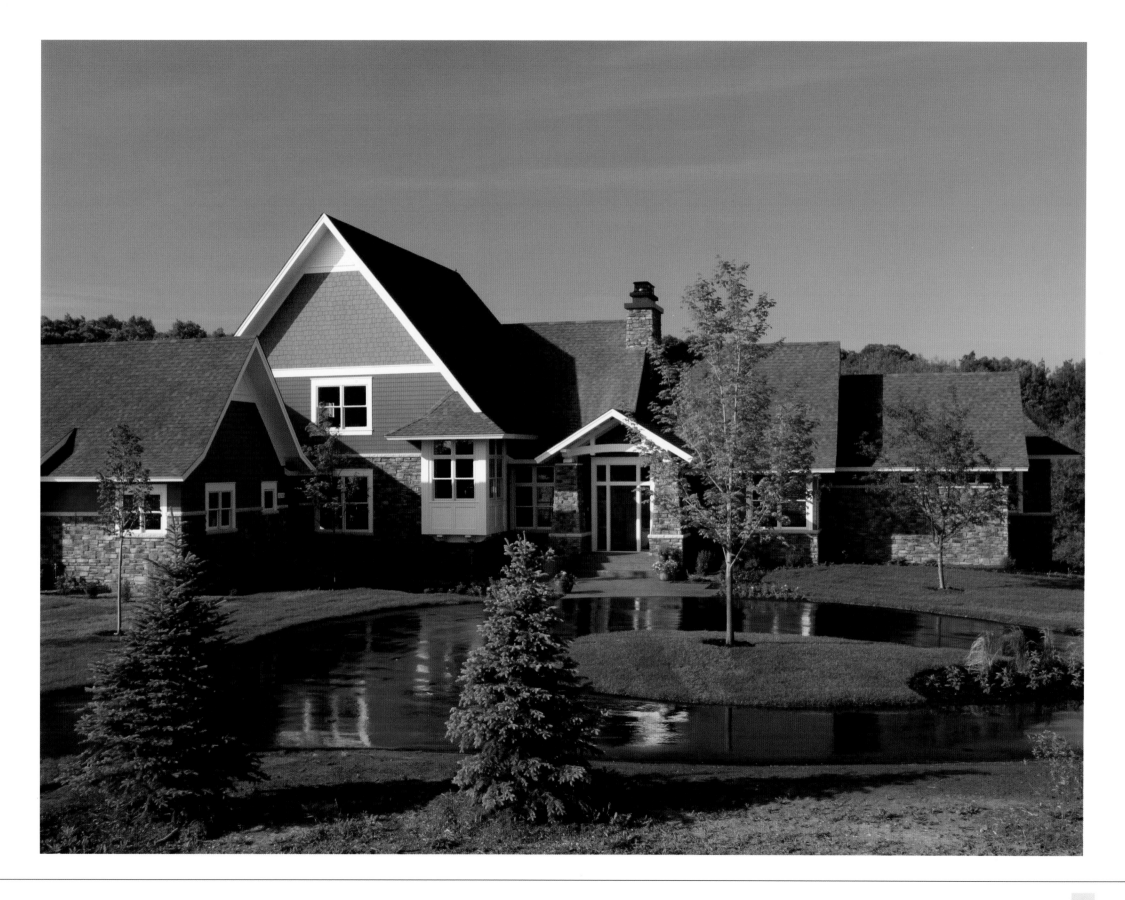

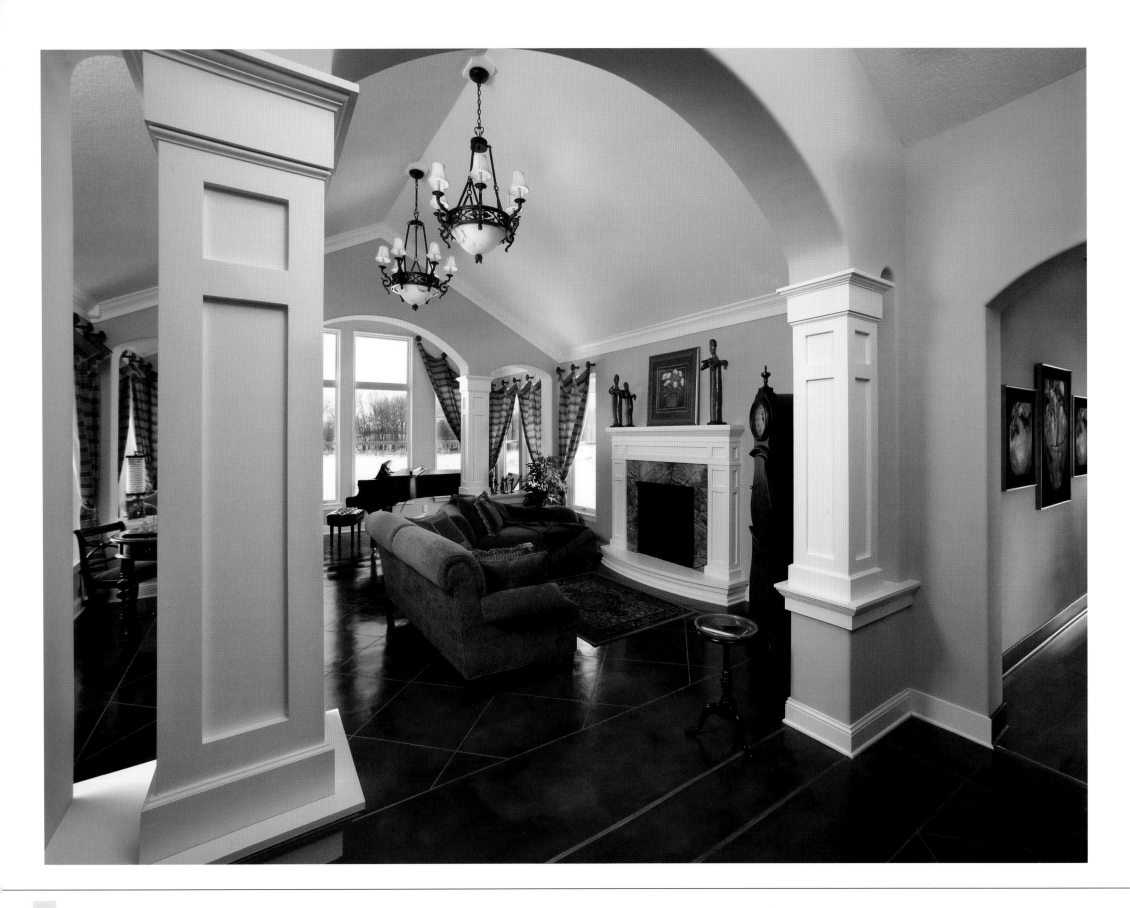

To stimulate ideas for a project, Jim looks to the demands of the site and the desires of the client rather than striving toward a single design concept. He spends a great deal of time at each site to fully familiarize himself with the lay of the land, the placement and quantity of trees and other relevant environmental concerns and then works to meld the site's requirements with the client's wishes. Each project is thus unique, indicative of Jim's—and the firm's—creative flexibility.

Jim's work does not stop with the plans for the building—indeed, his work extends to the interior, as well, and he frequently designs light fixtures, furniture and even ceiling and wall textures and floor patterns. For one home in particular, he hired a sculptor to create ceramic bas-relief detailing on the master bedroom walls, adding dimension and lending a tactile feel to the room. Details such as these set Jim apart as an artistic visionary, as does his ability to successfully blend seemingly disparate styles, which he did when he designed an Asian-Deco home for one client. With harmony as the overall objective, different styles are beautifully combined, resulting in surprising and powerful architectural designs.

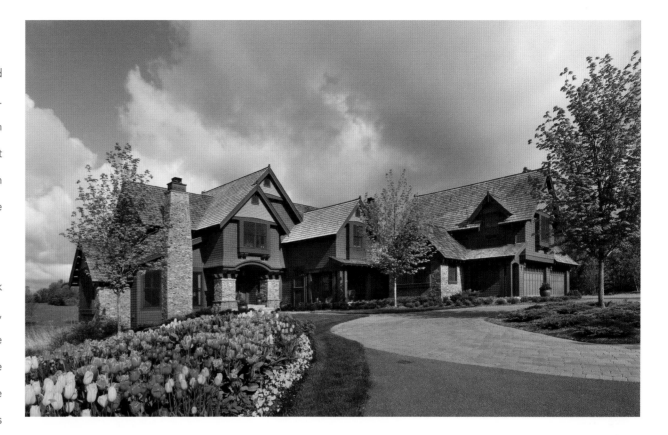

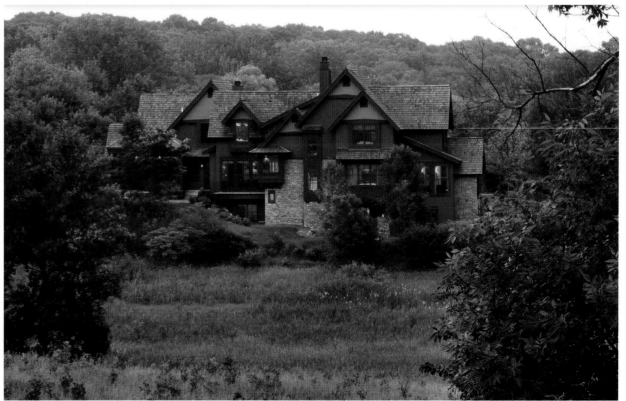

Top Right: The front of this Shingle-style home, with its use of form, materials and landscape design, creates a very attractive and inviting presence.
Photograph by Saari & Forrai Photography

Bottom Right: This rear elevation of the same house is clearly different. The gables work together to create intrigue and mystique in this rural wetland area.
Photograph by Saari & Forrai Photography

Facing Page: Traditional details are represented in the fireplace, columns and arches, making this space inviting and warm, while the colors bring in fun and a cheerful personality.
Photograph by Stuart Lorenz

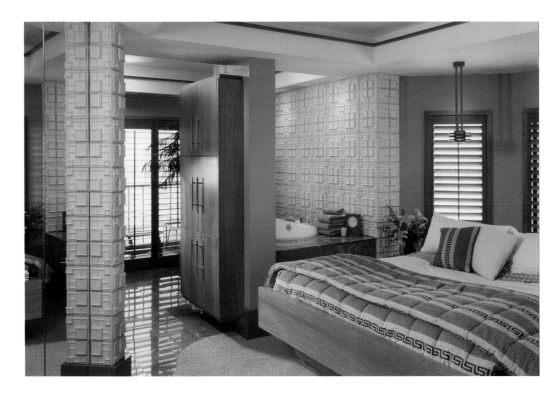

Paramount to the philosophy of De Novo Architects is the idea that a space should not merely be physically sound and visually pleasing but should also have "soul." This soul comes from Jim's insistence on both the successful union of a project's specifications with his aesthetic sensibility and the proper balance of the various design elements. A long-time student of Eastern philosophy and the martial arts, Jim understands and works with the concept that actions and subsequent reactions result in a flow of movement that is meaningful and purposeful. His process, therefore, is one of continual adjustment and refinement until harmony and equilibrium are established in the design. There is a synergy of elements that brings the space alive, so that not only do you see it, you feel it. It is what Jim refers to as "the gestalt experience," in which the completed design is greater than the sum of its individual parts.

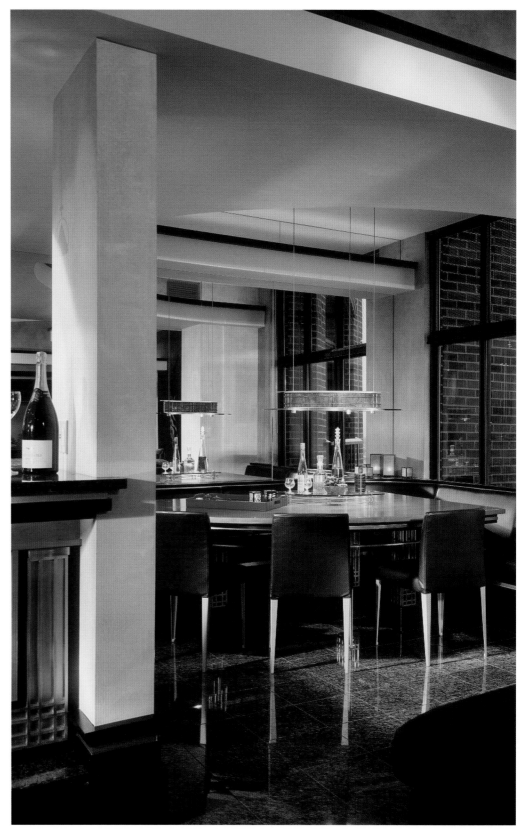

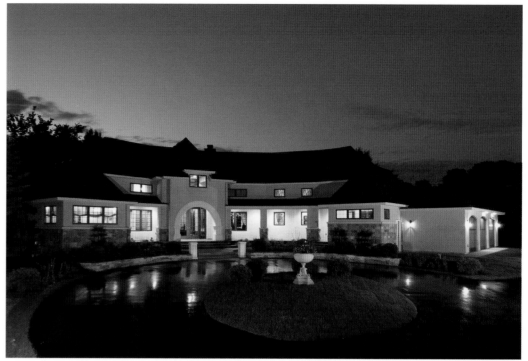

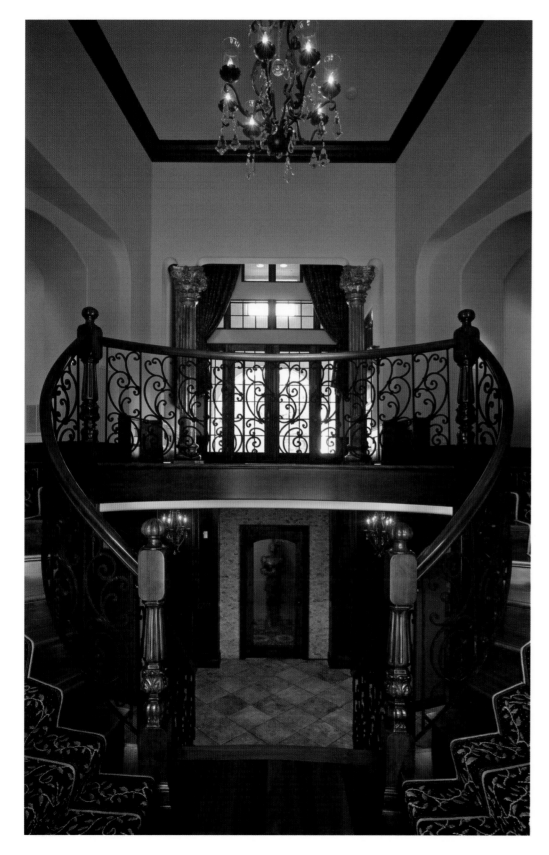

Above: The exterior view of the home shows a low-arched entry, which adds to the splendor as it opens to the grand entrance.
Photograph by Jon Huelskamp, Landmark Photography

Left: This grand entrance of the home shown above has been enhanced by the sculpted volume of space and details.
Photograph by Wheelock Photography

Facing Page Left: The tile work, in form and texture, was custom designed to stimulate the activities of this room, both visually and by touch.
Photograph by Karen Melvin Photography

Facing Page Right: The light fixtures, dining table with banquette, and steel and wood detailing were all custom designed to create a modern Asian-Deco space.
Photograph by Karen Melvin Photography

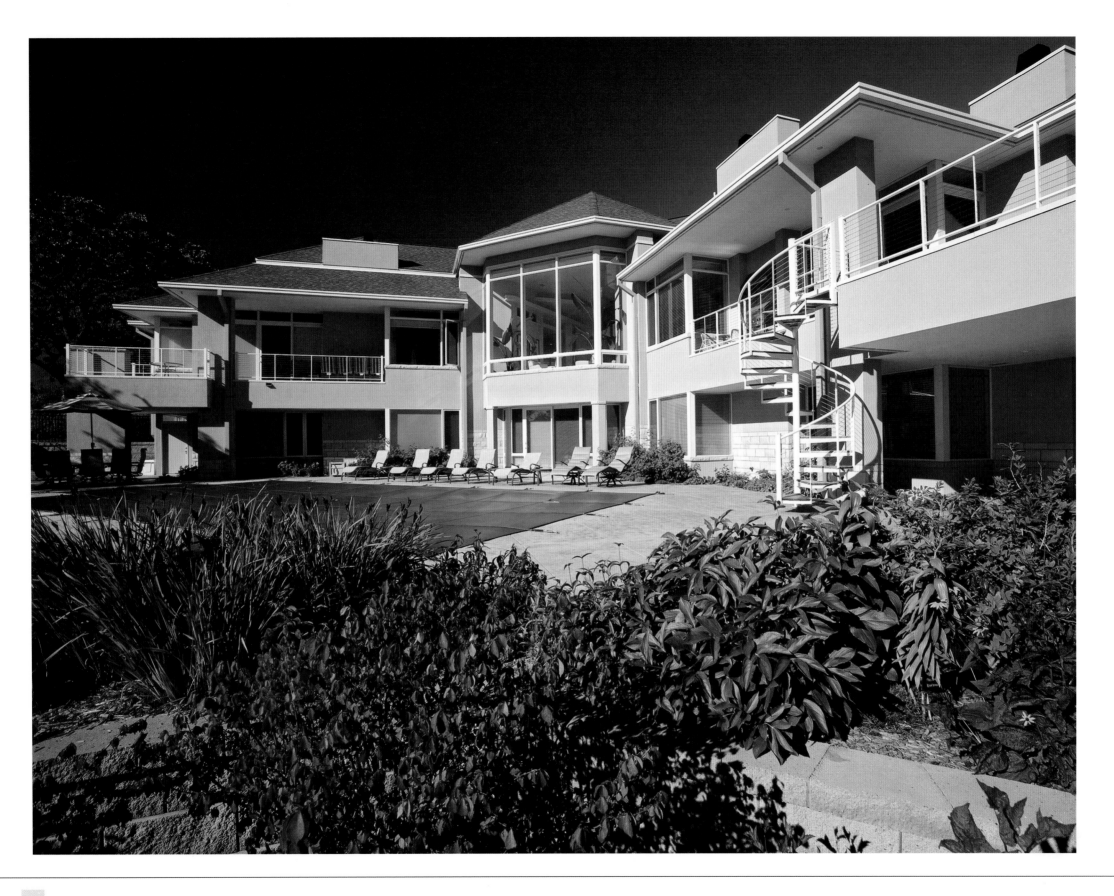

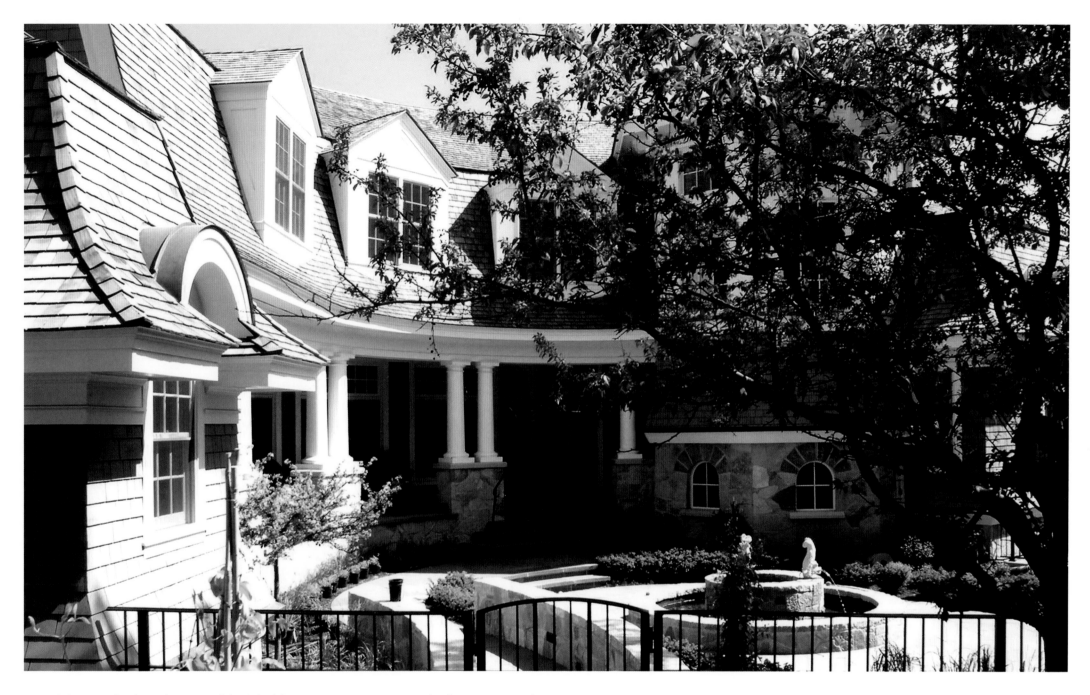

Jim's ability to make three dimensional that which begins as imaginative vision has been recognized by such publications as *Mpls. St. Paul Magazine* and *Midwest Home*. However, he fully admits that his staff is the foundation of his firm's success. For everyone at De Novo, the greatest joy comes from providing their clients with beautiful, aesthetic homes that support and reflect their lifestyles and desires. More than mere buildings, Jim's projects reveal his passion for architecture, and his designs become works of art in a living environment.

Above: The curvilinear design of this building, which wraps around an inner courtyard, was created to achieve yard space on a lot considered unbuildable.
Photograph by De Novo Architects

Facing Page: This modern-style home was designed and positioned on the site to create explosive views from multiple points within the house.
Photograph by Jim Kruger, Landmark Photography

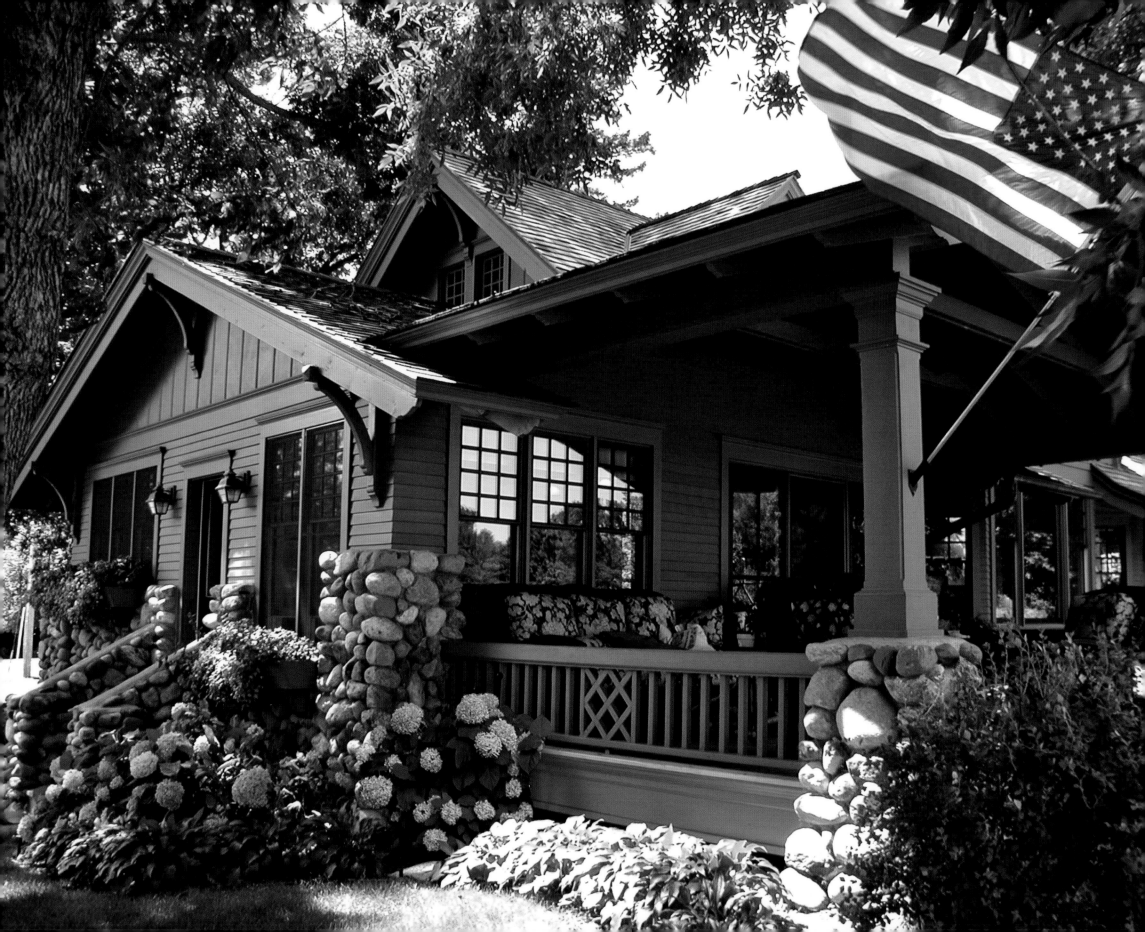

Jon & Mary Monson

The Landschute Group Inc.

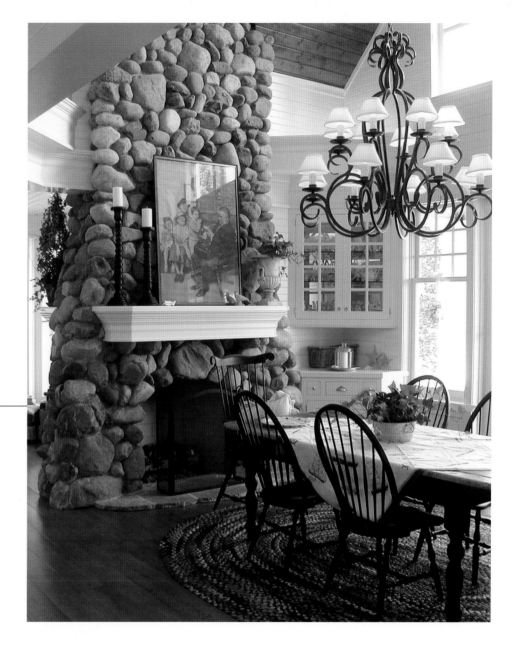

Above: Even with its soaring vaults, this dining room has a sense of warmth, thanks to indigenous stone and glowing wood ceilings and floors.
Photograph by Joe Paetzel

Facing Page: This lakeside porch has become the favorite room in the house for the family of this classic Lake Minnetonka cottage.
Photograph by Joe Paetzel

To fully understand how Jon Monson works, one must look to the origin of his firm's name. While earning his degree from the University of Minnesota's School of Architecture, Jon had the opportunity to study in a small medieval town in southern Germany. There he developed an appreciation for timeless architecture, one rich in texture and detail. He also developed a respect for historical context and an appreciation for the integration of architect and builder, according to the old master builder practice. These principles just seemed to make good common sense to Jon, so he kept them in the back of his mind as he returned home.

While Jon's formal architectural education provided him a solid foundation for creative problem solving, he was not sure how he was going to apply such an education. After spending time on the architectural

as well as the construction side of building, Jon concluded that one could not be a successful architect without being a competent builder. In 1980, he founded a business on those principles he first learned abroad. Today, that business, which gives credit to that little town in Germany, is known simply as Landschute.

Along with his wife Mary, a talented designer in her own right, Jon oversees a team of architectural and construction professionals dedicated to creating works of art that delight on many levels. To maintain the highest level of personal attention, Jon selectively limits the number of projects the firm accepts.

While traditional in form and detail, Landschute's projects are designed to support a contemporary lifestyle. Throwing out the static floorplans of old in which spaces were compartmentalized, Jon designs open interiors with a variety of volumes to foster family unity and create a dynamic ambience. Indeed, evoking emotion is key to Landschute's philosophy, and the team strives to infuse each project with soul—a word the firm uses to describe that intangible aspect which prompts clients to say, "This house just makes me feel good."

Top Left: Through the use of classic forms and details, the two new buildings at the Wyer Hill condominium project complement the historically designated, newly renovated Wyer-Pearce house.
Photograph by Jon Monson

Bottom Left: This "little house" is a new cottage finished with recycled wood from an old structure nearby—a technique Landschute has employed for more than 25 years.
Photograph by Joe Paetzel

Facing Page: The renovation of this tired old lake cottage resulted in a richly detailed empty-nester home, which functions beautifully for both formal and informal uses.
Photograph by Jon Monson

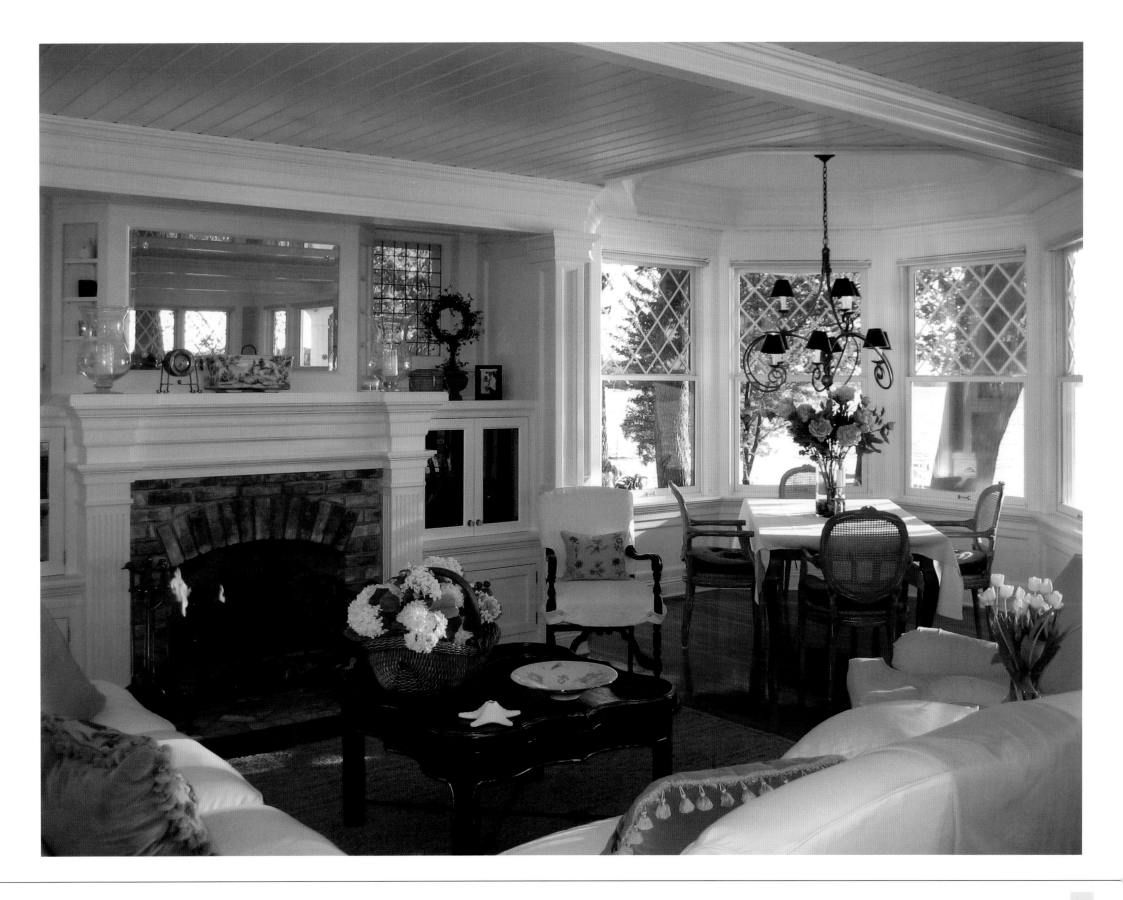

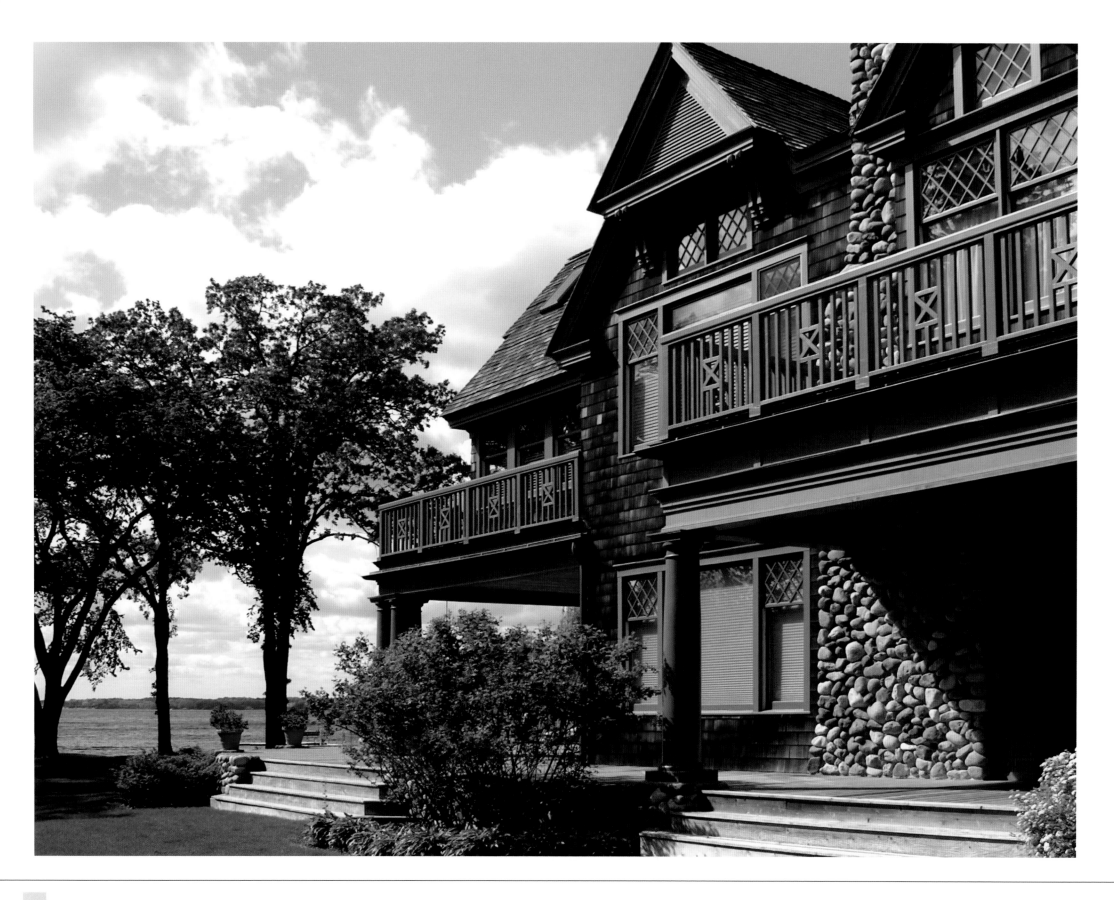

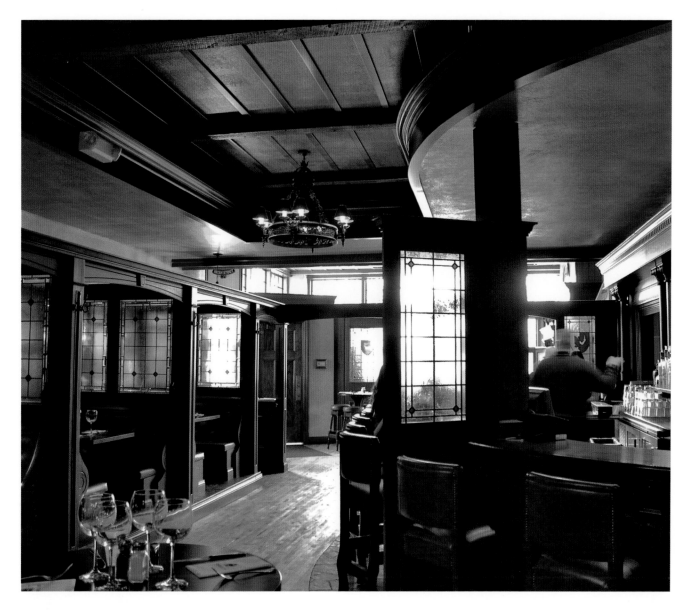

Landschute develops and builds both custom and spec projects for residential and commercial use in both new and renovated structures and developments. That means they are well diversified for a small business. In spite of that, their design/build approach is the same no matter what the project: pay attention to what the end users want, strive to give them more than they expect, pay attention to the details and do what you love. Jon is not worried about being considered profound; his goal is to make his clients glad they hired him.

A home completed in collaboration with Jim Sattler, Inc., a homebuilder from Cedar Rapids, Iowa, garnered the team a "Best in American Living 2002" award from the National Association of Homebuilders. The award is ironic, as Jon does not seek this kind of recognition. What drives Jon is a genuine love of what he does. As happy sketching a preliminary design as cleaning a construction site, Jon demonstrates by his actions that every work day is like being on vacation when you love what you do. He is a living testament that joy creates itself.

Above Left: A home away from home, this Irish pub is filled with authentic Irish millwork and other character that makes guests feel as though they are on the Emerald Isle.
Photograph by Joe Paetzel

Above Right: Small details make a big difference. The character of this dormer illustrates why new Landschute homes are often confused with original vintage structures.
Photograph by Joe Paetzel

Facing Page: The family of this lakeside home relishes their vast front porch for two reasons—it provides outdoor living at its finest, and it provides a much-needed sun screen for those hot Minnesota summer days.
Photograph by Joe Paetzel

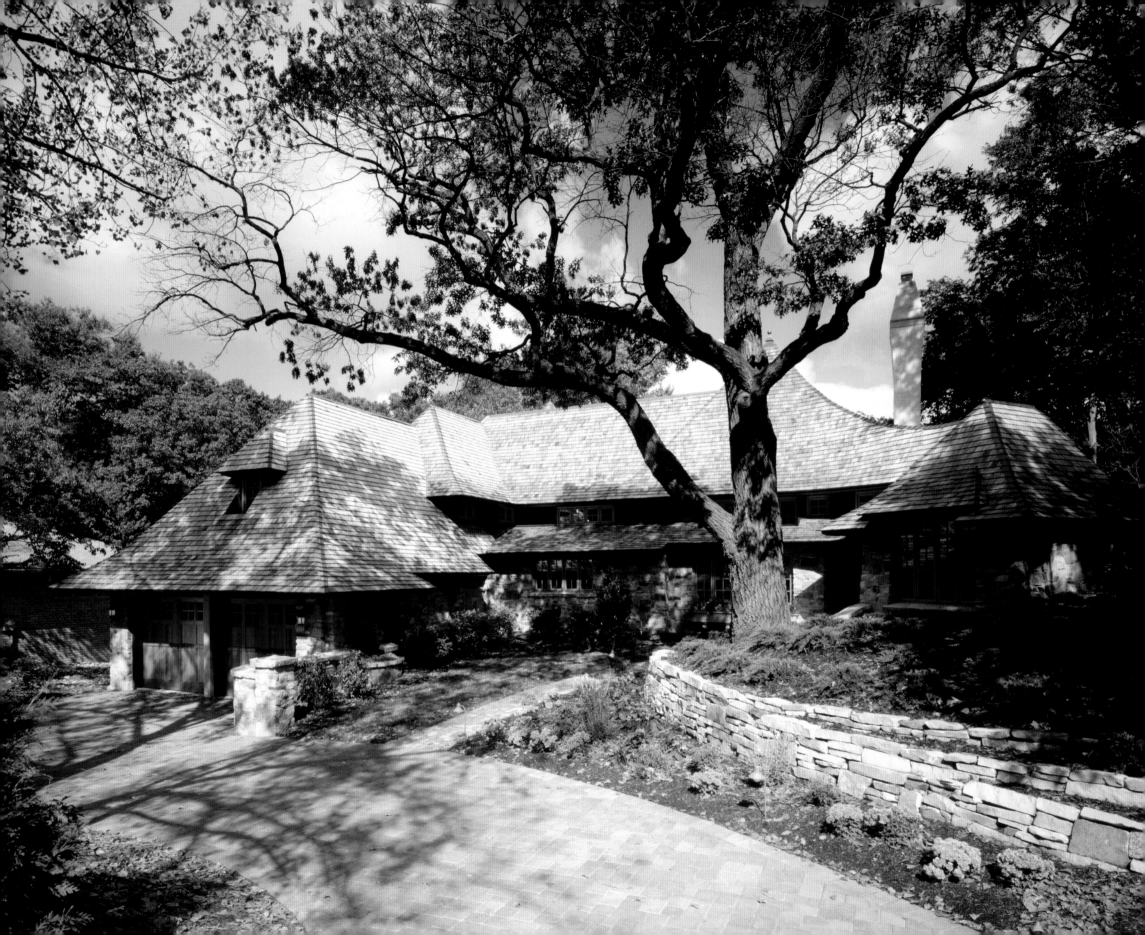

Dan Nepp
Tom Ellison

TEA₂ Architects

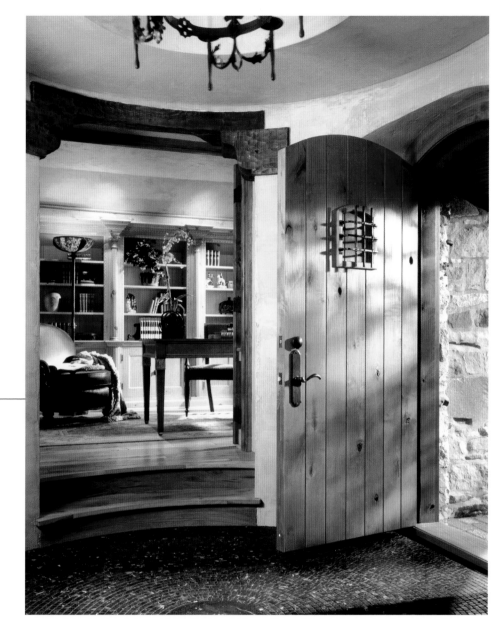

Above: A view from the living room into the entry and study beyond. The pigmented, textured plaster and hand-hewn timbers create a striking front entry and appear throughout the house.
Photograph by Karen Melvin

Facing Page: This English cottage in Edina is nestled into its site, with its entry tucked in around the mature tree. The deep, sweeping eaves provide a sense of shelter, while the clerestory windows allow light to permeate the first floor.
Photograph by Karen Melvin

Tom Ellison, AIA, and Dan Nepp, AIA, are firm believers in the idea that in order to be successful, architecture must effectively integrate function and art. In all of the projects they undertake with their residential architecture firm, TEA₂ Architects, they strive to strike a balance between logic and beauty in design, ensuring that their designs work from a technological and livable standpoint and also embody a pleasing scale, rhythm and proportion. The firm's nearly three decades of dedication to blending practicality and aesthetics ensures that each home designed not only succeeds but also thrives for years to come.

The firm's founding principal and namesake, Tom Ellison, began his career working as an architect for a Navajo tribe in northern Arizona and southern Utah. There, he developed an acute sensitivity to the natural environment that has since become an important aspect of the firm's design philosophy. Established in

1979 as Tom Ellison Architects, or TEA, the firm became TEA$_2$ when Dan Nepp, who joined Tom in 1986, became partner 10 years later. It has since grown to a team of 23, including one associate architect, multiple project managers, several architectural interns and drafting technicians and an office manager. Every member of this talented group works passionately to ensure that each home created reflects the thoughtful, intelligent design that has come to be the hallmark of TEA$_2$'s work.

The firm's strong focus on its clients' desires allows the architects to express their new construction and remodeling projects through many architectural vocabularies. Indeed, the client becomes their inspiration for each home they create—they listen very carefully to their clients, translating their ideas into tangible, three-dimensional designs completely tailored to the

way the homeowners live. Unlike many other architectural firms, TEA$_2$ works holistically to incorporate livability and aesthetics. For example, the team incorporates furniture layout from the very outset of a project, taking inventory of the clients' collections and considering how each piece functions to design rooms that will best support residents as they sit, dine, take in views or watch television. Clients thus feel very comfortable in homes that reflect rigorous attention to the way in which they live therein; put quite simply, their homes work.

Spatial sensibility is another cornerstone of TEA$_2$'s architecture. Rather than designing interior spaces that are similar in size and scale, the architects and their design staff diversify the rooms, creating a balance of large and small spaces and wrapping each around the living environment it encompasses. They also work to

actively relate the interior to the exterior of the home, extending rooms outside through thoughtfully placed window groups. A dining room might tuck into a large window bay that projects out of the home, with windows wrapping a corner to capture views but maintain privacy. Windows, room proportion and placement thus promote connectivity between indoors and outdoors, allowing residents to feel connected to the world outside their homes.

Above: Broad windows open to lake views while various small or screened windows maintain a sense of openness, letting in daylight while preserving privacy from the neighboring houses.
Photograph by TEA$_2$ Architects

Facing Page: An asymmetrical front façade on this Lake Calhoun home is formed by wrapping windows around the corner of the living spaces, allowing a sweeping vista of the lake and parkway. The raised house and terrace create privacy, and the entry tower provides access to the roof terrace.
Photograph by TEA$_2$ Architects

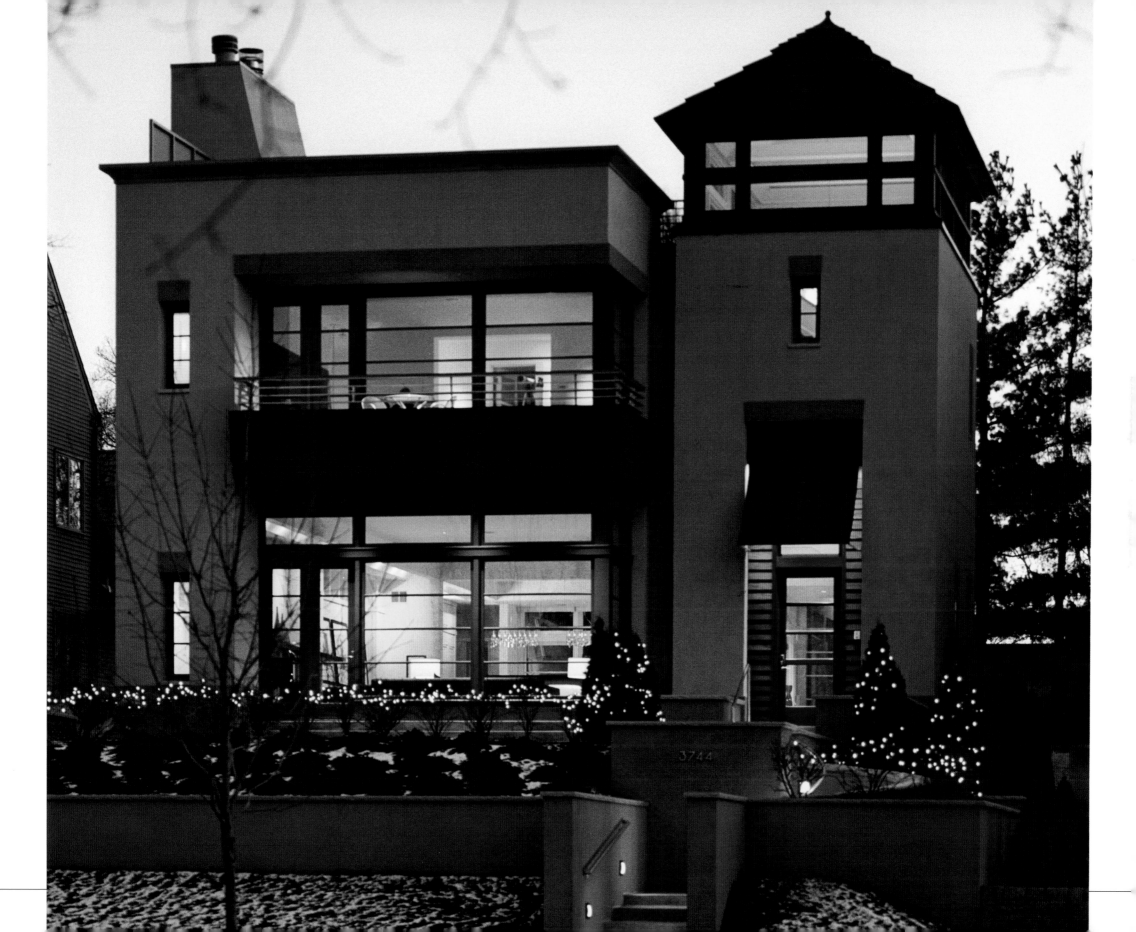

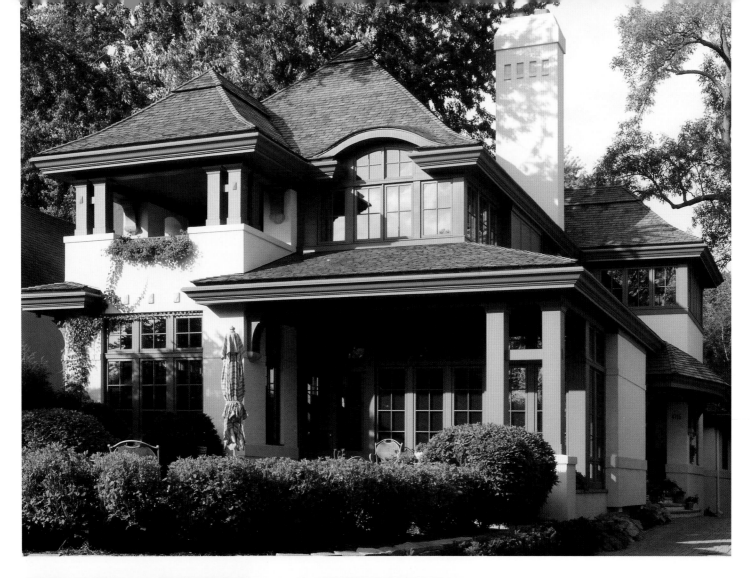

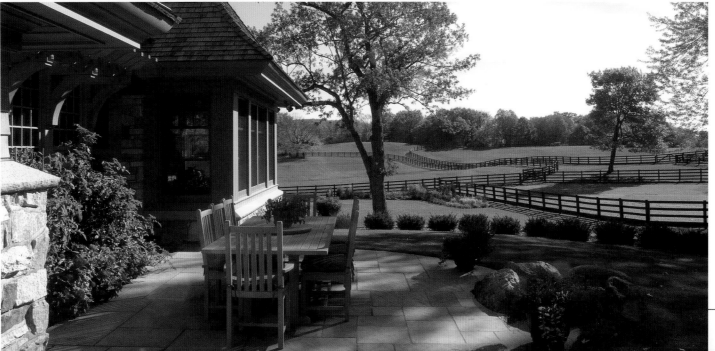

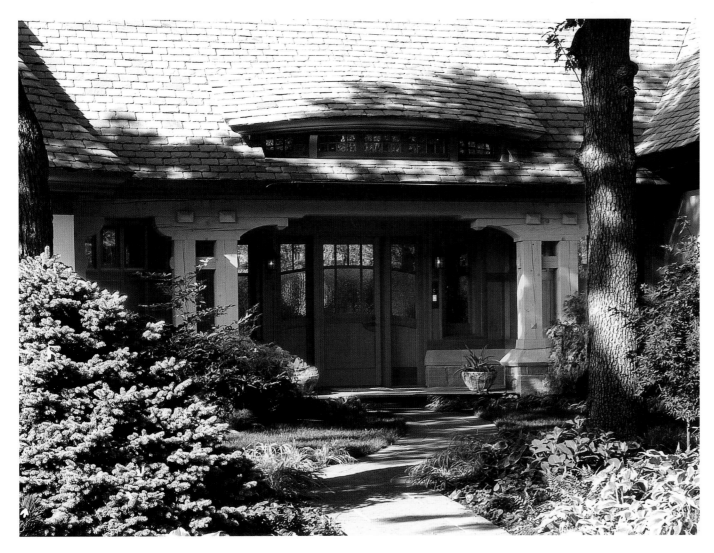

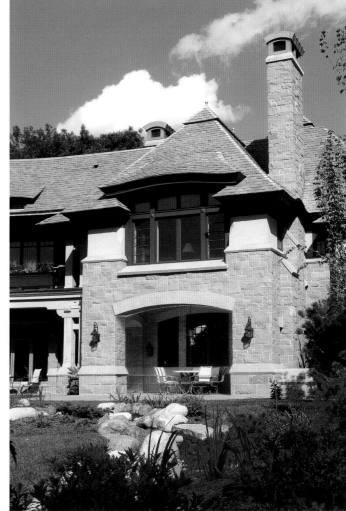

The team also strives to cultivate continuity within the house by designing interior architectural elements that support the overall design vision. They create a material sensibility that resonates from room to room and as often as possible design fireplaces, cabinetry, stair railings and light fixtures that allude to other components and foster a sense of unity within the home. The firm's ability to provide custom features and pieces for its projects allows TEA$_2$ to fully realize the clients' dreams for their homes.

TEA$_2$'s impressive residential work has earned many design awards and accolades, including AIA Minnesota's "Divine Detail Award" for a custom gutter, an award from the St. Paul Historic Preservation Commission for remodeling a historic home and multiple "Home of the Month" awards from the *Star Tribune*. Featured in more than 60 regional and national publications, the firm's homes have also appeared on 20 different episodes of "Hometime," and TEA$_2$ was profiled on HGTV. While certainly proud of these achievements, Tom and Dan insist that their clients are the true judges of their work. Clients' consistently and overwhelmingly positive responses to their homes are the greatest rewards of all.

Above Left: Infused with Old World-style details of finesse and substance, this warm, humanly scaled Edina home has a timeless grace, through the use of light, space and materials.
Photograph by TEA$_2$ Architects

Above Right: The rear exterior of the home rises to a stately two stories of slate shingles, stone and timber. Well-proportioned window groups and gracious terraces look over broad views of the grounds and pond.
Photograph by TEA$_2$ Architects

Facing Page Top: This Lake Harriet home steps back in form to allow more rooms to overlook the lake and scales the home to fit seamlessly with its neighbors.
Photograph by TEA$_2$ Architects

Facing Page Bottom: This European farmhouse-inspired home in Medina was carefully placed on its site to create a series of exterior living spaces that provide a feeling of visual connection to the land.
Photograph by TEA$_2$ Architects

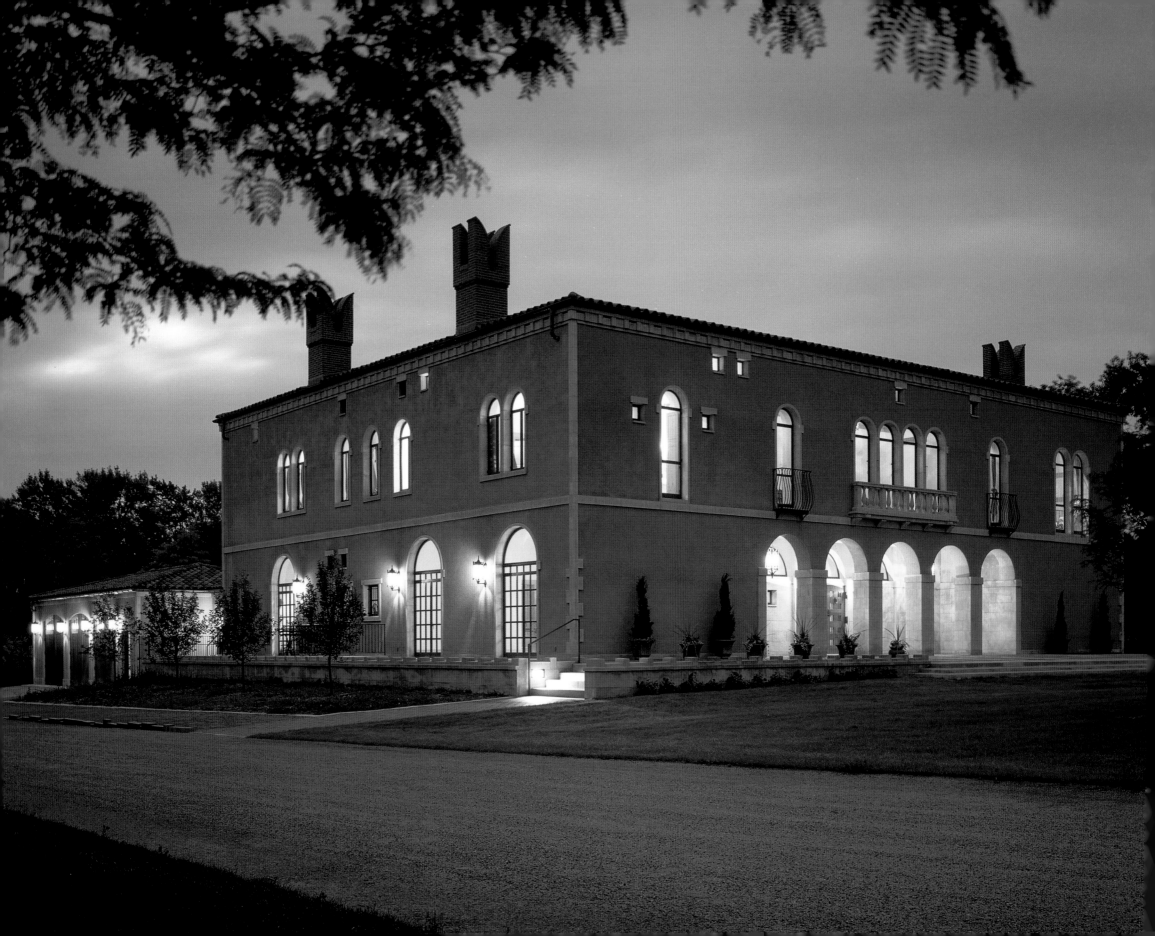

Mark Queripel
Charlotte Grojean
Jeffrey Van Sambeek
Brian Nelson
Todd Remington

Terra Verde Architects

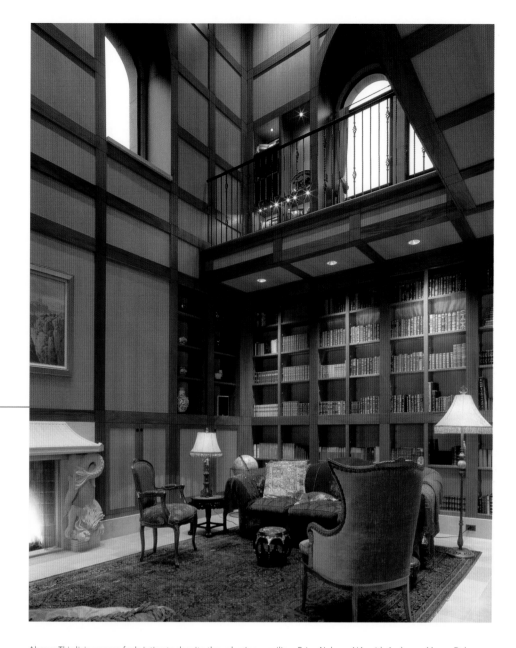

Above: This living space feels intimate despite the voluminous ceiling. Brian Nelson, AIA, with Anderson Mason Dale Architects designed the home.
Photograph by Frank Ooms

Facing Page: Symmetry and clean architectural lines inform this residence, which was designed by Brian Nelson, AIA, with Anderson Mason Dale Architects.
Photograph by Frank Ooms

Terra Verde Architects was established in Boulder, Colorado, in 1996 on a solid foundation of sustainable principles. The firm has more than lived up to its name's translation, "Green Earth." Terra Verde's principals and staff share a simple mission—to provide better architecture for a fragile environment.

The collective body of Terra Verde's work demonstrates ample experience in new custom home design, renovation and remodeling. Blending knowledge of environmental design and technology with its client's desires and needs, Terra Verde Architects consistently delivers highly advanced designs that provide beauty and comfort. These designs create homes that complement and support the environment they grace.

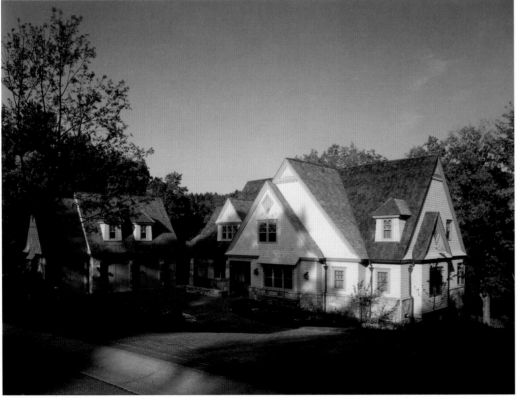

To achieve the level of sustainability it insists upon, the Terra Verde team works to design homes that have a positive impact, both visually and physically, on their sites. Whether designing a new home or remodeling an older home, Terra Verde thoughtfully integrates the architecture into the existing surroundings. Careful analysis of the site's amenities and constraints allows the architect to best position each home to capitalize on available views while providing for ample sunlight and passive solar energy. Recycled, recyclable and, as often as possible, indigenous materials are used to compose the homes. The firm encourages contractors to conserve and recycle materials during construction and remodeling, thus minimizing waste while maximizing resources.

There is no "signature style" of a home designed by Terra Verde Architects. The firm's design principals have worked in diverse styles such as log and timber frame, regional vernacular and urban contemporary. Whether designing a rustic lakefront hideaway, Craftsman cottage or historic renovation, Terra Verde designers infuse the architecture with a sense of place to arrive at a design that is appropriate in both look and feel. Most important to the design is the client, whose preferences and personalities bring the home to life. Each designer cultivates close connections with all clients, making them an integral part of the design team. Involving individuals and families in every decision at every critical stage of the process instills in them a deep sense of ownership, so that the final design is their own.

Good design does not stop with the site plan or structural elements. With a talented interior design team on staff, the firm approaches each project holistically, conceiving the interior and exterior concepts simultaneously. The team's plans thus take into account all of the furnishings, fixtures and lighting elements, allowing for spatial harmony from the inside out.

Top Left: Designed by Mark Queripel, AIA, and Robert Ross, this contemporary farmhouse is constructed of warm, natural, durable materials.
Photograph by Terra Verde Architects

Bottom Left: Located on Lake Minnetonka, this Todd Remington-designed Craftsman cottage is nestled comfortably into its wooded site.
Photograph by George Heinrich

Facing Page: Mark Queripel, AIA, and Robert Ross designed this contemporary Craftsman cottage.
Photograph by Kelly Bradford

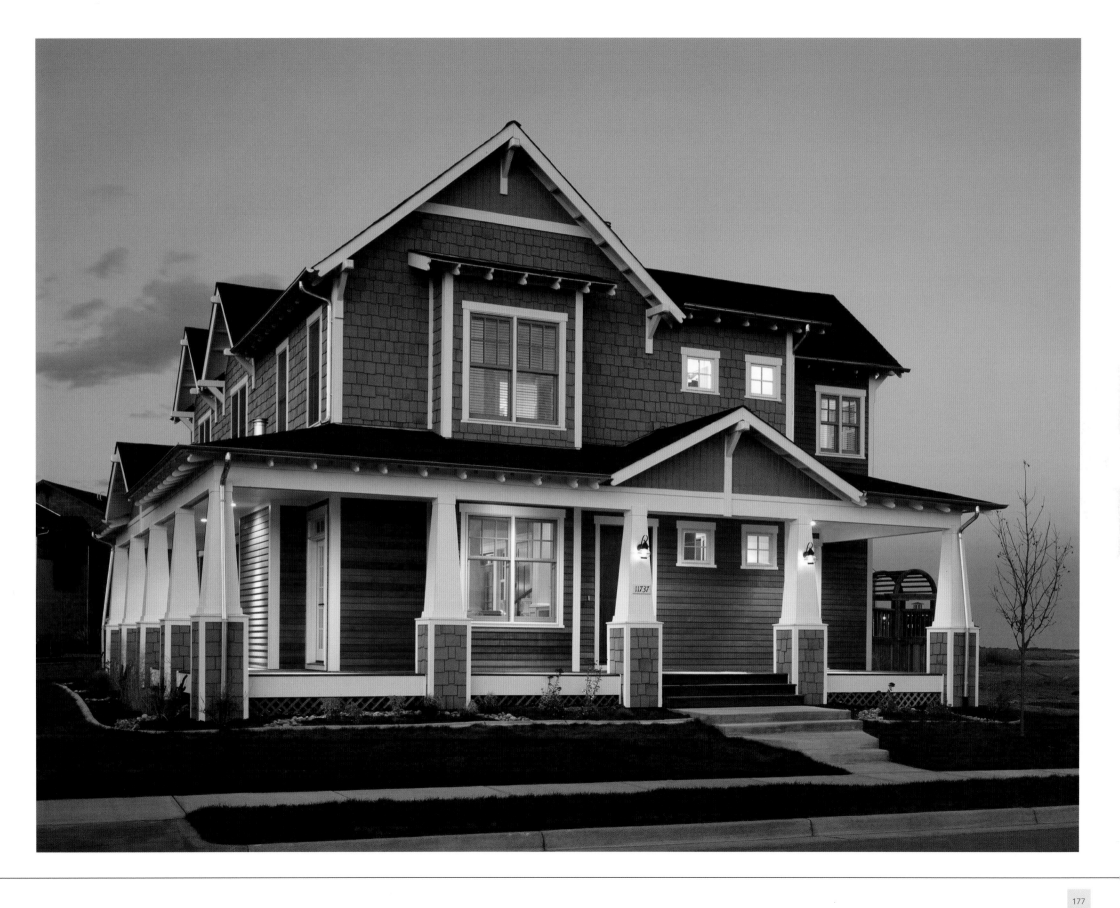

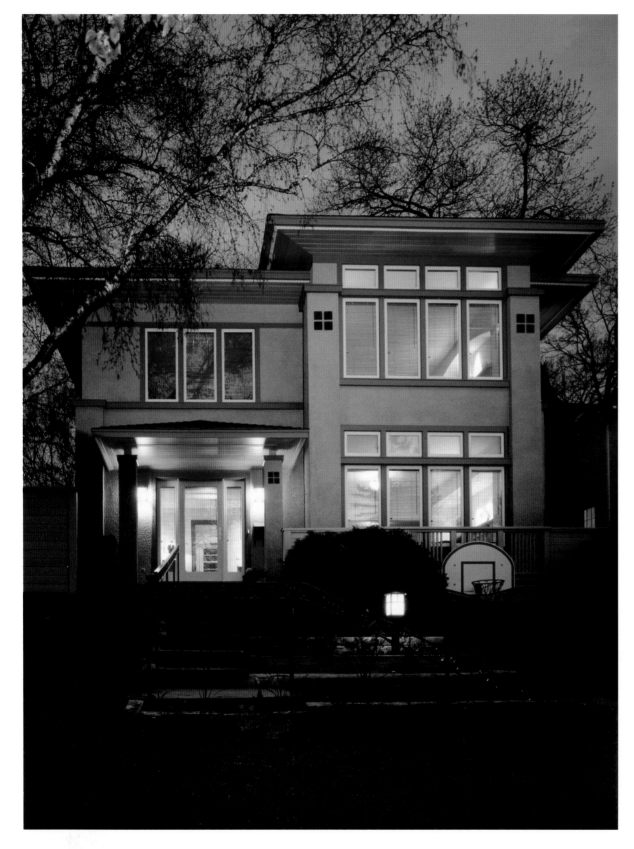

Terra Verde Architects has offices in Minneapolis, Minnesota, and Boulder, Colorado. The firm and its principals have garnered numerous awards and media attention for their Built Green and sustainability efforts. In 2006, Terra Verde's Parade of Homes entry for the Denver Home Builders Association was awarded the Built Green Award of Excellence. Terra Verde is committed to its participation in the national and local chapters of the American Institute of Architects, the National Association of Home Builders and the United States Green Building Council.

Guiding people to achieve their dream home's goals is the team's greatest reward, generating client referrals and the greatest contributing factor to the firm's continuing success. By creating architecture that elevates the human spirit by enriching people's lives, Terra Verde Architects truly produces "designs that rock."

Left: This residence was designed by Todd Remington, AIA, in the "Prairie School Pop-top" style.
Photograph by George Heinrich

Above: The "Prairie School Pop-top" home features beautiful wood detailing and rooms that harmoniously transition one into the next.
Photograph by George Heinrich

Facing Page: Located in Wisconsin, this Todd Remington-designed private retreat respects the local vernacular while making a beautiful statement of its own.
Photograph by Peter Bastianelli-Kerze

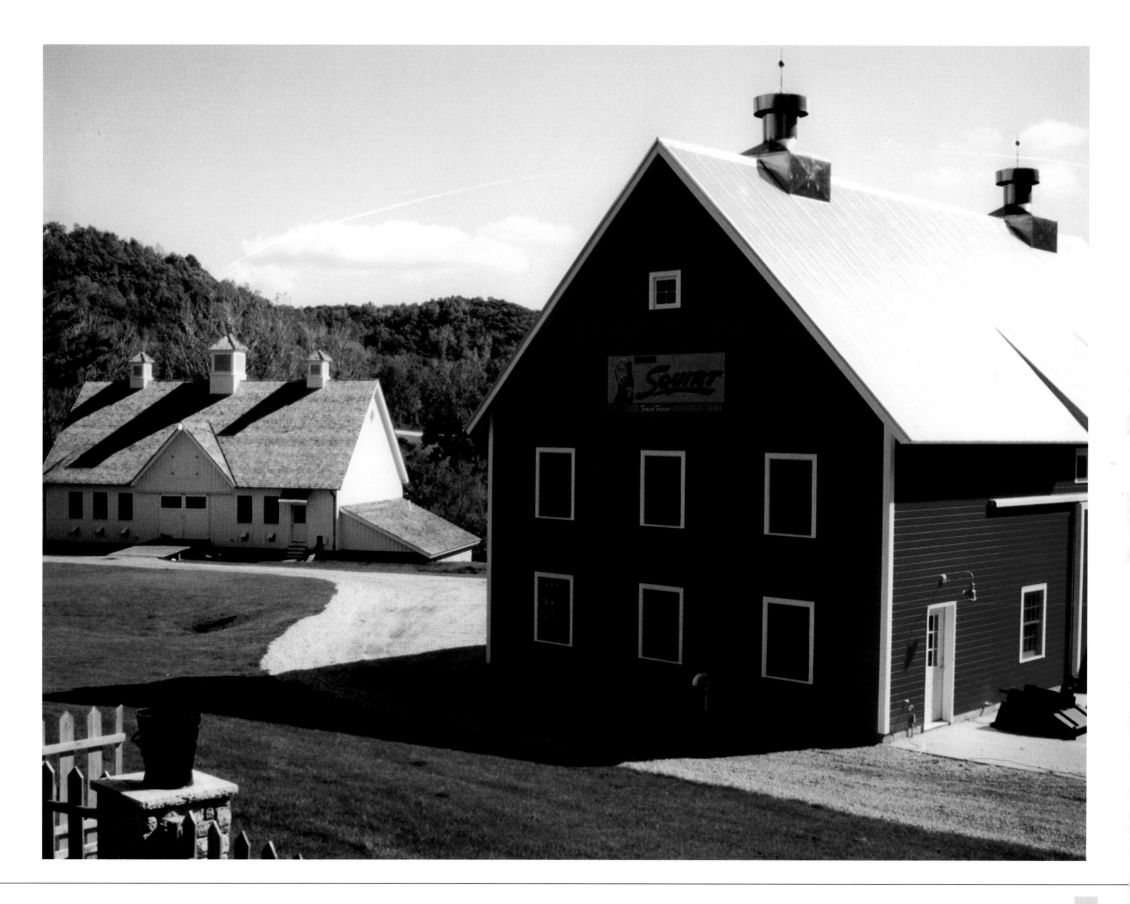

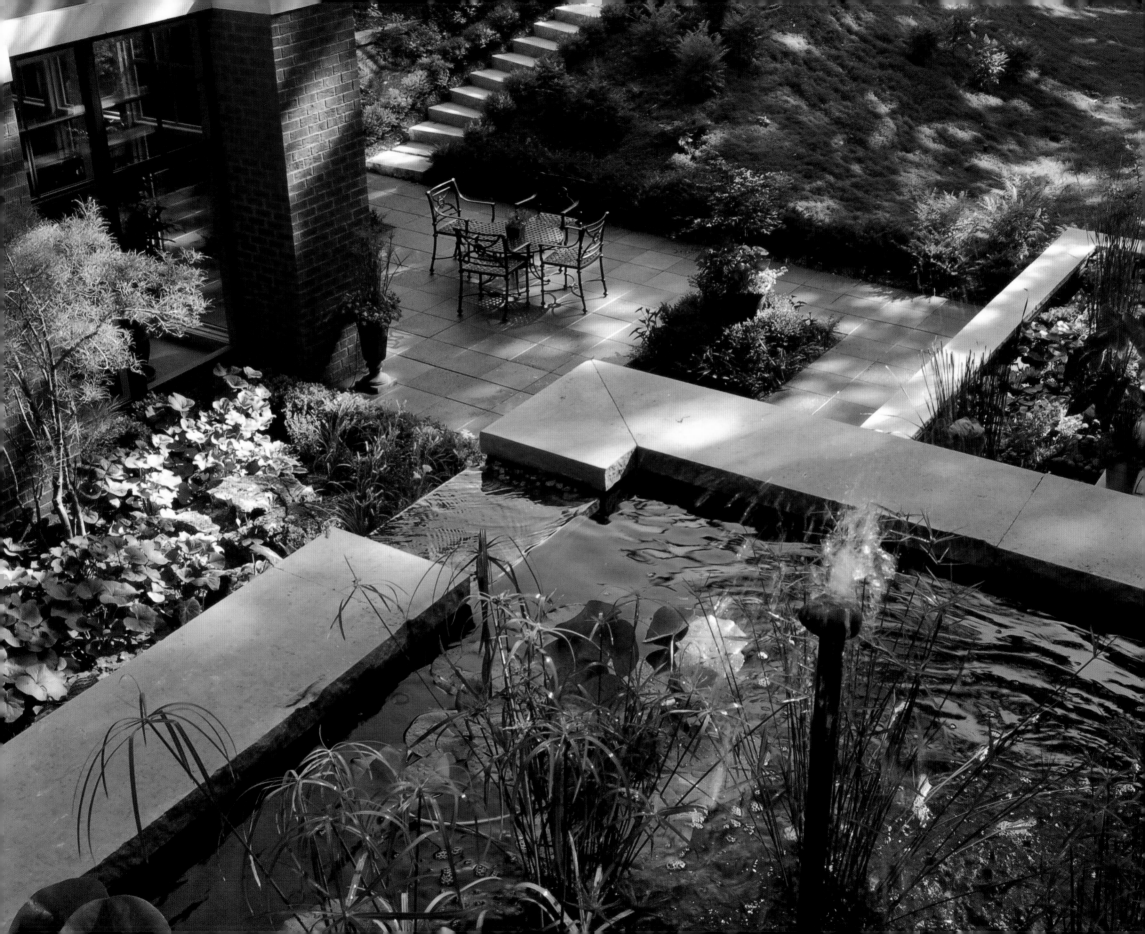

Scott Ritter

TNG, Inc.

Scott Ritter established The Nature Group (TNG), a design/build landscape architecture firm, in 1991 with a focus on creative design that seamlessly blends a home with its natural environment. The firm consists of a team of like-minded individuals who possess the desire to produce highly creative and detailed design. An intense team effort on each project has afforded the company its success at being regarded as a uniquely professional and creative team.

TNG focuses on three key elements in the design process: the client's design criteria, the architecture of the home and the site itself. Scott works with each client to understand his or her objectives for the site. He carefully studies the home and its natural surroundings with a strong belief that "if you look at a site long enough, it will eventually tell you what it wants to be." For example, careful site analysis will help one determine whether to add or subtract detail from the design.

The firm's approach to design is that "it is a process," extending past the drawing phase all the way through construction. Scott instills architectural order in every aspect of his landscape designs, creating an extension of the home on each project he undertakes. He marries the home to its natural surroundings, making both the landscape he created and the home feel as though they grew up together. He visits each site daily, ensuring accurate expression of the design and adding details as each project develops. Watching the landscape progress daily generates new ideas and details that ultimately combine art and architecture within the project space.

TNG puts much thought into selecting the plant material used on each project—so much so that the planting becomes an architectural form in itself. Colors tend to reflect and complement the architectural elements of the house while the textures of the plants reflect the textures of the surrounding environment. While he does not believe in applying his personal tastes to a client's project, Scott does believe that mass planting is a more natural and visually powerful effect.

Left: An urban front yard serves as both an entry to the home and an outdoor living space for people watching.
Photograph by Scott Ritter

Facing Page: The front entry begins at the driveway, leading you down some steps, under a tree, past the fountain and finally to the front door.
Photograph by Scott Ritter

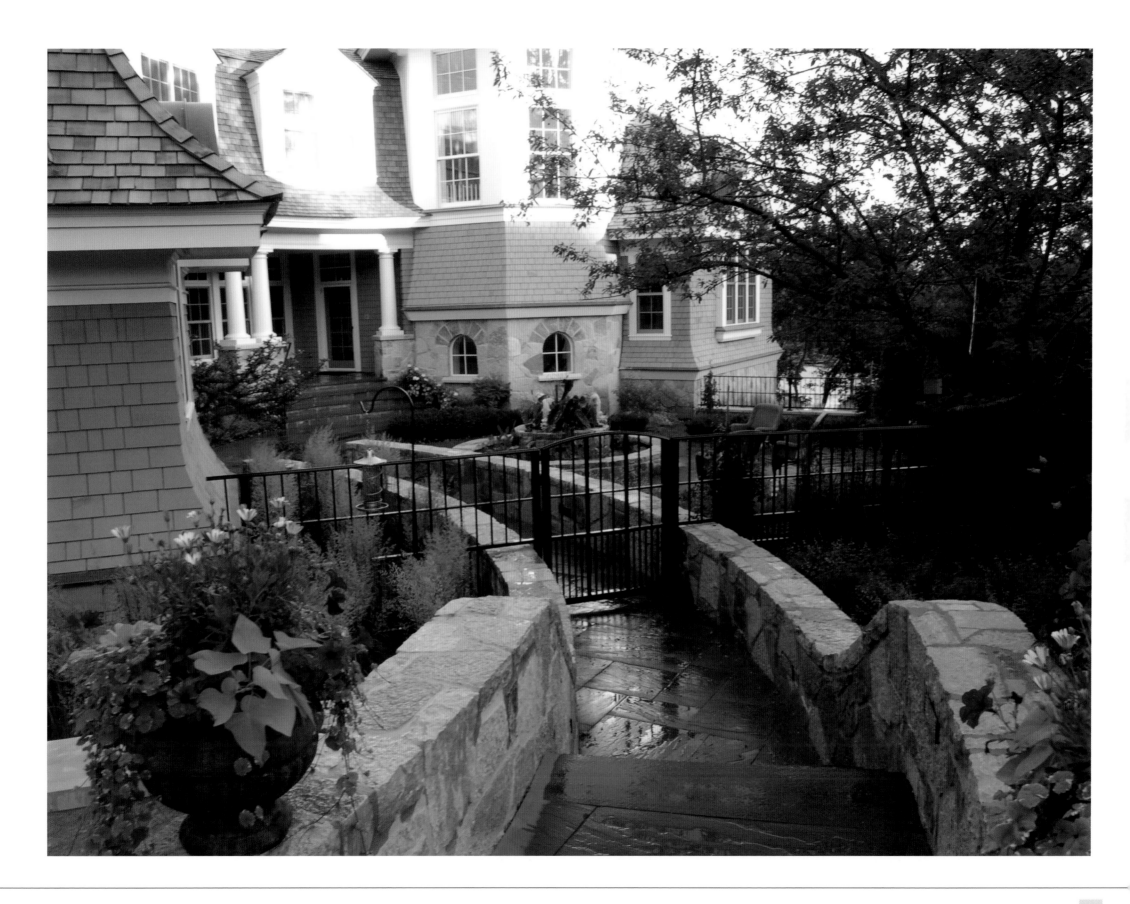

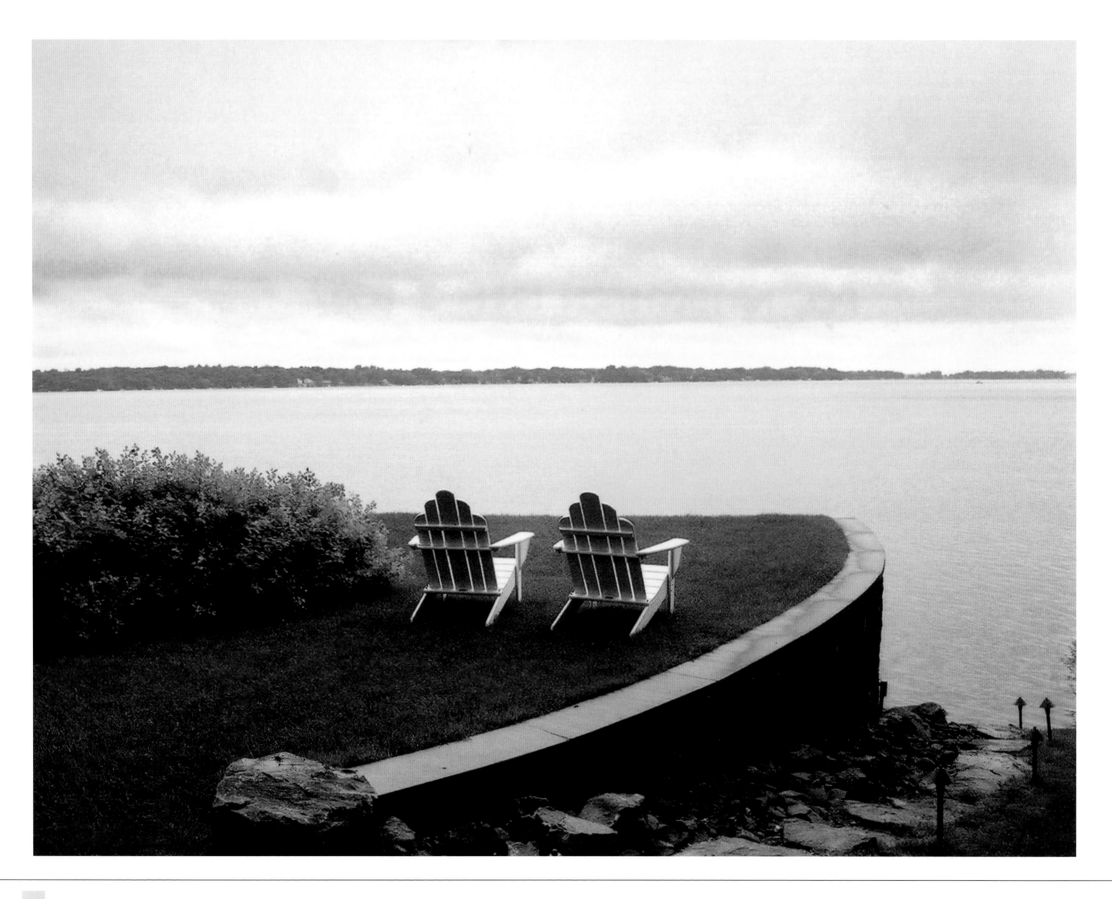

Scott's personal involvement in every stage of construction is a distinguishing characteristic of TNG, and this mentality of active engagement permeates the firm's philosophy. Clients become an integral part of the design process, helping determine the style and feeling they most want their landscapes to convey. Scott serves as their advisor, introducing different perspectives and helping guide clients to the best choices. Scott's passion for quality work is also shared by his employees, many of whom have been with TNG for more than 12 years. This team of craftsmen is skilled in all disciplines of the landscape construction process. A single crew of four executes every aspect of the project, ranging from building intricately engineered masonry walls to installing irrigation and plant materials.

The individuality of the clients and the architectural styles as well as the various regions in which the team works afford TNG the opportunity to create a wide variety of projects using local materials and indigenous vegetation. Taking cues from the home, the environment and the larger neighborhood context, Scott and his team arrive at designs that complement all three in form, color and composition. Believing that the landscape should marry the home to its site, Scott blends elements of both in his design work, repeating forms and materials found in the architecture and the horticulture naturally found on the site.

Top Right: In classical style, the landscape has a degree of both order and chaos playing in harmony.
Photograph by Scott Ritter

Bottom Right: After a 600-foot drive through the woods, you have arrived at the home. The walk to the front door is a walk through the garden.
Photograph by Scott Ritter

Facing Page: The grass roof of the screened porch below allows for an unobstructed view of the lake from the house—and a great place to relax in an Adirondack chair.
Photograph by Scott Ritter

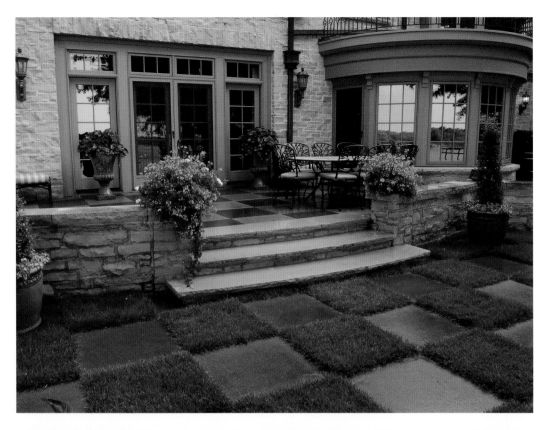

The projects take on a variety of classic styles, and each is tailored to reflect the client's individual lifestyle. Since the firm's inception, much of its business has been built on word of mouth, and the quality and creativity of its work earns the team second and third commissions. Its strong relationships with clients are a true measure of TNG's success.

Scott's commitment to continue to push the limits of design possibility and arrive at thought-provoking—even controversial—landscapes ensures his unrelenting growth and advancement. He aspires to one day be recognized among the renowned landscape architects he has admired for years, and his exquisite work situates that goal well within reach.

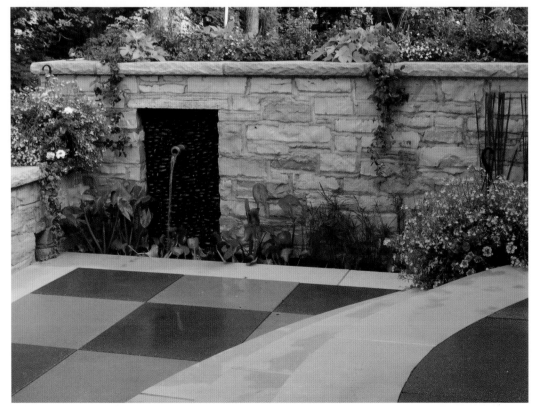

Top Left: The surface changes from one level to another, but the pattern remains the same.
Photograph by Scott Ritter

Bottom Left: A privacy wall off the master bedroom becomes a source of sound and sight exclusive to the master and mistress of the home.
Photograph by Scott Ritter

Facing Page: An auto court becomes a garden court with an emphasis on a water feature centered between the front door of the house and a gazebo overlooking a meadow.
Photograph by Scott Ritter

Nick Smaby

Choice Wood Company

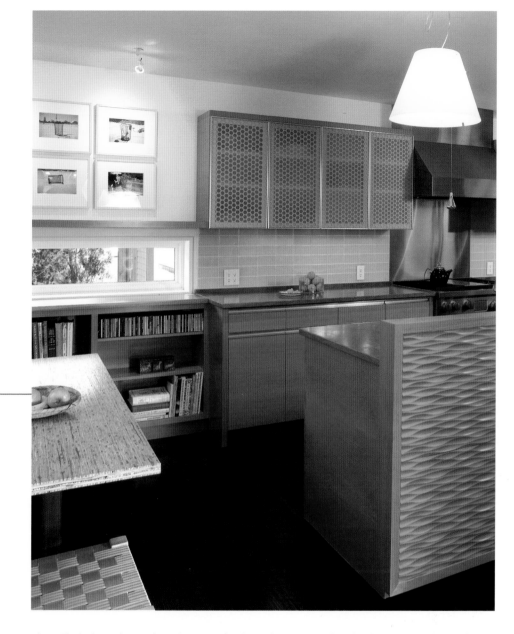

Above: This kitchen radiates with visual texture and a whimsical, creative use of novel and unique materials. Light flows in through a panoramic window.
Photograph by Troy Thies

Facing Page: The use of Rheinzink siding, contemporary forms and abundant color characterizes this art ranch rambler transformation.
Photograph by Troy Thies

Founded nearly 25 years ago, Choice Wood Company began as a result of a group collaboration on noted local architect and author Sarah Susanka's master's thesis, which involved renovating a home in south Minneapolis. The six individuals who worked on the project had such a gratifying experience collectively remodeling this home that they decided to form a company and do it full time. In the many years since its inception, Choice Wood has greatly expanded its range of services, slowly incorporating new home construction, a cabinetry and millwork shop, architectural design and most recently interior design into its repertoire. Throughout its evolution, the firm has garnered prominent national accolades and seen its demand for services rise steadily, but all the while it has never wavered from its commitment to quality craftsmanship.

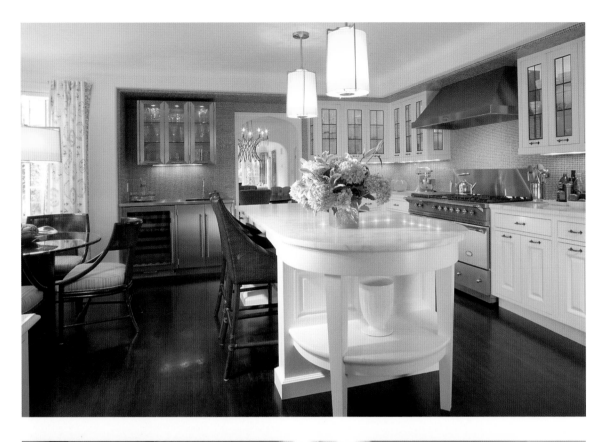

Now collaboratively led by current president and resident elder Nick Smaby; head of the cabinetry and millwork division Andy Berg; head of production Chris Jordan; and business manager John Greely, Choice Wood produces superior design and construction in a broad range of project sizes and scopes. Each lending a unique set of skills, fresh perspectives and abundant talent, the partners combine their specific areas of expertise to remarkable effect. Their implicit and complete trust in one another, coupled with their immense knowledge and talent, is a key element of the firm's success.

As the firm's managing principal, Nick supervises the firm's sales and marketing as well as strategic planning. Though well seasoned in the business, he did not initially set out to enter the building world. Indeed, he earned a psychology degree from Dartmouth and followed that by successfully completing law school. Harboring grand ambitions of being a successful fiction writer, Nick owned a bookstore in Minneapolis in the late '70s, which he found tremendously gratifying yet economically restrictive. Coming from an analytical background, he stumbled upon building when he helped a friend build a house and found he had a steady hand and a rare ability to visualize in three dimensions. More importantly, he enjoyed the work.

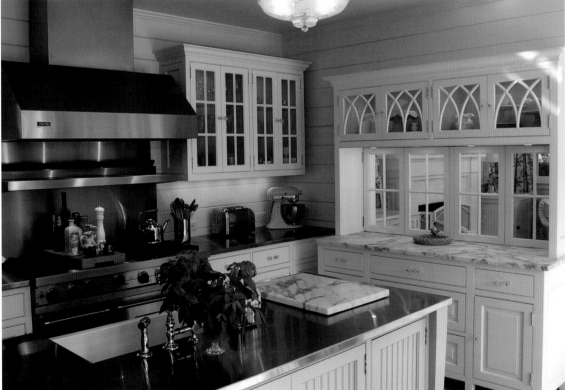

Top Left: Traditional design is accented by contemporary details and European sophistication.
Photograph by Dana Wheelock

Bottom Left: The kitchen in this traditional American cottage is open and airy.
Photograph by Choice Wood Company

Facing Page: The interplay of architecture and landscape elements, sun and stone composes an ordered outdoor space.
Photograph by Dana Wheelock

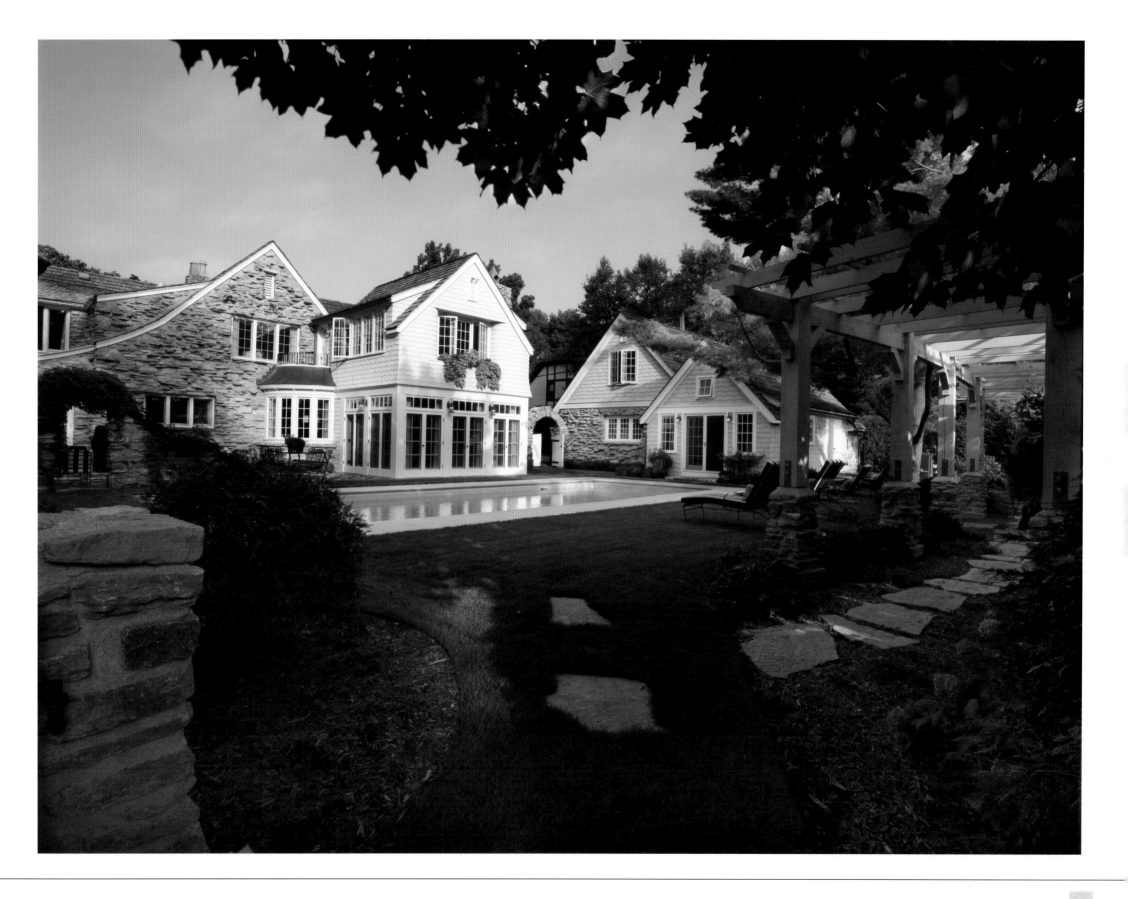

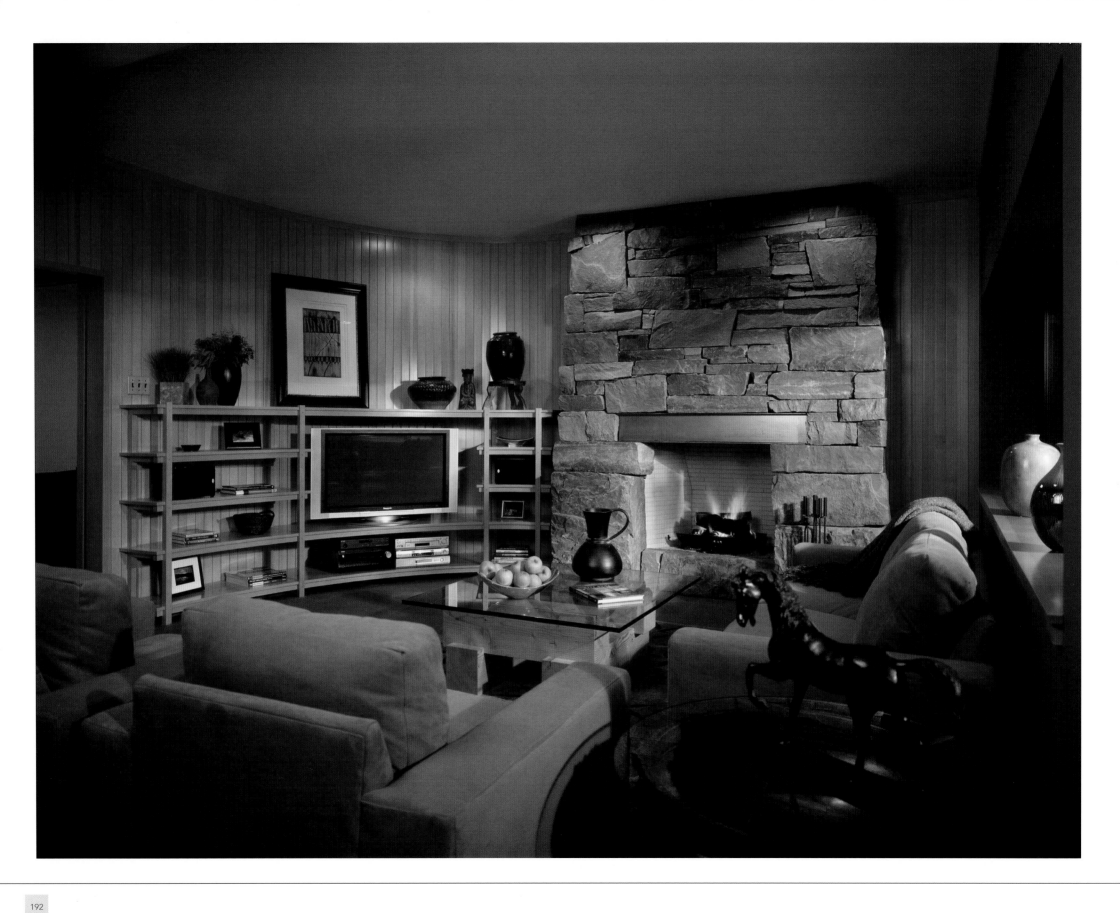

Nick was hired by Choice Wood to be a carpenter in 1983—the firm's first employee, outside the original six—and, with the help of his partners, now oversees the numerous renovation and new design/build projects the firm undertakes. In each endeavor, Choice Wood utilizes a process they refer to as "finding the project"—a creative process that encompasses considering the program and site, sorting through the variables and their infinite outcomes to arrive at the best possible solutions. Nick and his team hold dear the principle that the whole is greater than the sum of its parts: Each individual and element combines to create a home that exceeds the expectations and aspirations of all involved.

Deftly blending traditional design with modern details and styling, Choice Wood's projects encompass an array of styles that are highly customized and efficient, tailored to deliver realistic client desires—combined with a longstanding reverence for natural materials and, of course, an unwavering dedication to first-rate craftsmanship. The firm has realized great success over the years, but with the notable exception of expanding its client services, has largely retained a similar approach and business model. Choice Wood continues to serve the neighborhoods in which it got its start, well-known in the Twin Cities and their suburbs for its first-class work.

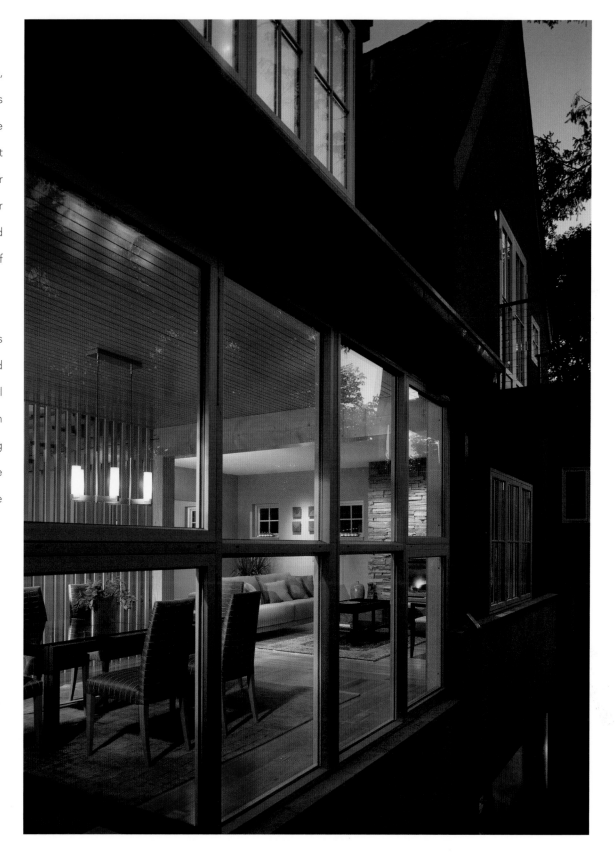

Right: The glass wall reveals views of the warm, natural wood inside and the creek outside.
Photograph by Karen Melvin

Facing Page: This elegantly curved natural wood wall contrasts with the natural stone fireplace.
Photograph by Karen Melvin

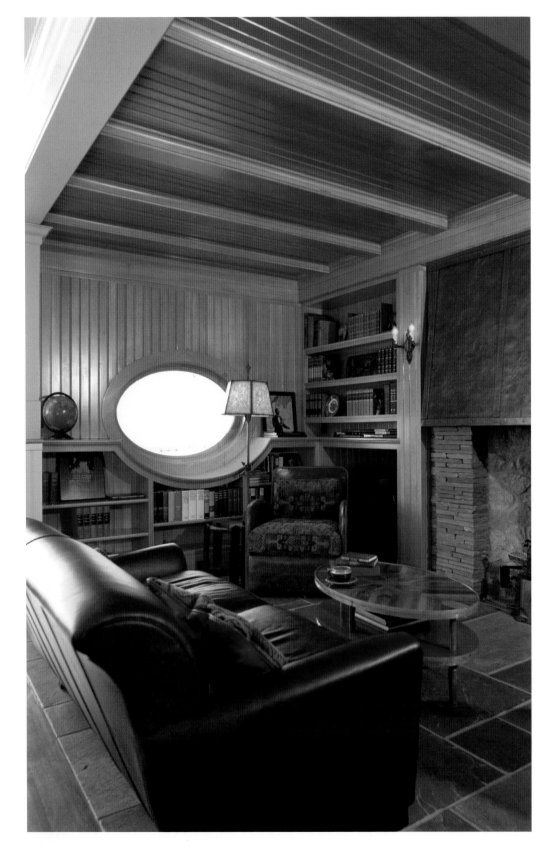

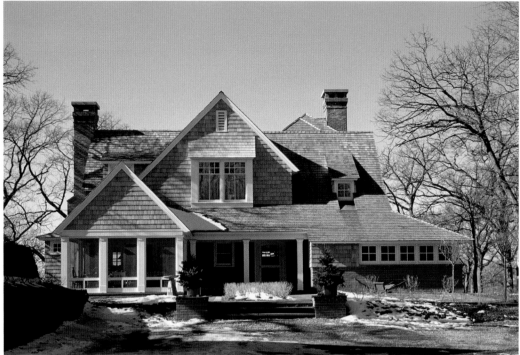

Satisfied clients and customers would surely speak fondly of their experiences working with Choice Wood Company over the years, but the efforts of this adroit firm are so manifest that national publications have heaped praise upon the St. Louis Park-based firm. Recognized by *Custom Home* as the 2006 Custom Builder of the Year, Choice Wood Company's stunning success demonstrates that the company has not only stood the test of time, but honed its focus and capabilities. It has grown from a brilliant cabinetry and millwork shop to a highly capable design/build firm devoted to quality craftsmanship.

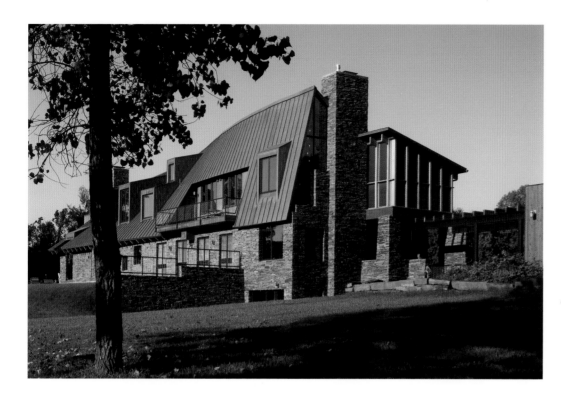

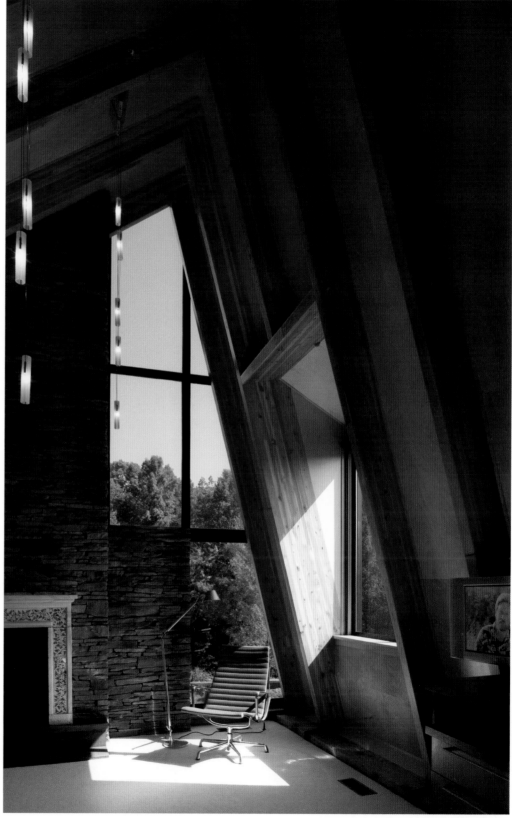

Above: With a curved copper roof, this sculptural Pennsylvania bluestone is expansive in its estate setting. Architecture by MS&R.
Photograph by Assassi Productions

Left: Glass fills the void between the stone fireplace and soaring wood beams. Architecture by MS&R.
Photograph by Assassi Productions

Facing Page Left: The stone from the fireplace surround extends out through this alcove, composing the floor. The fireplace features an artist's hand-hammered copper hood. Architecture by TEA$_2$ Architects.
Photograph by TEA$_2$ Architects

Facing Page Right: This new home could have been built 100 years ago: charming entry elevation; sweeping lake views; timeless character. Architecture by TEA$_2$ Architects.
Photograph by TEA$_2$ Architects

Jack Smuckler

Smuckler Architecture

An artist/cartoonist-turned-registered architect/builder, Jack Smuckler, AIA, has always been drawn to opportunities for creative expression. Whether working with oils, watercolors or just a stick of graphite, he has a natural ability to convey his ideas in various beautiful forms. When asked how he explains his artistic talent, he notes that it is a wonderful gift from God. Jack never takes his abilities for granted, but instead develops them each day while sharing the joy of the creative process with residential and commercial clients throughout the state of Minnesota and in many other scenic destinations across the country.

Left: This 6,500-square-foot residence on Lake Minnetonka features contemporary elements and classic lines for timeless design.
Photograph by Smuckler Architecture

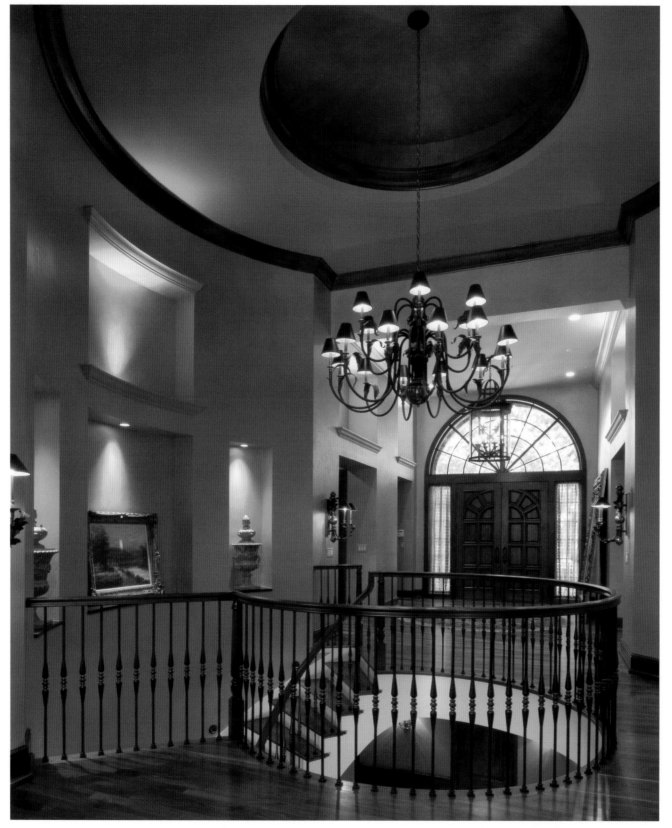

Long enamored with the idea of designing buildings, Jack feels that his career path became decidedly clear when he enrolled in a course on the history of architecture and loved every minute. Since studying at Lawrence College and the University of Minnesota, Jack has been actively engaged in the world of architecture for more than a quarter of a century. In that time, many honors have been bestowed on his firm, including being named to the 2005 list of the 50 leading residential architects nationwide and featured on the cover of *Builder's Journal*. Additionally, Jack has been recognized with the National Paris Peace Prize in Architecture, 2006 People's Choice Award, 2005 Reggie Award of Excellence, Roma Award for Remodeling Excellence, Trillium Award, Renaissance Design Award and the national AIA's Award of Excellence.

Because his artistic vision reaches far beyond that which may be documented in traditional building plans, Jack is also a licensed builder who savors the opportunity to help clients achieve their dreams from concept to completion. Jack notes that one of the most valuable things he has learned over the course of his career is that contractors should not have to read an architect's mind. The accomplished architect has the ability to envision spaces three-dimensionally even at the earliest stages of design, so clients respect his commitment to the flawless execution of their dreams.

Left: The grand entry foyer that features a circular staircase with display niches and a domed ceiling can accommodate large groups.
Photograph by Saari and Forrai Photography

Facing Page Top: This 10,000-square-foot residence in Edina features traditional Tuscan elements with architectural detail for scale and flow.
Photograph by Saari and Forrai Photography

Facing Page Bottom: The Edina home's high-ceilinged family room provides a splendid view through its grand Palladian-style window. The all-stone fireplace is in character with the home's exterior.
Photograph by Saari and Forrai Photography

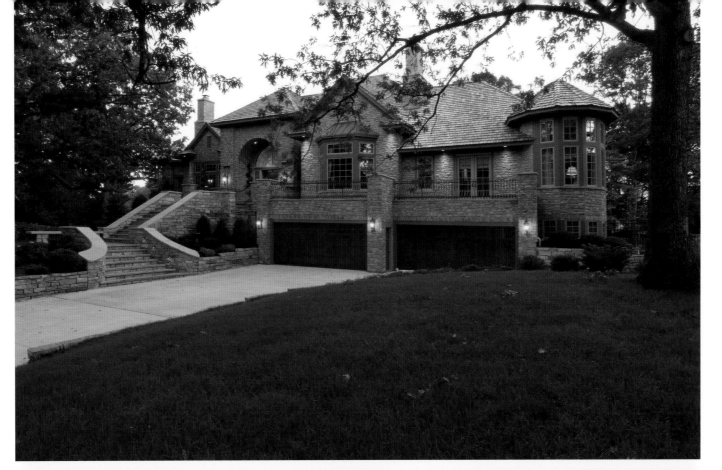

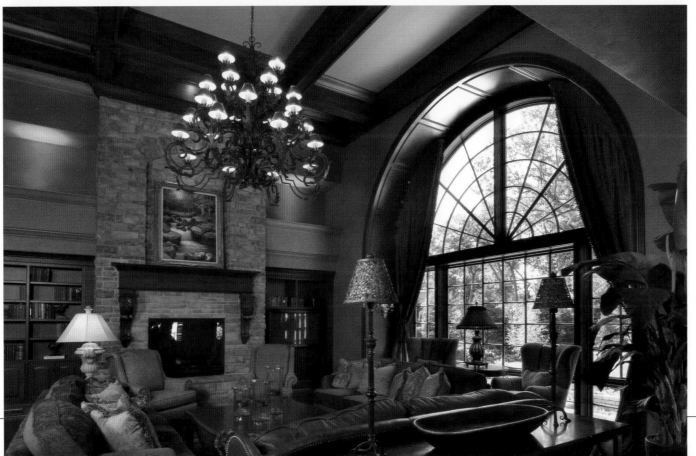

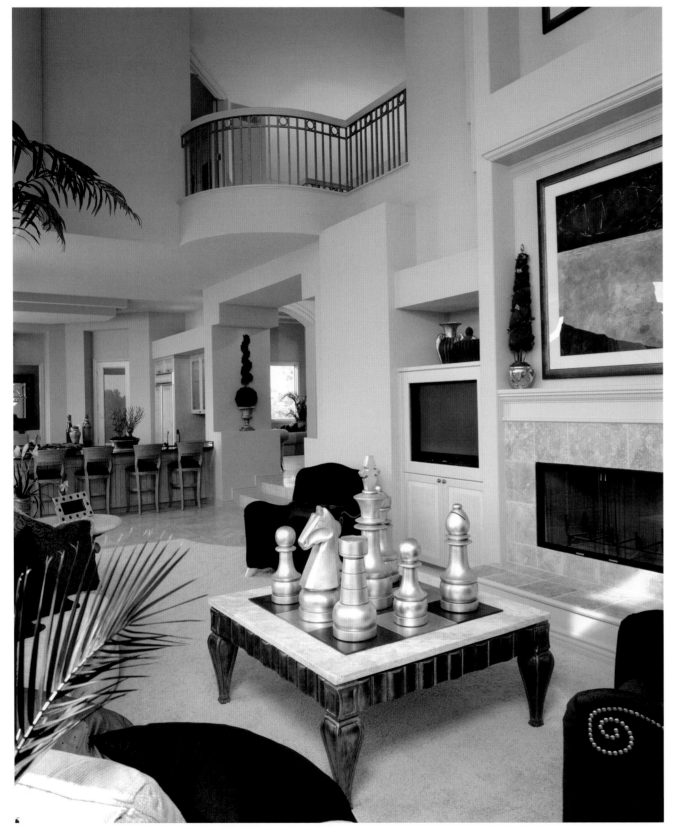

The mixture of residential, commercial, new construction and remodeling projects is a source of inspiration for Jack because each presents a different set of requirements and the occasion to experiment with new technique and design ideas. His range of styles is equally broad. Whether traditional or contemporary or a genre as specific as Prairie, Tuscan or European, Jack is confident in his ability to design a thoughtful reply to his clients' needs.

Although each response is completely original, a soft contemporary flavor subtly permeates the body of Jack's work. He utilizes principles of space, proportion, light and shadow as the foundation for his designs and tailors the application of these elements to the clients' programmatic needs. Jack is fond of specifying natural materials, perhaps a variety of woods, juxtaposed against contemporary lines that promote the feeling of openness. He often brings exterior materials inside to further enhance the notion of connectedness to nature.

It is the sum of thoughtful creative decisions that yields successful results, yet Jack has become somewhat known for his inventive treatment of soffits. He believes that when properly designed, soffits can change the whole scale of a room by creating a horizontal plane that makes large spaces feel more intimate. Jack looks at each element of architecture as an opportunity to make a statement, so he approaches design not from a purely programmatic standpoint, but from an artistic angle; he sees each room as a unique space rather than a mere grouping of walls.

Left: This two-story great room is sculpturally detailed to humanize the scale and provide display space for an art collection.
Photograph by Smuckler Architecture

Facing Page Top: This Prairie style home includes strong horizontal accents and natural elements of stone and redwood.
Photograph by Smuckler Architecture

Facing Page Bottom: Interior stone accents bring the exterior material inside. Soffits define scale and display niches.
Photograph by John Bishop

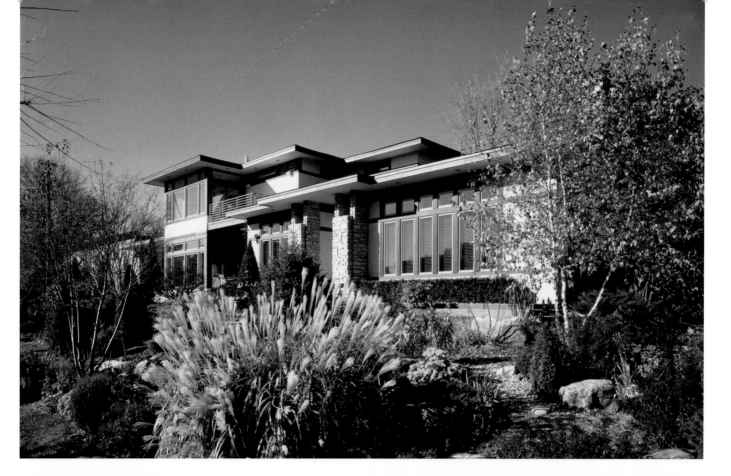

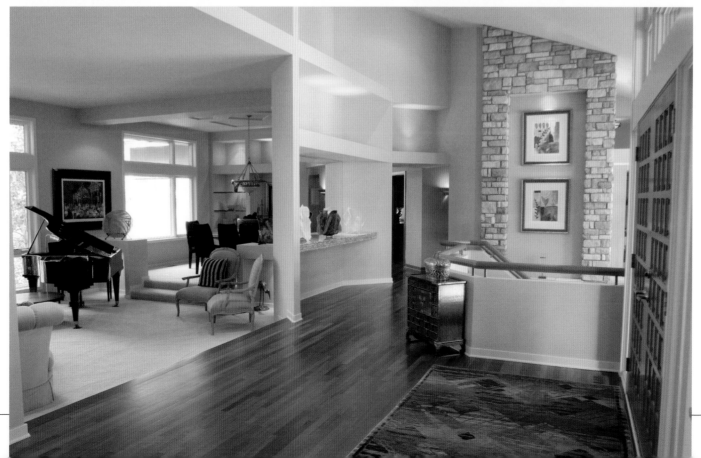

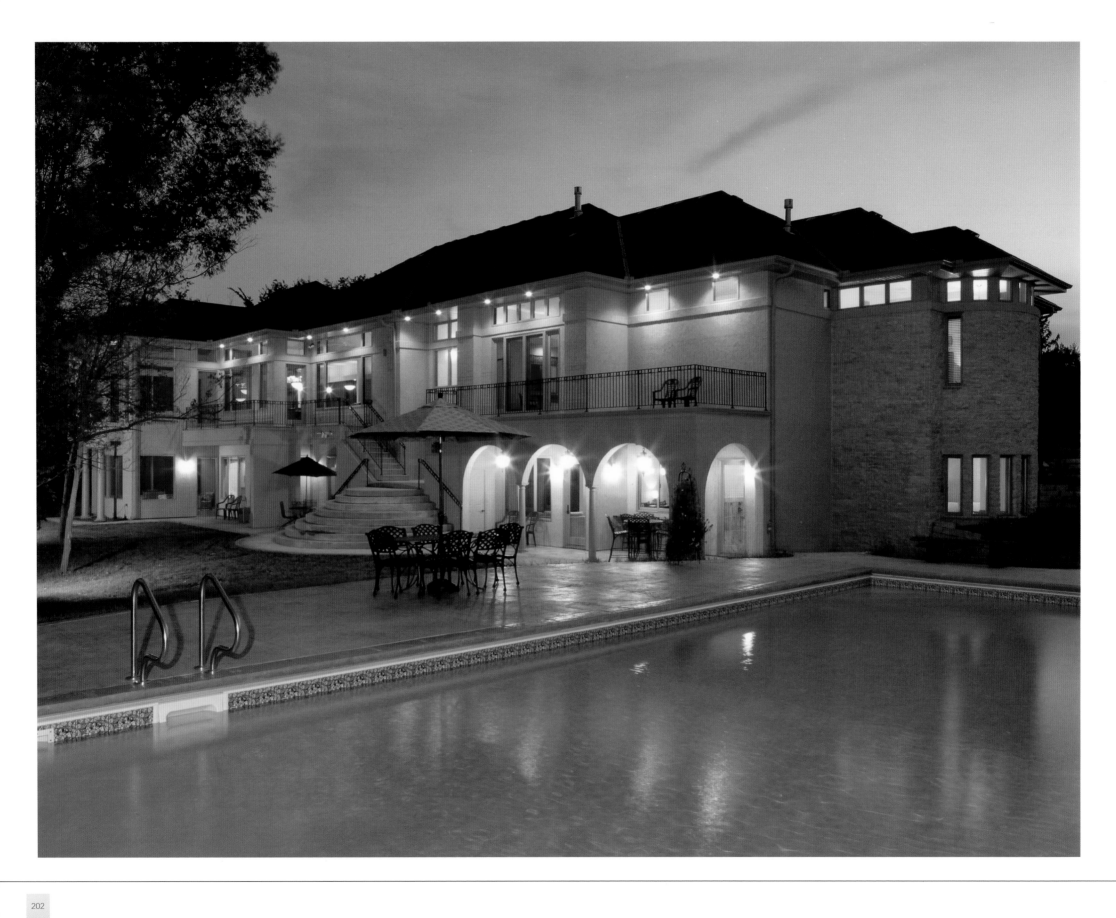

With as many projects as Jack has undertaken in his impressive career, it comes as no surprise that a number of them have presented quite interesting challenges. Jack's reputation has taken him to some of the most prestigious communities of Palm Springs, Arizona, Las Vegas and Naples, but he has also designed in North Dakota and the Midwest. One commission in particular offered implausible guidelines, in that the site was a severely sloping hillside overlooking a golf course. To the clients' desire for a home that would take advantage of the views, afford privacy and not disturb the natural elements, Jack responded with a five-level layout that steps inward down the side of the hill.

Jack's sculptural approach has resulted in a broad collection of awe-inspiring architectural masterpieces. He believes that hiring an architect is akin to commissioning an artist to create a unique work of art to live in and desires to surround each client with a sculptural haven that captures his or her personality and is a source of daily inspiration.

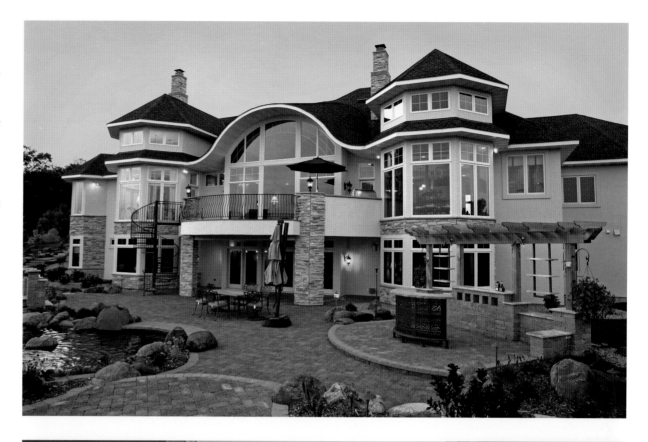

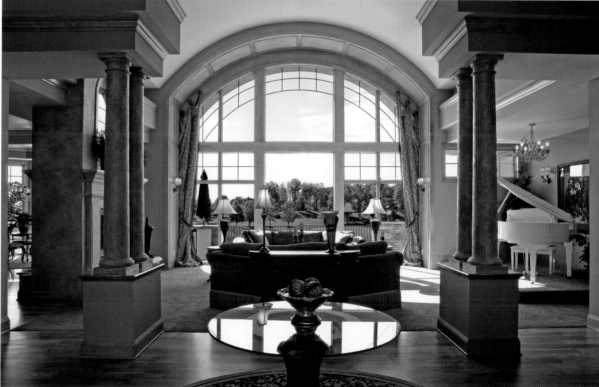

Top Right: This 8,500-square-foot English Manor-style home overlooks magnificent views of a golf course and pool with a fountain.
Photograph by John Bishop

Bottom Right: The barrel-vaulted ceiling and large-paneled arched window of the entry maximize the golf course view.
Photograph by John Bishop

Facing Page: Completely composed of brick, this magnificent one-story walk-out leads guests to the pool and provides a remarkable view of the lake beyond.
Photograph by Smuckler Architecture

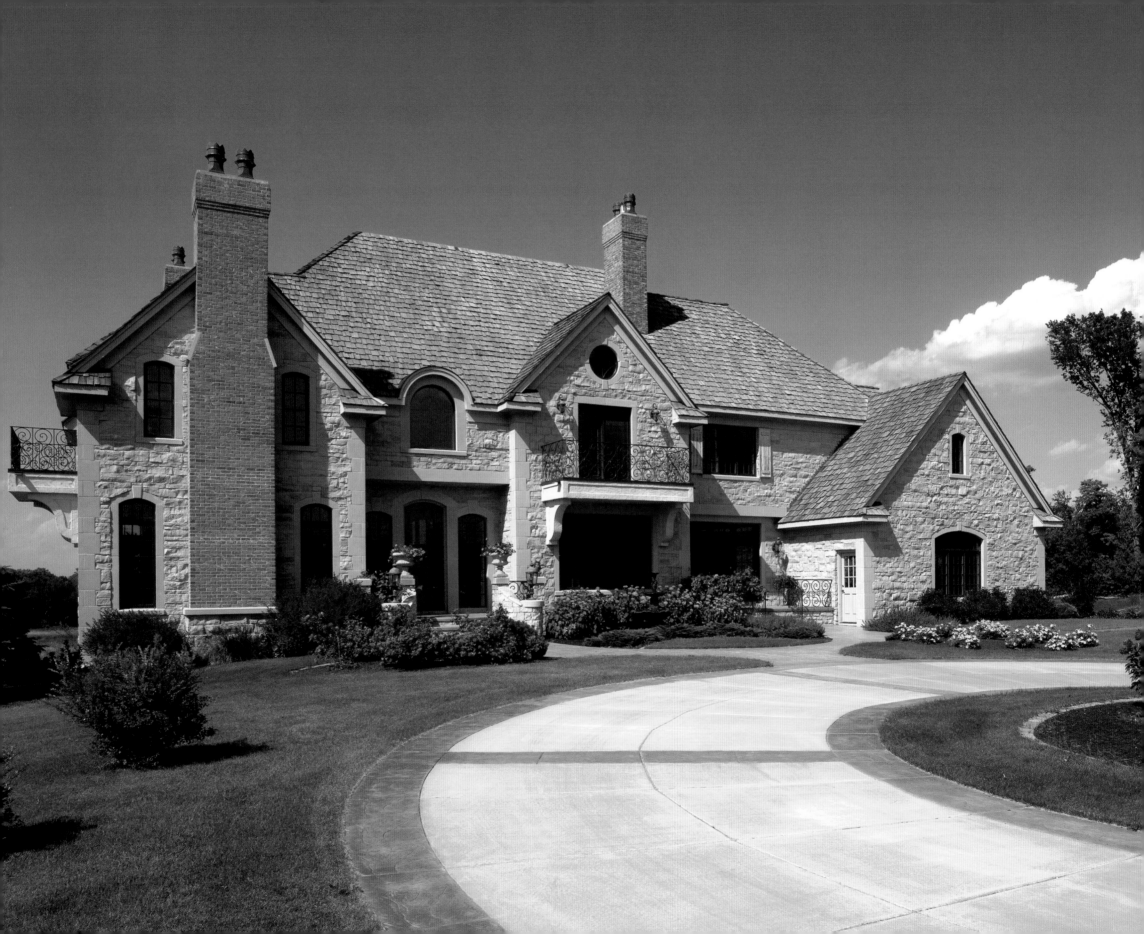

David Steingas
Dave MacPherson

Steiner & Koppelman

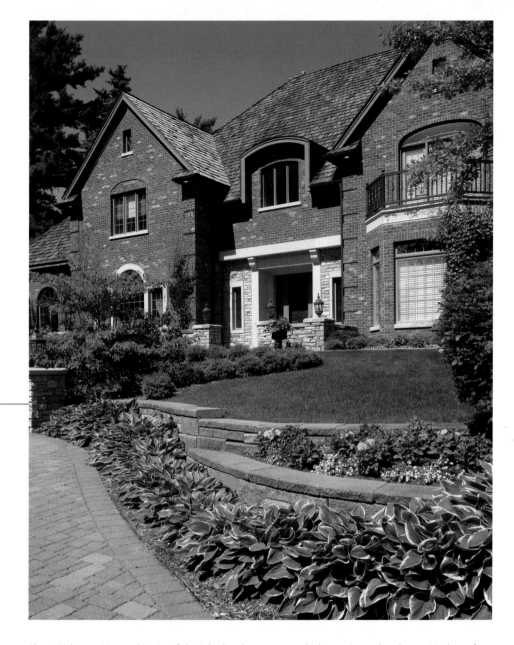

Above: With an enticing combination of classic brick and stone accents, this home seems to have been spirited away from the English countryside and repositioned in a heartwarming suburban neighborhood.
Photograph by Matthew F. Witchell

Facing Page: A European presence of brick, stone and arches welcome you to this fabulous country home where balance, proportion and artistry complete elegance and comfort.
Photograph by Matthew F. Witchell

David Steingas adheres to the idea that a person is only as capable as the people behind him—and the homes created by his residential construction company, Steiner & Koppelman, bear witness to the fact that he is backed by an outstanding team. Indeed, the 52 professionals who compose the firm, many of whom have worked there for more than 20 years, strive to uphold the prominent Twin Cities builder's commitment to providing the utmost in design and construction quality. With more than 60 years of continuous service, Steiner & Koppelman is a name synonymous with superior homes.

Exceptional cabinetry and millwork have long been a firm hallmark, due in no small part to David, himself. A cabinet maker for nearly 30 years—he had discovered his knack for woodwork as early as high school and built a company solely on referrals—David ran his successful enterprise devoted to crafting fine cabinetry for nearly a decade when he began working with Steiner & Koppelman to create interior woodwork and lighting elements. When the firm's partners announced their retirement in 1993, David

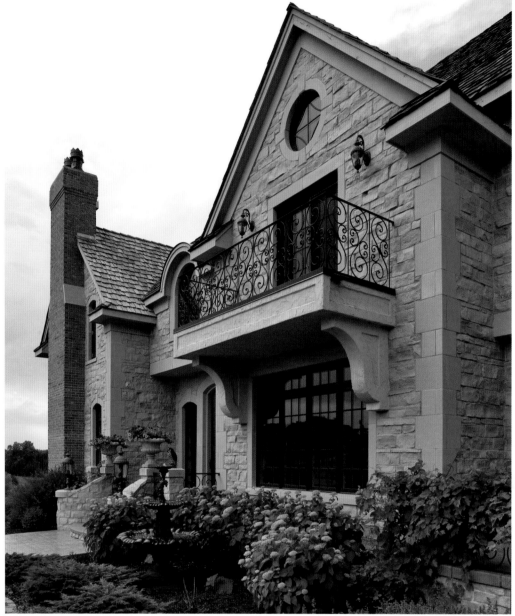

assumed ownership, running both companies simultaneously before uniting them in 1999. Each home built reflects David's ample experience and talent for crafting fine wood details.

While cabinetry is an essential element of the firm's work, Steiner & Koppelman offers clients a full range of services, from site selection to design and drafting to construction. The firm's on-staff registered architect, Dave MacPherson, proves invaluable to clients, conceiving the design vision alongside the clients and working with the construction team and in-house craftsman to ensure

that it is precisely and beautifully executed. Dave's presence at the firm eliminates the need for clients to seek outside design services, fostering a studio environment in which clients and architect collaborate to arrive at a program that pleases all.

Above Left: Doorway arches are echoed in structure, trim and windows, softening the materials of brick, stone and wood used in this stately entry.
Photograph by Matthew F. Witchell

Above Right: This distinctly designed railing atop a beautiful stone bracketed platform creates a fairy tale-like balcony.
Photograph by Matthew F. Witchell

Facing Page: This lake home features large windows that welcome natural lighting and offer stunning expansive views of Lake Minnetonka.
Photograph by Matthew F. Witchell

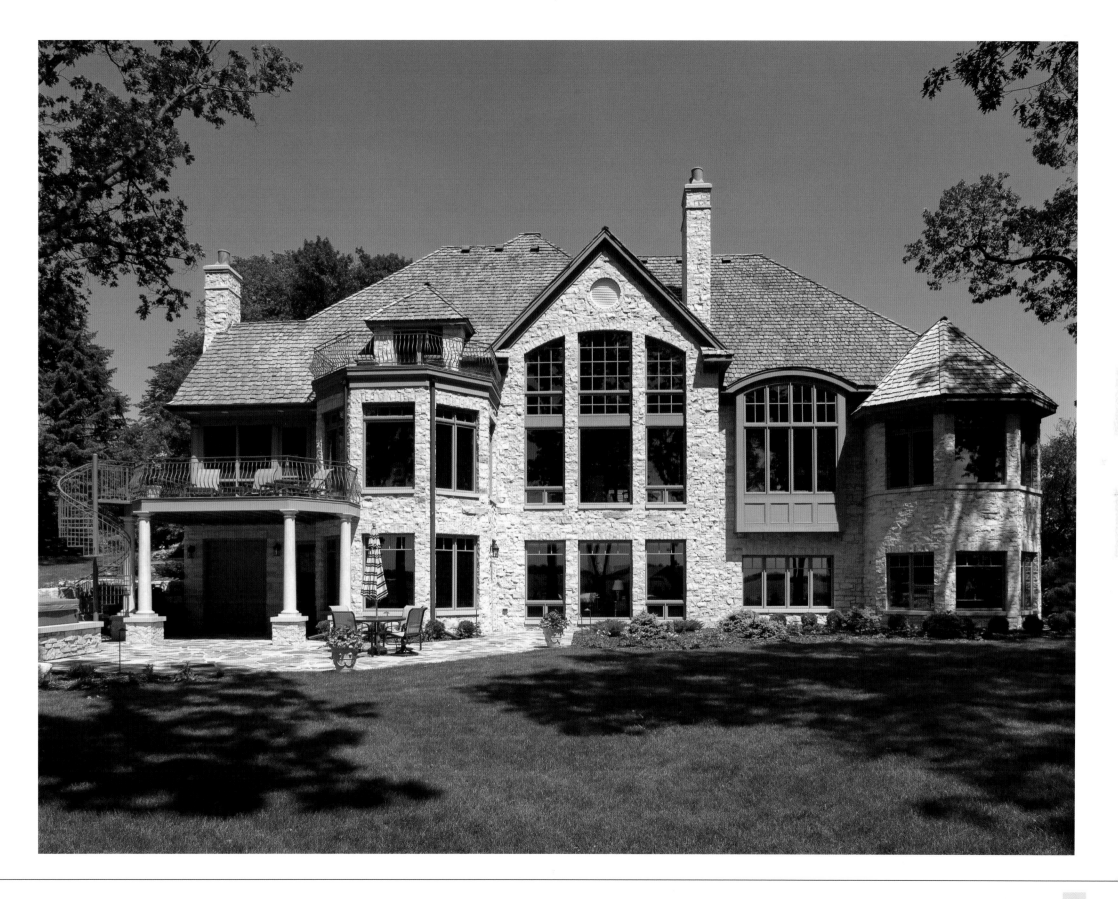

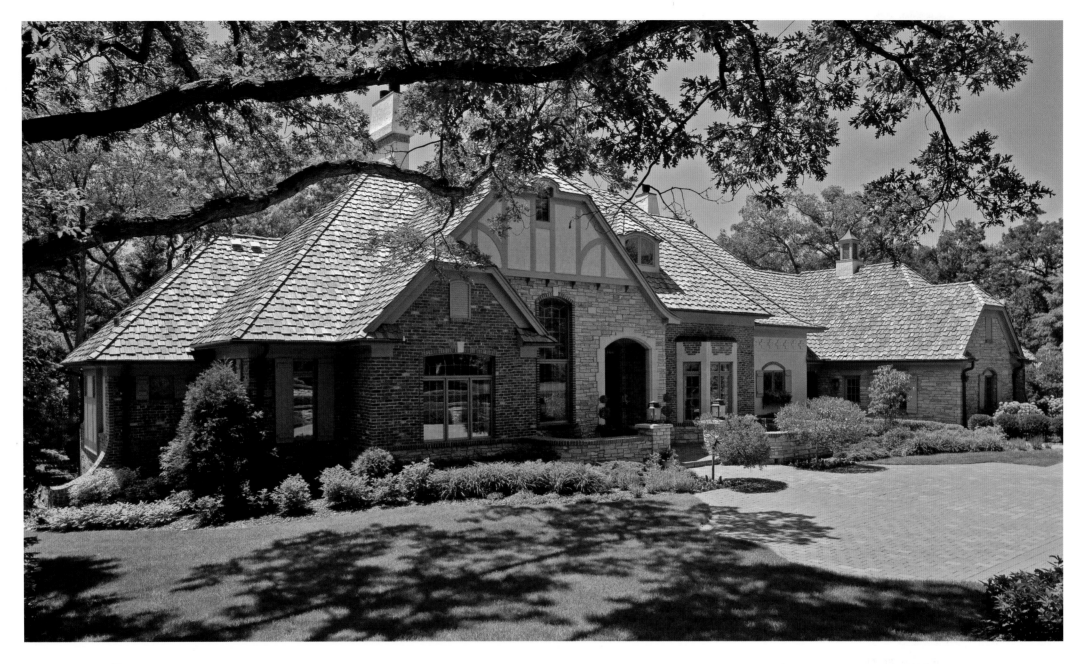

The firm's style has evolved since its inception, and its homes express a range of aesthetics. Whether infused with a French Country or English cottage flavor, each home is created for the family-oriented American way of life, with spacious, open floor plans and rooms that flow smoothly from one to the next. The particular style derives from both client preference and context, and care is taken to select forms and materials that are appropriate to the landscape and surrounding environment. Around Lake Minnetonka, for instance, the team constructs homes abundant in stone and brick, natural materials that resonate with the verdant setting.

The Steiner & Koppelman team prides itself on its ability to create anything clients envision for their homes. With its diverse portfolio of clientele, the firm has received and met a multitude of unique and challenging requests, consistently exceeding clients' expectations. From specialty rooms that house golf simulators and indoor gymnasiums to bookcases that pivot to reveal hidden rooms, clients' fantasies become reality in their very homes.

Above: This English Tudor is nestled in a well-established setting and exudes the natural feel of a Minnesota landscape.
Photograph by Matthew F. Witchell

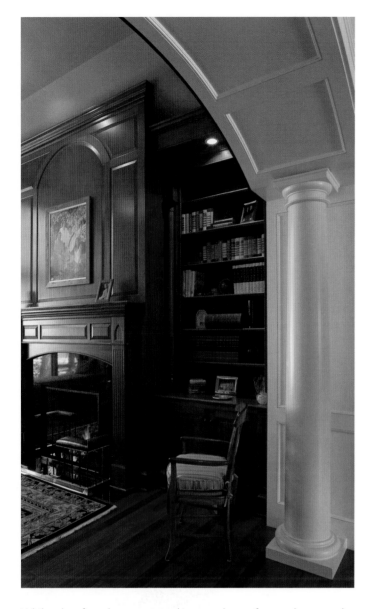

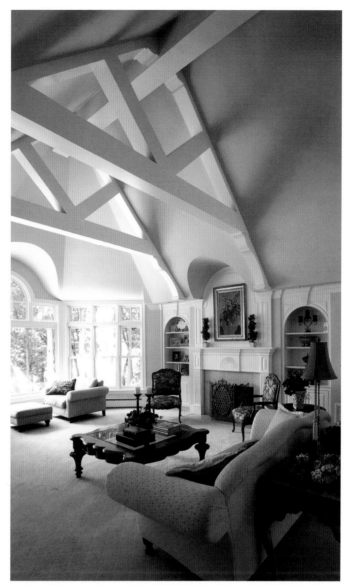

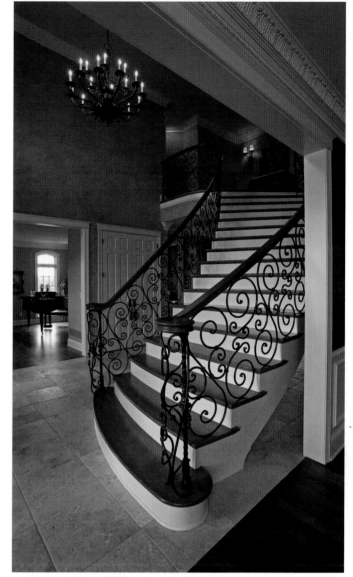

While the firm has garnered a number of awards over the years—Steiner & Koppelman won the very first Reggie Award in 1958—David Steingas' focus is on creating homes that best suit the needs and desires of his clients. He visits each site weekly, acting as the client's agent to ensure that the home is just as they and he want it. Demonstrating his remarkable ability to imagine a home's interior in three dimensions, David will sketch designs for cabinetry and bookcases literally on a sheetrock wall to help clients envision their completed homes. Photographs of these freehand sketches will become guides for his craftsmen to follow as they build what David has conceived.

Homeowners have bestowed abundant praise on the firm, but David is most gratified to have been called a "straight shooter." He states that his firm has adopted an open-book mentality, remaining honest and up front with each client throughout every stage of the process. Working with a number of CEOs and other executives, David understands the importance of professional integrity. Undoubtedly, the continued success of his firm is due to the team's balance of business acumen and artistry.

Above Left: Mahogany bookcases surround this story-and-a-half library while the foyer boasts enameled columns and a paneled archway.
Photograph by Matthew F. Witchell

Above Middle: A mingling array of barrel vaults curve along with perfectly proportioned beams that deliver inviting warmth upon entrance into this room.
Photograph by Matthew F. Witchell

Above Right: Ornate ironwork graces this grand sweeping staircase.
Photograph by Matthew F. Witchell

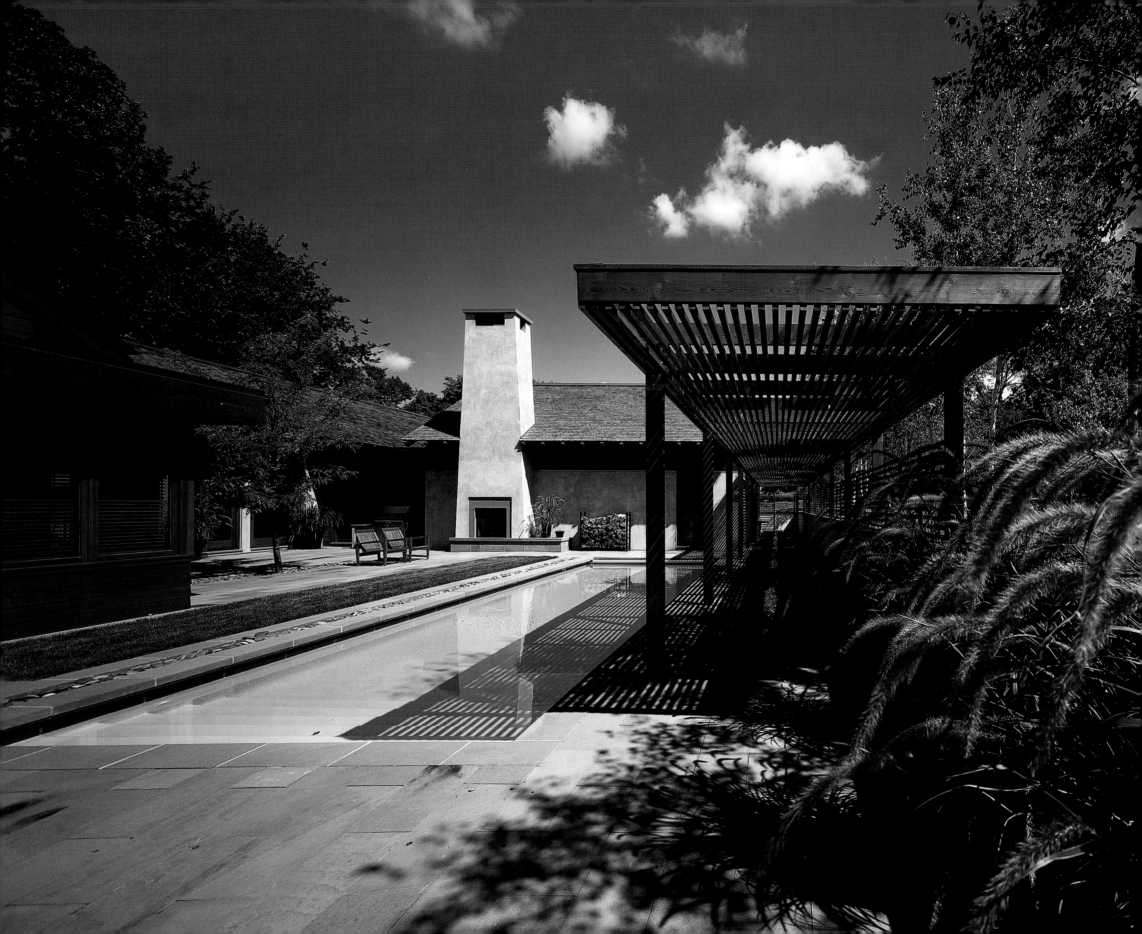

Steven Streeter
Donald Streeter
Kevin Streeter
Justin Streeter

Streeter & Associates

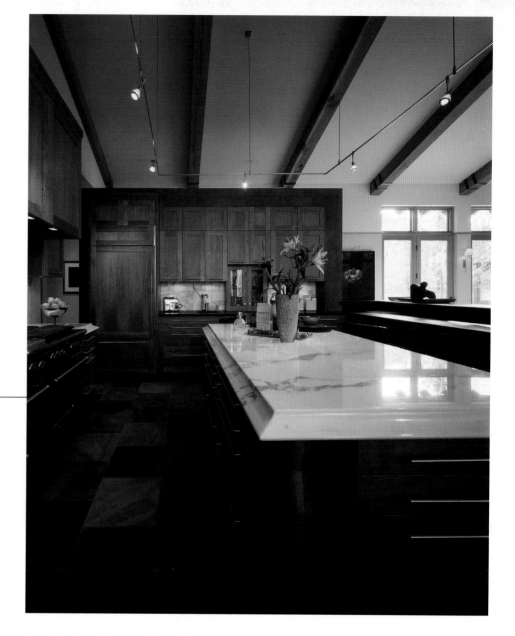

Above: This Napa Valley-inspired kitchen blends contemporary and traditional, with luxe white-marble countertops, a golden onyx-tile backsplash, slate floors and reclaimed birch cabinets. Home design by KBA Architects.
Photograph by Peter Bastianelli-Kerze

Facing Page: A bluestone courtyard surrounds a concrete lap pool, and swimmers can dry off and relax by the outdoor wood-burning fireplace. Landscape architecture by Coen + Partners.
Photograph by Peter Bastianelli-Kerze

Though he studied finance, Steven Streeter long harbored a passion for architecture. His passion grew and, coupled with his business savvy, facilitated his partnership with three of his brothers, Donald Streeter, Kevin Streeter and the late Mark Streeter, to form Streeter & Associates in 1985. Devoted to fine architectural construction, the strictly residential firm has since created fine custom homes and detailed renovations for clients across the Twin Cities metro area.

Now housing a staff of 43 building professionals who share the principals' dedication to high quality craftsmanship, the firm is proficient at expressing a variety of architectural design styles—predominately Modern and Prairie style—and executing complex architectural elements. Working with some of the most widely respected architects in the country, the Streeter team has honed its ability to preserve a home's architectural integrity, forging solid relationships with architects and clients alike. Their

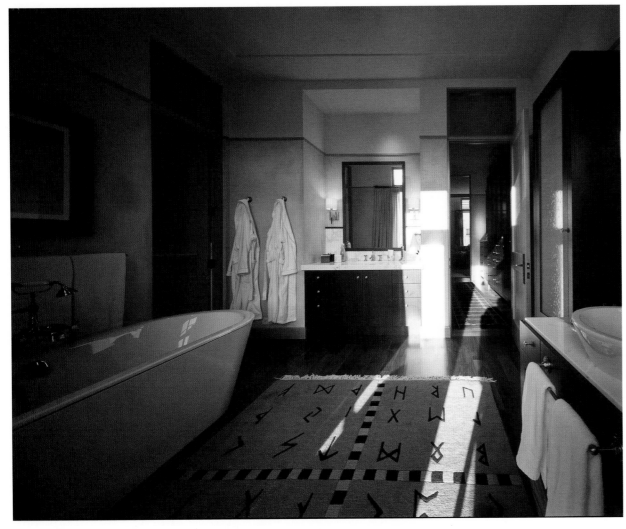

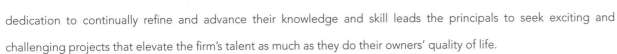

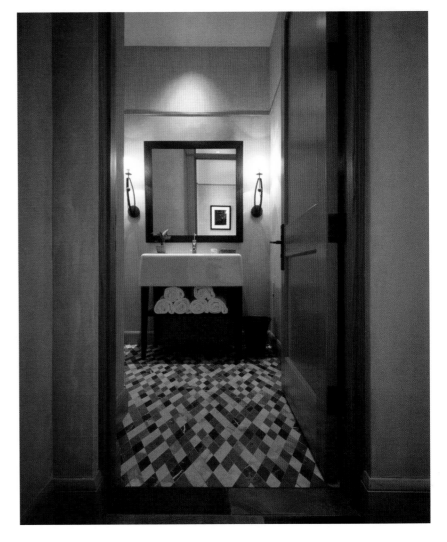

dedication to continually refine and advance their knowledge and skill leads the principals to seek exciting and challenging projects that elevate the firm's talent as much as they do their owners' quality of life.

Indeed, the client is the focus in every project, and Streeter & Associates' rigorous building process ensures that each individual receives the utmost service and care at every phase of construction. The Streeters encourage clients to collaborate with the design team to make certain that their desires and visions for their homes are fully and beautifully realized. Building the home of their dreams is a highly emotional process for clients, and the Streeter team is sensitive to this fact, supporting and fostering confidence in their clients throughout the process.

The firm's thoughtful approach to each project has garnered ample client praise and referrals. Numerous patrons have referred to the firm's work as "unsurpassable" and have extolled its character, attention to detail and ability to

consistently exceed expectations. Perhaps more significant is the frequent display of gratitude for the firm's philosophy of frank communication and its thoughtful, patient manner—characteristics that reassured them that they were in good hands. Overwhelmingly, one gets a sense that clients feel at home both creating and living in the homes of their dreams.

Above Left: Centered around the clean geometry of its Philippe Starck soaking tub, the high ceilings and Venetian plaster walls imbue the owners' bath suite with an Old World/Napa Valley atmosphere.
Photograph by Peter Bastianelli-Kerze

Above Right: This powder room is resplendent with a Philippe Starck Duravit sink and stunning mosaic limestone floor.
Photograph by Peter Bastianelli-Kerze

Facing Page: Slate floors, reclaimed fir beams from a bridge in northern Minnesota and an abundance of windows on either side give this great room/dining room a natural feel.
Photograph by Peter Bastianelli-Kerze

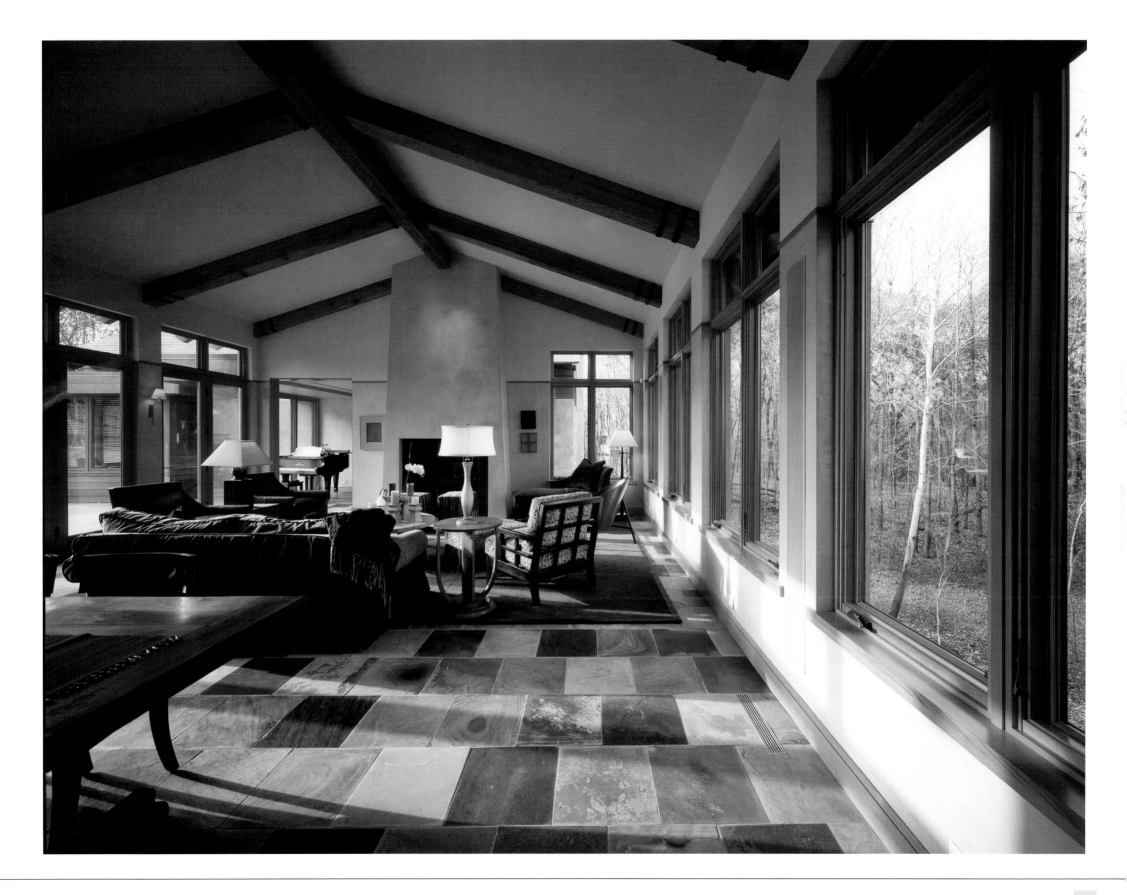

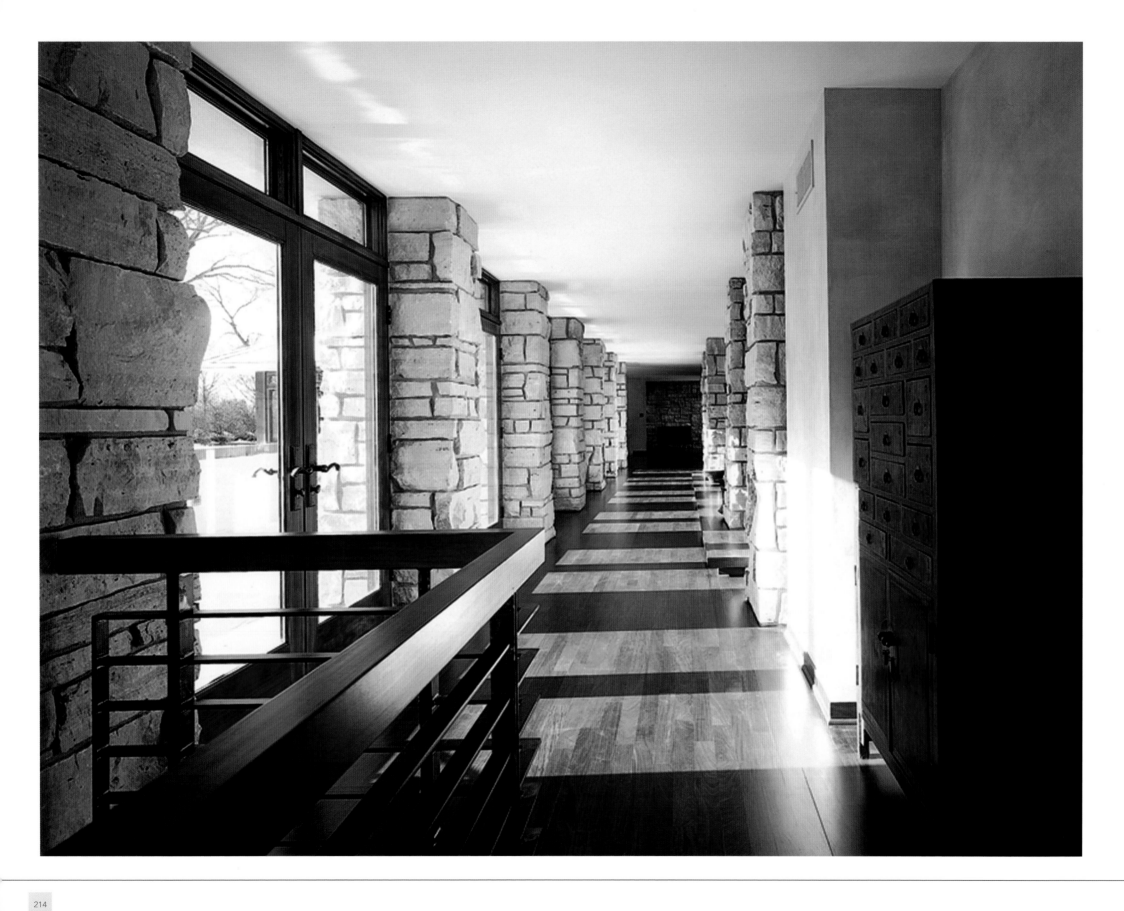

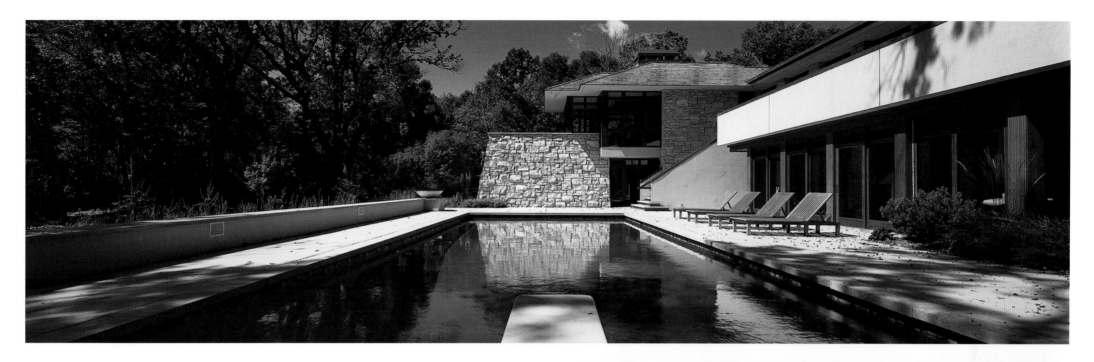

In addition to client recognition, Streeter & Associates has amassed numerous awards. The Builders Association of the Twin Cities has presented the firm the Trillium Award for Quality Achievement and the Reggie Award of Excellence for many consecutive years, and a good deal of its remodeling projects have earned the team Remodelor of Merit awards from the Builders Association of the Twin Cities Remodelers. Additionally, the firm's work has appeared in such publications as *Trends*, *Metropolitan Home* and *Better Homes and Gardens Special Interest Publications*, to name a few.

Clearly, the firm's professionalism, commitment and outstanding project management system have accelerated its success. Though the firm has grown and evolved, its mission to build the best possible homes remains constant. All of the individuals with whom the team works, from the suppliers to the subcontractors, share the team's dedication to accurate and precise implementation of every aspect of construction. The Streeter team's genuine pledge to sacrifice nothing and make every project extraordinary galvanizes its flourishing future.

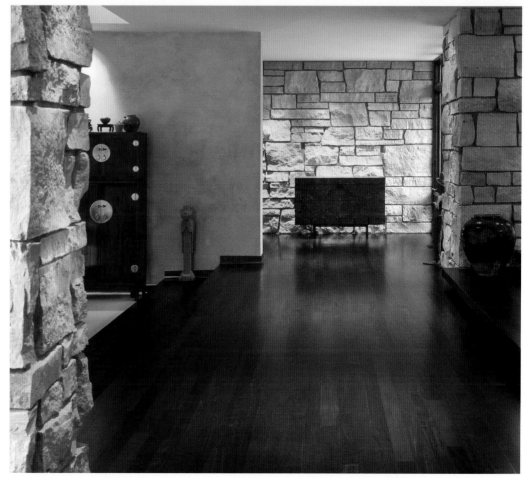

Above: This home's design reflects a heavy influence of Frank Lloyd Wright and Asian architecture. The dark swimming pool creates a dramatic mirrored effect. Architecture by Charles Stinson.
Photograph by Peter Bastianelli-Kerze

Right: Many of the homes' features were inspired by the homeowners' favorite places in Bali. The furniture and art hail from Asia.
Photograph by Peter Bastianelli-Kerze

Facing Page: Organic materials—glass, stone and wood—are employed throughout the house, which is completely spanned by this walkway. The light in the house is ever changing, reflecting off the Brazilian walnut floors and the Fond du Lac stone present inside and out, which was cut 50 percent larger than average to achieve a rugged effect.
Photograph by Peter Bastianelli-Kerze

Keith Waters

Keith Waters & Associates, Inc.

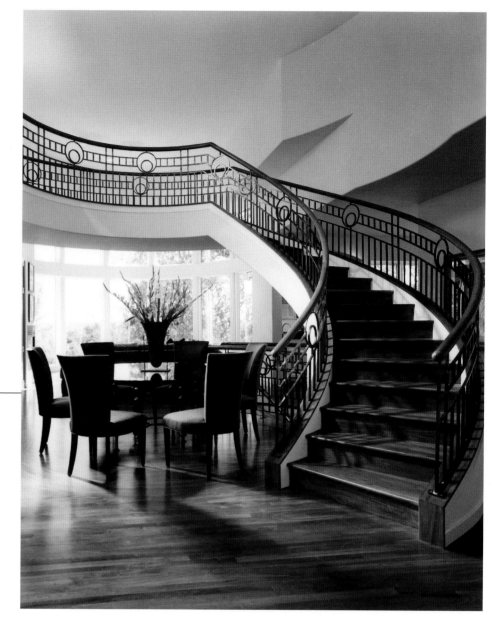

Above: Sweeping lines and bold contrasts in materials highlight this spectacular entry staircase.
Photograph by Karen Melvin

Facing Page: Surrounded by historic mansions, this understated but dignified residence overlooks the parkway on the south shore of Lake Harriet in Minneapolis.
Photograph by Page Studios Inc.

Keith Waters and his team of detail-oriented, architecturally trained designers are celebrated for their evident love of craft, unmatched level of client service, active engagement in Green building techniques and commitment to bringing superior quality, one-of-a-kind works of architecture to fruition. Yet, perhaps they are best known simply as providers of creative magic.

Keith finds that his clients often have dreams and parts of dreams in their heads but cannot express them dimensionally. In a sense, design is a process of exploring these dreams. Each project's design team—which usually includes Keith, a lead designer and a CAD technician—spends time with the client before beginning the design concept, and then continues the discussion through a series of design

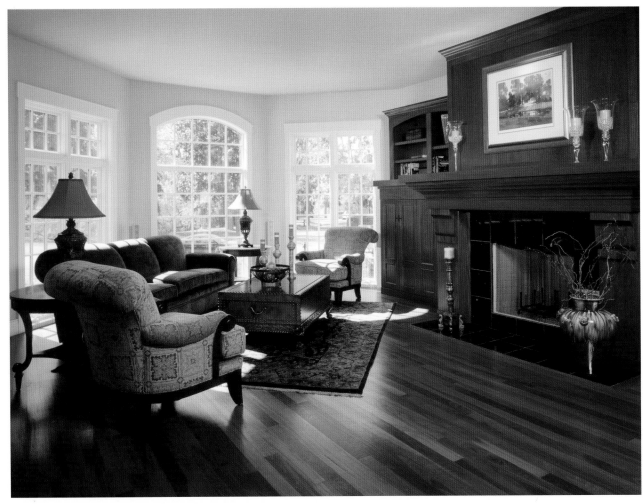

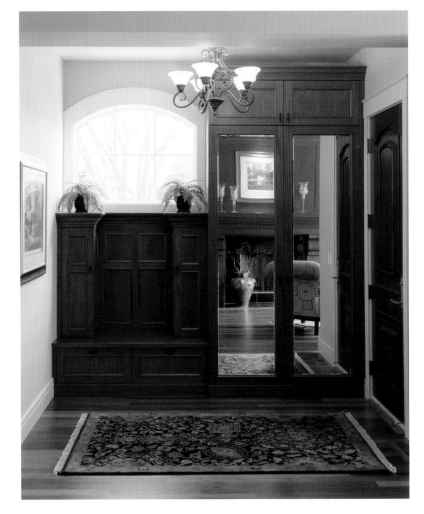

meetings in which the plans get progressively more detailed. Keith helps clients focus on how they plan to use the spaces and the overall look they would like to achieve, resulting in homes that are very luxurious for their owners yet have a very livable, casual elegance that reflects their tastes and lifestyle.

Working with clients from the broad strokes of conceptualization through completion—including many steps oft dismissed by architectural professionals like site and even cabinet knob selection—simply makes sense to the Keith. The company's design-build process allows the lead designer of each project to become the primary contact for clients, guiding them through the process while ensuring that their needs are met and their expectations exceeded. It also means that team members are able to combine their innate creativity with the nuts and bolts of construction, specifying high-end materials and a craftsman-like approach whereby state-of-the-art technologies are combined with Old World workmanship—carried out by trusted subcontractors, many of whom have worked with the firm for more than two decades—to create the ultimate in aesthetically exquisite, long-lasting quality architecture.

One of the hallmarks of a Keith Waters home is how well it takes advantage of the characteristics of its site. Prior experience in a landscape architecture firm imbued in Keith a critical understanding of site analysis. He developed a keen understanding of where to build, where not to build, what part of the land to salvage, how the sunlight should hit the architecture, the way in which to visually expand the site and more. His site planning

Above Left: Dramatic use of hardwoods and expansive windows creates an inviting living room.
Photograph by Page Studios Inc.

Above Right: Richly detailed cabinetry creates a warm alternative to a standard entry closet.
Photograph by Page Studios Inc.

Facing Page: Spectacular custom windows frame a breathtaking view of the Minnesota River Valley.
Photograph by Karen Melvin

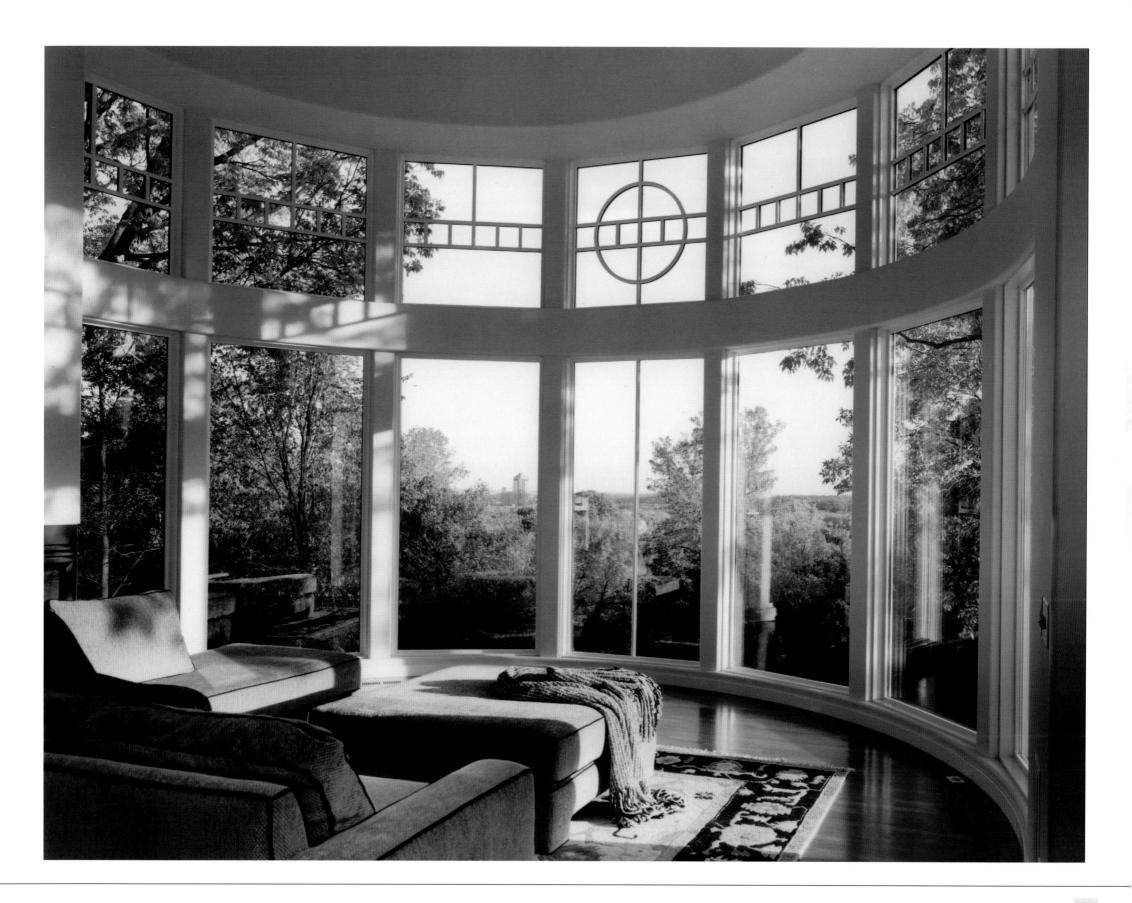

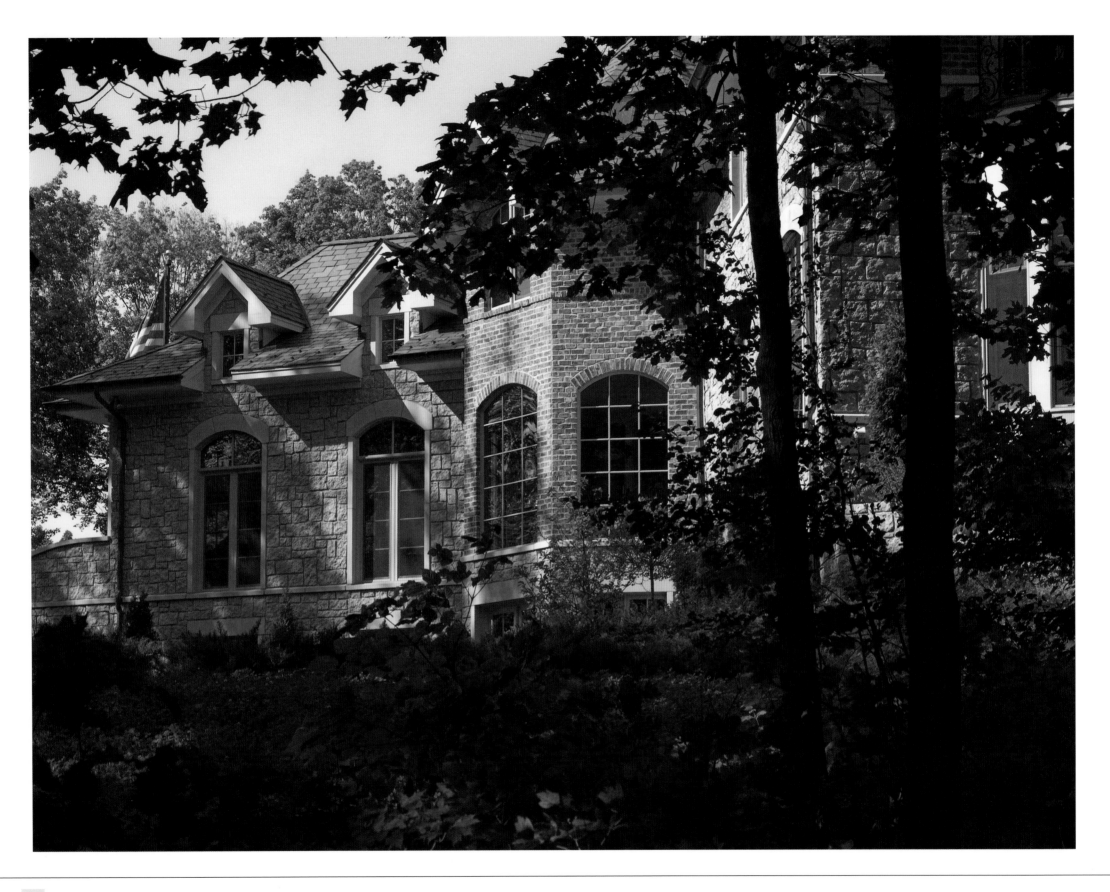

expertise affords the firm the unique ability to utilize pieces of property that are difficult to work with—whether steep, wooded, irregular in shape or very small—and, for this reason, remain largely overlooked.

Keith applies the same degree of planning foresight to the design of every home. Whether the style is modern or traditional, many things are carefully considered: functional relationships between rooms, the form of each room, sight lines from one room to another, acoustics, possible lifestyle changes and a host of other considerations. The scope of design typically includes all the fine details that give full form to their clients' individual sense of style: fireplaces, stairways, cabinetry, colors, door hardware and even cabinet knobs.

Following the philosophy that each home should reflect the client's needs, Keith recognizes that what is needed in the client's life at the moment will surely change in the future—and he plans for evolving needs when possible. For example, many of the firm's homes at its Portico neighborhood are designed as "Life Cycle" homes, with an additional dwelling unit included as part of each home—typically in the space over the three-car garage—for a mother-in-law, au pair or student newly out of college. Often, these units are equipped with a separate entrance, separate staircase and even space for a kitchen or eventual elevator.

Innovations such as these have caught the eye of publications like *Midwest Home* and *Better Homes and Gardens*. The firm has been recognized in the form of many awards, including the National Pacesetter Award for Design, but the most important reward for Keith is the satisfaction of his clients, who simply love his focus on "good sunlight, good spaces, good materials and clean lines."

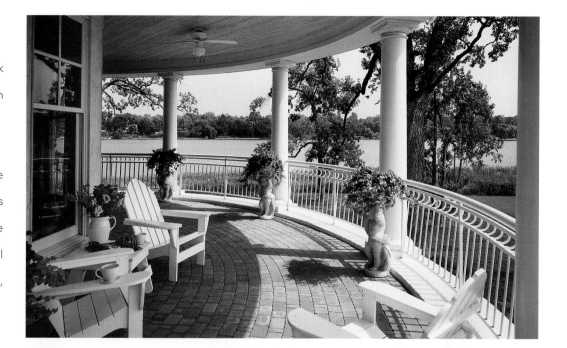

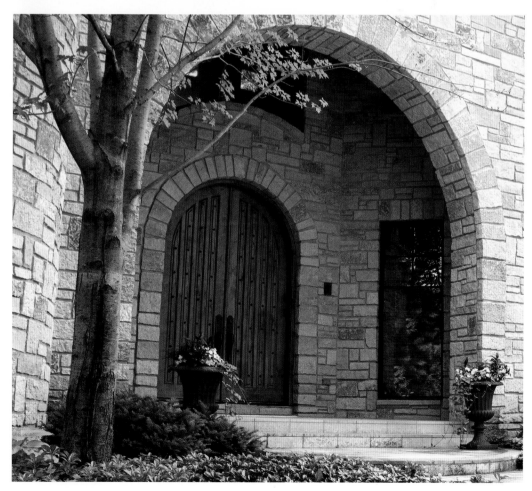

Top Right: Broad spacious verandas take advantage of the panoramic views and gentle breezes of Lake Minnetonka while giving this home a unique villa feeling.
Photograph by Karen Melvin

Bottom Right: Old World masonry construction and finely crafted detailing give this entry an endearing sense of shelter and permanence.
Photograph by William L. Meyer

Facing Page: A rich tapestry of stone, brick and slate gives this home a timeless quality within a woodland setting in Wayzata.
Photograph by William L. Meyer

PUBLISHING TEAM

Brian G. Carabet, Publisher
John A. Shand, Publisher
Steve Darocy, Executive Publisher
Joanie Fitzgibbons, Associate Publisher

Beth Benton, Director of Development & Design
Julia Hoover, Director of Book Marketing & Distribution
Elizabeth Gionta, Editorial Development Specialist

Michele Cunningham-Scott, Art Director
Emily Kattan, Senior Graphic Designer
Ben Quintanilla, Senior Graphic Designer
Jonathan Fehr, Graphic Designer

Rosalie Z. Wilson, Managing Editor
Katrina Autem, Editor
Lauren Castelli, Editor
Anita Kasmar, Editor
Ryan Parr, Editor
Daniel Reid, Editor

Kristy Randall, Managing Production Coordinator
Laura Greenwood, Production Coordinator
Jennifer Lenhart, Production Coordinator
Jessica Garrison, Traffic Coordinator

Carol Kendall, Administrative Manager
Beverly Smith, Administrative Assistant
Carissa Jackson, Administrative Assistant
Amanda Mathers, Sales Support Coordinator

PANACHE PARTNERS, LLC
CORPORATE OFFICE
13747 Montfort Drive, Suite 100
Dallas, TX 75240
972.661.9884
www.panache.com

MINNEAPOLIS OFFICE
612.423.1777

Robert Lund Associates Architects, Ltd.; *page 131*

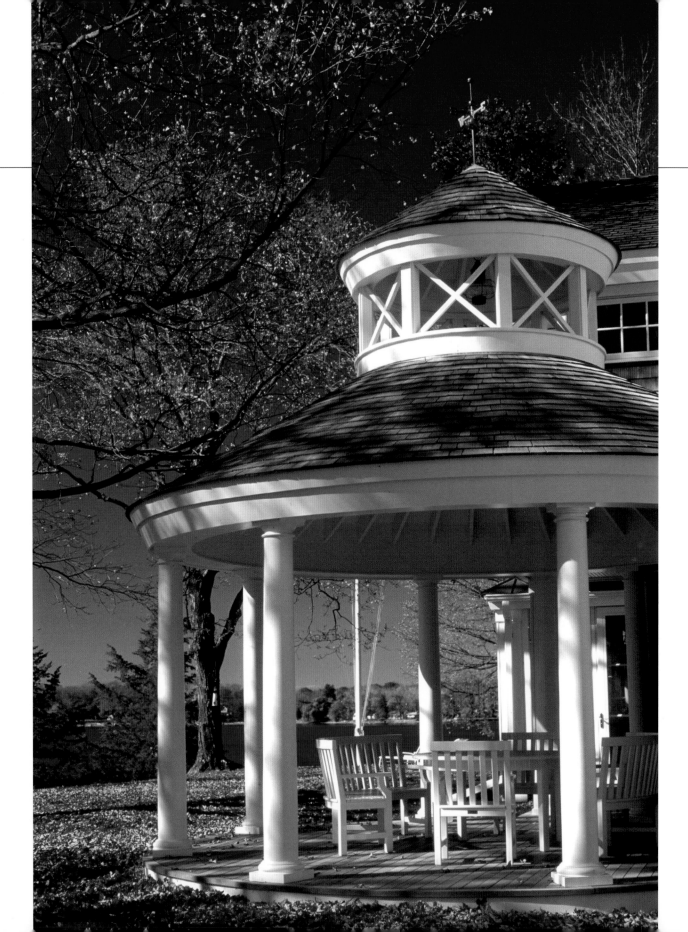

THE PANACHE COLLECTION

Dream Homes Series

Dream Homes of Texas
Dream Homes South Florida
Dream Homes Colorado
Dream Homes Metro New York
Dream Homes Greater Philadelphia
Dream Homes New Jersey
Dream Homes Florida
Dream Homes Southwest
Dream Homes Northern California
Dream Homes the Carolinas
Dream Homes Georgia
Dream Homes Chicago
Dream Homes San Diego & Orange County
Dream Homes Washington, D.C.
Dream Homes Deserts
Dream Homes Pacific Northwest
Dream Homes Minnesota
Dream Homes Ohio & Pennsylvania
Dream Homes California Central Coast
Dream Homes New England
Dream Homes Los Angeles
Dream Homes Michigan
Dream Homes Tennessee

Additional Titles

Spectacular Hotels
Spectacular Golf of Texas
Spectacular Golf of Colorado
Spectacular Restaurants of Texas
Elite Portfolios
Spectacular Wineries of Napa Valley

City by Design Series

City by Design Dallas
City by Design Atlanta
City by Design San Francisco Bay Area
City by Design Pittsburgh
City by Design Chicago
City by Design Charlotte
City by Design Phoenix, Tucson & Albuquerque
City by Design Denver
City by Design Orlando
City by Design Los Angeles

Perspectives on Design Series

Perspectives on Design Florida

Spectacular Homes Series

Spectacular Homes of Texas
Spectacular Homes of Georgia
Spectacular Homes of South Florida
Spectacular Homes of Tennessee
Spectacular Homes of the Pacific Northwest
Spectacular Homes of Greater Philadelphia
Spectacular Homes of the Southwest
Spectacular Homes of Colorado
Spectacular Homes of the Carolinas
Spectacular Homes of Florida
Spectacular Homes of California
Spectacular Homes of Michigan
Spectacular Homes of the Heartland
Spectacular Homes of Chicago
Spectacular Homes of Washington, D.C.
Spectacular Homes of Ohio & Pennsylvania
Spectacular Homes of Minnesota
Spectacular Homes of New England
Spectacular Homes of New York
Spectacular Homes of Vancouver

Visit www.panache.com or call

972.661.9884

PANACHE PARTNERS, LLC

Creators of Spectacular Publications for
Discerning Readers

FEATURED ARCHITECTS, DESIGNERS & BUILDERS

A. Maas Construction, Inc.
Al Maas
14551 Judicial Road, Suite 100
Burnsville, MN 55306
952.892.5469
Fax: 952.898.5145
www.amaashomes.com

Albertsson Hansen Architecture, Ltd.
Christine Albertsson, AIA
Todd Hansen, AIA
1005 West Franklin Avenue, Suite 5
Minneapolis, MN 55405
612.823.0233
Fax: 612.823.4950
www.aharchitecture.com

ALTUS Architecture + Design
Tim Alt, AIA, CID
1609 Hennepin Avenue South
Minneapolis, MN 55403
612.333.8095
Fax: 612.333.8098
www.altusarch.com

Barbour LaDouceur Design Group
F. John Barbour, AIA
Janis LaDouceur, AIA
129 North Second Street, Suite 103
Minneapolis, MN 55401
612.339.5093
Fax: 612.339.0499
www.bldgdesign.com

Carlson Custom Homes
Bruce Carlson
Sherry Carlson
1440 Bavarian Shores Drive
Chaska, MN 55318
952.200.3317
www.carlsoncustomhomesllc.com

CF design ltd
Cheryl Fosdick
230 East Superior Street, Suite 102
Duluth, MN 55802
218.722.1060
Fax: 218.722.1086
www.cfdesignltd.com

Charles Cudd Company
Charles Cudd
Charles Ainsworth
275 Market Street, Suite 445
Minneapolis, MN 55405
612.333.8020
Fax: 612.333.0516
www.charlescudd.com

Choice Wood Company
Nick Smaby
3300 Gorham Avenue
St. Louis Park, MN 55426
952.924.0043
Fax: 952.924.0269
www.choicecompanies.com

De Novo Architects, Inc.
James McNeal, AIA
275 Market Street, Suite 447
Minneapolis, MN 55405
612.332.4790
Fax: 612.343.4609
www.denovoarchitects.com

Erotas Building Corporation
David Erotas
Holly Erotas
21930 Minnetonka Boulevard
Excelsior, MN 55331
952.401.4300
Fax: 952.401.4330
www.erotasbuildingcorp.com

Eskuche Creative Group, LLC
Peter Eskuche, AIA
Minnetonka, MN
612.296.7575
Fax: 952.544.3844
www.timelessarchitect.com

John Kraemer & Sons
Gary Kraemer
4906 Lincoln Drive
Edina, MN 55436
952.935.9100
Fax: 952.935.9184
www.johnkraemerandsons.com

Keenan & Sveiven Inc.
Design/Build Landscape Architecture
Kevin Keenan
Tim Sveiven
15119 Minnetonka Boulevard
Minnetonka, MN 55345
952.475.1229
Fax: 952.475.1667
www.kslandarch.com

Keith Waters & Associates, Inc.
Keith Waters
6216 Baker Road, Suite 110
Eden Prairie, MN 55346
952.974.0004
Fax: 952.974.0005
www.keithwaters.com

Kurt Baum & Associates
Kurt Baum
314 Clifton Avenue, Carriage House
Minneapolis, MN 55403
612.870.1000
Fax: 612.870.2660
www.kurtbaumassociates.com

L. Cramer Designers + Builders
Larry Cramer
Jennifer Cramer-Miller
5500 Lincoln Drive
Edina, MN 55436
952.935.8482
Fax: 952.935.8468
www.lcramer.com

The Landschute Group Inc.
Jon Monson
202 Water Street, Suite 202
Excelsior, MN 55331
952.470.7416
Fax: 952.401.7609
www.landschute.com

McMonigal Architects, LLC
Rosemary McMonigal, AIA, CID
1224 Marshall Street NE, Suite 400
Minneapolis, MN 55413
612.331.1244
www.mcmonigal.com

Pillar Homes
K.C. Chermak
1700 Niagara Lane
Plymouth, MN 55447
763.475.1700
Fax: 763.476.1700
www.pillarhomes.com

Robert Lund Associates Architects, Ltd.
Robert Lund
4829 East Lake Harriet Parkway
Minneapolis, MN 55419
612.927.0680
Fax: 612.927.0382
www.rla-architects.com

SALA Architects
Bryan Anderson, AIA
326 East Hennepin Avenue, Suite 200
Minneapolis, MN 55414
612.379.3037
Fax: 612.379.0001
www.SALAarc.com

SALA Architects
Kelly R. Davis, AIA
904 South 4th Street
Stillwater, MN 55082
612.379.3037
Fax: 612.379.0001
www.SALAarc.com

SALA Architects
Dale Mulfinger, FAIA
440 2nd Street
Excelsior, MN 55331
612.379.3037
Fax: 612.379.0001
www.SALAarc.com

SALA Architects
Eric Odor, AIA
326 East Hennepin Avenue, Suite 200
Minneapolis, MN 55414
612.379.3037
Fax: 612.379.0001
www.SALAarc.com

Smuckler Architecture
Jack Smuckler, AIA
7509 Washington Avenue South
Edina, MN 55439
952.828.1908
Fax: 952.828.6007
www.smucklerarchitects.com

Steiner & Koppelman
David Steingas
Dave MacPherson
18340 Minnetonka Boulevard
Wayzata, MN 55391
952.473.5435
Fax: 952.473.5208
www.steinerkoppelman.com

Stonewood, LLC
J. Sven Gustafson
7407 Wayzata Boulevard
Minneapolis, MN 55426
952.697.5590
Fax: 952.697.5591
www.stonewood.com

Streeter & Associates
Steven Streeter
Donald Streeter
Kevin Streeter
Justin Streeter
18312 Minnetonka Boulevard
Wayzata, MN 55391
952.449.9448
Fax: 952.449.5784
www.streeter-associates.com

TEA₂ Architects
Dan Nepp, AIA
Tom Ellison, AIA
2724 West 43rd Street
Minneapolis, MN 55410
612.929.2800
Fax: 612.929.2820
www.tea2architects.com

Terra Verde Architects
Mark Queripel, AIA
Charlotte Grojean, AIA
Jeffrey Van Sambeek, AIA
Brian Nelson, AIA
Todd Remington, AIA
424 Washington Avenue North
Minneapolis, MN 55401
612.253.0504
Fax: 720.565.3931
www.terraverdearch.com

TNG, Inc.
Scott Ritter
420 North 5th Street, Suite 655
Minneapolis, MN 55401
612.929.2049
www.tng-inc.net

TreHus Architects + Interior Designers + Builders
David Amundson, CR
Meriwether Felt, AIA
3017 4th Avenue South
Minneapolis, MN 55408
612.729.2992
Fax: 612.729.3982
www.trehus.biz

The Urban Studio, LLC
Teresa McCormack, AIA
318 South Broadway
Rochester, MN 55904
507.285.5043
Fax: 507.285.5051
www.theurbanstudio.com

Water Street Homes, LLC
Rick Carlson, NAHB
464 Second Street, Suite 105
Excelsior, MN 55331
612.850.4002
www.waterstreethomes.com